ARTISTIC ANATOMY

ARTISTIC ANATOMY

BY

Dr. Paul Richer

Professor of Anatomy at the Ecole des Beaux-Arts
and the Academy of Medicine, Paris

TRANSLATED AND EDITED BY

Robert Beverly Hale

Instructor of Drawing and Lecturer on Anatomy
at the Art Students League, New York
Adjunct Professor of Drawing at Columbia University
Curator Emeritus of American Paintings
at The Metropolitan Museum of Art

WATSON-GUPTILL PUBLICATIONS/NEW YORK
PITMAN PUBLISHING/LONDON

Paperback edition 1986

Copyright © 1971 by Watson-Guptill Publications

First published in 1971 in the United States and Canada by Watson-Guptill Publications,
Nielsen Business Media, a division of The Nielsen Company
770 Broadway, New York, NY 10003
www.watsonguptill.com

Distributed in the United Kingdom by Phaidon Press Ltd.,
Littlegate House, St. Ebbe's St., Oxford

Library of Congress Catalog Number: 73-146794
ISBN 0-8230-0297-7

Manufactured in the U.S.A.

17 18 19 20 / 11 10 09 08

Contents

Part Two: Morphology, 83-135

Plates

Introduction

I am delighted to have the opportunity of offering an English translation of Dr. Paul Richer's *Anatomie Artistique* to artists and students of art. The term artistic anatomy implies a delicate and dynamic balance between the esthetic and the scientific. Very seldom are these two qualities combined in a single individual. Dr. Richer, however, was a first rate artist as well as a distinguished scientist. He was, furthermore, a man of truly wide interests. He was familiar with the full flow of the history of art; he was even aware of the then budding science of anthropology. He was, indeed, the first to fully realize the importance of this discipline to the teaching of artistic anatomy.

Every work on the subject of anatomy that has appeared since this book was first published has been strongly influenced by Dr. Richer's approach. It is not only the most complete but the most accurate of contemporary works on artistic anatomy. It has, indeed, the accuracy of a medical anatomy. But it must be remembered that medical anatomies are not written with the selective and esthetic requirements of the artist in mind. This book, however, meets both these requirements.

It is selective in that if offers only such material as an artist-student needs. It provides information on bone, muscle, function, and proportion that will enable him to arrive at the precise shape of all bodily forms. Further, it describes how these forms change in shape as the body alters its position. In short, it offers the student the understanding necessary to become aware of the movements and meeting places of all bodily planes. Frankly, it is only through such understanding that a successful rendering may be completed.

The author is aware of the dangerous possibilities of esthetic misinterpretation and over-influence. He is conscious, for instance, of the confusing relationship between perspective and proportion. I know of no other contemporary work in this field where these elements remain constant from plate to plate. And in the plates themselves the style is deliberately subdued so that it may not prove infectious to the student. These, I feel, are matters of considerable importance. Students are deeply influenced by books on drawing, but they are seldom mature enough to judge the qualifications of the author, the accuracy of his statements, or the qualities of his style.

From the point of view of traditional drawing, it is assumed that an artist cannot draw a form successfully unless he can draw that form from his imagination alone. In other words, when an artist draws from a model, he does not attempt the impossible task of directly copying every detail he sees before him. He already has in mind a full image of the human figure, its forms, planes, and proportions, decided upon according to his taste. He has patiently constructed this figure through study and observation. To a great extent, when the artist draws from the model, he visualizes and sets down the image he has long since created. Thus the artist's personal image of the human body, his secret figure, so to speak, becomes the implicit vehicle of his style.

Naturally, as the artist draws, he makes changes here and there in order to conform to certain obvious characteristics of the model. But I assure you, he makes fewer changes than you might think. This is because laymen, on the whole, are unaware of the majority of the forms which together make up the human body. Being unaware of the identity—or even the existence—of these forms, they can have no conception as to the shapes of these forms. Thus, they cannot be too critical of what the artist chooses to set down.

Let us take an example. Let us suppose that the inferior termination point of the fleshy mass of the tensor fasciae latae, on the artist's personal image of the human body, is precisely at the bottom level of the buttocks. Artists like to put this termination point at this level as a matter of convenience. (It is easy to remember.) Now the actual termination point *upon the model* may be a touch higher or a touch lower. The artist, however, will place the termination point on his drawing exactly where it is upon his personal image. And why not? The mental effort needed to determine the precise solution of such a trivial matter might well impede the flow of his style. And he is, of course, aware that hardly anyone has even heard of the tensor fasciae latae. He is also aware that among those who have, very few indeed will be concerned as to its exact shape or its proportional relationship to the rest of the body.

Or let us suppose that the navel on the artist's personal image is vertical. This may well be, because a vertical navel suggests very nicely the extent of the rotation of the pelvis. Now even though the model has a horizontal navel, the artist may follow his image and draw a vertical navel. Who cares? Who knows? Probably not even the model.

In another matter, a matter most mysterious to the layman, the artist follows his personal image almost exactly. The layman may notice that the artist places upon his drawing certain lines and passages of light and shade that he, the layman, cannot see at all upon the

model. As a matter of fact, the artist cannot see them either. What the artist is doing is this: he is visualizing his personal image in the same position as the model; he is illuminating this image with lights of his own choosing; he is transferring to his drawing the lines and tones he sees upon this image. His lines are indications of the meeting of planes; his varying tones are indications of the changing shapes of the planes on which these tones move.

In the creation of his conception of the figure, the student must realize that the shapes of its forms are essentially based upon the skeleton. Naturally, the shapes of the forms of all the hard parts of the body—the head, the hands, the feet, the joints—are dependent upon bone. But it must be understood that the shapes for all other bodily forms are basically dependent on bones as well. The neck, for instance, rises from the first two ribs. Together, these ribs create an almost perfect circle; hence the cylindrical shape of the neck. The palpable mass of obliquus externus moves from the pelvic crest to the lower ribs. An understanding of the shapes of these bony parts will lead to an understanding of the shape of this muscular mass.

Anatomical plates, no matter how excellent, are essentially two dimensional; they cannot suggest the full shape of the bones. They can, however, point out proportional relationships and salient areas to be studied. I therefore strongly urge any student who is studying this (or any other) work on artistic anatomy to make every effort to acquire some bones. Real bones are the best, though nowadays medical supply houses have excellent plastic reproductions that are not too expensive.

To a great extent, the creation of a personal image of the human body consists of the formulation of questions and the search for answers. Questions such as, what is a proper shape for the rib cage from all aspects? Where should the high points of the pelvis be placed? What is a convenient proportional relationship for the carpus and the rest of the hand? Most works on artistic anatomy will give you varying answers, but Richer will answer all your questions precisely. And you can always rely on his knowledge and his taste.

I should like to thank my dear friend Mary Lyon for the help and advice she gave me. And I should like to offer my appreciation to my brilliant student Heather Meredith-Owens. As my editor, she has had the difficult and detailed task of checking the anatomical nomenclature used in this book, of preparing the anatomical plates, and finally, of bringing this book to press.

Robert Beverly Hale

Preface

I feel sure that it is not necessary for me to explain here why studying anatomy is important for all painters or sculptors who have to recreate all the varied aspects of the human figure in their work. Although it used to be a debatable issue, it is no longer.

"Anatomy" Gerdy said, "increases the sensitivity of the artist's eyes and makes the skin transparent; it allows the artist to grasp the true form of the surface contours of the body because he knows the parts that lie hidden beneath a veil of flesh." It is as though anatomy were a magnifying glass, making forms visible in minute detail. Through this glass the artist is able to see more clearly, and more quickly. As a result, he can render forms with greater fidelity; they have become distinct to his eyes because they are clear in his mind.

In fact, this is only another way of stating the same principle that Montaigne formulated: "It is the mind that listens, the mind that sees." Peisse, too, made the same point when he said: "The eye sees in things only that which it has observed; it observes only that which is already an image in the mind."

When a knowledge of anatomy is applied in the plastic arts, it leads to an understanding of exterior form through the relationship that exists between it and the underlying forms. Studying anatomy teaches the artist why the exterior forms of the body appear as they do, in action and in repose.

I have undertaken this work with the object of easing the path of artists in these highly specialized studies; they are always long and arduous. Its aims may be summed up as follows. First, to place paramount importance on the drawings—almost literally replacing verbal description with graphic—so that the entire work is encompassed in the plates. The text is to be considered merely as an accompaniment to the plates. Second, to follow, in order of the plates, the same analytical method as in the development of the text; proceeding, that is, from the simple to the complex, from the known to the unknown, from the part to the whole.

To facilitate these studies, all necessary caption information has been inserted beside the figures rather than grouped remotely at the bottom of the page.

However, an effective, articulate treatise on anatomy should go further. It should not consist solely of a series of reasonably clear anatomical drawings with a written summary of descriptive anatomy. Such a work should establish relationships, down to the smallest detail—relationships between the deep forms and the surface contours, relationships between the artistic concept and the figure itself. This means that the nude subject should be studied exhaustively, and drawn repeatedly from life.

I have concluded, therefore, that there is room for another work on anatomy in addition to the books already available to artists. (The most highly esteemed of these, and for good reason, is that of Mathias Duval.) The work which I have undertaken contains more than the usual number of illustrations, and besides the anatomical description, it contains a quite separate study of exterior form.

This book, then, is divided into two parts: the first, *anatomy*, is devoted to detailed anatomical studies; the second, *morphology*, to the study of exterior form.

The first part examines the bones, the joints, and the muscles. It ends with a description of certain superficial veins and a most important study of the skin and the layer of fatty tissue which underlies it.

Throughout the anatomical part, man is shown standing erect and motionless, eyes front, arms alongside the trunk with forearms in supination, palms facing forward and feet together, touching. This attitude has become a convention used in anatomical study.

It is in this attitude that anatomists have always described the human figure, and it is this attitude that has created terms and a certain nomenclature that are universally accepted today. We can scarcely alter this now.

The plates, therefore, represent man in this conventional attitude. They are drawn from the two basic points of view: anterior or posterior, and in profile. For academic reasons, all intermediate points, such as a three-quarters view, have been avoided. Finally, the plates adhere as far as possible to what in descriptive geometry is called "orthogonal projection." All perspective is thus eliminated with the consequent inevitable distortions. If the drawing suffers from an artistic point of view, much has been gained in clarity, it seems to me, and clarity is our main objective.

In the osteological plates, the bones are first seen one by one, independently of their relationship to each other. The description of a joint follows the explanation of the bones that form it; this is accompanied by sufficient physiological information to make clear the mechanism of the articulation. Then the effect of bone structure on the outer form is explored. To this end, a special paragraph is devoted to each major region of the body.

Further, in the osteological plates, bones are recorded in full detail. This holds true also for the plates on the

muscles. On the whole, these studies are carried much further here than is customary in the works on anatomy for art students.

In the plates devoted to myology, the first drawings concern the deepest muscles, those resting directly on the skeleton. The middle layers follow, progressing logically outwards to the superficial muscles. The student will thus observe the skeleton "clothing" itself, so to speak, with the successive thicknesses of muscle, from the center to the periphery. This will fully reveal to the student all that constitutes the true mass of the body and will enable him to render its outer form with accuracy. The exterior shape can hold no mystery for one who has studied the underlying forms.

It is of the utmost importance to study the deeper muscles; at times these may influence the surface form more than the superficial muscles, especially in the performance of certain movements.

In the text which accompanies the plates on myology—and following the established plan—each muscle is described separately. Its precise origins and insertions are given, its shape, its volume. That part of the muscle which contributes to the exterior form is carefully indicated.

Thus understood, the anatomical section of this work already has supplied numerous hints as to the *raison d'etre* of certain exterior forms. But, as I have said, this constitutes only half of the task we have undertaken, namely, to present an analysis of form. It therefore becomes necessary, in the second section of the book, to reestablish a synthesis of form.

The second part of the book was conceived according to certain principles which I shall explain briefly. I am among those who think that science has nothing to teach the artist concerning the direction of line, or the aspect of a surface. An artist worthy of the name is uniquely endowed to grasp the form instantly, instinctively, to judge it and then to interpret it. I should add that, as with form, so with color. Each artist, according to his temperament, has a vision which is his alone. Thus the artist cannot demand of anatomy that it provide him with unique ideas, beautiful surfaces, majestic lines, and voluptuous contours.

On the contrary, the anatomist should avoid esthetic considerations as superfluous. With total detachment, in the interest of his art, he should confine himself to portraying nature, live, and exactly as it is in its exterior form and its deeper parts. He should seek not so much to describe as to demonstrate, to explain, showing cause and effect. For this he needs only two qualifications: clarity and precision.

With this in mind, and following the example of Gerdy, I have divided the human body into regions and defined these different areas in a special terminology which explains their morphological details, their planes and depressions. This was necessary in order to simplify and clarify this entire study. It allows the same part in different models to be compared, or the same part on one model in different positions. One can see how useful this plan is in defining the limits, for instance, of the several areas of the trunk.

In the plates depicting the nude, the first anatomical illustrations (Plate numbers 74, 74, 76), show the human body (male) in the conventional attitude. They present the entire body, from three points of view, providing a true topography, or "contour map," of the human form. In the other plates, large segments of the body are presented separately, facilitating the study of the different regions in minute detail. Furthermore, there are sketches in the text itself comparing the morphology of the human body in male and female.

In the second series, the plates demonstrate the changes in the exterior form brought about by different movements. This is an exceedingly important part of the work as a whole. In fact, it might be said that all the preceding plates have been leading up to them.

Since it is impossible to represent all the movements of the body in their almost infinite variety, it was necessary to make a choice and proceed through analysis. Combined movements may be broken down to movements of diverse parts. These last have been stressed. In short, the movements of each part, however varied they may be, can quite easily be reduced to a few. These constitute the basic, elementary movements of which the others are but combinations.

Thus only the elementary movements of each part of the body need be represented because it is always through one, or several, of these movements that the entire body is portrayed in action.

Accordingly, for the movements of the head and neck, there are four drawings showing flexion, extension, rotation, and rotation and lateral inclination.

For the trunk, I have first shown the effects of moving the shoulder and the arm; then the movements of the trunk on itself which resolve themselves into four principal motions: flexion, extension, rotation, and lateral inclination.

As for the arm, its movements have been studied in particular detail and shown in four different positions: in supination, in pronation, in semi-pronation, and in forced pronation. Flexion of the arm is shown in its various degrees.

The plates devoted to the leg show it in extreme flexion and moderate flexion, the foot lifted or on the ground.

In order to further the analytical process, the plates described above are supplemented by anatomical sketches in the text. Moreover, there is text corresponding to all the plates on exterior form. This text, besides explaining the morphology, includes a study of movement itself, detailing the displacement of various bones in action as well as the powerful musculature brought into play.

Finally, the work ends with a study of the proportions of the human body. In conclusion, I owe the reader a few words of explanation concerning the morphological drawings. But first I should like to assure him that I have never presumed to offer artists what purports to be the perfect model of exterior form.

The matter of the form itself is therefore entirely optional. I feel impelled here to define clearly the role which I have assumed: it is purely that of purveyor of information.

The drawings were made from life and, after careful research, from two models (one served for the torso, one for the limbs). They were chosen not according to any

esthetic formula, but for reasons of clarity and academic method. Their bodies provided fine skin, powerful musculature, an almost complete lack of fatty tissue. Their forms were not by any means simple, but they were very clear-cut, made to order, for study and demonstration. Once familiar with these forms, one should be able to recognize them in other models who may perhaps be younger, fatter, or simpler but more "difficult to read."

To sum up, my aim has been to put in the hands of artists a manual which is entirely technical, which will not attempt to tell them how to choose a model but will tell them how to read and understand a model when they have chosen one.

And now a few words to doctors for whom this book also is intended, even though it is primarily for artists.

Long ago Gerdy became aware that anatomical knowledge of the surface forms of the human body might well be of value to surgeons. "The exterior forms," he said, "show what is hidden within the depths of the body by what is visible on the surface."

However, there is another point I must bring out which should be of interest to physicians as well as surgeons. It is the incontestable value of a precise understanding of the normal exterior form. Only in this way, in the course of a diagnosis, can a doctor recognize any abnormality that results from disease. Dr. Jean-Martin Charcot, with all the authority attaching to his eminent position, recently told an audience at the Salpetriere:

"I must emphasize strongly the importance, in matters of neuropathology, of examining the patient in the *nude*, whenever the susceptibilities of the moral order do not oppose it.

"In fact, gentlemen, we doctors ought to know the nude as well as or even better than do the artists. If a sculptor or a painter makes a mistake in drawing it is a serious matter, no doubt, from the point of view of art. But from a practical standpoint it is of no consequence.

"But what about a doctor, a surgeon, who mistakes— and this happens often—a prominence, a normal contour, for a deformity? I hope this digression will serve once more to stress the need for medicosurgical study of the nude by both physician and surgeon."*

In order to profit from an examination of the pathological subject it is necessary to know the normal nude thoroughly. Nevertheless, this is a study somewhat neglected by doctors. Actually there exists, among us doctors, a sort of prejudice which allows us to consider the anatomy of forms as an elementary science which we gladly abandon to the artists; we assume the doctor already knows enough about it.

Indeed, the anatomist who has often visited the amphitheaters and watched the scalpel explore the cadaver in every possible way, inside and out, can convince himself, and with every appearance of reason, that he knows human morphology even though he has not studied it specifically. Having neglected not even the smallest organ or tissue, he believes that the knowledge of exterior form is implicit with this accumulation of anatomical insight. However, this is an illusion. I have seen distinguished anatomists show confusion in the presence of the living nude, searching memory in vain for the anatomical cause of a certain unexpected bulge or prominence which, in fact, was perfectly normal.

But this is easy to explain. The study of the corpse cannot offer what it does not have. Dissection, which reveals all the hidden areas of the human machine, does so at the cost of destroying the exterior form. Death itself, from the first hour, brings on the final dissolution. Through the subtle modifications that occur then, throughout all the tissues, the exterior appearance is profoundly altered. Finally, it is not from the inert corpse that one grasps the incessant changes with which life, in its infinite variety of movement, imbues the entire human body. It might even be desirable to arrange, in our anatomical amphitheaters, the study of the living model in conjunction with that of the cadaver. This could well prove useful.

As a matter of fact, the anatomy of exterior form can only be studied from the living model. It is true that it is based on ideas provided by the corpse and its dissection, but these must be supplemented by observation of the living model.

The procedure is synthesis; its method is observation. To observe is to discover the multiple causes of the forms that make up the living human body and to capture this in a description. The living form asks only to be studied in itself and for itself. It provides the awareness that conventional anatomy cannot.

It is fitting that I should record here my deep indebtedness to Dr. Jean-Martin Charcot, the great master, for his encouragement and advice given generously throughout the course of this work, which was carried on in the laboratory of the Salpêtrière.

I am also grateful to Monsieur Le Bas, director of the Salpêtrière, from whom I have, once again, received warm cooperation; also to my good friend, Dr. Paul Poirier, chief of anatomical studies of the Faculty of Medicine. Without reserve he has put at my disposal his anatomical knowledge and the incomparable facilities of the amphitheaters of which he is director.

Paul Richer

Paris, July, 1889

* *Leçons du Mardi*, Oct. 30, 1888.

Part One
ANATOMY

This section of the book comprises the study of the bones (osteology) and the joints (arthrology); the study of the muscles (myology) as well as some observations on the superficial veins; finally, a study of the skin and the fatty tissues lying beneath it.

1. Osteology and Arthrology

Of all the components of the body, the bones have the greatest solidity and stability. The bones are the means of support and protection for the softer parts of the body. In the living, a fibrous membrane called the *periosteum* adheres to the bones except at the points of attachment to the tendons and ligaments and to the articular surfaces where cartilage is substituted. All this has been removed from bones that have been prepared for study.

CLASSIFICATION OF BONES

Anatomists divide the bones into three classes, according to their shape. First, the long bones—those in which length surpasses other dimensions. These have a shaft and two extremities. Examples: the humerus, the femur. Second, the large or flat bones—those which have a considerable extent as compared with their thickness, such as the shoulder blade or coccyx. Third, the short or mixed bones, that is to say, those which are neither long nor large, such as the vertebrae and those of the carpus or the patella.

For easy description, the bones are compared to geometrical solids. One considers their surface, their angles, and their sides. The exterior configurations are comprised of the general shape, the projections, and the cavities. The projections take on the aspect of lines, crests, tuberosities, and spines. The cavities are simple depressions, holes, grooves, sunken curves and so forth. The projections, like the cavities, are articular or non-articular, depending upon whether they do or do not form a joint.

SUBSTANCE OF BONES

To the naked eye, the bone presents a compact and a spongy substance. The *compact substance* forms a sort of crust, more or less thick, on the exterior of all bones. In this compact mass of the bone, cavities are scarcely perceptible. The *spongy substance* is formed of reticular layers of spicules and lamellae surrounding the irregular cells which intercommunicate with each other. This osseous substance is found in the interiors of bones, especially the short bones and at the extremities of the long bones, although the bodies of the long bones are formed almost completely of compact tissue. At the center of the bones is a sort of cavity or canal for the marrow.

In the interior of the bones, filling the canal, is a soft substance which constitutes the *bone marrow*. Marrow is composed of cellular tissue and fat and is reached by blood vessels which pass through the wall of the bone.

On the outside, the bones are covered by a membrane of tendinous fibers called the *periosteum*, and by a layer of special tissue called *cartilage* which we shall study later. Cartilage covers those parts of the bones which come together to form articulations; the periosteum covers the rest.

Cartilage is much softer than bone and has great elasticity. When cartilages are fresh they have a bluish-white tint, when they are dry they become yellowish, transparent, and brittle. Free cartilage, such as the cartilage of the ribs, is covered by a membrane analagous to the periosteum called the *perichondrium*. Cartilage with an intermixture of fibrous elements is called *fibrocartilage*.

All the bones, supplemented by cartilage, are joined together to form the framework of the body. This is called the *skeleton*.

ARTICULATION OF THE BONES

The study of the joining, or articulation, of the bones, accomplished in various more or less complicated ways, is called *arthrology*. The degree of "give" or movement of the bones within an articulation, one against another, is highly variable. The several types of articulation fall into three categories: the *sutures* or *synarthroses*, the *symphyses* or *amphiarthroses*, and the *diarthroses*.

Sutures. In sutures, the bones are fastened together by an intermediate mass of fibrocartilage. The periosteum is continuous from one bone to another, rendering the articulation immovable.

Amphiarthroses. In the *amphiarthroses* or *symphyses*, the contiguous bony surfaces are covered with cartilage; the ligamentous mass between them is much thicker than in the sutures, allowing a certain mobility for the bones in contact. Sometimes this connecting mass is filled out, sometimes it is hollowed out to form one, or even two, cavities.

Diarthroses. The *diarthrodial* articulations are the most complex. The contiguous bony surfaces are covered with a thin layer of *articular cartilage*, at the periphery of which the periosteum stops. They are connected by a fibrous element, shaped like a sleeve, and reinforced on the exterior by peripheral ligaments. The inner surface of this is lined by the *synovial membrane*, composed of a

continuous layer of epithelial cells. The bony extremities are in close contact so that the articular cavity is reduced to almost nothing. It is filled with a fluid which is secreted by the synovial membrane to facilitate the sliding action. In the case of the articular bony surfaces which are not contiguous, they are separated by a fibrocartilaginous ligament fastened, in turn, to the peripheral ligaments whose purpose is to adjust this discrepancy, adapting each of its surfaces to the bony part they control. The articular cavity is thus divided in two, each half provided with a synovial membrane.

OSSIFICATION OF THE BONES

In the foetus, the skeleton is at first entirely cartilaginous. Ossification—that is, the transformation of cartilage into bony tissue—takes place progressively and starts at several points in each bone. The ossified portions spread and eventually merge so that all trace of their cartilaginous origin disappears.

In the new-born, the skeleton is still mostly cartilaginous and it is due to the cartilaginous nature of this tissue that the growth of the bones is possible. It is not until the age of about twenty-five that growth stops and ossification is complete.

INFLUENCE OF BONES ON FORM

The study of the bones is the basis of all anatomy. From the standpoint of the morphological approach, which is our principal objective, it is of no less fundamental importance. It is the bones and their rigidity that give the body its proportions. By the stability of their subcutaneous projections, they make possible exact measurements. Even when the bones are deeply situated, they often determine the general form of a particular region. When they are superficial, they play a direct part in creating the actual exterior form. The shape of the articular extremity of any particular bone indicates the direction and the limitation of the movements allowed by their articulation. Finally, their relationship to the muscles, whose extremities are almost all attached to bones, makes a profound knowledge of the bones necessary to understand myology.

In the study that follows, the bones are not separated from their joints; their articulations are described along with the parts of the skeleton that make them up.

2. The Skeleton of the Head

I shall not describe separately all the bones anatomists consider to be distinct pieces which, taken together, compose the skeleton of the cranium and the face. These bones, which number eight for the cranium, and fourteen for the face, are as follows:

Bones of the cranium: one frontal, two parietal, two temporal, one occipital, one sphenoid, one ethmoid.

Bones of the face: two maxillary, two palatine, two nasal, one vomer, two inferior nasal conchae, two lacrimal, two zygomatic, one mandible.

Except for the mandible, however, all these bony parts are so closely fused together that it would be impossible for any one of them to perform the slightest independent movement. The skeleton of the head is, therefore, a single bone structure; it can be considered as a whole complete form by itself, or even as a single bone artificially divided by anatomists for purposes of description.

Be that as it may, the anatomy of form need not go into the complex details of the head. It can quite simply consider the skull as two distinct pieces: one, the cranium and upper part of the face; two, the lower jaw or mandible.

CRANIUM AND UPPER PART OF THE FACE

The cranium is a sort of bony box, irregularly ovoid in shape. It stands at the top of the vertebral canal and opens into it. In fact, it has been quite correctly regarded as an enlargement of the vertebral canal. The cranium encloses the brain, just as the vertebral column encloses the spinal cord, which is itself but an extension of the brain. It forms the superior and posterior parts of the head. From its anterior part the bones of the face are suspended, crowned by the forehead, or frontal bone, which closes the front of the cranial cavity.

Behind the bones of the face, on the under side of the skull, a vast orifice (*foramen magnum*) opens up, connecting the cranial cavity with the vertebral canal; the cervical column reaches as far up as the cranium, behind the skeleton of the face.

To make description easy, let us consider the skeleton of the head from its various aspects: the anterior, the lateral, the posterior, the inferior, and the superior.

ANTERIOR ASPECT (PLATE 1, FIGURE 1)

The entire superior front part of the skull is formed by the frontal bone. From our special point of view, the following characteristics are important.

In very young subjects, the frontal bone is divided from top to bottom on the median line by a denticular suture which generally disappears toward the age of two years; at that period, a complete fusion of the two halves of the bone has taken place. It is not unusual, however, to find traces of this suture in individuals of a more advanced age.

On each side, toward the center of the bone, lie two symmetrical bumps (*frontal eminences*) marking the points of ossification of the two halves. These eminences, most noticeable in infancy, are exaggerated in craniums deformed by rickets.

Above the root of the nose there is a small median protuberance at the same level as, and corresponding with, the frontal sinus. This is the *nasal eminence* but, because of the shape of the surrounding muscles, it becomes a depression in the living. Two elongated protuberances which support the eyebrows (*superciliary arch*) extend laterally and obliquely upward from the nasal eminence. Below these are two curving borders, the *supraorbital margins*, which terminate the frontal bone in this region. These orbital margins are joined at their extremities with other bones of the face in the following manner: their external extremities (*external orbital apophyses*) unite with the superior angles of the *zygomatic bones*; their internal extremities unite with the ascending processes of the superior maxillary. Between the two internal orbital apophyses, or processes, are the nasal bones.

The nasal bones are two small osseous pieces which lie very close against the median line, forming the root of the nose. At their inferior borders they articulate with the lateral cartilages of the nose.

The *superior maxillary* bones form the entire median portion of the skeletal face. They are symmetrical, fused on the median line, and contribute to the formation of the orbital cavities, the nasal cavity, and the buccal, or oral, cavity.

The median portion of the superior maxillary provides for the insertion of a great many of the facial muscles; the body of the bone is hollowed so that a groove connects it with the nasal cavity fossae. Four processes extend from this central point: above, the rising frontal process which, with the nasal bones, surround the anterior orifice of the nasal cavity; on the outside, the zygomatic processes which are joined to the zygomatic bones; below, the alveolar process shaped like a horseshoe and containing sockets for the teeth. And last, inside and extending transversely toward the back, are the palatine processes which join medially to form the vault of the palate.

The zygomatic bones define the sides of the frontal aspect of the face. Shaped like a four-pointed star, they

complete the orbital orifices. The superior angle rises to the external orbital process of the frontal bone. The anterior angle runs along the orbital edge toward the superior maxillary. The inferior angle articulates with the zygomatic process of the superior maxillary. And the posterior angle supports the zygomatic process of the temporal, thus forming an arch which we find repeated on the lateral aspect.

The only independent bone of the skull, the inferior maxillary, or mandible, completes the skeleton of the face. More on this later.

The different bones of the head surround the cavities which hold several of the sensory organs. These are the nasal and the oral cavities. The orbits are the cavities which hold the eyes. They are situated on each side of the median line, separated by the nose, directly beneath the cranial cavity. Each one is cone-shaped, like a four-sided pyramid of which the base is pointing to the front.

This base, surrounded by the bones described above, is shaped like a square with rounded corners and four margins. The lateral margin is almost vertical and is situated on a plane behind the internal margin. The other two, superior and inferior, run at a slightly oblique angle from within to without, from above to below. The superior external angle shelters the lacrimal gland. At the inferior internal angle the superior orifice of the *nasal canal* is situated.

The four walls of the orbit correspond with the four margins. The walls are formed not only by the bones already described, but also by others which lie deeper in the skull and are of little importance to artists. I shall merely say that the internal wall is situated on the vertical anteroposterior plane, while the outer wall is obliquely inclined toward the outside.

The summit of the orbital cavity, directed upward and inward, has a number of small openings leading to other deeper cavities. Most important is the optic foramen, through which the optic nerve passes. The orbits are subject to marked differences in conformation depending on the individual subject.

The nasal cavities, lying between the orbits, are much more extensive than the anterior orifice suggests. Above, they rise as far as the frontal bone, below they descend as far as the root of the palate, in the back they open into the throat. In addition to these bones the nasal cavities are formed in large part by a bone deeply situated and called the *ethmoid*. They are separated by a vertical partition on the median line; this is a single bone: the *vomer*. The anterior opening of the nasal orifice has been compared to the heart on a playing card, in reverse. We have already named the bones which encircle it. On the median line of the inferior part the nasal spine is situated.

POSTERIOR ASPECT (PLATE 2, FIGURE 2)

The posterior view shows the back of the great ovoid of the cranium, formed by the junction of three bones: above by the two parietals, below by the occipital.

LATERAL ASPECT (PLATE 1, FIGURE 2)

On the side view all the features of the skull which we have been examining from the front are shown in profile. The prominence of the nasal bones and the inferior nasal spine are clearly defined. The orbital orifice becomes an irregular line. The zygomatic bone presents details merely glimpsed from the front view; its posterior angle articulates with a long process from the *temporal bone*. This forms a solid, bony arch, the *zygomatic arch*.

The temporal bone is at the center of this region. Toward the middle of the temporal bone the external orifice of the auditory canal can be seen and descends into the massive portion of the bone. In front and below, the *styloid process* descends in an oblique direction. The mastoid portion of the bone reaches behind to the occipital bone where it ends below in the rounded *mastoid process*, always clearly visible under the skin behind the ear. Immediately above and in front of the auditory orifice the zygomatic process begins and, with the zygomatic bone, it forms the zygomatic arch described above. All the superior part of the bone is thin and forms the *squama*. This is shaped like an oyster shell; it is joined to the parietal bone in an irregular curve.

Above the squama of the temporal bone, the parietal forms the roof of the cranium. Toward its center there is a considerable eminence, *parietal eminence*, and near its lower edge there is a curved line which, above and behind, delineates the *temporal fossa*. In the front on the profile, and at the back of the occipital, the frontal bone appears. This will be described in detail later.

Toward the middle of the lateral view of the cranium lies a hollow, shallow above and in back, deep below and in front. This is the *temporal fossa* which is bounded above by the curved temporal line of the parietal and the line of the frontal. The temporal fossa is limited in the front by the orbital process of the zygomatic bone; it is limited below by the zygomatic arch.

The temporal fossa is seamed in various directions by sutures which mark the points of juncture of those bones which combine to form it. Among these, at the anterior part, is the great wing of the sphenoid bone.

INFERIOR ASPECT (PLATE 2, FIGURE 3)

All the inferior part of the skeleton of the head (minus the lower jaw) is called the base of the cranium. Although it is quite hidden by the soft parts of the neck, its most important characteristics should be pointed out briefly. The occipital takes up half of the posterior and median part of the cranium. The bone presents a great orifice, *foramen magnum*, which enables the cranial cavity to communicate with the spinal canal. In front of this orifice is the *basilar part*, the thickest portion of the occipital, which is joined with other bones to form the base of the cranium. On the sides, in the anterior part, two oblong, protruding surfaces articulate with the atlas; these are the condyles. In the back, the bone is thinnest and it is marked on the outside by roughnesses for the insertion of the neck muscles. This sometimes shows as a depression on a model. On the median line, the *external occipital protuberance* is connected with the foramen magnum by the *median nuchal line*. At the sides there are two curved lines reaching to the extremities of the bone. One is the *superior nuchal line* which, on the flayed figure, marks the separation of cranium and neck; the other is the *inferior*

nuchal line which is surrounded and hidden by muscular insertions.

The occipital is wedged, so to speak, between the two temporal bones, of which the petrous portion converges on each side of the basilar part of the occipital. Further to the outside the mastoid process appears; it is marked, within and below, by the mastoid notch.

The anterior half of the base of the cranium is not situated at the same level as the posterior half which we have just described.

Finally, I should point out the zygomatic arch which appears completely detached. Its posterior extremity contains a depression, the *glenoid cavity*, which serves as the point of articulation for the mandible. The glenoid cavity is bordered in front and outside by a process from which the zygomatic arch originates. This process is transverse and rounded; it plays an important part in the temporomaxillary articulation.

SUPERIOR ASPECT (PLATE 2, FIGURE 1)

Viewed from above, the cranium manifests its ovoid shape, formed in front by the frontal, on each side by the parietals, and in back by the occipital. These diverse bones are finely and irregularly united at their borders in a most solid fashion. The places of junction form the sutures which are at times visible on the scalps of bald people. These sutures are three in number: in front, the *coronal suture*; in the middle, the *sagittal*; and in the back, the *lambdoidal*.

THE MANDIBLE (PLATE 1, FIGURE 1 and 2)

The mandible has the form of a horseshoe though its two ascending branches (*rami*) form a right angle with the body which is the middle part.

The body, flattened from the front to the back, carries the teeth on its superior border. Its inferior border, rounded, is prominent under the skin of thin subjects and its middle part supports the chin. Its anterior aspect shows the oblique external line, directed backwards as if to join the front border of the corresponding ramus. On its posterior surface one might note four little tubercles (*mental spines*) on the median line, and on the sides an oblique line (*mylohyoid line*).

The rami are quadrilateral and present two faces and four borders. On the internal surface near its middle is the *mandibular foramen*, limited on the outside by a bony projection. Its external surface is roughened for the insertion of the masseter muscle. The superior border is formed by two processes separated by the *mandibular notch*. The anterior process (*coronoid process*) thin and triangular, gives attachment to the temporalis muscle. The posterior process or *condyle* is an oblong projection, and its long axis is perpendicular to the plane of the ramus. It is supported by a thin neck which articulates with the glenoid cavity of the temporal at the base of the cranium. The anterior border is grooved; the rounded posterior border forms an obtuse angle with the inferior border (*inferior maxillary angle*). This angle varies strongly with age. In the foetus the rami are but prolongations of the body, the angle only appears toward the third month of intrauterine life. Children have a most open angle; in adults it is about 120° on the average, although at times it approaches a right angle.

TEMPOROMANDIBULAR ARTICULATION (PLATE 6, FIGURE 1 and 2)

The temporomandibular articulation is a double condyloid articulation and includes an articular disk.

The articular surfaces are, on one aspect, the condyles of the mandible and, on the other, the glenoid cavities of the temporal with the transverse eminence of the zygomatic process which takes equal part in the articulation.

The articular disk, thick at its borders and thin in the center, elliptical in shape, presents different curves on its two faces. Above, it is alternatively convex in the part corresponding to the glenoid cavity and concave in respect to the transverse eminence of the zygomatic process; below, it is concave where it is applied to the condyle of the mandible. The articular disk is not horizontal but strongly drawn down below and in front. Connected to the condyle by fibrous bonds, it is displaced from it in certain movements of the joint.

Ligaments. These are three in number. The *lateral ligament* designates those fibers which come from the periphery of the glenoid cavity and go to the neck of the condyle and the posterior border of the ramus. The *internal lateral ligament (sphenomandibular)* comes from the spine of the sphenoid and divides itself into two bundles; the shortest one, at the back, going to the internal part of the neck of the condyle, the other, to the lingula mandibulae. Finally, the *stylomandibular ligament* runs from the styloid process to the angle of the jaw. The synovial membranes are double, the upper thick, the lower more compact.

Mechanism. The movements of the lower jaw are of three types. First, the movement of lowering and raising (opening and closing of the mouth). This movement consists of a combined double action taking place above and below the articular disk. In the superior articulation, the disk with the condyles is displaced and carried ahead under the articular tubercle; from being oblique below, the disk is able to become transverse and even oblique above. In the inferior articulation, the condyle rolls in the cavity of the disk. The jaw is thus carried forward and completely lowered, the condyle turning about a fixed axis which passes through the mandibular foramen. In this movement, the relief formed by the condyle of the mandible in front of the ear can be seen moving backwards and forwards, leaving a strong depression in the place which it had occupied when the mouth was closed.

Second, movements forward and back. These movements, which may consist of the total movement of the jaw to the front, in such a fashion that the lower teeth may place themselves in front of the upper, take place only through the superior articulation and constitute the displacement described above.

Third, lateral movements. In this case the movements differ in the right and left articulations: one condyle rolls in its cavity while the other describes an arc of a circle around the first and places itself under the articular tubercle.

3. The Skeleton of the Trunk

We will study successively the vertebral column, the thorax, the bones of the shoulders and the pelvis.

VERTEBRAL COLUMN

The vertebral column is formed of the vertebrae, the sacrum, and the coccyx. The vertebrae, twenty-four in number, are called true vertebrae, as opposed to the false vertebrae which compose the sacrum and coccyx.

TRUE VERTEBRAE

According to their regions, the true vertebrae are divided as follows: seven cervical, twelve thoracic, and five lumbar. Besides common characteristics, they have characteristics peculiar to each region. Certain vertebrae have unique characteristics.

CHARACTERISTICS COMMON TO ALL VERTEBRAE

Each vertebra is a ring of which the anterior part, formed by a massive enlargement (*body*), communicates with the posterior part, usually thinner (*a vertebral arch*), thus forming an orifice (*vertebral foramen*), which contains the spinal cord.

From the vertebral arch originate several bony prolongations or processes, directed in various ways: in back and in the middle, the *spinous process*; on each side and somewhat transversal, the *transverse processes*; also on the sides, above and below, four *articular processes*. The *superior* and *inferior*, two on each side. Very near the body, the vertebral arch becomes narrower (*the pedicle*). The superior and inferior parts of the pedicle are depressed and form, with the depressions of the other pedicle above and below, a channel for the passage of nerves which emanate from the spinal cord. The parts of the arch immediately outside the spinous process are generally thin and are called *laminae*.

DISTINCTIVE CHARACTERISTICS OF VERTEBRAE

All the common characteristics previously described assume a particular disposition according to the region in which they are located, and we shall describe them briefly. The same order of description will be followed in each region to make comparison easier. The distinctive characteristics of vertebrae not encountered to the same degree in all the vertebrae of a similar region will thus be classified. However, the central vertebrae possess the common characteristics to the highest degree and these characteristics attenuate at the extremities of the vertebral column through a gradual transition from region to region.

CERVICAL VERTEBRAE (PLATE 3, FIGURE 1)

The *bodies* are small. They are enlarged in the transverse direction. On the sides and on the superior parts, they are furnished with little vertical ridges and on the inferior parts with corresponding depressions.

The *vertebral foramen* is triangular. The *spinous process* is horizontal, grooved below and double pointed at its extremity. The *articular processes*, inclined at a 45° angle, are situated behind the transverse processes. The superior face above and behind, the inferior below and in front. The articular facets are almost flat. The *transverse processes*, situated on the sides of the bodies, have a superior groove, are double pointed at their extremities, and pierced by a hole at their base. Their *superior notches* are deeper than the inferior ones.

DORSAL VERTEBRAE (PLATE 3, FIGURE 2)

The *bodies* present on their lateral aspects two demifacets for the articulation of the ribs, the one superior, the other inferior.

The *vertebral foramen* is small and oval. The *laminae* are high and straight. The *spinous process* approaches the vertical; it is long, triangular, with one tubercle at the end. The *articular processes* are vertical, flat. The articular facets are almost planes, the superior ones are directed backwards and without, the inferior ones forward and within. The *transverse processes*, very large, are twisted to the back and swollen at their ends. In front they present articular facets for the tuberosities of the ribs. The *superior notches* are scarcely present, while the inferior ones are very deep.

LUMBAR VERTEBRAE (PLATE 3, FIGURE 3)

The *body* is very large. The *vertebral foramen* is triangular. The *laminae* are thick and straight. The *spinous process* is strong, directed transversely, rectangular in shape, with one tubercle at the summit. The *articular processes* are vertical. The superior ones have concave facets directed backwards and within and are furnished in

back with a tubercle; the inferior ones have convex facets, looking out and forward. The *transverse processes* are rib-like and slender. The *inferior notches* are more pronounced than the superior.

SPECIAL CHARACTERISTICS OF PARTICULAR VERTEBRAE

In each region, vertebrae which are distinguished by particular characteristics are those which are situated close to a neighboring region. Examples are the seventh cervical vertebra, the first dorsal, the last dorsal, and the fifth lumbar. They are thus, in a sense, vertebrae in transition, possessing characteristics of both regions. We will not dwell on them here. But there are two other vertebrae which merit our attention. These are the first two cervical vertebrae, of which the conformation plays a special role both in the static and moving head.

FIRST CERVICAL VERTEBRA OR ATLAS (PLATE 4, FIGURE 1)

The body is replaced by a transverse arch (*anterior arch*) which presents in front a blunt tubercle (*anterior tubercle*), and in back a concave facet which articulates with the odontoid process of the axis.

The *foramen* is large, to be filled in front by the odontoid process of the axis. This process ought to be considered as the actual body of the first cervical vertebra although it is fixed to the second. The *spinous process* is lacking; it is replaced by a rudimentary tubercle, the *posterior tubercle* of the atlas. The *articular processes* are massive; they form what are called the lateral masses of the atlas. Their superior surfaces, long and concave, articulate with the condyles of the occipital; their inferior surfaces, oblique and somewhat flat, articulate with the axis. The *transverse processes* have but one tubercle at their ends; they are pierced by a hole at their bases and are situated outside of the lateral mass.

The superior *notch*, in back of the superior articular process, continues on the outside with a horizontal canal which leads to the base of the transverse process. There is no inferior notch.

SECOND CERVICAL VERTEBRA OR AXIS (PLATE 4, FIGURE 2)

The body of the axis is surmounted by a long process (*odontoid process*) narrowed at the base (neck of odontoid process) and offering two articular surfaces—the one in front for the arch of the atlas, the other in back for the transverse ligament.

The *vertebral foramen* has the form of a heart in a pack of cards. The *spinous process* is heavy and has the characteristics of its region. The *superior articular processes* are circular and their superior articular surfaces face above and without. The *transverse processes* are small and there is only one tubercle at their summit. They are hollowed by a groove. There are no superior notches.

SACRAL VERTEBRAE, OR SACRUM (PLATE 4, FIGURE 3)

The sacrum is formed by the joining together of five vertebrae, and although they are deformed to a certain degree, it is still possible to distinguish the parts we have pointed out. The sacrum is, therefore, a single bone, large, flattened, its surfaces curved, of triangular form.

Its *base*, or superior portion, turned up and to the front, suggests somewhat the superior aspect of a lumbar vertebra. One finds here, in front and at the center, the oval superior surface of the body of the first sacral vertebra; immediately behind, the triangular superior opening of the sacral canal; behind and on the sides, the superior articular processes and the notches; finally, completely to the outside of the oval surface, two smooth triangular surfaces.

The *inferior apex* is truncated and presents an oval facet which articulates with the coccyx.

The *anterior surface* is concave and looks down. It presents, across the median line, four transverse ridges whose length diminishes progressively from top to bottom. These trace the unions of the five false vertebrae whose fusion forms the sacrum. Laterally these transverse ridges lead into large openings, the *anterior sacral foramina*.

The *posterior aspect*, which is subcutaneous, is divided by the *sacral crest* formed by the spinous processes of the sacral vertebrae; it ends at the bottom with an opening (*sacral hiatus*) bordered by two little processes (*sacral cornua*). On each side are four *posterior sacral foramina*, limited on the outside by rough tubercles.

The *sacral canal*, which runs through the thickness of the bone, terminates the spinal column; it travels from the base of the sacrum to the inferior end (*sacral hiatus*). The sacrum is much larger in women than in men.

COCCYX (PLATE 4, FIGURE 3)

The coccyx (*os coccygis*) is usually formed of four rudimentary vertebrae diminishing in size from above to below and terminating in a bony nodule. The first vertebra presents a rudimentary transverse process and two small vertical prolongations (*cornua*) which articulate with the sacral cornua.

ARTICULATIONS OF THE TRUE VERTEBRAE (PLATE 6, FIGURE 6 and 7, and PLATE 7)

The vertebrae articulate together through their bodies and through their articular processes. The spinous processes and the laminae are, on the other hand, united by ligaments.

The vertebral bodies are separated from one another by a sort of fibrous and elastic pad (the intervertebral disk) to which they closely adhere. In back and in front this articulation is reinforced by the two great ligaments that reach from one end of the vertebral column to the other (*anterior longitudinal ligament* and *posterior longitudinal ligament*).

The articulations of the articular processes are provided by a *fibrous capsule*, thicker on the outside, which covers a synovial capsule that is quite loose at the neck and in the lumbar region. The space left in the back by the laminae of the two contiguous vertebrae is filled by a very tough ligament almost entirely composed of elastic tissue of which the fibers stretch directly from one vertebra to another. These ligaments, called *yellow ligaments* because of their color, enclose the spinal canal at the back.

The spinous processes are held together by a wall of

ligament, *interspinal ligament*, descending from one to another in the anteroposterior direction. Further, a long fibrous cord (*supraspinal ligament*) stretches along the top of the spinous processes throughout the whole length of the spinal column except for the cervical region. At the level of the seventh cervical vertebra the ligament is deflected from the spinous process toward the external occipital protuberance, although it sends out fibrous offshoots to the spinous processes. It is called the *ligamentum nuchae* or *posterior cervical ligament*.

ARTICULATIONS OF THE FALSE VERTEBRAE (PLATE 7)

Coccygeal articulations. The different segments of the coccyx are joined together by an intervertebral disk and by the anterior and posterior ligaments; the whole articulation has a rudimentary nature.

Articulation of the sacrum and coccyx. In addition to the intervertebral disk, frequently ossified, this articulation has the following ligaments: an anterior ligament; a posterior ligament which closes the sacral canal below; two lateral ligaments which link up the transverse processes of the last sacral vertebra to the first coccygeal vertebra.

ARTICULATIONS OF THE ATLAS, AXIS, AND OCCIPITAL (PLATE 6, FIGURE 3, 4, and 5)

The occipital, by means of its condyles, articulates with the superior articular facets of the lateral masses of the atlas.

The curvature of the condyles is less marked in the transverse than in the anteroposterior direction; they overlap in front and in back of the corresponding surfaces of the atlas, a fact that indicates the chief direction of movement. The outside edge of the facets of the atlas is higher than the inside edge. Both surfaces are encrusted with cartilage. The synovial membrane is lined with connective tissue, in layers, and reinforced by ligaments which we shall come to in a moment.

The atlas and the axis are joined by a double articulation. In fact, as the atlas moves around the odontoid process as though around a pivot, it slides on the superior articular facets of the axis (*atlantoaxial articulation*). The anterior convex surface of the odontoid process is in contact with a concave facet of the posterior surface of the anterior arch of the atlas.

The lateral masses of the atlas rest on the superior articular facets of the axis.

The two articulations are provided with synovials and reinforced by ligaments which we shall now describe.

Transverse ligaments. The odontoid process of the axis is received in an osteofibrous ring formed in front by the anterior arch of the atlas and in back by a transversely directed ligament which is inserted into the lateral masses of the atlas. This ring has the form of a half funnel so that the interior tightly squeezes the neck of the process. From the transverse ligaments, one above and one below, extend two weak vertical ligaments; the superior one goes to the anterior border of the foramen magnum, the inferior to the posterior surface of the axis.

Odontoid ligaments. These ligaments are arranged so that they firmly hold the odontoid process, from which they rise to attach themselves in the occipital. They are, first, two strong fascious fibers coming from the lateral and superior parts of the odontoid process. These fibers go a little obliquely up and outside and insert into the condyles of the occipital. Second, a weaker vertical median ligament runs from the summit of the odontoid process and inserts into the anterior border of the foramen magnum.

I should like to also point out the ligaments in the form of a membrane which serve to connect the anterior and posterior arches of the atlas to the borders of the foramen magnum (*anterior* and *posterior atlantooccipital membranes*); those of the same form which unite the anterior and posterior arch of the atlas to the body and to the posterior arch of the axis (*anterior* and *posterior atlantoaxial ligament*); and finally, the ligaments which go from the anterior border of the foramen magnum to the posterior part of the body of the axis, covering the transverse and odontoid ligaments (*occipitoaxial*).

ON THE VERTEBRAL COLUMN IN GENERAL (PLATE 5 and 7)

Placed vertically on the median line, the vertebral column plays a double role. It serves, so to speak, as a column of support for other parts of the skeleton to which it is attached directly or indirectly and it protects the spinal marrow or spinal cord.

Curves of the vertebral column. Viewed in profile the vertebral column presents, in the anteroposterior sense, several curves. These alternate differently according to their region. The cervical region, composed of seven vertebrae, offers an anterior convex curve, the most projecting part of this curve corresponds to the fourth vertebra. The dorsal region (twelve vertebrae) is curved in the other direction, and the posterior convexity projects most at about the dorsal spine of the seventh thoracic vertebra. The lumbar region repeats the convex anterior curve and the maximum convexity corresponds to the third vertebra in this region. These diverse curves follow each other gracefully until the level of the junction of the vertebral column with the sacrum where there is an abrupt change in angle, the *sacrovertebral angle*.

The curves of the vertebral column, which we have just described, are most strongly formed by the anterior part, that is to say by the succession of the vertebral bodies. It is important to note that the line formed in back by the spinous processes does not follow exactly the same direction. This fact is significant for artists, especially in relation to the lumbar region. At the neck and in the back, the curves described by the spinous processes repeat those formed by the bodies of the vertebrae (Figure 1). They are the same sort of curves but they are related to the circumferences of different radii. Thus, in the cervical region, the curve described by the spinous processes is more closed than that of the vertebral bodies. Inversely, in the dorsal region, the posterior curve is more open. This results in a flatness which contributes, together with the overlapping of the dorsal spines, to a reduction of the dorsal projection in this region. But in the lumbar region the difference is marked. Here the spinous processes only

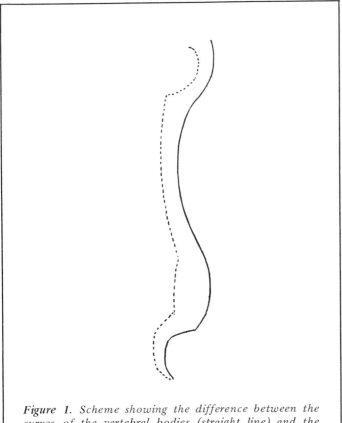

Figure 1. Scheme showing the difference between the curves of the vertebral bodies (straight line) and the curves described by the spinous processes (dotted line).

approximate the direction of the vertebral bodies. A line, touching their summits, becomes a straight line which descends from the last dorsal vertebra to the sacrum. At times it bends in an inverse sense, becoming a contraposterior curve. This condition is in accord with the development of the sacrolumbar muscle masses; it explains the more or less pronounced projections that one observes in certain subjects in the lumbar furrow even in the upright position. In flexion of the trunk these bony projections show clearly.

Let us now consider the vertebral column from other points of view.

Anterior aspect. The series of vertebral bodies, separated by their fibrous "washers" (*intervertebral disks*), and growing progressively larger from top to bottom, assures the solidity of the supporting column. Behind them runs the spinal canal, formed by the succession of intervertebral foramina that contain the spinal cord.

Lateral aspect. The presence of the central canal is revealed by a series of openings which communicate with it and through which pass the nerves which come from the spinal cord. One sees on the sides of the vertebral bodies in the dorsal region, at the level of the intervertebral disks, the articular facets destined for the heads of the ribs. The line of the transverse processes in the thoracic region deviates strongly from the line of the spinous processes. The transverse processes of the lumbar region represent the ribs of the thoracic region; the tubercles of the superior articular processes can be considered as the analogues of the transverse processes.

The lateral prolongations of the vertebral column should then be divided into two series. First, the anterior series consisting of the anterior half of the transverse processes of the cervical region, the ribs of the thoracic region, and the rib-like transverse processes of the lumbar region. Second, the posterior series, consisting of the posterior half of the transverse processes of the cervical vertebrae, the thoracic or dorsal transverse processes, and, in the lumbar region, the tubercles of the articular process.

Posterior aspect. The succession of the spinous processes surmounted by the supraspinal ligament create a long ridge called the *spinal crest*. On each side are the *vertebral grooves*, the bases of which are formed by the laminae of the vertebrae.

Dimensions. It is necessary to distinguish between the length and the height of the vertebral column. The length is measured by a line following the flexuosities of the column, the height by the distance of the diverse parts above the horizontal. The intervertebral disks form about a quarter of the total length. But the height is the sole dimension in which we are interested.

The vertebral column varies slightly in height according to the individual. M. Sappey has assigned it, on average, 61 centimeters, and divides it as follows: 13 centimeters for the cervical region; 30 centimeters for the thoracic region; and 18 centimeters for the lumbar region.

In height the proportions of the trunk are maintained by the vertebral column. Measured from the dorsal spine of the seventh vertebra to the summit (or bottom) of the sacrum, the trunk is about one third of the figure. Generally speaking it is longer in the yellow races, shorter in the Negroes, and intermediate in Caucasians. At least among European people, women have a longer trunk. Tall subjects tend to have a shorter trunk. The trunk triples its length from birth to maturity, growing until about the twenty-fifth or thirtieth year.

MECHANISM OF THE VERTEBRAL COLUMN

The spine is an elastic and mobile column. The elasticity is created by the thickness of the intervertebral disks, through them shocks are absorbed so that they are only transmitted in a diminished form to the head. This mobility is equally due to the compression and distension which the disks are able to undergo, as well as the sliding of the articular processes.

The cervical column is the most mobile part of the spine. It owes this mobility to the thickness of the intervertebral disks; to the oblique direction of the articulations; to the shortness and horizontal direction of the spinous processes of the average vertebrae of the region; and to the looseness of the vertebral ligaments.

In the thoracic region the spine is less mobile. This is because the ribs are like so many flying buttresses that maintain it laterally. The lack of mobility is also due to the vertical direction of the articular planes; to the tightness of the ligaments; and to the length of the spinous processes which overlap like the tiles of a roof.

In the lumbar region mobility becomes greater—the intervertebral disks are thicker, the ligaments laxer, and the spinous processes straight and short.

Equilibrium of the spinal column. The viscera, which one may regard as suspended from the anterior part of the vertebral column, seem to invite the spine to incline forward. It is maintained vertically by the yellow ligaments stretched between the vertebral laminae. The elastic force of these ligaments, continually in play, counterbalances the movement of weight. The muscles thus appear to be unnecessary for the maintenance of the column. They only intervene under particular circumstances.

The head is placed on the vertebral column so that it is almost in equilibrium, a condition which is peculiar to man. In animals, the center of gravity of the head lies well to the front, and requires the presence at the nape of the neck of a strong ligament to hold the head solidly against the vertebral column and prevent it from falling. This ligament exists in man only in a rudimentary state.

Movements of the vertebral column. The vertebral column is susceptible to three sorts of movement. Movements around a transverse axis (flexion and extension); movements around an anteroposterior axis (lateral inclination); and movements around a vertical axis (torsion or rotation).

Flexion is made possible by the compression of the anterior parts of the intervertebral disks. It is limited by the distension of the yellow ligaments and the supraspinal ligament. In this movement the spinous processes separate and project under the skin, especially if the flexion is extreme.

Extension is less extensive than flexion and it is limited by the distension of the intervertebral disks.

Lateral inclination depends on the articular processes impeding or favoring this movement according to the direction of their surfaces. At the neck where they are placed obliquely at 45°, this movement can be produced only when accompanied by a sliding of the articular surfaces which rotates the bodies of the vertebrae.

It is not the same in the lumbar region where the vertical direction of the articular surfaces allows complete separation of rotation and lateral inclination. Moreover, these two movements, disassociated for study, are almost always combined in nature.

Mechanism of the articulations of the atlas, axis, and occipital. The head is very movable on the vertebral column. Its movements, like those of the column itself, may be reduced to three. However, instead of taking place at the same time in all the articulations, these movements are divided between the two articulations which connect the head to the vertebral column. In consequence, movements of rotation take place between the atlas and the axis, and movements of flexion and lateral inclination take place in the articulation of the atlas and the occipital.

This last articulation is composed, as we have seen, of the two condyles of the occipital which are received exactly in the superior articular cavities of the lateral masses of the atlas. This articulation is designed so that only movements of flexion, extension, and lateral inclination are permitted. In rotation, on the contrary, the atlas and occipital act as one and turn together on the axis bone. The axis of this last movement passes through the odontoid process and the transverse ligament; at the same time a sliding movement takes place between the articular lateral masses of the atlas and the body of the axis.

4. The Thorax

The thorax is a vast cavity occupying the superior part of the trunk. It is composed of two median pieces, the *dorsal column* in the back and the *sternum* in front; these are connected to each other by the bony arches of the *ribs*. Supported in back by the vertebral column, the ribs move to the sternum in front by means of cartilaginous extensions, the *costal cartilages*. We have just studied the spinal column, let us now describe the sternum and the ribs.

STERNUM (PLATE 8, FIGURE 1)

A single and symmetrical bone situated in the front of the chest, the sternum is inclined obliquely from top to bottom and from back to front. In the child it is composed of four or five contiguous bony pieces which in the adult are reduced to two through the joining of three or four of the inferior pieces into a single bone. It is terminated by a cartilaginous extension. The ancients compared the sternum to the sword of a gladiator with its point turned downward. The superior part (manubrium) represented the handle, the second part (gladiolus) the body or blade, and the cartilaginous appendage the point, hence its name xiphoid (sword).

The anterior surface, almost entirely subcutaneous, offers an appreciable angle across the skin at the level of the junction of the first piece with the second. The posterior surface, in contact with the thoracic viscera, corresponds to the projecting angle of the anterior surface.

On the lateral surface there are hollows which correspond to the number of pieces of which the sternum is formed in the infant. They are eleven in number: seven articular facets for the costal cartilages, and four others which form the free borders of the first parts of the sternum.

The superior or clavicular extremity is marked by three hollows, one median and subcutaneous, forming the bottom of the pit of the neck, and two on each side which, in living subjects, are encrusted with cartilage and destined for articulation with the clavicles. Below, the sternum is terminated by the *xiphoid process*. This is most variable in form. Although it is ordinarily straight, sometimes it is projected in advance, its point lifting the skin in the region of the pit of the stomach.

The sternum, on the average, is 19 centimeters long and divided thus: first piece, 5 centimeters; second piece, 6 centimeters; appendage, 3 centimeters. It is 5 or 6 centimeters across at the widest part of the manubrium.

The narrowest part corresponds to the junction of the body with the manubrium.

RIBS (PLATE 8, FIGURE 2)

Numbering twelve on each side, the ribs are divided as follows: *true ribs*, numbering seven, from which the cartilages go directly to the sternum; *false ribs*, numbering five, of which only the first three join the sternum by means of the cartilage of the seventh rib. The two others do not attach to the sternum. Their anterior extremities rest free in the flesh, they are called *floating ribs*.

The ribs are designated by number from the first to the twelfth proceeding from top to bottom.

GENERAL CHARACTERISTICS OF THE RIBS

The ribs are flat bony arches which present two curves on their surfaces. The first curve may be seen easily from above or below. It is not completely regular; towards the back, at about the fourth or fifth rib, the curve bends abruptly, forming an angle called the *angle of the rib*. The other curve is called a curve of torsion. It is a more complex curve; the rib makes a complete twist, the external surface looks down in the back and up in the front. The inverse is true for the internal surface.

There is also a gentle curve that follows the borders of the ribs in the form of a very much elongated italic S (concave behind and in front). It can only be seen from the fifth to the tenth ribs.

The ribs are composed of a body and two extremities, the anterior and posterior.

The posterior extremity offers three parts for study: at the very end of the rib, the *head*, where there is a double articular facet; at the back of the rib, the *neck*, a rough contracted part of bone; and, finally, a bony projection or tuberosity, of which the rough superior part offers attachment to ligaments, and the inferior part carries a facet for articulation with the corresponding transverse process.

The *body* of the rib presents two surfaces and two borders. On the internal surface there is a *costal groove*. The external surface is convex and often shows under the muscles and skin which cover it. The superior border is very thick in back, where it is slightly grooved. The inferior border is sharp.

The *anterior extremity* of the rib is slightly enlarged and forms a sort of nodule which is sometimes visible under the skin. It articulates with the costal cartilage.

The first rib, broad and short, has curved edges and its surfaces lie almost horizontally. The most projecting part (projecting angle) corresponds to the tuberosity. The neck is narrow and rounded. There is one facet at the head.

The second rib also has a pronounced curve along its borders. The blunt angle is situated about one centimeter from the tuberosity. The anterior extremity is straighter than the body.

The two last ribs only have a single articular facet. On the eleventh, the angle is far from the head; there is no tuberosity.

The twelfth has no angle, tuberosity, or groove. The anterior extremity is more or less pointed.

ARTICULATIONS OF THE THORAX (PLATE 10, FIGURE 2 and 3)

Articulations of the ribs with the vertebral column. The head of the rib presents a jutting crest separating two demifacets. This crest corresponds to the intervertebral disk, to which it is joined by an *interarticular ligament* which separates the articulation into two secondary articulations. The two costal facets are in accord with the corresponding demifacets of the bodies of the vertebrae.

In front, a strong, fan-like ligament runs from the rib to the neighboring part of the body of the vertebra (*anterior costovertebral ligament*); this ligament consolidates the articulation.

The articular facet of the tuberosity of the rib connects with the articular facet of the summit of the transverse process. A short solid ligament holds the articular surfaces together. This ligament extends obliquely from the summit of the transverse process to the external part of the tuberosity of the rib; it is called the *costotransverse ligament.*

The ribs are also attached to the vertebrae by ligaments which run from the transverse processes to the neck of the rib. These ligaments are of two kinds. They both originate at the neck of the rib. The ones which go to the upper side of the transverse process are called the *superior costotransverse ligaments.* The others, which go to the lower side of the transverse process, are called the *inferior costotransverse ligaments*.

Articulations of the costal cartilages. The articulations of the ribs with the cartilages (*chondrocostal articulation*) are a simple continuation of the rib into the cartilage. They are marked by a swelling. The costal cartilages then unite with the sternum (*chondrosternal articulation*). The cartilage of the first rib is directly united with the sternum. Although the movements of the other ribs are very limited, they have an articular cavity and a synovial membrane. The second rib has, moreover, an interarticular membrane which divides the articulation into two secondary articulations. Finally, I should point out the *radiate sternocostal ligaments* (anterior and posterior).

THE THORAX IN GENERAL

The ribs are all directed obliquely from above to below and from back to front. The tip of the last rib is separated from the iliac crest by an interval of 4 or 5 centimeters.

The ribs are placed, in relation to the median axis of the chest, in the following manner: the first four withdraw progressively; the following five maintain about the same relationship (the eighth, however, projects the most); and the four last ones draw back, each further than the one preceding.

The ribs are separated by a space, called the intercostal space, which is occupied by small muscles which form a wall and close the thoracic cavity. The *intercostal spaces* toward the middle part of the thorax equal the width of the ribs; they are larger below and still larger above. The same intercostal space is larger both in the front and back.

ANTERIOR ASPECT (PLATE 9, FIGURE 1)

The sternum does not enter into direct relation with the ribs; it is separated by the costal cartilages, which are designated by number according to the particular rib which they prolong. The first is short and ascends slightly from the sternum. The second is transverse. The following costal cartilages are longer and progressively decline from the sternum as they descend. The fifth, sixth, and seventh cartilages at first continue the direction of the rib and then form a band as they mount to the sternum. The eighth, ninth and tenth terminate in points and are attached to the cartilage above. The eleventh and twelfth ribs terminate in a free, attenuated extremity.

On the borders of the sternum the articulations project and may be seen externally, if the pectoral muscles are but slightly developed, in a series of corresponding nodules. To the side are a second series of nodules and these follow an oblique line from above to below and from within to the outside. They correspond to the articulations where the ribs meet the cartilages.

The anterior surface of the thorax is not subcutaneous, except on the median line. The rest of its extent is covered by muscles; below it supports the breasts.

POSTERIOR ASPECT (PLATE 10, FIGURE 1)

The median part is occupied by the posterior aspect of the spinal column, which presents the spinal crest in the middle and the series of transverse processes laterally. Between these are the vertebral grooves. The ribs relate, through their tuberosities, to the transverse processes; the heads and necks of the ribs are concealed by the spinal column.

The angles of the ribs, situated further outside, follow an oblique line from above to below and from within to the outside. This line starts above from the transverse process of the first dorsal vertebra, the angle of the first being identical to its tuberosity. Between the line formed by the angles of the ribs and the jutting of the transverse processes one finds, on each side, a veritable groove which is filled by the spinal muscles. Above and to the outside of the line of the angle of the ribs the scapula is situated.

LATERAL ASPECT (PLATE 9, FIGURE 2)

The posterior profile is limited by the line of the angle of the ribs which is exceeded a little by the spinal crest,

especially in the upper half. It is regularly curved. The anterior profile is equally curved and is formed first by the sternum, oblique from above to below and from back to front, and by the cartilages of the false ribs which prolong the direction of the sternum.

This anterior curve descends down well below the sternum and gives to the whole of the thorax, in the profile view, the appearance of an accentuated ovoid. The jutting forth of the costal cartilage, which forms the inferior extremity of the ovoid, is generally misjudged. It is, however, from the point of view of morphology, of great importance, as we shall see later when we study the region below the breasts.*

The inclination of the sternum in relation to the vertical is about 20° to 21°.

The *superior circumference* of the thorax is circumscribed in the back by the body of the first dorsal vertebra, in front by the sternum, and on the sides by the first ribs and their cartilages. The circumference is an oblique plane from above to below and from front to back. In the standing position the median groove on the top of the manubrium is about on a level with the middle of the body of the second thoracic vertebra.

The *inferior circumference* presents a vast anterior hollow marked at the top by the xiphoid process and bounded laterally by a border formed by the cartilages of the seventh to the tenth ribs. This hollow, in the form of a pointed or Gothic arch, is expressed on the skin of thin subjects by a marked relief, dividing the chest from the abdomen in front. On more strongly developed subjects this anterior hollow of the thorax often takes the form of a simple or Roman arch, as it does so often in the antique. This is because the superior part of the rectus abdominus muscles are stressed rather than the superior angle of the hollow itself.

Dimensions. For the dimensions of the thorax, Sappey gives the following averages: transverse diameter, measured at the eighth rib, 28 centimeters; anteroposterior diameter, 20 centimeters; vertical anterior diameter, 13.5 centimeters; vertical posterior diameter, 31.5 centimeters.

MECHANISM OF THE THORAX

The thorax is able to undergo the changes of volume necessary for respiration. It is able to augment its capacity (*inspiration*) and diminish it (*expiration*).

Without mentioning here the muscular forces that enter into the movement of respiration, I should point out the mechanism by which the enlargement of the thorax takes place. It is the result of a double movement of the arches of the ribs which may be analyzed as follows. First, enlargement of the anteroposterior diameter of the thorax takes place through a movement of the elevation of the anterior extremity of the rib. The axis of rotation of this movement, nearly horizontal, passes through the head of the rib and through the tuberosity. Second, enlargement of the transverse diameter takes place at the

* On almost all mounted skeletons the thorax is too short and too open in front. It is also much too far from the pelvis. This is even true in most anatomical drawings.

middle of the costal arc. The anterior posterior axis of rotation passes through the neck of the rib in back and through the chondrosternal articulation in front.

The diminution of the capacity of the thorax takes place by an inverse mechanism.

It is evident that all the ribs do not take an equally active part in these movements.

In a woman, the greater mobility of the first ribs permits, in the movement of respiration, a considerable amplification of all the upper parts of the thorax. This is *thoracic respiration* which compensates for the lack of action of the diaphram (*abdominal respiration*), when the movement of this muscle is impeded, for instance, in pregnancy.

SHOULDER

The skeleton of the shoulder consists of two bones—the clavicle in front and the scapula in back.

CLAVICLE (PLATE 11, FIGURE 1)

The clavicle is situated on the upper part of the chest. It is supported by the sternum at its inner end and it maintains contact with the scapula through its outer end. It is directed from within to without, slightly from the front to the back and slightly from below to above. It offers two curves in the form of an italic S. The internal curve is of anterior convexity, the exterior of posterior convexity.

The internal part of the bone is like a triangular prism. The middle part is rounded and the external portion flattened from above to below.

The upper surface is smooth and entirely subcutaneous. It stands out under the skin and the S shape is easily recognizable.

SCAPULA (PLATE 11, FIGURE 2)

The scapula, flat and triangular, is situated at the back and lateral part of the thorax. The base of the triangle of the scapula is turned above and the summit below. It is placed in an oblique plane from back to front, and from within to without. It extends from the first intercostal space as far as the seventh rib. Its internal border is nearly vertical.

Its anterior surface (*subscapular fossa*) is concave and filled by a single muscle. It is furrowed by oblique ridges for muscular insertions. The anterior surface rests on the thorax throughout its extent.

The posterior or cutaneous surface is divided into two unequal parts by the *spine*; above there is the *supraspinatous fossa*, below the *infraspinatous fossa*. The spine springs from the internal border by a small triangular surface which usually can be seen on the nude as a depression. From there the spine moves to the outside and above, forming a projection which becomes stronger and stronger. It terminates in a large process, flattened from above to below, the *acromion process*. The deep depression that the spine of the scapula leaves on the superior surface is increased by the muscles. The posterior surface of the spine is, with the acromion, the only part of the bone which is subcutaneous. It shows on the exterior either as a projection or as a depression.

The acromion forms the summit of the shoulder, where its superior surface is easily seen under the skin.

The superior border of the scapula, very thin toward the inside, terminates toward the outside in a process (*coracoid process*) which is curved in the form of a half-flexed finger.

The external angle is occupied by a concave oval hollow (*glenoid cavity*) of which the largest diameter is vertical. This articulates with the humerus and is supported by a narrow portion of the scapula (*neck of the scapula*). Above the cavity, there are the two processes mentioned; the acromion behind, and the coracoid in front.

ARTICULATION OF THE CLAVICLE

The clavicle articulates at its inner end with the sternum (*sternoclavicular articulation*) and at its outer end with the acromion process (*acromioclavicular articulation*). It is, besides, united to the coracoid process by ligaments (*coracoclavicular ligaments*).

STERNOCLAVICULAR ARTICULATION

The clavicle projects from the sternal facet with which it articulates. It forms, in consequence, an appreciable projection under the skin; moreover, the two articular facets are not in accord. They are separated by an articular disk which divides the articulation into two. The surfaces of the disk adapt themselves exactly to the facets with which they are in contact.

The synovial capsules are reinforced by the fibers of anterior and posterior ligaments.

Two other ligaments assure the solidity of the articulation. The *interclavicular ligament* runs from the sternal end of one clavicle to that of the other. The *costoclavicular ligament* runs from the superior part of the first costal cartilage to the internal part of the clavicle.

ACROMIOCLAVICULAR ARTICULATION

The articular surfaces, oval and almost flat planes, are maintained by short fibers. These fibers are very resistant at the superior part where they are called the superior *acromioclavicular ligament*.

Coracoclavicular ligaments. The coracoclavicular ligaments are very strong and are two in number. Their names indicate their form. The *trapezoid ligament*, anterior and external, goes from the base of the coracoid process to the interior surface of the clavicle. The *conoid ligament* (cone-like) is attached to the internal border of the coracoid process, near its base, and goes to the posterior border of the clavicle.

SKELETON OF THE SHOULDER IN GENERAL

The clavicle and the scapula join on the outside of the body forming an acute angle opening within. The bony demi-girdle thus formed embraces laterally the summit of the thorax to which it is firmly united by its anterior extremity (*sternoclavicular articulation*).

The scapula, in effect, does not articulate at all with the thorax; it simply rests upon it.

The bony girdle of the clavicle and the scapula considerably enlarges the superior transverse diameter of the chest. The arm hangs from its external angle and through it the arm is attached to the trunk.

The position of the scapula in relation to the rib cage shows much variation in individuals; this results in a great variety in the form of the shoulder, chest and neck.

In women, the shoulders are relatively lower, which gives the clavicle a slightly oblique inclination from within to without, and from above to below.

MECHANISM OF THE ARTICULATIONS OF THE CLAVICLE AND SCAPULA

Sternoclavicular articulation. The movements, of limited range, are of two types: movements of elevation and lowering; and movements forward and backward.

In all these movements, the internal extremity of the clavicle undergoes a movement which is in a sense the reverse of that of the external extremity. The bone acts as a sort of lever of two unequal parts, the fixed point being close to the attachment of the costoclavicular ligament. Therefore, the projection of the internal extermity of the clavicle should be less marked when the shoulder is moved forward, more marked when the shoulder is moved back.

Acromioclavicular articulation. The ligaments which join the clavicle to the coracoid process are long enough to permit the angle formed by the plane of the scapula and the clavicle to vary its opening, following the transverse sliding of the scapula on the posterior wall of the thorax. This results in the withdrawal or approach of the interior border of the scapula from or to the dorsal spine and in a movement forward or back of the end of the shoulder.

Further, the end of the shoulder may be moved up and down.

PELVIS

The pelvis is formed by the union of the sacrum, the coccyx, and the two hip bones. The sacrum and the coccyx having been described, we have only to study the hip bone.

HIP BONE (OS COXAE, INNOMINATE BONE) (PLATE 12)

The hip bone, paired, large, irregular, narrowed at its middle part, is twisted on itself in such a way that the superior half is not in the same plane as the inferior half. At the center, on the external surface, is a hemispheric cavity (*acetabulum*) articulating with the femur. The superior part of the bone is called the *ilium*. The inferior part of the bone is pierced by a large opening (*obturator foramen*) in front of which is the *pubis* and in back the *ischium*.

Descriptive anatomy should concern itself with the two surfaces and the four borders. On the external surface there is: above, the *external iliac fossa*, unequally divided by a curved line (the anterior gluteal line). From this fossa the gluteal muscles originate. At the middle, the *acetabulum*, surrounded by a lip. It is open below (*acetabular notch*), and has a central groove (*acetabular fossa*). Below is the *obturator foramen*, oval in men, triangular in women. It is surmounted by the obturator groove.

The internal surface is divided into two parts by an oblique crest (*iliopectineal* and *arcuate lines*) which contribute in the formation of the superior *circumference* of

the pelvis. Above this there is the *internal iliac fossa* from which the *iliacus* muscle originates. Behind it the *iliac tuberosity* is situated together with the articular surface for articulation with the sacrum. Below the arcuate line there is a quadrilateral surface containing both the base of the acetabulum and the obturator foramen which is surmounted by the obturator groove.

Of the four borders, two are convex: the superior and the inferior. The two other borders, the anterior and posterior, are profoundly and very irregularly notched.

Proceeding from above to below, the anterior border presents the following particulars (see Plate 12, Figure 2): the *anterior superior iliac spine*; the *anterior inferior iliac spine*; the *iliopectineal eminences*; the *pectineal surface*; and the *crest of the pubis*.

At the posterior border we note, proceeding from above to below: The *posterior superior iliac spine*; the *posterior inferior iliac spine*; the *greater sciatic notch*; the *ischial spine*; the *lesser sciatic notch*; and the *tuberosity of the ischium*.

The *inferior border* goes from the ischium to the pubis and forms, with that of the opposing side, the *pubic arch*.

The superior border, or the *iliac crest*, plays an important role from the point of view of exterior morphology. It is broad, thick and divided into an external lip, an interstice, and an internal lip. It describes, in a horizontal sense, a double curve in the form of an *S*, as can be seen from the superior aspect (Plate 12, Figure 1). The anterior curve occupies the greatest length; it is a great segment of a circle, its convexity turned within, its anterior extremity slightly turned down. The posterior curve is short, it contains a sharp angle (*the reentering angle*), and it is marked by a very consistent depression in the nude, as we will see later on.

ARTICULATIONS AND LIGAMENTS OF THE PELVIS (PLATE 15)

The two iliac bones unite in front forming with the sacrum, which is interposed between them in back, a true girdle.

We shall study the articulation of the iliac bones with the sacrum (*sacroiliac articulation*), the articulation of the two iliac bones between themselves (the *pubic symphysis*), and the ligaments of the pelvis which constitute remote articulations.

Sacroiliac articulation. The articular surface of the iliac bone presents a roughness which engages with the analogous articular surface of the sacrum. It is oblique from above to below, and from front to back, in such a fashion that the sacrum, enclosed by the two iliac bones, forms an angle at its inferior base.

There are two *anterior ligaments*, one superior and one inferior (*iliolumbar* and *anterior sacroiliac*).

In the back, the deep excavation left between the sacrum and the iliac tuberosity is filled by very strong ligamentary masses. The deep part of these masses forms the *short posterior sacroiliac ligament*, and the superficial part forms the *long posterior sacroiliac ligament*.

Symphysis pubis. The two articular surfaces are separated by a fibrous disk, the *interpubic disk*.

All around there are ligamentary fibers. The thickest are below and form the *arcuate pubic ligament*. It has a triangular form and occupies the summit of the pubic arch.

Ligaments of the pelvis. The *iliolumbar ligament*, formed of a thick horizontal fasciculus, extends from the transverse process of the fifth lumbar vertebra to the superior border of the iliac bone. The *sacrotuberous ligament* is attached through an enlarged base to the posterior iliac spines and to the sacrum; its other part is attached to the internal edge of the ischium. Fibers run from its anterior surface and they insert into the sciatic spine forming the *sacrospinous ligament*. The *obturator membrane* is formed of intersecting fibers which close the obturator foramen except for the superior part where the obturator groove becomes an orifice which allows for the passage of nerves and vessels. The *inguinal ligament (Poupart's ligament)* extends from the anterior superior iliac spine to the spine of the pubis. This ligament circumscribes, with the anterior border of the iliac bone, an elongated space.

The superior surface of the inguinal ligament gives insertion to the muscles of the abdomen. Its anterior surface is united to a deep layer of the skin which creates the constant crease of the groin.

THE PELVIS AS A WHOLE (PLATE 13, 14, and 15)

The pelvis is a vast bony girdle supporting the vertebral column in the back. The pelvis in turn is supported by the two heads of the femur bones.

The interior surface is divided in two by a circle which goes from the pubis in front to the base of the sacrum in back. Above is the greater or *false pelvis*, below the lesser, or *true pelvis*.

The opening of the false pelvis is large. It is composed in front of the iliac crest and the inguinal ligament.

The true pelvis is small and it is enclosed by the pubic arch, the tuberosities of the ischium, the sciatic ligaments, and the coccyx.

The pelvis, when the model is in an upright position, is inclined slightly forward. The acetabulum is directed downwards. A line running from the base of the sacrum to the superior part of the symphysis forms an angle of about 60° with the horizon.

In women, the pelvis undergoes notable modification due to childbearing. It is larger yet not so high as that of man. The dimensions of the two principal diameters are generally given as follows: transverse diameter, taken from the widest points of the iliac crest, 28 centimeters in men and 30 centimeters in woman; vertical diameter in the height of the pelvis, 20 centimeters in men and 18 in women.

The pelvic arch is more open in women, the ischia further apart, the sacrum and coccyx less elevated and flatter, and the great sciatic groove more open and not so deep.

Mechanism. The different parts of the pelvis do not move against each other; the pubic and sacroiliac articulations serve to soften any shocks received by the pelvis.

SKELETON OF THE TRUNK IN GENERAL: ITS INFLUENCE ON EXTERIOR FORM (PLATE 16, 17, and 18)

All the bony pieces which we have studied constitute, when united, the skeleton of the trunk. We should now

study them as assembled. The vertebral column forms the center; it rests on the pelvis and supports the head at its superior extremity. At its sides, toward the middle, it is attached to the rib cage, of which the inferior extremity is no further from the iliac crest than 4 or 5 centimeters.

The vertebral column determines the height of the torso, while the thorax, of which the width never reaches that of the pelvis, determines, following its degree of development, the width of the chest. The rib cage terminates in the form of a cone at its superior extremity. By the addition of the skeletal shoulder girdle upon the ribs, the torso acquires that superior lateral enlargement which we call the breadth of the shoulders. The scapula rests on the posterior part of the rib cage, just outside of the line formed by the angle of the ribs. It reaches from the second to the eighth rib and its spinal border is almost vertical. The distance which separates the shoulder blades is about equal to the length of the clavicle. Although these measurements are approximate, they have some practical utility. The skeleton of the trunk ends at the pelvis and the development of the pelvis determines both the size of the hips and the modifications which, in this region, differentiate the sexes.

The measures of the height of the trunk are determined by the dimensions of the vertebral column which have already been given (see page 27). As to the measures of width, they are reduced on the skeleton to the transverse diameter from shoulder point to shoulder point and to a diameter across the pelvis. The first extends from the extremity of the acromion process on one side to the same point on the other side. The second measures the distance between the two iliac crests. Among men the acromial measurement is usually 32 centimeters, and the iliac measurement is 28 centimeters. Among women the relationship is reversed because of the great width of the pelvis: the acromial measurement is 29 centimeters, the iliac 30 centimeters. These figures, however, do not have much academic interest, although they have their value as measures of width characteristic of the sexes. On the actual model it is difficult to think in terms of the trunk alone. Perhaps it is better to think of the measurement as going from the head of one humerus to another and from one great trochanter to another. The relationship of these two measurements is in a sense the same in the two sexes. In men, as well as in women, the superior diameter surpasses the inferior, though in different quantity, as the following figures show:

	Male	Female
Humeral measurement	39	35
Trochantic measurement	31	32

The role which the diverse bony pieces of the skeleton play in the morphology of the trunk is considerable.

The vertebral column, mostly buried in the soft parts, reveals but few anatomical details on the surface. Only the crest, formed by the series of spinal processes, is subcutaneous throughout most of its length along the posterior medial line of the trunk. The muscles rising on each side transform the crest into a groove of which the depth varies in different regions and in this groove one may discern certain details of the bony processes. However, although the processes are visible in the small of the back, they ordinarily disappear as we ascend. They reappear toward the base of the neck where the prominence of the spinous process of the seventh cervical vertebra is constant; in fact, it constitutes a landmark used in measurements of the trunk in the living. The spinal process of the sixth cervical often forms an eminence, though less appreciable. Above this the spinal column is more deeply buried; it disappears completely in the soft parts of the neck.

The curves of the spinal column express themselves in the general form of the posterior part of the trunk. The small of the back responds to the lumbar curve; the rounded back, to the convexity of the dorsal curve; at the neck the concavity of the curve is always mitigated, if not straightened, through the presence of the muscles of the nape.

The thoracic cage is the key to the general form despite the muscles disposed upon its surface. Here, more than in any other part of the body—the cranium always excepted—the skeleton plays a considerable morphological role in spite of the fact that it seldom appears immediately under the skin. The crest formed by the dorsal spines in the back plays a similar role. In front the sternum is subcutaneous throughout all its length, but not all its width. It should be pointed out that in back, toward the angle of the scapula, there is a small triangular space of which the dimension varies with the movements of the shoulder. Everywhere else the rib cage is covered with muscle.

The sternum underlies the somewhat profound median groove that extends from the pit of the neck to the epigastric hollow.

The epigastric hollow corresponds to the xiphoid cartilage which is always situated on a plane more drawn back than the body of the sternum. The point of the xiphoid cartilage, at times bent forward, raises the skin in that area.

On thin persons, the ribs may be seen. They are visible in front, on each side of the sternum; and in back, below the scapula. In front the costal cartilages, and their articulations with either the sternum or the ribs, may also be clearly seen. We shall return to study these bony forms in detail when we study the separate regions.

By their union, the cartilages of the ribs create, with those of the opposite sides, a pointed arch which forms the anterior opening of the chest. This arch projects in both erect and bent positions even in individuals with well developed muscles. It should also be noticed, as can be easily seen in the profile, that the cartilages of the false ribs protrude more in the area below the pectoral muscles and the sternum, than those above. Their projection continues the general oblique direction of the rib cage. Therefore, the most forward point of the rib cage is not approximately at the bottom of the sternum or fifth rib, but lower, at the level of the projection formed by the cartilages of the ninth and tenth ribs.

The last two ribs, the floating ribs, disappear in the soft parts of the flank. They may be felt by strongly pressing the integument in this region, and will be found to be close neighbors of the iliac crest as we have already noted.

The clavicle is a bone which reveals itself clearly under the skin. It is, actually, subcutaneous along its anterior and superior surface. It curves in the form of an italic S and may be easily seen. The interior half is convex, the exterior, concave.

In the position of a soldier at attention—the chest jutting forward, the shoulders thrown back, and the palms of the hands turned to the front—the direction of the clavicle is slightly oblique, rising to the outside. When the hands are turned naturally along the side of the trunk it is a little more horizontal. However, these directions vary with different subjects. The clavicle is often inclined slightly downwards from within to without. Its internal extremity, articulating with the sternum, makes a notable prominence which deepens the central notch of the manubrium. This projecting extremity goes completely beyond the articular facet of the sternum to which it is attached only through the intervention of a fibrocartilage.

Its external extremity, flat in the transverse sense, unites with the acromion and thus forms the summit of the shoulder.

The clavicle sometimes makes a distinct projection under the skin at the point of the shoulder. This should not be confused with the external extremity of the acromion, the relief of which is sometimes marked by the insertions of the deltoid.

The body of the scapula disappears in the midst of the muscles of the back. The spine and the acromion process, which, of course, is at the outer end of the spine, project on the surface.

On thin subjects, the spine forms a projection between two planes which correspond to the supraspinatous fossa and the infraspinatous fossa. These planes are filled, though not completely, by muscles. On well built models the spine becomes a groove created by the swelling of the neighboring muscles. The direction of this groove is naturally the same as that of the spine, rising obliquely from within to without. It starts from the inside, near the interior border of the bone, with a small triangular depression. This depression is caused by a special disposition of the fibers of the trapezius as we will see later. From there it rises as a sort of platform to terminate at the shoulder above.

The internal border of the scapula, when the arms fall naturally along the side of the body, forms a longitudinal ridge which is transformed into a depression by the contraction of muscles attached to it when the shoulders are moved forward or backward. The direction of the scapula when it is at rest is almost parallel to the center line of the back, from which it is separated by 7 or 8 centimeters. This distance is slightly more at the bottom of the scapula. The inferior angle of the scapula projects when the shoulders are lowered, but this projection is lessened by the muscular fibers of latissimus dorsi which pass over and around it.

Lower down, the skeleton of the trunk is terminated by the bony girdle of the pelvis. The pelvis is buried in powerful muscular masses and is subcutaneous only at points corresponding to the surface of the sacrum in the back, the pubis in front, and the iliac crests on the sides.

The depressions on the posterior surface of the sacrum are filled by muscle masses. These are the sacrolumbar muscle masses and they are maintained by a solid aponeurosis which is attached at each side to the lateral projections of the sacrum, and to the posterior iliac spine. In the middle the aponeurosis is attached to the spinal crest. The disposition of these muscles results in a medial groove above the crest of the sacrum. This groove continues the lumbar groove, which disappears below a little above the great crease of the buttocks. The groove is marked by a depression corresponding to the junction of the sacrum with the lumbar column which results from the angle formed by these two bony pieces.

The superior border of the iliac bone, or the iliac crest, receives numerous muscular insertions and is subcutaneous only along its external contour.

Toward its posterior third the iliac crest turns to the outside (reentering angle) and is marked on the outside by a depression (superior lateral lumbar fossa). The two anterior thirds of the crest only project in very thin subjects. In muscular subjects, the muscles which are attached above and below create a groove. However, this groove does not exactly follow the bony line, as we shall see further on. The superior anterior iliac spine is always a little projection at the anterior extremity of this groove.

In back, at the limits of the sacral region, the iliac tuberosity becomes a depression because of the muscles which surround it (*the inferior lumbar fossa*).

The pubic bone is covered by a thick fatty cushion which masks its form. It is fastened to the anterior superior iliac spine by a solid aponeurotic line (*inguinal ligament*). This ligament is attached to the two bony points and runs like a bridge between them. It creates a line which corresponds to the crease of the groin and marks the point of separation between the abdomen and thigh.

5. The Skeleton of the Upper Limb

The shoulder having been studied along with the trunk, we shall now describe the bones of the upper arm, the forearm and the hand. These bones are divided in the following fashion: in the upper arm, one bone—the humerus; in the forearm, two bones—the radius and ulna; in the hand, three bony segments.

The first segment of the hand is composed of the *carpus* which consists of eight bones: the scaphoid, the lunate, the triangular, the pisiform, the trapezium, the trapezoideum, the capitate, and the hamate. The second is the *metacarpus* which is composed of five bones: the five metacarpals. The third is the *fingers* which each have three bones: the three phalanges. The thumb is an exception—it only has two bones.

BONE OF THE UPPER ARM: HUMERUS (PLATE 13)

Situated in the middle of the soft parts of the arm, the humerus is a long bone which appears to be twisted on its axis. Anatomists, for purposes of description, think of it, like all bones, in terms of a body and two extremities.

The body, somewhat cylindrical above, is triangular below where it enlarges transversely; the superior extremity is rounded but the inferior extremity is enlarged transversely and flattened in front and in back.

Body. One notes three surfaces and three borders. The anterior border is more or less equally distinct down the whole length of the bone; above it blends into the anterior edge of the *intertubercular groove,* dividing below to embrace the coronoid fossa. The two lateral borders are most noticeable on the inferior part of the bone; they are sharper than the anterior border.

The external surface has a roughness toward its center in the form of a *V* for the insertion of the deltoid.

The *superior extremity* is separated from the body by the *surgical neck.* This extremity is divided into two parts by an *anatomical neck.* These parts are the articular part, directed up and within, in the form of a one third of a sphere; and the non-articular part, formed of two tubercles to which muscles are attached (in front, the *lesser tubercle,* and on the outside, the *greater tubercle*). The two tubercles are separated by a groove through which the tendon of the long head of the biceps passes. This groove (intertubercular groove) continues down toward the internal surface.

The *inferior extremity* has two distinct articular surfaces at its center for the bones of the forearm. On the outside, for the radius, the *capitulum* presents a rounded surface directed to the front. In the center, for the ulna, the trochlea has the form of a bony spool, with its internal border descending lower than the external. A bony eminence surmounts each one of these articular surfaces. On the outside, there is the *lateral condyle,* and on the inside, the *medial condyle.* We ought also to note the following depressions: in front, above the *trochlea* the *coronoid fossa*; in back, above the *trochea,* the *olecranon fossa*; and above the capitulum, in front, the *radial fossa.*

After Rollet,* for the average height of 1 meter, 66 centimeters, the humerus, in its greatest dimension, should be 32.08 centimeters.

BONES OF THE FOREARM: ULNA (PLATE 20)

The ulna is a long bone which is a triangle in cross section. It is situated on the internal part of the forearm.

The *body,* most voluminous above, has three surfaces and three borders. The anterior surface is concave and smooth. The posterior surface is unequally divided into two parts by a bony crest which runs down its whole length. The internal surface, convex, smooth and rounded, is subcutaneous.

Of the borders, the external one is the most prominent: it offers attachment to the interosseous ligaments. The anterior border is smoother; it starts at the medial edge of the coronoid process and ends at the styloid process. Finally, the posterior border, not visible on the inferior quarter of the bone, rises to the olecranon above.

The *superior extremity* has an articular cavity, the *trochlear notch,* which opens to the front and above. It is unequally divided by a bony longitudinal crest which articulates with the trochlea of the humerus. This cavity is formed, so to speak, by the anterior surface of the olecranon and the superior surface of the coronoid process.

The *olecranon* forms the point of the elbow and offers attachment to the muscle triceps brachii. It terminates, in front and above, in a curved beak which is received by the olecranon fossa of the humerus when the arm is in extension.

The coronoid process offers attachment, on its triangular anterior surface, to the brachialis muscle. Its external border is notched by an articular facet for the radius

* De la Mensuration des Os Longes des Membres by Dr. Étienne Rollet, 1889.

(*radial notch*), and its summit, also in the form of a beak, is received by the coronoid fossa of the humerus when the arm is flexed.

The *inferior extremity*, or *head of the ulna*, is surmounted by a *styloid process* and contains a shallow groove for the tendon of the *extensor carpi ulnaris*.

For the average height of 1 meter, 66 centimeters, the ulna is 25.9 centimeters long (Rollet).

BONES OF THE FOREARM: RADIUS (PLATE 20)

A long bone, triangular in cross section like the ulna, the radius is situated at the external part of the forearm.

The *body*, more voluminous at the inferior end, offers three surfaces and three borders. Their arrangement is symmetrical to the surfaces and borders of the ulna.

The external surface has an impression towards its middle for the insertion of the pronator teres.

The internal border is prominent and gives attachment to the interosseous ligament. The anterior border, starting at the *bicipital tuberosity*, terminates at the styloid process. The posterior border is only marked toward the middle of the bone.

The *superior extremity* is formed by a rounded articular part, the *head*, supported by a narrow portion, the *neck*. The head is hollowed out above for articulation with the humerus, and it is bordered by a periphery which rolls in the radial notch of the ulna.

The neck is united to the body in an obtuse angle opening to the outside. At the summit of this angle is the *radial tuberosity*, which offers insertion to the biceps.

The *inferior extremity*, large, flattened in front and in back, is hollowed out below by an articular surface divided by a crest from front to back.

In the back of the inferior extremity there are grooves for the following muscles. Reading from without to within: abductor pollicis longus and extensor pollicis brevis; extensor carpi radialis longus and brevis; extensor pollicis longus; extensor indicis and extensor digitorum. On the outside, there is a styloid process which extends lower than the styloid process of the ulna.

For the average height of 1 meter, 66 centimeters, the radius has a length of 24.02 centimeters (Rollet).

BONES OF THE HAND

The skeleton of the hand is composed of three segments: the carpus, the metacarpus and the phalanges.

THE CARPUS

The carpus is composed of eight bones arranged in two rows. From without to within they are: first row—scaphoid, lunate, triangular and pisiform; second row—trapezium, trapezoideum, capitate and hamate. These bones are juxtaposed in each row, except for the pisiform, which is somewhat outside the first row, in front of the triangular bone.

The carpus is composed of the following: a superior articular surface formed by the scaphoid, the lunate and the triangular (these articulate with the radius directly, and with the ulna through a triangular ligament) and an irregular inferior surface which articulates with the meta-

carpals. The posterior surface is convex and the concave anterior surface is converted into a groove by the presence of four bony processes on its sides; two processes are internal, the pisiform and the hook-like process of the hamate, and two external, the tubercle of the scaphoid and the ridge of the trapezium.

METACARPUS

The metacarpus is composed of five bones, the metacarpals. They are designated by number, counting from without to within. They are separated by interosseous spaces.

The first metacarpal is isolated, the others maintain a certain relationship with each other. Altogether they form, when seen from the front, a concave mass, which prolongs the hollow of the carpus. In back the metacarpals are convex.

Below, the heads of the four last metacarpals are disposed along a curved line. The third metacarpal projects the most.

Common characteristics of all the metacarpals are as follows. The *body*, triangular in cross section, has two sides and one dorsal surface. The *base*, or *superior extremity*, has articular facets for the carpal bones and the neighboring metacarpals. The *head*, or *inferior extremity* terminates in a spherical articular surface marked on the sides by rough depressions.

Distinctive characteristics occur particularly at the base and may be summed up as follows. The first metacarpal is short and large. The articular surface of the superior extremity, or base, is in the form of a saddle and is prolonged in front by a jutting point. The second metacarpal has at its base three articular facets for the bones of the carpus and one for the third metacarpal. On its dorsal surface there is a tubercle for the insertion of the extensor carpi radialis longus. The third metacarpal has a median articular surface for the capitate and two lateral ones for the neighboring metacarpals. The base is prolonged in back and on the outside by a *styloid process* which gives insertion to extensor carpi radialis brevis. The base of the fourth metacarpal has three articular facets—one median for the hamate and two lateral for the neighboring metacarpals. Finally, the base of the fifth metacarpal has one articular surface for the hamate and another for the fourth metacarpal; on the outside, there is a rough tuberosity for the attachment of extensor carpi ulnaris.

PHALANGES (PLATE 21, FIGURE 6)

The thumb has two phalanges, the four other fingers have three. These segments are called, going from top to bottom: the first, second, and third phalanges. The phalanges diminish in size from top to bottom.

The first phalanges each have their superior extremity hollowed by an articular cavity to fit one of the metacarpals; their inferior extremity has an articular surface in the form of a pulley for contact with the next phalange.

On each of the second phalanges the articular facet of the superior extremity is divided in two from front to back by a crest. The inferior facet is like that of the preceding phalange.

Finally, the third phalanges have a superior articular facet resembling that of the second phalange, and their bodies, thin and short, carry an elevation at each extremity which serves to support the nail.

ARTICULATION OF THE SHOULDER (PLATE 22, FIGURE 1)

Articular surfaces. The humerus is brought into contact with the glenoid cavity of the scapula through the spheroid portion of its upper extremity. The depth of the glenoid cavity is augmented by a rim of fibrocartilage (*labrum glenoidale*).

Above an osteofibrous vault completes this articulation. It is formed by the acromion and the coracoid process united by a strong ligament, the *coracoacromial ligament*.

Ligaments. The two bones (humerus and scapula) are united by a sort of sleeve, or fibrous capsule, which is attached to the anatomical neck of the humerus and to the periphery of the glenoid cavity. Their union is reinforced by the *coracohumeral ligament*, the suspensory ligament of the humerus, which arises from the internal border of the coracoid process at its posterior superior surface. It is also reinforced by all the tendons of the muscles which insert into the tuberosities and blend into the fibrous capsule.

The tendon of the long head of the biceps emerges from the interior of the articulation at the intertubercular groove; it originates at the upper part of the glenoid cavity from the labrum glenoidale.

Mechanism. The articulation is remarkable for its excessive mobility which is due to the shallow nature of the glenoid cavity and the flexibility of the articular capsule. It allows movement in three principal directions: adduction and abduction, movement front and back, and rotation.

ARTICULATION OF THE TWO BONES OF THE FOREARM (PLATE 22, FIGURE 3)

The two bones of the forearm articulate with each other at their extremities.

Superior radioulnar articulation. The cylindrical border of the head of the radius is received in an osteofibrous ring formed by the radial notch of the ulna and by a ligament, the *annular ligament*.

Inferior radioulnar articulation. The articular surfaces here are the inverse of the superior articulation. It is the radius that furnishes the sigmoid cavity (ulnar notch) against which the head of the ulna is applied. However, the head of the ulna is only articular throughout about two thirds of its circumference, and the bones are maintained in contact by the *triangular ligament*, disposed transversely below the head of the ulna. This ligament is attached at its base to the radius at the angle where the ulnar surface meets the carpal surface. At its summit it is attached to the external portion of the styloid process of the ulna.

An interosseous membrane fills the space between the two bones, except for the area above and below, and it is attached to the borders of the bones.

ARTICULATION OF THE ELBOW (PLATE 22, FIGURE 2)

Articular surfaces. The great trochlear notch of the ulna is molded to fit exactly the trochlea of the humerus of which it embraces about half. On the outside the capitulum is in contact with the head of the radius.

Ligaments. A somewhat loose capsule surrounds the articulation in front and in back. The bones are maintained in contact by solid lateral ligaments. The *ulnar collateral* ligament, in the form of a fan, goes from the medial condyle to the medial border of the olecranon and to the coronoid process. The *radial collateral ligament* goes from the external condyle to the annular ligament without any insertion into the radius.

Mechanisms of the elbow and of the forearm. The articulation of the elbow is a true hinge, and movements are only possible in a single direction.

Flexion, which brings the forearm toward the upper arm, is limited only by the meeting of the coronoid process with the coronoid fossa. Extension, in which the forearm directly prolongs the upper arm, is checked by the meeting of the point of the olecranon and the olecranon fossa.

The axis of rotation is transverse, and not perpendicular to the axis of the humerus; it is inclined from above to below and from without to within. The result is that in extension the hand withdraws from the median plane of the body and the forearm diverges from the upper arm creating an obtuse angle opening to the outside.

In flexion the hand approaches the median line and the forearm creates an extremely acute angle with the upper arm.

Pronation and supination. These are the terms used to designate the rotation of the forearm on its axis, and the movements are due to the displacement of the two bones, radius and ulna. In supination, the palm of the hand is directed forward; in pronation, the palm of the hand is directed to the rear.

These movements are not (as described by most authors) the result of a simple movement of rotation by the radius around the ulna, which remains fixed. Duchenne de Boulogne has demonstrated perfectly that, during pronation and supination, these two bones clearly move throughout their inferior quarter, above all at the inferior extremities, and each describes a circular arc in an opposite direction. He has also demonstrated that these two movements are interdependent. It is in the inferior radioulnar articulation that this double movement is, in a sense, inverse. In the superior articulation, the head of the radius rolls by itself, maintained by the annular ligament, while the ulna undergoes a very slight movement of flexion and extension.

ARTICULATION OF THE WRIST AND THE HAND (PLATE 22, FIGURE 4)

I shall first describe the articular surfaces of the diverse articulations of the hand, and then the ligaments which surround them.

Articulation of the radius and the carpus, or radiocarpal articulation. On one side the cavity created by the radius

receives a rounded eminence formed, on the other side, by the superior surfaces of the bones of the first row of the carpus—except for the pisiform. The first row of the carpus consists of the scaphoid, the lunate, and the triangular bones.

Articulation of the two rows of the carpal bones with each other. The *articular surfaces* are very complex, formed above by the inferior surfaces of the bones of the first row, except for the pisiform, and below by the superior surface of the second row.

Each of these surfaces is alternately concave and convex, the convexity of the one moving on the concavity of the other.

Articulation of the trapezium with the first metacarpal. The articulations are saddle shaped, and enjoy reciprocal reception.

Articulations of the metacarpals with the carpus. The line of articulation is most irregular. It is formed by the inferior surfaces of the bones of the second row of the carpus with the superior extremities of the last four metacarpals.

Ligaments of the articulations of the wrist and the carpus. First of all, it is necessary to draw attention to the *interosseous ligaments* which solidly unite between them the small bones constituting each row of the carpus, with the exception of the trapezium. There exists, besides, an interosseous ligament, extending from the capitate and the hamate to the third and fourth metacarpals.

The peripheral ligaments are divided into the dorsal, palmar, and lateral ligaments. They extend between neighboring bones. I shall point out the principal ones. In the back, there is an oblique fascia, going from the radius to the triangular bone, which is called the *dorsal radiocarpal.* In the front, two oblique fasciae go from the two bones of the forearm toward the capitate, which is in the center of the carpus: one, very large, the *palmar radiocarpal ligament*, and another, straighter, the *ulnacarpal ligament.* On the sides the lateral ligaments can be seen. On the outside, the lateral ligaments run from the styloid process of the radius to the scaphoid and from there to the trapezium (*radial collateral* or *external lateral ligament*). On the inside, they run from the styloid process of the ulna to the triangular bone. From there they run to the pisiform (*ulnar collateral* or *internal lateral ligament.*)

The pisiform is, moreover, solidly held by two ligaments of which one goes to the hamulus of the hamate bone and the other to the fifth metacarpal. The articulation of the trapezium and the first metacarpal is surrounded by a fibrous capsule.

Finally, the hollow of the carpus is transformed into a ring by a strong ligament, the *annular ligament*, which attaches on the outside to the scaphoid process and to the crest of the trapezium, and on the inside to the pisiform and to the hamulus of the hamate. Through this ring pass the tendons of the muscles that flex the fingers.

Mechanism of the articulations of the wrist and hand. The radiocarpal articulation and the intercarpal articulations are susceptible to considerable movement.

They do not (exactly) act alone and it is their combined action that gives rise to the movements of the hand on the forearm. These movements can take place in two principal directions: in the anteroposterior sense, flexion and extension; and in the lateral sense, adduction and abduction.

The extent of flexion and extension amounts to more than two right angles; that of the lateral inclinations, from 45° to 50°.

The articulations of the second and third metacarpals with the carpus are almost immobile. The fourth metacarpal is capable of considerable movement. The capacity for movement is even more pronounced in the fifth where the articulation with the hamate is a true saddle joint.

The articulation of the first metacarpal with the trapezium is the most mobile. These movements are in two principal directions. First, the thumb approaches or removes itself from the axis of the hand: adduction or abduction. This movement is limited within by the contact of the two metacarpals, and without by the tension of the articular capsule. Second, the thumb moves forward and back: flexion and extension. The obliquity of the trapezium is such that, in flexion, the first metacarpal places itself in front of the others and results in the movement of opposition.

Articulation of the metacarpus and the fingers, or metacarpophalangeal articulations. The head of the metacarpal rests in the cavity of the superior extremity of the phalange; this cavity is completed by a thick ligament, the *palmar ligament.* The *transverse metacarpal ligaments* unite the palmar ligaments of the four last fingers.

Very strong triangular lateral ligaments (*collateral ligaments*) run from the posterior tubercles at the head of the·metacarpals to the lateral parts of the phalanges and to the palmar ligament.

Mechanism. The movements are of two types. First, flexion and extension. Limited by the resistance of the ligaments, flexion seldom exceeds a right angle. Second, adduction and abduction. The extent of this movement is limited by the resistance of the lateral ligaments.

There exists besides a slight movement of circumduction.

Articulations of the phalanges. These articulations are of little trochleas furnished with an anterior, or palmar ligament, and two lateral ligaments. They constitute true hinges of which the only two possible movements are flexion and extension.

SKELETON OF THE ARM IN GENERAL: ITS INFLUENCE ON EXTERIOR FORM (PLATES 23, 24 and 25)

The humerus supports the soft parts of the upper arm. The swelling of its superior extremity is reflected in an extension at the shoulder and it juts out beyond the bony arch formed by the acromion. Its inferior extremity on the inside (medial epicondyle) creates a pronounced prominence under the skin, while on the outside (lateral epicondyle) it disappers under the relief of the external muscles of the forearm.

The axis of the forearm forms with the axis of the upper arm an obtuse angle opening to the outside, as pointed out before. In the position of pronation this angle disappears and the forearm continues the direction of the

upper arm. Placed side by side, the two bones of the forearm, when in supination, contribute a flat quality to the forearm both in front and behind. In back and above, the olecranon forms the projection of the elbow. The whole posterior border of the ulna is subcutaneous and may be seen on the model as a furrow caused by the high relief of the surrounding muscles. Below, the two styloid processes make distinct projections: on the inside, that of the ulna; on the outside and lower, that of the radius.

The hand is, in its natural position, somewhat inclined medially from the ulna border. As a result its axis forms, with that of the forearm, an obtuse angle opening to the inside, which is, so to speak, the opposite of that formed by the forearm and the upper arm.

The anterior groove of the carpus, crossed by tendons and filled by ligaments, scarcely reveals itself on the surface. The heel of the hand is formed by the promi-nence of the trapezium outside and by the projection of the pisiform inside. The projection of the pisiform is much higher.

The hollow of the hand and the convexity of the back of the hand suggest the shape of the metacarpus. The phalanges may be discerned on the dorsal surfaces of the fingers.

The proportional length of the humerus and the radius are of great importance as they determine the proportions of the two great segments of the arm. These proportions vary somewhat according to race.

Broca has shown that if the humerus is equal to 100, the average radius of a European would be 73.8, while that of a Negro would be 79.4. The result is that Negroes have longer arms than Europeans and this difference in length is due to the longer dimensions of the forearm.

6. The Skeleton of the Lower Limb

The bones of the lower limb may be divided as follows. In the thigh, one bone: the femur. In the lower leg, two bones: the tibia and the fibula. In the foot there are the following three segments. First, the tarsus which is composed of seven bones: the talus, the calcaneus, the navicular, the three cuneiforms, and the cuboid; second, the metatarsus, composed of five bones: the five metatarsals; third, the toes, consisting of three bones each: the proximal, middle and distal phalanges. The big toe has only two phalanges: the proximal and the distal.

BONE OF THE THIGH: FEMUR (PLATE 26)

A long bone, the femur has an anterior convex curve; it is bent sharply above and directed obliquely from above to below and from without to within.

The *body*, a triangular prism, presents an anterior surface, two lateral surfaces, two lateral borders, and a posterior border.

The anterior surface is smooth, convex, and hollowed out below. The two lateral borders are rounded, but the posterior border, in contrast, is rough and prominent. The posterior border is called the *linea aspera*. The linea aspera has two superior origins. One part springs from the great trochanter and the other from the lesser trochanter. Below the linea aspera divides, forming a triangular space, the *popliteal surface.*

The superior extremity of the femur is composed of a rounded head supported by a neck which leads to a portion of the bone enlarged by the presence of two tuberosities, the *great trochanter* and the *lesser trochanter.*

The *head* represents about two thirds of a sphere directed within and above. It is marked by a depression on its median line for the attachment of a round ligament. This depression is somewhat nearer to the inferior than to the superior border.

The *neck* forms an obtuse angle with the body opening within. It is more closed on the female.

On the outside the *greater trochanter* occupies the summit of the angle we have mentioned. It presents a prominent superior border, and its internal surface is marked by a depression, the *trochanteric fossa.* The *lesser trochanter* is situated within and below. The *intertrochanteric line*, in front, and the *intertrochanteric crest*, in back, unite the two trochanters.

The *inferior extremity* is large and quadrilateral. It is formed by two condyles separated in the back by a large groove. The axis of this groove is directed from above to below and from without to within. Thus the femur, though resting on a horizontal surface, does not rise vertically. It inclines obliquely to the outside in the human body.

In front, the two condyles unite to form a true articular spool on which the patella rests. The external border rises higher and projects more than the internal. The two condyles, directed obliquely, deviate from the median plane. They are separated by a deep depression in the back (*intercondyloid fossa*) and their posterior extremity projects strongly. On their sides, the two condyles are surmounted by two bony prominences (the *medial* and *lateral epicondyles*). Above the medial epicondyle is the *adductor tubercle.*

For the average height of 1 meter, 66 centimeters, the femur is 45.03 centimeters long (Rollet).

BONES OF THE LOWER LEG: TIBIA (PLATE 27 and 28)

A long bone, directed vertically, the tibia presents three slight curves in relation to its length. The superior curve is an external concavity; the inferior, an internal concavity. The tibia is twisted upon itself, and the transverse axes of the superior and inferior articular surfaces make an angle between them of about 20°. The result of this twist is that the direction of the foot is to the outside.

The body is a triangular prism with two lateral surfaces and a posterior surface, an anterior border, and two lateral borders. The external surface, concave above, becomes convex and moves to the front below. The internal surface, smooth and slightly convex, is subcutaneous throughout its entire length. The posterior surface is divided into two unequal parts by an oblique line directed from above to below and from without to within. Above the oblique line is the *popliteal surface.*

The anterior border, or *crest of the tibia*, forms an elongated italic S, ending in front of the medial malleolus. The external border divides in order to receive the fibula.

The *superior extremity* is large and flattened above. It is in contact with the condyles of the femur. The superior surface presents, on the anteroposterior axis, two shallow articular cavities which are separated by the *intercondylar eminence*. These two cavities are of slightly different form: the external one is larger and longer than the internal. They rest upon an enlargement of the bone which is composed of condyles. On the lateral condyle, at the outside and in the back, there is an articular facet for the fibula. The medial condyle is crossed by a transverse

groove for the tendon of the semimembranosus. Finally, in front and lower down, there is the *anterior tuberosity of the tibia*. This tuberosity offers attachment to the lower patella ligament and surmounts the anterior border of the bone.

The *inferior extremity*, which is quadrangular, offers a trapezoidal excavation on its lower part which articulates with the talus.

On the inside, the surface is prolonged by a thick process which forms the medial malleolus.

On the outside, there is a triangular surface which articulates with the fibula. In back, there is a groove for *tibialis posterior*.

According to Rollet, for a figure of 1 meter, 66 centimeters, the tibia has a length of 36.06 centimeters.

BONES OF THE LOWER LEG: FIBULA (PLATE 27 and 28)

The fibula is long, slender, triangular in cross section, and twisted upon itself.

At the superior part of the bone two lateral surfaces and a posterior surface can be distinguished. As a result of the twisting of the bone, the exterior surface becomes, below, a posterior surface. The other surfaces and borders follow the same deviation.

The internal surface is divided by a longitudinal crest, the *interosseus border*.

The *superior extremity*, or head, has a flat articular surface. Outside of the head the bone forms a prominence, the *styloid process* of the *fibula*.

The *inferior extremity*, or *external malleolus,* triangular in form, is subcutaneous on its external surface. Its interior surface has a vertical facet which articulates with the talus. Below, it has a rough depression for the insertion of ligaments. On its posterior border there is a groove for the tendons of the lateral peroneal muscles. The fibula is the same length as the tibia, more or less.

For a height of 1 meter, 66 centimeters, the fibula has a length of 36.02 centimeters (Rollet).

PATELLA (PLATE 27)

A flat triangular bone, the patella is situated at the anterior part of the articulation of the knee, reposing on the femoral condyles. Its superior part is attached to the tendon of the quadriceps; its inferior part to the lower patellar ligament.

It presents two surfaces and a circumference. The anterior surface is rough and subcutaneous.

The posterior surface is the articular surface. It is separated into two unequal portions by a bony crest which corresponds to the groove on the patellar surface of the femur.

The circumference has the form of a triangle of which the base points upward. The patella give attachment to ligaments on all of its sides.

BONES OF THE FOOT

Like the hand, the skeleton of the foot is composed of three segments: the tarsus, the metatarsus, and the toes.

TARSUS (PLATES 28 and 29)

The tarsus is composed of seven bones, divided into two rows. The first row consists of the talus, the calcaneus and the navicular. The second row consists of the three cuneiforms and the cuboid.

Talus. The talus forms the summit of the skeleton of the foot. Its superior surface is in touch with the bones of the lower leg and it surmounts the calcaneus. It has a head, a body, and a neck. Without entering into a detailed description of each of these parts, let us examine the diverse surfaces of the bone as a whole.

Above, there is an articular surface in the form of a spool for the tibia, wider in front than behind, and separated from the head (which is in front) by a depression.

The external or lateral surface presents a triangular articular facet for the inferior extremity (*lateral malleolus*) of the fibula, below which the bone projects somewhat.

On the medial surface there is a *medial malleolar facet*, shaped like a crescent.

In back, the bone is grooved obliquely for the tendon of the flexor hallucis longus. In front, the head of the talus shows a rounded surface for articulation with the navicular.

Finally, on the inferior surface there are three facets (posterior, middle and anterior) which articulate with the calcaneus. The posterior calcaneal articular surface is separated from the middle and anterior surfaces by a groove (*sulcus tali*).

Calcaneus. The calcaneus is the bone of the heel. It is massive and somewhat cuboidal in form. In front, a large and a small process can be distinguished. The body forms all the posterior part of the bone.

Like the talus, we shall consider the various surfaces.

The superior surface, in back, is narrow and rough. In front, there are two articular surfaces, separated from the posterior articulated surface by a groove (*sulcus calcanei*). These surfaces articulate with the inferior surface of the talus.

Below, the bone forms three unequal prominences; one is anterior, the *calcaneal tuberosity*, and two posterior, the *lateral* and *medial processes*. The posterior prominences are situated side by side, the larger on the inside.

The lateral surface is flat, rough, and vertical; a tubercle (*trochlea process*) separates two grooves for the tendons of *peroneus longus* and *brevis*.

The medial surface, on the contrary, is smooth. It is completely transformed into a groove for the tendons of the deep posterior muscles of the lower leg, owing to the projection of the *sustentaculum tali*.

In back, the calcaneus carries an impression for the insertion of the Achilles tendon.

In front, the greater tuberosity presents an articular surface which is in contact with the cuboid.

Navicular. The navicular, of smaller size than the two preceding bones, has the form of an oval disk. It presents two surfaces and a circumference.

The two surfaces are articular. The anterior surface is divided into three facets for the cuneiforms; the posterior

surface has but a single facet which is hollowed out to receive the head of the talus.

The circumference is rough and convex above. On the inside it is prolonged into a considerable swelling. On the outside it usually has an articular facet for the cuboid.

Cuneiforms. The cuneiforms, three in number, articulate with the navicular in back, and the three first metatarsals in front. They owe their name to their shape and are designated by their number reading from the inside of the foot.

The first (medial) cuneiform is the largest; its base is rounded below, and its edge is directed above. The medial surface is rough and it is marked in front and below by an impression for the attachment of tibialis anterior. The lateral surface articulates along its *superior and posterior borders* with the second (intermediate) cuneiform and in the front with the second metatarsal.

The two other (intermediate and lateral) cuneiforms are smaller and their bases are turned to form their superior surfaces. They create the most projecting part of the dorsum of the foot. The third (lateral) cuneiform articulates at its medial surface with the second (intermediate) cuneiform, and with a part of the head of the second metatarsal. Its lateral surface articulates with the cuboid bone.

Cuboid. This bone is formed like an irregular cuboid, hence its name. It is situated at the external border of the foot, beyond the navicular and the cuneiforms. The dorsal surface is rough and is strongly inclined toward the external border of the foot.

The plantar surface of the cuboid is crossed by an oblique groove (*peroneal sulcus*), for the tendon of peroneus longus. This groove is separated from the rest of the bone by a blunt tuberosity. The posterior surface articulates with the calcaneus, the anterior surface with the last two metatarsals. The flat medial surface articulates with the navicular and the third cuneiform, and the lateral surface, which is reduced to a heavy border, has a slight hollow which is the point of departure for the groove (peroneal sulcus) of peroneus longus.

METATARSUS (PLATE 28 and 29)

The metatarsus consists of five bones which articulate in back with the bones of the second row of the tarsus. They are designated by number reading from within to without.

They are, like the metacarpals, small long bones each offering a body and two extremities. The body, triangular and prismatic in cross section, turns one of its surfaces toward the dorsum of the foot. The tarsal extremity is a thick irregular cuboid. The anterior extremity, or head, offers a rounded articular surface, most prominent on the plantar surface. This anterior articular surface terminates in two tubercles.

The distinctive characteristics of the metatarsals are as follows. The first metatarsal is short and voluminous and its proximal extremity terminates below in a very large tuberosity. The base of the second metatarsal enters as a sort of wedge into a recess formed by the three cuneiforms. Besides their articulations with the tarsus, the proximal extremities of the second, third, fourth, and fifth metatarsals articulate one with the other by their corresponding facets. The fifth metatarsal has at its proximal extremity in back and to the outside, a large tuberosity.

PHALANGES

I shall not describe the phalanges in detail since they are analogous to those of the fingers.

ARTICULATIONS OF THE HIP (PLATE 25)

The articular surface is the acetabulum which is situated on the side of the iliac bone. The depth of the acetabulum is augmented by a prismatic extension or lip analogous to that of the glenoid cavity at the shoulder. The base of the lip lies on the superior part of the cavity and its internal surface prolongs the articular surface. The whole lip rests like a bridge above the acetabular notch.

On the side of the femur, the articular surface is formed by the spherical head of the bone of which the radius is the same as the cavity which receives it.

Ligaments. A *fibrous capsule* surrounds the articulation in the form of a complete fibrous sleeve running from all around the acetabulum to the base of the neck of the femur.

There are also longitudinal fibers of which the most considerable go from the lower part of the anterior inferior iliac spine to the intertrochanteric line. They form the *iliofemoral ligament*. There exist, besides, circular fibers which form the inferior and posterior parts of the capsule.

Several of these ligamentary fibers, besides those which originate at the anterior inferior iliac spine, come from the pubis and the ischium.

The longitudinal fibers have a disposition to spiral around the neck of the femur, through which their tension is augmented in extension and diminished in flexion.

Ligamentum capitis femoris. Lodged in the depth of the acetabulum, this ligament has a vertical direction. It descends and expands from the depression of the femoral head toward the acetabular notch, to the border of which it is inserted. It attaches to either side of the bottom of the acetabulum and to the cross ligaments which traverse the notch. It is formed of extremely strong fibers. This intraarticular ligament (the importance of which has long remained unrecognized) does not maintain the contact of the two articular surfaces but supports a part of the weight of the pelvis which would otherwise fall on the femoral heads. It is, in fact, a true suspensory ligament of the trunk as my friend Paul Poirier has demonstrated.

Mechanism. The femoral head exactly fills the acetabular cavity augmented as it is by its lip. However, the acetabular lip, which is not flexible, cannot maintain the two surfaces in contact without assistance. The contact of the two surfaces is, therefore, also maintained by the resistance of the ligaments, the tonicity of the neighboring muscles, and above all by atmospheric pressure.

The movements of the femur, because of the spherical

nature of the articular surfaces of the bone, can take place in any direction, nevertheless these movements can be broken down into three principal types.

Flexion and extension take place around a transverse axis passing through the center of the femoral heads. Flexion is limited by the meeting of the thigh and the trunk, extension by the tension of the anterior ligament.

Inward and outward rotation are carried out around a vertical axis. It is limited by the opposition of the capsular ligaments.

Lateral movements or abduction and adduction pass around an anteroposterior axis. They are limited in adduction by the iliofemoral ligament and in abduction by the meeting of the acetabular border and the neck of the femur.

ARTICULATIONS OF THE KNEE (PLATE 30)

The articular surfaces belong to three bones. The first surface lies on the *femur*. The articular surface is divided into three parts: in front, there is the patella surface which is hollowed at its center by a vertical groove and in back there are two condyloid surfaces which are separated from the patellar surface by two small oblique grooves. The secondary surface lies on the *patella*. The posterior surface of this bone is entirely articular. The third surface is situated on the *tibia*. The glenoid cavities of the tibia, quite flat and separated by the spine of the tibia, present articular surfaces on which the condyles of the femur rest. These cavities are surmounted by two fibrocartilages which increase their depth, and supplement or reduce the concordance of the two surfaces in contact. These fibrocartilages are crescent shaped and are called the *menisci*. The thick convex edge of each is attached to the periphery of the glenoid cavities. The concave borders are thin and turned toward the center of the cavity. The lateral meniscus is nearly circular. It is inserted by its two extremities into the spine of the tibia. The medial meniscus, which is attached in front and in back of the insertions of the lateral, is crescent shaped.

In the movements of articulation, the ligaments move with the tibia.

Ligaments. At the center of the articulation the *cruciate ligaments* are situated. These are very strong ligaments which partially fill the intercondylar fossa of the tibia and pass to the medial surfaces of the femoral condyles. They cross each other in both an anteroposterior and a transversal direction. The anterior, which starts in front of the spine of the tibia, moves back and outwards to insert into the posterior part of the medial surface of the lateral condyle of the femur. The posterior, which moves in a contrary direction from back to front, goes from the posterior part of the tibia to the anterior part of the intercondylar fossa. From there it runs to the medial surface of the medial condyle of the femur.

All around the articulation there are the following ligaments. The *anterior ligaments* are formed at the center by a very strong ligament. This ligament goes from the anterior tubercle of the tibia to the patella and joins with the most anterior fibers of the tendon of the quadriceps muscle. On each side thinner membranous ligaments go from the edges of the patella and attach to the condyles.

Posterior ligaments do not really exist. They are replaced by the neighboring muscles and their tendons.

The *collateral ligaments* are extremely distinct. The fibular collateral ligament, in the form of a strong resistant cord, goes from the lateral epicondyle of the femur to the head of the fibula. The tibial collateral ligament, on the contrary, is flat. It is attached above to the medial condyle of the femur, and below to the posterior and superior internal surface of the tibia.

Mechanism. The articulation of the knee is that of an imperfect hinge. It permits not only flexion and extension, but also rotation. It is true that this latter movement is incompatible with extension; it only takes place in demiflexion. Flexion and extension take place through the sliding and the rolling of the condyles of the femur upon the medial and lateral menisci.

Extension is arrested, as soon as the tibia and the femur form a straight line, through the tension of the cruciate ligaments and the collateral ligaments. Flexion may be carried out until the lower leg muscles meet the thigh.

Rotation can only take place in the intermediate positions between extension and complete flexion. The movement is located, above all, at the lateral condyle of the tibia, and dies out, so to speak, around the medial condyle. This is partly because the fibular collateral ligament is more relaxed in flexion than the tibial collateral ligament. The latter ligament maintains a more solid contact between the tibia and the femur on the medial side. In rotation to the inside, the intersection of the cruciate ligaments is augmented and this very quickly limits the movement. These ligaments do not intersect in rotation to the outside so that this movement is only limited by the resistance of the collateral ligaments.

ARTICULATION OF THE TIBIA AND FIBULA

The fibula articulates with the tibia by its two extremities. The two bones are also united by an interosseous membrane which inserts medially to the external border of the tibia, laterally to the interosseous crest of the internal surface of the fibula, and along its inferior third to the anterior border of this bone.

The superior *tibiofibular articulation* is formed by two articular facets which are almost flat planes. They are surrounded by a fibrous capsule.

The inferior *tibiofibular articulation (tibiofibular syndesmosis)* does not really have an articular surface. The two bones are solidly united at their inferior extremity by an interosseous ligament and by two exterior ligaments, the anterior and the posterior tibiofibular ligaments. These ligaments secure the tibiofibular mortise.

ARTICULATION OF THE ANKLE JOINT (PLATE 31)

This is a hinge-like articulation formed by the talus with the tibia and fibula.

Articular surfaces. On the talus bone the surfaces take on the form of a segment of a spool which is disposed in an anteroposterior direction. The hollow is above, larger in front than in back, and the external border projects more than the internal.

Laterally there are two facets which continue into the superior surface without interruption. They are somewhat different in shape: the external facet is triangular; the internal facet is sickle shaped.

On the fibula and the tibia the articular surfaces (tibiofibular syndesmosis) fit the spool-like surface of the talus, but not exactly. Since their articular surfaces are not as long from front to back, they only rest on a part of the surface of the talus.

Ligaments. The ligaments of this articulation are disposed on each side. In front and in back the synovial membrane is loose and sheathed with fibers.

The *internal lateral* or *deltoid ligament* is thick and triangular. It is attached at its summit to the medial malleolus from where it fans out and inserts on three ankle bones: on the navicular, on the lesser process of the calcaneus, and on the posterior part of the talus. Its deepest fibers, which are somewhat separate, all go to the medial surface of the talus.

There are three external lateral ligaments. In front, the *anterior talofibular ligament* goes from the anterior border of the fibular malleolus to the talus, in front of its lateral articular facet. In the middle, the *calcaneofibular ligament* transcends from the summit of the fibular malleolus and goes to the lateral surface of the calcaneus. In the back, the *posterior talofibular ligament*, running transversely, goes from the medial posterior surface of the fibular malleolus to the posterior border of the talus immediately to the outside of the groove for the flexor hallucis longus.

ARTICULATIONS OF THE FOOT (PLATE 31)

Articulations of the talus. The inferior articulation of the talus (subtalar articulation) is divided into two distinct articulations: the first, posterior, the body of the talus articulating with the calcaneus; the second, anterior, the head of the talus articulating with the calcaneus and the navicular. These two articulations are separated by extremely strong sheaths of fibers which fill the cavity of the tarsus and bind the talus and the calcaneus firmly together. These fibers form the *interosseous talocalcaneal ligament.*

Inferior posterior articulation of the talus. Articular surfaces. The head of the talus is received in a cavity formed in back by the concave anterior facet of the calcaneus, and in front by the concave posterior facet of the navicular. A fibrocartilaginous ligament unites the calcaneus and the navicular. It is called the *plantar calcaneonavicular ligament.*

There are two other ligaments reaching from the calcaneus to the external part of the navicular: on the outside, the medial branch of the *bifurcated ligament*; on the superior part, the dorsal *talonavicular ligament* reaching from the neck of the talus to the navicular.

Articulation of the calcaneus and the cuboid (calcaneo-cuboid articulation). This is a saddle joint. The articular surface of the calcaneus is convex from within to without and concave from above to below. The articular surface of the cuboid has inverse curves.

There are three ligaments: first, the *dorsal calcaneocuboid ligament*; second, the lateral branch of the *bifurcated ligament*; third, an inferior ligament, the *long plantar ligament*. The latter goes from the tuberosities of the calcaneus to the whole inferior surface of the cuboid. Some of its most superificial fibers reach as far as the third cuneiform and the bases of the four last metatarsals.

Articulations of the navicular, cuboid and cuneiforms. The three cuneiforms and the cuboid articulate with each other through flat surfaces, and the navicular articulates with the three cuneiforms through triangular surfaces which are almost flat. There is sometimes a fourth facet on the navicular in contact with the cuboid.

Ligaments. The cuneiforms and the cuboid are united by three types of ligaments: a dorsal ligament, a plantar ligament, and an interosseous ligament. Besides, all four bones are united to the navicular by a dorsal and a plantar ligament; there is, in addition, an interosseous ligament going from the navicular to the cuboid.

Tarsometatarsal articulations. The first metatarsal articulates with the first cuneiform, the second with the three cuneiforms, the third with the third cuneiform, and the last two with the cuboid. Moreover, the metatarsals, with the exception of the first, articulate between themselves through their lateral facets.

All these bony parts are maintained in contact by three types of ligaments: the dorsal ligaments, the plantar ligaments, and the interosseous ligaments.

Metatarsophalangeal articulations. These are condyloid articulations formed by the reception of the convex heads of the metatarsals by the concave facets of the phalanges. Below fibrocartilaginous ligaments (*plantar ligaments*) fill the phalangeal cavity. These ligaments are all united by a transverse plantar band, the *transverse metatarsal ligament*. On either side of each joint there are very resistant lateral ligaments.

Mechanism of the Foot. The foot forms a rising flattened vault held above the ground by several points of support: in back, by the calcaneus; in front, by all the heads of the metatarsals; and, on the outside, by the entire length of the external border. This vault, which supports the whole weight of the body, is maintained by the shape of the bones; by the resistance of the ligaments (above all the great plantar ligaments); and finally by the muscles and the aponeuroses.

The movements of the foot upon the lower leg are of two kinds. Both these movements may be divided into two different articulations.

Flexion and extension take place at the ankle joint proper (tibiotarsal articulation); adduction and abduction take place beneath the talus (subtalar articulation).

The tibiotarsal articulation is a true hinge of which the axis is horizontal and transversal. In virtue of the movements which take place through this joint, the point of the foot is lifted or lowered. In extension, because the articular surfaces are larger in front than behind, the narrowest part of the talus is placed in the largest part of the tibiofibular mortise. Certain lateral movements are thus possible which are not possible in flexion.

Flexion and extension are limited by the meeting of the bony surfaces.

During adduction (subtalar articulation) the point of the foot turns to the outside and the external border is lowered. This movement is the inverse of abduction. During these movements, the calcaneus and the navicular, and with them the rest of the foot, move upon the talus. At this point the talus becomes immobilized within the tibiofibular mortise. Adduction is greater than abduction.

The other tarsal articulations also come into play during these movements.

The *tarsometatarsal articulations* are limited; they permit very slight movements. In the *metatarsophalangeal articulations*, flexion is more extensive than extension.

SKELETON OF THE LOWER LIMB IN GENERAL: ITS ACTION ON EXTERIOR FORM (PLATES 32, 33, 34 and 35)

The femur does not occupy, as the humerus does, the center of the limb of which it forms the skeleton. However, it appears to be in the center on the side view (Plate 34), apparently situated in the center of the soft parts and parallel to the axis of the thigh. However, in considering the front view (Plate 32), it can be seen that it is obliquely directed and that, flush with the skin (through the great trochanter) at the superior and external part of the thigh, it only approaches the axis of the thigh at the bottom. Its inferior extremity occupies the center of the knee.

The bones of the lower limb are directed almost vertically and in such a manner that they form with the femur an extremely obtuse angle opening to the outside. The summit of the angle corresponds to the internal part of the knee.

In the standing position, the superior border of the patella juts forward. Its inferior extremity does not quite reach the line of articulation of the knee.

Besides maintaining proportions in height, the femur directly affects the surface in numerous places. Above the great trochanter it creates a strong hollow which is easily seen in the erect position. (This hollow becomes somewhat obscure in flexion of the thigh, and we shall see the reasons for this later.)

I should mention here that the anterior convexity of the femur contributes to the curve of the anterior exterior surface of the thigh.

At the knee, the skeleton strongly affects the exterior surface. Taking into account the projection of the patella in front, a cross section of the knee has a quadrangular appearance of which the bony extremities of the femur and the tibia form the framework. Among the many forms seen on the surface, a certain number are directly caused by bony prominences. In front is the well known projection of the patella, and some distance below the anterior tuberosity of the tibia. In extension the intercondyloid fossa of the femur is masked by the presence of the patella. However, in flexion of the knee conditions change; the external border of the intercondyloid fossa stands out in sharp relief while the internal border is masked by the vastus medialis muscle.

On the external surface, the superimposed lateral condyles of the femur and the tibia sustain the form by their projection. However, the muscular shapes above and below place this side of the knee at the bottom of a large depression.

It is not the same on the inside. The medial condyles fall at the summit of the angle formed by the skeleton of the thigh and the lower leg. The condyles are expressed on the outside by two projections between which a transverse furrow, sometimes visible, marks the line of articulation.

The head of the fibula may always be seen, although its projection, much diminished by the muscles which attach to it, is not very large.

At the knee, the whole interior surface of the tibia is subcutaneous. At the ankle, on the inside, the inferior extremities of the tibia, and, on the outside, those of the fibula, constitute the two malleoli. The internal or medial malleolus is larger, nearer to the anterior border, and more elevated. The external or lateral malleolus is narrower, situated more or less at an equal distance between the anterior and posterior surfaces, and lower.

The projection of the heel is due entirely to the volume of the calcaneus. The arch of the foot is sustained by the skeleton of this region; the bones are disposed with this end in view. Along the internal border one notes, toward the middle, the projection of the navicular, and, at the anterior extremity of the border, the outline of the first metatarsal. The external border rests entirely on the ground; at the middle part of its outline the tuberosity of the fifth metatarsal is visible.

Anthropologists have sought to establish relative dimensions for the femur and the tibia.

According to Topinard, if the femur is equal to 100, the tibia, for the European, has a length of 80.4, and for the Negro, 82.9. Thus the tibiofemoral relationship in the white and black races resembles that of the bones of the forearm.

7. Myology

Between the bones (which form the framework of the body) and the skin, there are muscles which fill almost all the intervening space. The volume of the vessels and the nerves is, in fact, so slight that it hardly counts as far as the mass of the body is concerned. The fat, which is mostly disposed at the undersurface of the skin, is also of morphological importance, but I shall discuss this later. Myology is primarily concerned with the nature, structure, and function of the muscles in the human body.

COMPOSITION OF MUSCLES

The total mass of the muscles may be evaluated as a little more than half of the total weight of the body. They are composed of a central red contractile part, called the *belly* or *body*, and of resistant extremities of a mother-of-pearl color, called *tendons* or *aponeurotic insertions*. The tendons consist of fibrous tissue and they attach themselves to the fleshy part of the muscles and to diverse parts of the skeleton. Certain muscles are attached by their extremities to the undersurface of the skin itself (*cutaneous muscles*). Others are disposed circularly around natural openings (*sphincter muscles, orbicular muscles*).

The fleshy body is made up of primitive muscular fibers which join to form primitive fasciculi. These fasciculi join to form in their turn the secondary and then tertiary fasciculi. An envelope of connective tissue surrounds the entire organ and sends prolongations between the diverse fasciculi of which it is fashioned.

The skeletal muscles are divided into the long muscles, the short muscles, and the large muscles. The first are mostly encountered in the arms and legs; the second near the spinal articulations; and the last on the trunk.

DISPOSITION OF MUSCLE FIBERS

It is most important to consider the direction of the fleshy fibers of muscles and the fashion in which they grow into the tendon. Sometimes the fleshy fibers continue in the direction of the tendon. Most often, however, the fleshy fibers are implanted obliquely on the tendons in such a manner that each tendinous fiber receives a considerable number of fleshy fibers, and the muscle, which takes on a fusiform or spindle-like shape, then terminates in a point toward the tendon.

Diagrams can be easily made to show the variable dispositions of the fleshy fibers in relation to the tendons between which they are usually placed (Figure 2).

(A) represents the case already mentioned in which the tendinous fibers follow the direction of the fleshy fibers. In the figure (B), the superior tendon, in the shape of a simple cone, receives the fleshy fibers on its surface. These fibers are inserted at their base into the interior of a

Figure 2.

hollow cone formed by the inferior tendon. This type of muscle is called *penniform*, because the disposition of the fibers resembles a feather. The type drawn in (C) is another type which is but a half of the preceding. It is called *semipenniform*.

This same disposition of fibers is accentuated in (D). In (E) it still exists, but an inverse relationship may be observed between the dimensions of the tendinous parts and the fleshy parts.

From this variable arrangement of fleshy fibers we are able to deduce several important facts. The fleshy fibers are of the same length on A, B, and C, but the fleshy body is longer on B and C than it is on A. The fleshy bodies are of equal size in D and E, but the muscular fibers are much shorter in D than in E. Therefore, in considering the length of a muscle, it is wise to consider the length of the tendons, the length of the fleshy body, and the length of the individual muscle fibers.

The first two of the preceding ideas have great morphological importance. If muscles are superficial the outline of the fleshy fibers and the manner in which they are implanted into the tendons is always apparent on the surface. The last idea is important in physiology, for the length of the different parts of a muscle indicates the amount of shortening of which the muscle is capable, as well as the amount of stretching. These amounts indicate the degree to which the muscles may move.

In the examples we have noted above, the fleshy fibers of the same muscle are of the same length. However, this is not always so. Particularly in the flat muscles one may observe differences in the length of the fibers of which the muscles are composed.

FASCIA

All muscles are enclosed in veritable scabbards or sheaths of fascia. As all the sheaths of the same region are intimately joined where their surfaces meet each other, a reciprocal relationship is maintained. This fascia or aponeurosis, coming from bony eminences, is at times reinforced by the expansion of tendons. Some muscles attach themselves directly to the fascia. They have, like the tensor of the fasciae latae, a tendon which fills the role of an aponeurosis in regard to other muscles. Finally, these aponeurotic envelopes vary in thickness depending on the regions which they occupy. They exercise a permanent compression on the muscles contained in their sheaths and thus augment the muscle's power of contraction.

MUSCULAR CONTRACTION

Without entering into great detail on a phenomenon so complex as muscular contraction, I will say a few words.

The red muscular fiber is the generator of mechanical work; the tendon is only an inert organ of transmission. Therefore, the capacity for contraction is located in the red fiber and consists of a shortening under the influence of an excitant. These fibers are, besides, endowed with elasticity; that is to say, they may be stretched by pulling. After extension they recover their original form.

When a muscle is free at its extremities, it is soft and malleable both in contraction and repose. It only becomes hard under the influence of the pull of its two extremities, with the result that the hardness of a muscle is not a sign of its degree of contraction. A muscle stretched by the action of an antagonistic muscle, or simply by the mechanical separation of its points of attachment, may be as hard as a contracted muscle. A muscle free of its extremities forms, in the moment of contraction, a somewhat globular mass which is about a third of its original length. The shortening does not extend beyond this length in the living.

The amount of work of which a muscle is capable is proportional to the amount of active substance of which it is made: that is to say, to the weight of the red fibers. But a muscle's capacity for work would have a different proportional relationship to weight, depending on whether the weight was due to a certain quantity of long fibers, or to a more considerable quantity of short fibers. Physiologists have, in fact, stated that the extent of movement which a muscle may produce is proportional to the length of its fibers, while its force is proportional to the transverse section, that is to say, to the sum of the elementary fibers which the muscle contains. As a result, there is a necessary relationship between the form of a muscle and its function. This shows that the morphogenic point of view is of considerable importance as Marey* has pointed out.

MUSCULAR FORCE

If a muscle is attached at both extremities to two bones which are united by an articulation, when it contracts it moves the mobile bone in a direction determined by the conformation of the articular surfaces. The power of the movement depends on the manner in which the muscle is inserted on the mobile bone.

From elementary mechanics we learn that a force is exerting its maximum action when it is held perpendicular to a moving lever; it exerts less and less action as it is held in a direction more parallel to the lever. Therefore, a muscle would have the greatest possible power when its fibers are disposed in a perpendicular direction to the bone which it must move.

This disposition is, however, rare in the organism. The muscles of the members are, for the most part, placed in a parallel fashion to the great axis of the bones which they are destined to put in motion. But the importance of articular projections should be noticed in this respect. They perform the function of pulleys for certain tendons and, in augmenting the angle at which the muscular insertion is made, to a certain extent correct the defective arrangement I have just pointed out.

It follows from the preceding that, because the angle of insertion of the same muscle varies with the displacement of the mobile bone, its power varies correspondingly; if this angle is a right angle, the muscle will have at that point the greatest power. This point is what is called the *moment* of a muscle.

In these movements, the mobile bone represents a lever of which the point of support is at the articulation, the

* "Des Lois de la Morphogénie chez les Animaux" by E. J. Marey, *Archives de Physiologie*, 1889, Numbers 1 and 2.

power at the insertion of the muscle, and the resistance toward the free extremity of the displaced bone. This resistance takes the form of the weight, of the resistance of the antagonists and, in short, of all the obstacles which are opposed to the displacement. Depending on the respective positions of the three points of resistance, the mobile bone is a lever of the first, second, or third degree.

MUSCLE GROUPS

Muscles may be thought of in groups that act in the same way. Thus there is the group of flexors, of extensors, of adductors, etc.

These muscular groups, disposed around the articulation, impel the mobile segment by rotations in opposite directions. When a movement is produced in one direction under a given muscular action, there is always a muscular force in the opposite direction which produces an inverse movement. This inverse movement is destined to replace the member in the position of its point of departure.

Muscles acting in a given direction (flexors, for example) are the *antagonists* of muscles acting in the opposing direction (extensors).

It is important to list here certain laws which control the complex play of the muscular system.

A muscle, even in a state of repose, is always in a certain degree of tension and if, in the living, a muscle was divided through its middle, the two fragments could be seen pulling away from each other. This tension has been named *tonicity*.

ANTAGONISTIC ACTION OF MUSCLES

A muscle never contracts alone. Its action is accompanied by that of one or several of the congenerous muscles which surround it, and also by the antagonistic muscles themselves which enter into contraction. The action of the antagonistic muscles has the effect of moderating or rendering more precise the movement provoked by the first, so much so that it is false to say that in flexion, for example, it is only the flexors that contract. Whatever movement is produced, the antagonistic groups enter into the same action at the same time, and the direction of the movement (flexion or extension) is only determined by the predominance of the action of one group over that of its antagonist. The flexors, for example, may predominate over the extensors, or vice versa. Finally, all segments of the skeleton have a certain mobility upon one another. Therefore, if a muscle is to displace with sureness and precision the bone attached to one of its extremities, it is necessary that its other extremity should be inserted in a fixed place, and that, in addition, this place be immobilized by the contraction of other muscles which are attached to it. This is why, in somewhat violent movements, this synergetic contraction takes place to some extent even in parts far away from the scene of the action.

RELATIONSHIP OF MUSCLES TO EXTERIOR FORM

Before terminating these general considerations, let us draw from them the principal points that relate particularly to exterior form.

First, at the place where they are attached to the aponeurotic fibers, the fleshy fibers form an outline clearly visible under the skin. Here muscular contraction, which enlarges the volume of the fleshy portion, can be clearly seen. The surface relief of a superficial muscle will show a depression at the level of its aponeurotic portions, leaving out the prominence caused by the tendon.

Second, the relative lengths of the fleshy body and the tendinous fibers within one muscle are not the same in all individuals. There is great variety. The fleshy part being the essential part of the muscle, I shall designate under the term *long muscle* those in which the fleshy part is relatively longer, and, in a like manner, by the term *short muscle* those in which the fleshy body is relatively shorter. If we imagine a flayed figure whose muscles are of the long type, we would see the red fibers descending lower on the pearly aponeuroses and, therefore, as a whole the flayed figure would be quite red.

If, on the contrary, the muscles were of the short type, the red parts would lose their importance and the aponeuroses would be longer. The flayed figure would seem more pearly. However, these differences of color, invisible under the skin of the model, may be discerned on the exterior form through a difference of shape. The red parts generally correspond to the prominences and the pearly parts to the depressions.

Nevertheless, subjects who have long muscles may be recognized by their general slenderness of shape (despite the muscular volume), by the absence of violent indentations at the level of muscular insertions, and by the fusiform aspect of the members. Classical forms, for the most part, belong to this type.

The short muscled subjects, on the contrary, are all bumps and hollows. The bellies of their muscles are short and projecting, and there are marked depressions at their extremities. The general form is abrupt in style; there is less harmony.

Third, some aponeuroses are composed of distinct and resistant fasciculi which bind the fleshy body of the muscle and in certain positions cause important modifications on the model. Their effect can be seen, for example, low on the thigh, at the level of vastus medialis, when the leg is extended, and at the buttock, at the level of gluteus medius, during flexion of the thigh. However, the influence of the aponeuroses is difficult to formulate.

Fourth, when muscles enter into action they become short and thick. The result is that their relief under the skin increases and becomes hard. The modeling of a contracted muscle is therefore considerably different from that of one in repose. However, I should point out here that the state of repose does not exist for a single muscle of a member in the movement. It is important not to exaggerate the modeling of antagonistic groups. The harmony of the muscular play should correspond to the harmony of the form. Remember too, that the synergetic action of muscles, even in limited movement, may have an effect in varied and distant parts of the body.

Fifth, a relaxed muscle is subject to gravity, a fact which will explain certain shapes we shall study later.

Finally, if the points of attachment, in approaching each other, surpass the limits of the elasticity of the muscle, the fleshy body forms wrinkles perpendicular to the direction of its fibers. This may often be observed in the spinal muscles at the small of the back.

8. Muscles of the Head

The muscles of the head (Plates 36 and 37) may be divided into three groups. The epicranial muscles; the muscles of the face; and the muscles which move the lower jaw.

Among the muscles of the head, one epicranial muscle, the *frontalis*, and all the muscles of the face have the function of moving the integument of the face. This allows our expressions to reflect our sentiments and passions. However, I do not wish to undertake a study of physiognomy. I shall reserve that for a special work. Here, I shall simply set down the movements and wrinkles each muscle causes on the skin according to the remarkable work of Duchenne de Boulogne.

EPICRANIAL MUSCLES (EPICRANIUS)

These muscles, all superficial, are disposed about an aponeurosis which covers the vault of the cranium much in the manner of a skull cap. They form four groups: in front the frontal, in back the occipital, and on the sides the auricular.

FRONTALIS

Attachments: origin, from the anterior border of the epicranial aponeurosis; *insertion*, into the skin in the region of the brow and the nose.

This flat muscle is separated from its opposite side by a straight triangular space opening above. Its superior border describes a superior convex curve which can often be seen on the skin of the forehead if the hair line is high.

Action. Besides being a tensor of the epicranial aponeurosis, this muscles wrinkles the skin of the forehead transversely and elevates it at the same time when its fixed point is taken from the occipital. It expresses astonishment or attention. The elevated eyebrow describes a curve of superior convexity, and the frontal wrinkles are concentric to the arc of the eyebrow.

OCCIPITALIS

Attachments: origin, from two thirds of the superior curved line of the occipital bone; *insertion*, into the posterior border of the epicranial aponeurosis.

Action. It stretches the epicranial aponeurosis.

AURICULARIS MUSCLES

These are divided into the anterior, posterior, and superior auricularis. The muscles arise from the epicranial aponeurosis and are inserted into the external cartilage of the ear. Their action is very limited, and movements of the ear by these muscles are possible in some individuals, but not in others.

MUSCLES OF THE FACE

These muscles are divided into three groups. They are placed about the orifices of the eyelids, the nostrils, and the lips.

CORRUGATOR (CORRUGATOR SUPERCILII)

Attachments: origin, from the medial end of the superciliary arch; *insertion*, into the skin of the eyebrow. Stretching transversely, covered by the orbicularis muscle, the corrugator is slightly oblique from the outside and above.

Action. This muscle expresses grief. The head of the eyebrow lifts and swells; the eyebrow itself is oblique from below to the outside. Vertical wrinkles appear in the middle part of the forehead and become smooth below the external half of the eyebrow.

ORBICULARIS PALPEBRARUM (ORBICULARIS OCULI)

Very thin, set in a circle around the palpebral orifice, this muscle is divided into two parts; the palpebral portion and the orbital portion. The palpebral portion is in the eyelids. Its action closes the eye by lowering the superior eyelid and raising the inferior eyelid.

The orbital part, eccentric to the preceding, lies on the bony portion of the orbit. This muscle has a tendon which goes from the internal angle of the eye to the lacrimal crest of the rising apophysis. The outline of this tendon, slightly oblique from without to within and from below to above, may be easily seen across the skin.

The orbicularis muscle is also attached to the internal border of the orbit. From there the fibers move outwards to describe a line around the eye which is an almost complete circle.

Action. The superior orbital part pulls down the eyebrow mass and erases the frontal wrinkles. The eyebrow becomes rectilinear and vertical wrinkles appear above it. It is the muscle of concentration. The inferior orbital portion lifts the inferior eyelid which swells slightly. This is the muscle of benevolence.

PROCERUS (PYRAMIDALIS NASI)

Attachments: origin, from the skin over the inferior part of the nasal bone; *insertion*, to the skin between the two eyebrows at the origin of the nose. Situated close to the median line, this little muscle is sometimes confused with the internal fascia of the frontalis. But, according to Duchenne, its action is most important.

Action. It pulls down the head of the eyebrow, of which the internal half is directed from above to below and from without to within. The skin of the middle part of the forehead is smooth and stretched, and the bridge of the nose is marked with several transverse wrinkles. These express aggressive sentiments.

NASALIS (COMPRESSOR NARIS)

Extending transversely on the lateral surface of the nose, this muscle meets the muscle on the other side along the median line through the intermediary of a fibrous strip. On the outside it is attached to the integuments above and behind the wing of the nose.

Action. It draws the wing of the nose up and to the front which creates wrinkles across the lateral parts of the organ.

NASALIS (DILATOR NARIS)

This little muscle is situated in the thickness of the nostril itself. In contracting, it enlarges the inferior orifice.

DEPRESSOR SEPTI

Attachments: origin, from the incisive fossa of the mandible, *insertion*, into the skin of the wing of the nose and into the division of the nostrils.

Action. It constricts the nostrils.

CANINUS (LEVATOR ANGULI ORIS)

This little muscle, deeply situated, rests directly upon the superior maxilla.

Attachments: origin, from this bone, directly beneath the infraorbital foramen; *insertion*, into the fibers of the upper lip.

Action. It lifts the lip and pulls it a little to the outside.

LEVATOR LABII SUPERIORIS ALAEQUE NASI

The levator labii superioris alaeque nasi is the deep elevator of the wing of the nose and the upper lip.

Attachments: origin, from the maxilla above the infra-orbital foramen; *insertion*, into the skin of the wing of the nose, and to the skin of the upper lip.

Action. The same as that of the following muscle.

LEVATOR LABII SUPERIORIS

Attachments: origin, from in front of the lower margin of the orbit, at the crest of the mounting branch of the superior maxilla; *insertion*, to muscular substance of the upper lip.

Action. It draws up the wing of the nose. The lengthened nasolabial furrow becomes straighter. The upper lip itself is drawn up. It contributes to the expression of disdain.

ZYGOMATICUS MINOR

Attachments: origin, from the cheekbone; *insertion*, into the skin of the upper lip.

Action. It draws up and to the outside the middle portion of half of the upper lip. The nasolabial furrow describes a curve of inferior convexity. It is a muscle of grief. The muscle that follows, although it has much the same name, is a muscle of laughter.

ZYGOMATICUS MAJOR

Attachments: origin, from the zygomatic process and from the skin at the angle where the upper and lower lips join each other.

Action. The angle of the mouth is drawn up and out. The nasolabial furrow describes a slight curve. The flesh over the cheekbone swells and slightly raises the lower eyelid. It is the smiling muscle.

ORBICULARIS ORIS

This muscle creates the thickness of the lips; it is disposed in the manner of a sphincter around the orifice of the mouth. The most internal fibers form a complete circle. The peripheral fibers commingle with the muscles that radiate from the mouth.

Action. Under the action of the central fibers, the lips pucker and are brought together. Under the influence of the contraction of the peripheral fibers, the lips are pulled back on the outside and projected forward. It contributes to the expression of doubt and to the expression of certain aggressive and evil feelings.

BUCCINATOR

Attachments: this muscle has three fixed insertions. It originates from the superior maxilla, above the alveolar border and from an aponeurotic band which comes from the internal wing of the pterygoid process to the inferior maxilla. It inserts toward the angle of the lips and continues in part into the orbicularis oris muscle.

Action. When the two buccinator muscles contract at the same time, they open the angles where the lips meet and elongate the lips transversely and thus compress them.

DEPRESSOR LABII INFERIORIS

Attachments: origin, from the oblique line of the mandible; *insertion*, into the skin of the lower lip.

Action. It draws the corresponding half of the lip below and to the outside. When the two muscles are contracted simultaneously, the lip stretches and turns over in front.

DEPRESSOR ANGULI ORIS

Attachments: origin, from the oblique line of the mandible; *insertion*, into the angle of the mouth.

Action. The angles of the mouth are pulled down and out. The lips describe a convex inferior curve, the lower lip is somewhat pushed to the front, the nasolabial furrow becomes straighter and longer. This muscle contributes to the expression of grief and disgust.

MENTALIS

Attachments: origin, from the incisive fossa of the mandible; *insertion*, into the integument of the chin.

Action. This muscle lifts the skin of the chin and wrinkles it. In doing so it protrudes the lower lip and turns it down a little on the outsides.

MUSCLES OF THE JAW

There are four muscles of the jaw; two superficial and two deep.

The two deep muscles are hidden by the branch of the inferior maxilla. They are both inserted to its internal surface. On the other side both muscles are attached to the pterygoid plate, hence their name. The internal one (pterygoideus medialis) is really a deep masseter. Like the masseter, it lifts the jaw. The external one (pterygoideus lateralis), moves the jaw to the front and to the sides.

The two superficial muscles, which merit a detailed description, are the masseter and the temporalis.

MASSETER

Attachments: origin, from the inferior border of the zygomatic arch; *insertion*, into the inferior part of the ramus of the mandible. This quadrilateral muscle, short and thick, occupies the posterior part of the face. Its contraction may be seen most clearly in movements of the jaw.

Action. It lifts the lower part of the jaw.

TEMPORALIS (PLATE 37, FIGURE 1)

Attachments: origin, from the whole length of the temporal fossa; *insertion*, into the summit of the coronoid process. Fan-like in form, this muscle is covered by a very strong aponeurosis which is attached all around the temporal fossa and to the zygomatic arch. It is thus contained in an osteofibrous box. Its considerable volume allows it to fill up the bony fossa in which it is placed and its relief may be clearly seen, especially under contraction.

Action. It lifts the lower jaw.

9. Muscles of the Trunk and Neck

The muscles of the trunk and neck are extremely complex. I will deal with them in detail in this chapter.

POSTERIOR REGION

Deep layer. I should like to point out the small *interspinales muscles* which exist both at the neck and in the lumbar region. Disposed in pairs, they unite the spinous processes of neighboring vertebrae.

Let me also describe the *intertransversarii muscles*, of which the name indicates their arrangement. They are again, only found in these same parts of the body. At the neck, they are disposed in pairs and divided into anterior and posterior muscles. They run from the two lips which limit the superior groove of the transverse process to the inferior border of the process which is immediately above. They do not strictly belong to the dorsal region, but the intercostales muscles, which we shall soon discuss, can be considered analogous to them, since the ribs are but a prolongation of the transverse processes.

TRANSVERSOSPINAL MUSCLES (PLATE 38)

Attachments: some, to the summit of the spinous processes (that of the axis is included); *others,* to the external tubercles of the sacral foramina, to various tubercles in the lumbar vertebrae, to the transverse processes of the dorsal region, and to the articular processes of the five last cervical vertebrae.

These muscles (*semispinalis thoracis, semispinalis cervicis, semispinalis capitis, multifidus, rotatores, interspinales, intertransversarii*) partially fill up the lateral groove of the spine. The foundations of these grooves are formed by the vertebral processes. They are limited within by the spinous processes and without by the transverse processes. The transversospinal muscles are formed by a series of small obliquely directed muscles.

Action. These muscles are extensors of the vertebral column. They incline it laterally when they only contract on one side. At the superior part of the vertebral column, the greater scope of the movement of the first two vertebrae necessitates a more complex disposition of muscles. Situated in the back we find rectus capitis posterior major, rectus capitis posterior minor, obliquus capitis inferior, and obliquus capitis superior. On the sides and in front we find rectus capitis lateralis, longus capitis, and rectus capitis anterior.

RECTUS CAPITIS POSTERIOR MAJOR (PLATE 38)

Attachments: origin, from the spinous process of the axis; *insertion,* into the lateral part of the inferior nuchal line of the occipital bone.

Action. Extends the head and rotates it toward the same side.

RECTUS CAPITIS POSTERIOR MINOR (PLATE 38)

The rectus capitis posterior minor is a muscle of triangular form.

Attachments: origin, from the posterior arch of the atlas; *insertion,* into the medial part of the inferior nuchal line of the occipital bone and the surface below and adjacent to it.

Action. Extends the head.

OBLIQUUS CAPITIS INFERIOR (PLATE 38)

Attachments: origin, from the spinous process of the axis; *insertion,* into the inferior and dorsal part of the transverse process of the atlas.

Action. Rotates the head to the side.

OBLIQUUS CAPITIS SUPERIOR (PLATE 38)

Attachments: origin, from the transverse process of the atlas; *insertion,* into the most lateral portion of the occipital bone.

Action. Extends the head and inclines it laterally.

RECTUS CAPITIS LATERALIS (PLATE 45, FIGURE 2)

Attachments: origin, from the transverse process of the atlas; *insertion,* into the jugular surface of the occipital.

Action. Inclines the head laterally.

LONGUS CAPITIS (PLATE 45, FIGURE 2)

Attachments: origin, from the anterior tubercle of the transverse processes of the third to sixth cervical vertebrae; *insertion,* into the inferior surface of the basilar part of the occipital bone.

Action. The action is the same as that of the preceding.

MIDDLE LAYER

The muscles which compose this layer have a considerable influence on the exterior form. I am placing them before the flat superficial muscles because the superficial muscles model themselves upon the deeper form. Starting with the most internal, these muscles are: at the neck, the semispinalis capitis, along the whole length of the trunk, the spinal muscles and the serratus, and finally, two muscles near the limits of the neck and torso, the rhomboids and the levator scapulae.

SEMISPINALIS CAPITIS (PLATE 39, FIGURE 1 and 2)

A long muscle, deeply situated in the neighborhood of the median line at the back of the neck where it is thickest, semispinalis capitis descends as far as the middle of the back.

Attachments: origin, from the cervical vertebrae, except the atlas (the articular and transverse processes), and from the dorsal vertebrae (the transverse processes of the first and second); *insertion*, into the occipital bone (from the roughness outside of the external occipital crest between the two nuchal lines).

Action. Extends the head and turns the face to the opposite side.

Semispinalis capitis plays a large role in the exterior form of the neck. Even though it is deeply situated, covered by the splenius and the superior part of the trapezius, its form reveals itself on the exterior surface by two longitudinal depressions along each side of the median line. In thin subjects this relief is exaggerated. It then takes the form of two cords separated by a depression which becomes deeper as it approaches the occipital.

In young, muscular subjects, these two cords become a sort of flat surface which is slightly indented along the median line and marked by a more accentuated depression near the attachment of the muscle to the occipital bone. This constant depression, usually hidden by the hair, corresponds to the external occipital protuberance.

The thick, stretched, posterior border of this muscle seems much like two ropes stretched between the back and the occipital. The median depression corresponds to the ligament of the neck.

LONGISSIMUS CAPITIS (PLATE 39, FIGURE 1 AND 2)

Placed on the sides outside the preceeding.

Attachments: origin, from transverse of the first three or four thoracic vertebrae; *insertion*, from the mastoid process.

Action. It inclines the head laterally.

SPLENIUS CAPITIS AND SPLENIUS CERVICIS (PLATE 39, FIGURE 3 and 4)

Attachments: origin, from the ligament of the neck, from the seventh cervical vertebra and from the first five dorsal (spinous processes). *Insertions, splenius capitis* to the mastoid process (posterior half of the external surface) and to the lateral third of the superior nuchal line;

splenius cervicis to the three first cervical vertebrae (posterior tubercles of the transverse processes).

Flat, triangular in form, these muscles are influenced by the deeper muscles we have described. They combine to fill up the empty space on the skeleton which exists between the cervical column and the inferior surface of the occipital. They soften the median longitudinal furrow created by the underlying muscles. Their forms maintain the thickness of volume above and on the outside of the neck.

Action. Extends the head, inclines it to the side and turns the face to the same side.

SACROSPINALIS: ILIOCOSTALIS, LONGISSIMUS, SPINALIS (PLATE 40)

Attachments: origin (for the common mass), from the deeper surface of a strong aponeurosis which runs up as far as the middle of the dorsal region (this aponeurosis is attached to the superior iliac spine and to the neighboring part of the iliac crest); from the posterior surface of the sacrum, from the sacral crest, and from the spinous processes of the lumbar and the last thoracic vertebrae.

Insertions, to the external part of the angle of all twelve ribs and by its fascia of reinforcement to the posterior tubercles of the transverse processes of the five last cervical vertebrae; (spinalis thoracis), to the transverse processes of the lumbar vertebrae and into all twelve of the ribs between their tubercles and angles (external fascia); and to the accessory processes of the lumbar vertebrae and to the transverse processes of the thoracic vertebrae (middle fascia).

These fasciculi are prolonged as far as the neck by a distinct muscle which stretches from the transverse processes of the second, third, fourth, fifth, and sixth thoracic vertebrae to the articular process of the five last cervical (longissimus capitis.).

Certain distinct fasciculi run from the lumbar spinous processes to the thoracic spinous processes (internal fascia).

These muscles (spinalis, iliocostalis, and longissimus dorsi), undivided below, as I have said, separate above into a considerable number of fasciculi. Anatomists have grouped these fasciculi according to their insertions. They should be combined, from the point of view of morphology, into the mass at the posterior part of the trunk which fills the large furrow limited on the inside by the spinal crest and on the outside by the angle of the ribs and the iliac tuberosity.

This fleshy mass, strong and powerful below, diminishes gradually and in proportion to its ascent towards the neck through the intermediary of its fibers of reinforcement. It can be divided into two regions, lumbar and dorsal.

This division, justified by morphology, is equally sanctioned by physiology, as Duchenne de Boulogne has demonstrated.

Lumbar part. Very thick, presenting an ovoid cross section, it fills the empty space between the thoracic cage and the pelvis posterior to quadratus lumborum. Its superficial surface is covered, below and within, by a large

aponeurosis the insertions of which I have already pointed out. On the outside, the fleshy fibers descend, more or less, to near the inferior insertion at the iliac crest (at the reentering angle), and attach themselves to the aponeurosis following a curved line. This line is convex on the inside and it is directed from below to above and from without to within. The fleshy body forms on the outside, in the region of the small of the back, an appreciable outline.

When the trunk is slightly flexed, this outline stands in clear relief. It is limited on the inside by an oblique depression which corresponds to the insertion of the fleshy fibers into the aponeurosis. This depression should not be confused with that formed by the line of insertion of the fleshy fibers of latissimus dorsi which is situated, in general, above and to the outside. Within this depression one can see, in certain movements of the trunk, a cord-like swelling. This swelling limits the lumbar depression at the center and is due to deep fleshy fibers held in place by the superficial aponeurosis.

Dorsal region. Here the muscles we are discussing do not influence the exterior form half as much as they do in the small of the back. Their rounded surface is limited on the outside by the line of the angle of the ribs which is most apparent when the arms are lifted. One often observes, at the level of the inferior angle of the trapezius, a rounded form created by the fleshy fibers of latissimus dorsi.

Action. Despite the diversity of their superior insertions, all the spinal muscles exercise the same action on the vertebral column. The action is that of oblique extension or lateral inflexion, depending on which side is stimulated.

Only the interspinous fasciculi of the spinalis muscle produce direct extension. Duchenne de Boulogne has demonstrated that the spinal muscles, in the lumbar region, have an action independent of the spinal muscles of the dorsal region. The first gives the vertebral column a dorsolumbar curve, the second a dorsocervical curve. These two curves may be produced simultaneously in an opposite direction on each side, giving to the whole column the form of an *S*. This occurs in certain physiological postures, which, when pathologically exaggerated, create the deformation known as scoliosis.

The principal function of the spinal muscles lies in producing an extension of the torso which they can do with force. In the standing position, they are ordinarily inactive, as the relief in this region clearly indicates. (This will be covered later in the morphological section, lumbar region.)

As soon as the equilibrium is disturbed by a slight forward inclination of the trunk, they contract with vigor.

Immediately above the spinal muscles there are the following two muscles.

SERRATUS POSTERIOR SUPERIOR (PLATE 41)

Attachments: origin, from the ligamentum nuchal and from the spinous processes of the seventh cervical and the three first thoracic vertebrae; *insertion,* through four fleshy digitations to the superior external surfaces of the second, third, fourth, and fifth ribs.

SERRATUS POSTERIOR INFERIOR (PLATE 41)

Attachments: origin, from the spinous processes of the last two thoracic vertebrae and from the first three lumbar the origin is in the middle of a large aponeurosis, fascia thoracolumbalis and it is connected to that of latissimus dorsi, *insertion,* into the inferior border of the last four ribs.

These two muscles are connected by an intermediary aponeurosis which helps to keep the spinal muscles in a fixed position. The serratus posterior inferior may influence the exterior form, when, in certain movements in which the back is rounded, the inferior and posterior part of the thoracic cage is uncovered. When this occurs the digitation of the muscle may be seen because the latissimus dorsi is relaxed.

Finally, I should like to describe certain muscles which, although they are attached to the scapula, contribute much to the modeling of the back.

RHOMBOIDEUS, MAJOR AND MINOR (PLATE 43)

Attachments: origin, from the interior part of the ligamentum nuchae, from the spinous processes of the seventh cervical and the first thoracic vertebrae (rhomboideus minor) and the first five thoracic vertebrae (rhomboideus major); *insertion,* to the spinal border of the scapula.

Action. They draw the scapula toward the median line and at the same time they elevate and rotate the scapula. The serratus anterior acts as their antagonist. These flat muscles, together forming a lozenge shape, are covered by the trapezius. They form a considerable mass between the median line of the back and the scapula. Their fleshy body grows thicker from below to above.

LEVATOR SCAPULAE

Attachments: origin, from the first four cervical vertebrae (posterior tubercle of the transverse process); *insertion,* to the internal angle of the scapula and to the vertebral border above the spine.

Action. It lifts the shoulder. This muscle, from which the scapula is, so to speak, suspended by its superior angle, contributes to the widening of the neck below and in back.

SUPERFICIAL LAYER

Two large muscles, stretched out over those we have just described, complete the myology of the posterior part of the neck and the trunk. They are latissimus dorsi on the lower part and the trapezius on the upper part.

LATISSIMUS DORSI (PLATE 43)

Attachments: origin, from the spinous process of the six last thoracic vertebrae and all the lumbar vertebrae; from the sacral vertebrae; from the iliac tuberosity; from the posterior third of the iliac crest; and from the external surface of the three last ribs; *insertion,* at the base of the intertubercular groove of the humerus.

A large muscle of unequal volume, it is thickest at the area surrounding its superior insertion. It forms there, at the place where it spirals around the teres major, a fleshy body which can be clearly seen when the arm is raised. Its anterior border creates a vertical bulge on the sides of the trunk. At that point its costal insertions form, on muscular subjects, digitations similar to those of the anterior serratus. Its superior border, which is almost horizontal, is covered in the middle of the back by the tail of the trapezius. Outside this point the latissimus dorsi runs over the inferior angle of the scapula and holds it against the rib cage. In certain movements, the outline of the superior border may be easily traced beneath the skin along almost its whole length.

The line of implantation of the fleshy fibers on the lower aponeurosis is in an irregular curve of internal convexity. This curve runs from below to above and from outside to within and goes from the inferior insertion in the crest of the ilium to the superior insertion in the thoracic vertebrae. This line is usually situated above and outside of the analogous line formed by the implantation of the fleshy fibers of the spinal muscles in their aponeurosis (see page 55). However, the nature of this line depends on the length of the fleshy fibers and these vary according to the individual subject. At times the line meets the line of the spinal muscles on which it is superimposed but it usually ends much higher. The spinal line itself is susceptible to variation. Gerdy has made the line of the latissimus dorsi the superior limit of the loins. I believe it would be better to take the limit at the line of the spinal muscles because of its consistency and because of its generally lower situation. (We shall discuss this later in the morphological section, region of the loins.)

The fleshy body of the muscle, of medium thickness, thinner inside than outside, reveals the form of the serratus anterior beneath it. This relief is limited below by an oblique depression of variable depth. When the arms are elevated, the forms of the spinal muscles and the ribs are revealed.

Action. When both sides are contracted simultaneously, the latissimus dorsi, by its superior third, brings the scapulae together, throws back the shoulders, and produces a strong extension of the trunk. Through the inferior two thirds, it pulls the shoulder down firmly.

TRAPEZIUS (PLATE 44)

Attachments: origin, from the spinous processes of the first ten thoracic vertebrae and the seventh cervical, from the ligamentum nuchae, and from the occipital bone (medial third of the superior nuchal line); *insertion*, to the clavicle (lateral third of the superior border), to the scapula (the superior border of the acromion process and on the spine).

For the most part these insertions are made by short aponeurotic fibers, but these fibers, long in three places, form small aponeuroses that should be described. Around the protuberance of the dorsal spine of the seventh cervical, an *oval* aponeurosis is formed by the union of each side of the trapezius. A *triangular* aponeurosis terminates the tail of the trapezius at its base. In the area

of its insertion into the spine of the scapula, there is a second *triangular* aponeurosis.

These three aponeuroses influence the exterior form. The first produces a little median flat plane at the limit of the neck in the spinal region. In the middle of this plane one finds the prominence of the *vertebra prominens*. The second aponeurosis truncates the inferior tail of the trapezius. The third is the cause of the depression which may be seen at the root of the spine of the scapula, near its vertebral border. These aponeuroses vary in different individuals.

The trapezius is a flat muscle of most unequal thickness. Thin above and below, it becomes very thick in the middle part which includes the whole area of the lateral angle which inserts at the clavicle and the acromion process of the scapula. This thick part of the muscle rests on the supraspinatus and the levator scapulae muscles.

Above, at the back of the neck, the muscle molds itself on the deeper layers; the anterior border alone shows clearly from the occipital to the clavicle. Below, the trapezius is raised by the powerful mass of the rhomboids. It then covers the spinal muscles and latissimus dorsi. The triangular form of its inferior extremity can generally be easily seen under the skin.

Action. By its occipital fascia, it extends the head, inclines it to the side and turns the face in the opposite direction. When the two sides of the trapezius contract simultaneously, the head is directly extended. By its middle part it lifts the shoulder. By its inferior third, it lowers the shoulder and brings the scapula toward the median line.

ANTEROLATERAL CERVICAL REGION

This region is composed of several layers—deep, middle, and superficial. I shall outline the muscles of each layer.

DEEP LAYER

This layer is composed of longus colli, scalenus anterior and posterior.

LONGUS COLLI (PLATE 45, FIGURE 1)

This muscle, directly applied to the cervicothoracic column, has three portions.

The superior oblique portion is inserted into the anterior tubercle of the atlas and arises from the anterior tubercles of the transverse processes of the third, fourth, and fifth cervical vertebrae.

The inferior oblique portion is inserted into the anterior tubercles of the transverse processes of the fifth and sixth cervical vertebrae, and arises from the bodies of the first three thoracic vertebrae.

The vertical portion is inserted into the bodies of the second and third cervical vertebrae and arises from the bodies of the last four cervical vertebrae and the first three thoracic.

Action. It inclines the vertebral column to the front, and it slightly rotates the cervical portion of the vertebral column. This muscle has no influence on the exterior form.

SCALENUS ANTERIOR (PLATE 45, FIGURE 3 and 4)

Attachments: origin, from the third, fourth, fifth, and sixth cervical vertebrae (anterior tubercles of the transverse processes); *insertion,* into the scalene tubercle of the first rib.

Action. It lifts the first rib (it is an inspiratory muscle) and bends and slightly rotates the neck.

SCALENUS POSTERIOR (PLATE 45, FIGURE 3 and 4)

Attachments: origin, from the transverse processes of the last two or three cervical vertebrae (posterior tubercles); *insertion*, to the outer surface of the second rib.

Action. It has much the same action as that of scalenus anterior. Stretched across the lateral part of the neck, from the cervical column to the thoracic cage, the scalenus muscles contribute to the lateral thickness of the neck at its lower part They are superficial along one portion of their length, in the triangle above the clavicle, and so is the splenius above them, and the omohyoideus below them.

MIDDLE LAYER (PLATE 46)

At the anterior part of the neck there are organs related to the digestive and respiratory apparatus. We should note them because they provide insertion points to certain muscles of the region.

The esophagus is in the deep middle part of the neck next to the vertebral column. In front of it is the trachea, terminating above in the larynx, which is surmounted by the hyoid bone. A gland of variable volume, the thyroid gland (more accentuated in women), covers the superior and lateral parts of the tube of the trachea (Plate 46, Figure 1).

The hyoid bone is situated at the edge of the region, beneath the chin. This region, morphologically, should pertain to the head, but anatomically it should be attached to the neck under the name of the region above the hyoid (suprahyoid region).

The muscles of the anterior part of the neck have been divided by anatomists into two groups because of their situation relative to the hyoid. These groups are the muscles above the hyoid and the muscles under the hyoid (suprahyoid and infrahyoid muscles).

SUPRAHYOID MUSCLES

The suprahyoid region forms the floor of the mouth. It is composed of muscles arranged in different directions which run from the hyoid bone to the lower jaw, to the mastoid process, and to the styloid process at the base of the cranium.

These muscles, from the point of view of exterior form, are of but secondary importance. They are, from deep to superficial, as follows.

GENIOHYIODEUS

Attachments: origin, from the inferior mental spine on the inner surface of the symphysis menti; *insertion*, to the anterior surface of the body of the hyoid bone.

MYLOHYOIDEUS (PLATE 47, FIGURE 2)

Attachments: origin, from the mylohyoid line of the mandible; *insertion*, close to the symphysis. The medial tendon of the muscle is attached to the hyoid bone by an aponeurotic expansion (suprahyoid aponeurosis).

INFRAHYOID MUSCLES

These muscles, numbering four, form two layers: a deep layer composed of the sternothyroideus and the thyrohyoideus; and a superficial layer composed of the sternohyoideus and the omohyoideus.

STERNOTHYROIDEUS (PLATE 46 and 47)

Attachments: origin, from the oblique line of the thyroid cartilage; *insertion*, into the inferior border of the greater cornu of the hyoid bone.

Action. It lowers the hyoid bone and elevates the thyroid cartilage.

THYROHYOIDEUS (PLATE 46 and 47)

Attachments: origin, from the oblique line of the thyroid cartilage, *insertion*, to the inferior border of the greater cornu of the hyoid bone.

Action. It lowers the hyoid bone and elevates the thyroid cartilage.

OMOHYOIDEUS (PLATE 46, FIGURE 2 AND PLATE 47)

Attachments: origin, from the superior border of the scapula; *insertion*, into the body of the hyoid bone.

Action. It lowers the hyoid bone. It is the tensor of an aponeurosis which unites the muscles on each side.

The two muscles which go to the sternum, the sternohyoideus and the sternothyroideus, are flat and ribbonlike. They are raised somewhat on the sides of the larynx by the thyroid gland.

The omohyoideus traverses the supraclavicular triangle where, in certain movements, it forms a noticeable cord.

SUPERFICIAL LAYER

This layer is composed of the sternocleidomastoideus and the platysma.

STERNOCLEIDOMASTOIDEUS (PLATE 47)

Attachments: origin, from the sternum (sternal portion) and from medial third of the superior surface of the clavicle (clavicular portion); *insertion*, to the mastoid process (lateral surface) and to the superior nuchal line of the occipital bone (lateral two thirds).

Flat and quadrilateral, subcutaneous along its full length, this muscle spirals down the neck from the sides toward the anterior median line.

Single above, it divides below into two portions: the medial, or sternal portion, is rounded above and terminates in a tendon which inserts on the sides of the jugular notch; the lateral, or clavicular portion, is very flat.

These two portions are separated from each other by a triangular space.

The anterior border of the muscle is thicker than the posterior border. This is due partly to a deep fascia which starts high on the mastoid process and crosses the general direction of the superficial fibers obliquely as it descends. It is inserted below, at the back of the attachment of the clavicular portion.

Action. The sternocleidomastoideus of either side may incline the head to that side and turn the face in the opposite direction; bilateral action flexes the vertebral column and elevates the chin.

PLATYSMA (PLATE 53)

This large, thin muscle mingles at its superior insertion with the muscles of the chin and the lower lip. From there its fibers run down and to the outside, covering all the lateral and anterior part of the neck. These fibers attach themselves below to the aponeurosis of pectoralis major and to the deltoid.

Its medial border, taken with that of the other side, forms a triangle elongated along its inferior base. Its irregular lateral border covers the anterior border of the trapezius.

When it is relaxed, it reveals clearly the parts which it covers. When it is contracted, it enlarges the neck and draws down the lower lip. It contributes to the expression of terror and fright.

MUSCLES OF THE CHEST: INTERCOSTALES (PLATE 38)

The intercostal muscles round out the thoracic cage by filling the intercostal spaces. They stretch between the ribs forming two layers of which the fibers have different directions.

The *external intercostals* (intercostales externi) arise from the inferior border of a rib and are inserted to the superior border of the rib beneath. They fill all the intercostal space in the back and on the sides. They extend in front as far as the region of the costal cartilages.

The direction of their fibers is oblique from above to below, and from back to front. At the posterior part of the thorax, the *subcostals* each arise from the inner surface of a rib near its angle and are inserted into the inner surface of the second or third rib beneath. Their fibers run in the same direction as those of the external intercostals.

The *internal intercostals* (intercostales interni) arise from the inner border of the inferior intercostal groove on one rib and are inserted into the superior border and the inner surface of the rib beneath.

They fill all the intercostal space in front and to the sides. In back they stop at the angle of the ribs.

Their fibers run obliquely, in an inverse direction to those of the external intercostals.

The intercostales muscles play an important part in the function of respiration.

ANTERIOR AND LATERAL REGIONS OF THE CHEST

This layer is composed of the subclavius, pectoralis minor and major, and serratus anterior.

SUBCLAVIUS (PLATE 48, FIGURE 2)

This is a small muscle hidden under the clavicle.

Attachments: origin, from the first rib and its cartilage at their junction; *insertion,* to the clavicle (inferior surface).

PECTORALIS MINOR (PLATE 48, FIGURE 2)

Attachments: origin, from the external surface of the third, fourth and fifth ribs; *insertion,* to the coracoid process (anterior border).

This muscle, triangular in form, is divided below into three sections. It maintains the exterior form of pectoralis major on the front plane which, in the ordinary position of the arms, covers it completely. In vertical elevation of the arm, the inferior part of the lateral border of pectoralis minor becomes visible and forms a distinct relief.

Action. This muscle pulls down the point of the shoulder.

PECTORALIS MAJOR (PLATE 48, FIGURE 1)

Attachments: origin, from the clavicle (medial two thirds of the anterior border), from the sternum (anterior surface), from the cartilages of the first six ribs, from the fourth and fifth ribs (lateral surface) and from the abdominal aponeurosis; *insertion,* into the humerus (anterior border of the intertubercular sulcus).

This muscle is formed of fasciculi converging toward the humeral insertion. The superior fasciculi are directed from above to below, the median transversely, and the inferior from below to above. These fasciculi cross before reaching the humerus, the superior ones passing in front of the inferior. The highest and thickest fasciculus comes from the clavicle. Its fleshy fibers flow to the anterior surface and inferior border of an aponeurosis of insertion which is distinct from the aponeurosis beneath. They contribute posterior and inferior fibers to the aponeurosis of insertion. The latter aponeurosis functions for the remainder of the muscle.

The crossing of the fleshy fibers creates a thickening of the muscle on the outside at the place where it leaves the thorax to form the front wall of an armpit.

Pectoralis major is most important from the point of view of the exterior form of the chest. The whole muscle is subcutaneous except for its tendon and a small triangular portion of the clavicular fibers which are covered by the deltoid. Resting on each side of the median line on the anterior and superior part of the thorax, this muscle widens the chest considerably although it still reveals the arched form of the thorax.

The whole surface of the muscle is more or less convex. It does not face directly to the front, but above and to the outside.

When pectoralis major is well developed, the diverse muscular bundles, converging toward the external angle, are separated by oblique grooves which can be clearly seen across the skin. The groove that is most consistently visible is the one that limits, below, the clavicular portion. From the point of view of the exterior form, the abdominal portion of pectoralis major attenuates the transition between the plane of the pectoral muscles and the convex surface beneath the breast.

If, on the other hand, the muscle is not developed, the costal protrusions may be seen running across the form. Also, at the medial part, two corresponding series of nodes are visible. One series is caused by the articulations of the costal cartilages with the sternum, and the other, to the outside, by the articulations of the ribs with those same cartilages.

Action. From the point of view of the action which it produces, pectoralis major should be divided into two parts. The superior part, corresponding to that part of the muscle which is attached both to the clavicle and the manubrium, and the inferior part, comprising the rest of the muscle.

The inferior part lowers the arm. It also pulls the point of the shoulder down when the arm is lowered.

The superior part acts in a different way according to the position of the arm. If the arm is well down, it lifts the point of the shoulder (as in the action of carrying a burden on the shoulder, or hunching the shoulders in an expression of fear or humiliation). If the arm is horizontal, it makes the arm describe a curve carrying it within and to the front. Finally, it lowers the arm if the arm is raised vertically, bringing it back toward the median line as in the action of striking something with a saber or cudgel.

SERRATUS ANTERIOR
(PLATE 48, FIGURE 3 and 4 and PLATE 49, FIGURE 2)

Attachments: origin, from the first eight or nine ribs (lateral surface); *insertion,* into the spinal border of the scapula.

This very large muscle (serratus magnus) is situated on the lateral parts of the thorax against which it is directly applied throughout its whole length. The ventral surface of the scapula rests on its most posterior part. Its insertions into the ribs consist of eight or nine digitations which follow a toothed line in a convex anterior curve. These digitations group together into fasciculi of which the most important is the fan-shaped mass which attaches to the inferior extremity of the vertebral border of the scapula.

The serratus anterior is subcutaneous only at its most anterior and most inferior parts. Here the four last digitations show clearly under the skin in front of the anterior border of latissimus dorsi and behind the costal insertions of the external oblique (obliquus externus abdominis) (see Plate 55).

The rest of the muscle, although it is deeply situated, has an important influence on the exterior form. The fan-shaped mass which inserts into the inferior angle of the shoulder blade creates a relief which can be seen clearly beneath the latissimus dorsi which covers it.

Action. The serratus anterior, together with the rhomboid muscles which extend as far as the spine, holds the vertebral border of the scapula against the thorax. It raises the whole mass of the shoulder. By enabling the scapula to rotate, it assists in the movement of raising the arm.

MUSCLES OF THE SHOULDER

The muscles of the shoulder may be divided into the following two groups. First, the muscles which surround the scapula: subscapularis, supraspinatus, infraspinatus, teres minor, and teres major; and second, a superficial muscle: deltoideus.

SUBSCAPULARIS (PLATE 49, FIGURE 1 and 2)

Attachments: origin, from the shoulder blade (subscapular fossa); *insertion,* into the lesser tubercle of the humerus. This muscle fills the subscapular fossa of the scapula. It rotates the humerus medially.

SUPRASPINATUS (PLATE 49, FIGURE 3)

Attachments: origin, from the scapula (supraspinous fossa); *insertion,* into the greater tubercle of the humerus (superior impression). Covered by the trapezius, this muscle, depending on its development, fills the supraspinatous fossa to a greater or lesser extent. Its relief can be seen on the exterior form.

Action. Abducts the arm.

INFRASPINOUS (PLATE 49, FIGURE 3)

Attachments: origin, from the scapula (infraspinous fossa); *insertion,* into the greater tubercle of the humerus (middle impression). This muscle is superficial throughout the greater part of its length. Maintained by a strong aponeurosis, it forms a flattened relief in the center of the scapular region.

Action. It rotates the arm laterally.

TERES MINOR (PLATE 49, FIGURE 3)

Attachments: origin, from infraspinatus fossa of the scapula, near the axillary border; *insertion,* into the greater tubercle of the humerus (inferior impression). This muscle is of small volume and it is cylindrical and elongated in form. It should be combined with the preceding muscle in considering the exterior form.

Action. Rotates the arm laterally.

TERES MAJOR (PLATE 49, FIGURE 1 AND 2)

Attachments: origin, from infraspinatus fossa of the scapula (inferior and lateral part); *insertion,* into the humerus (medial lip of the intertubercular sulcus).

This muscle plays an important morphological role. It forms, together with latissimus dorsi, the back wall of the armpit. When the arm falls naturally alongside the body, it creates a rounded prominence outside the inferior angle of the scapula. This relief may be observed even in thin models.

Action. Adducts, extends, and rotates the arm medially.

DELTOIDEUS (PLATE 49, FIGURE 4 and 5, PLATE 55)

Attachments: origin, from the clavicle (lateral third of the anterior border) from the scapula (external border of the acromion process and from inferior border of the spine); *insertion,* into the humerus (deltoid prominence).

The deltoideus is entirely subcutaneous and it forms the projection of the shoulder. This muscle covers the scapulahumeral articulation on all its sides: in front, in back, and on the outside. It is composed of three principal fasciculi which divide the muscle approximately into thirds.

The middle third, or *acromion portion*, is composed of numerous secondary fasciculi which run obliquely in miscellaneous directions. This portion rises from the acromion process by very short aponeurotic fibers and goes to the region of its inferior insertion through several vertical aponeurotic dividing membranes to which the fleshy fibers are attached. The middle third, at its base, forms the point of the muscle. The other two portions, the anterior and posterior, plunge in beneath this point at their inferior extremity.

The *anterior portion* arises from the clavicle by very short aponeurotic fibers which are joined by the fleshy fibers, all running in a parallel direction. The *posterior portion* arises from the spine of the scapula by a triangular aponeurosis. This portion is composed of longitudinal fibers which describe a slight spiral movement as they run, below, to beneath the middle portion.

The deltoideus, detached from its places of insertion, is a flat muscle of triangular form. It is like the Greek letter delta, hence its name. It is thicker at the center than at its extremities. On the model the relief of the deltoideus muscle is not uniform. It is raised more in front because the head of the humerus makes a greater thrust in this area. In the back, on the contrary, its surface is flat. The superior border follows the projection of the bones. The anterior border is clearly outlined by a linear depression which separates it from pectoralis major. The posterior border is much less distinct. It is broken to a certain extent, toward its center, by an aponeurosis which comes up from the armpit and, in binding the muscle in this area, creates a smooth plane.

Its inferior insertion is marked on the outside by a depression at about the center of the arm.

Action. The deltoideus is an elevator of the humerus, and, according to its center of contraction, it lifts the arm to the front, to the back, or directly to the outside. When the deltoideus acts alone, the arm cannot be raised above the horizontal. The vertical elevation of the arm is made possible through the cooperation of other muscles (serratus anterior and trapezius).

MUSCLES OF THE ABDOMEN

Deep muscles. First, I shall briefly describe the muscle quadratus lumborum. It is deeply situated in the abdomen and forms part of its posterior wall. Then I shall discuss the diaphragm which closes off the abdominal cavity above and separates it from the thoracic cavity.

QUADRATUS LUMBORUM (PLATE 38 and 52, FIGURE 1)

Attachments: origin, from the iliolumbar ligament and the adjacent portion of the iliac crest; *insertion*, into the inferior border of the last rib and into the transverse processes of the first four lumbar vertebrae.

Action. It flexes the vertebral column and the trunk laterally.

DIAPHRAGM

This musculofibrous septum, in the form of a vault, stretches transversely to form the floor of the thoracic cavity and the roof of the abdominal cavity.

The convex surface of the vault faces the thoracic cavity. The muscular fibers only take up its periphery and the remaining or central part is formed of interlaced fibrous fasciculi.

From the center part, divergent muscular fibers spring and attach themselves by their other extremities to the periphery of the inferior aperture of the thorax. In front, they are very short and they are attached to the posterior surface of the sternum, level with the xiphoid appendage. At the sides, they descend as far as the costal cartilages of the last six ribs. In the back, they are prolonged as far as the lumbar region of the vertebral column (second, third, and fourth lumbar vertebrae).

Deeply hidden in the center of the organism, the diaphragm plays a most important physiological role in the action of respiration, but we shall not discuss this here.

ANTERIOR REGION

This region is composed of the rectus abdominis and the pyramidalis.

RECTUS ABDOMINIS (PLATE 51, FIGURE 2)

Attachments: origin, from the crest of the pubis; *insertion*, into the xiphoid process and into the cartilages of the seventh, sixth and fifth ribs. The superior insertions of rectus abdominis mingle with those of pectoralis major.

Situated on each side of the median line, the two parts of the muscle, slightly separated above, come together completely above the umbilicus. The division of the muscle gives rise to a groove which, continuing on from the epigastric furrow, becomes thinner and descends as far as the umbilicus before it disappears. The external border of rectus abdominis, limited by a second depression, rises from the aponeurosis of the external oblique.

The muscle is divided transversely by aponeurotic intersections which delimit quadrilateral areas of projecting fleshy fibers. In general these intersections are three in number; the lowest is situated at about the level of the umbilicus. Occasionally, below the umbilicus there is an indication of a fourth transverse furrow.

The highest transverse aponeurotic intersection is a continuation of the furrow which follows the cartilages of the false ribs on the sides. The superior extremity of the muscle thus fills up the angle formed by the opening of the thorax and transforms it, so to speak, from an ogival, or pointed arch, to a simple curve, convex above. Thus, on the nude the projecting line, formed on the sides by the edge of the cartilages of the false ribs, does not run (as on the skeleton) to the top of the epigastric hollow, but continues above and within along the outline of the relief formed by the superior extremity of rectus abdominis. At

this level, the superior extremity seems to belong much more to the chest than to the abdomen.

This form, resembling a concave arch, was well understood and even exaggerated in classical works of art.

Action. This muscle is a flexor of the trunk.

PYRAMIDALIS (PLATE 51, FIGURE 2)

A small triangular muscle; it is situated at the inferior extremity of rectus abdominis and stretches from the pubis to the linea alba.

LATERAL REGION

On the sides, the wall of the abdomen is formed by the superposition of three muscles. The two most profound, obliquus internus abdominis and transversus abdominis, stretch from the inferior costal border to the pelvis. The most superficial, obliquus externus, mounts much higher, thus covering the thoracic cage to a certain extent.

We shall study these three muscles successively, from the deepest to the most superficial.

TRANSVERSUS ABDOMINIS (PLATE 50, FIGURE 1)

Attachments: origin, from the last six ribs (internal surface), from the posterior abdominal aponeurosis and from the iliac crest (anterior three quarters of the inner lip); *insertion*, into the linea alba. The fleshy body is thin and the fibers are directed transversely.

Action. It constricts the abdominal cavity like a girdle and compresses it.

OBLIQUUS INTERNUS ABDOMINIS (PLATE 51, FIGURE 2)

Attachments: origin, from the posterior abdominal aponeurosis, from the anterior three quarters of the iliac crest, and from the lateral third of the inguinal ligament; *insertion*, into the three or four last ribs and into the linea alba.

This muscle is larger in front than in back, and its fibers fan out in three directions as they leave the iliac crest: the superior fibers go above and to the front, the middle ones transversely, and the inferior ones below and to the front.

Action. If these two muscles act together, they flex the trunk. When one side alone contracts, it bends the vertebral column laterally and rotates it, bringing the shoulder of the opposite side toward the front. It is thus the antagonist of obliquus externus abdominis.

OBLIQUUS EXTERNUS ABDOMINIS (PLATE 51)

Attachments: origin, from the external surface of the last eight ribs; *insertion*, into the iliac crest (anterior half of the outer lip), into the inguinal ligament, and into the anterior abdominal aponeurosis.

Its superior insertion is formed of digitations which create a toothed line running obliquely downward toward the back and the outside. This line interlaces with the digitations of the serratus anterior and latissimus dorsi.

From the line of digitations fibers descend obliquely toward the front and inside, crossing perpendicularly the superior fibers of obliquus internus. Obliquus externus is not much thicker than a centimeter where it is applied to the superior ribs, but in the part which corresponds with the abdomen its thickness is doubled by the two preceding muscles, obliquus internus and transversus.

Obliquus externus can be thought of as having two parts, the superior, or thoracic, and the inferior, or abdominal.

The relief of the whole thoracic part is created by the bones which it covers and the varied forms of the skeleton can be seen on the surface (the ribs, the intercostal furrows, the articulations of the costal cartilages, etc.). However, this may be modified by the degree of development of the obliquus externus muscle and the varying thickness of its digitations.

The abdominal portion corresponds to the flank and it forms a characteristic relief in the back which mingles with a fatty pad which I shall describe later. (See fatty skin and tissue, Chapter, 12.) The lower border of this portion ends in the furrow of the flank. However, the direction of this furrow is not the same as that of the iliac crest, as we shall see later. In front, the fleshy fibers stop a short distance from rectus abdominis in a descending line. This line swerves below and doubles back sharply toward the outside, going a little above the superior anterior iliac spine. The result is that the furrow, which separates obliquus externus from rectus abdominis above, terminates below in a triangular surface of which the base is at the wrinkle of the groin. This surface is slightly convex, and it contributes to the uniform curve of the hypogastric region. This region encompasses the inferior median portion of the abdomen.

Action. The two sides, acting together, flex the trunk. The isolated action of one side turns the anterior surface of the trunk to that side. It also bends the vertebral column laterally.

MUSCLES OF THE PELVIS

I shall divide the muscles of the pelvis into two groups. First, the deep muscles: psoas major, psoas minor, iliacus, piriformis, gemellus superior, gemellus inferior, obturator internus, and quadratus femoris. Second, the gluteal muscles: gluteus minimus, gluteus medius, and gluteus maximus.

DEEP MUSCLES

These are composed of psoas major and minor, iliacus, piriformis, obturator internus, gemelli, quadratus femoris and obturator externus.

PSOAS MAJOR, PSOAS MINOR AND ILIACUS (PLATE 52, FIGURE 1)

Attachments: origin (considered as one muscle), from the lateral part of the bodies of the vertebrae in the whole lumbar region, from the transverse processes of the lumbar vertebrae (psoas), and from the internal iliac fossa (iliacus); *insertion*, into the lesser trochanter.

These muscles are situated on the interior of the pelvis. They line the internal fossa by their lateral or iliac parts and extend down the sides of the lumbar column by their medial parts (psoas). They are directed toward the same inferior tendon. The fleshy fibers of the psoas muscles unite in a fusiform body which moves over across the anterior rim of the lesser pelvis before reaching the lesser trochanter.

Action. These muscles are flexors of the thigh.

PIRIFORMIS (PLATE 52, FIGURE 4)

This muscle and the following ones, deeply situated at the posterior surface of the pelvis, have no influence on the external form. I shall simply describe their attachments and their actions.

Attachments: origin, from the anterior surface of the sacrum and from the margin of the greater sciatic foramen; *insertion*, into the superior border of the greater trochanter behind gluteus minimus and above obturator internus.

Action. It is an abductor and, to some extent, an extensor of the thigh. It also rotates the thigh laterally.

OBTURATOR INTERNUS AND GEMELLI (PLATE 52, FIGURE 4)

Attachments: origin, from the interior surface of the lesser pelvis around the obturator foramen, from the pelvic surface of the obturator membrane (obturator internus), and from the spine of the ischium (gemellus inferior); *insertion*, into the superior border of the greater trochanter below piriformis.

Action. These muscles rotate the thigh laterally.

QUADRATUS FEMORIS (PLATE 52, FIGURE 4)

Attachments: origin, the external border of the ischium, in front of semimembranosus; *insertion*, into the proximal part of the linea quadrata, a line running between the greater and lesser trochanter.

Action. It is an outward rotator of the thigh.

OBTURATOR EXTERNUS (PLATE 63, FIGURE 2)

Attachments: origin, from the periphery of the obturator foramen, and from the obturator membrane; *insertion*, into the femur (trochanteric fossa).

Action. It rotates the thigh laterally.

MIDDLE LAYER

This layer is composed of gluteus minimus, medius, and maximus.

GLUTEUS MINIMUS (PLATE 52, FIGURE 3)

Attachments: origin, from the external surface of the ilium between the anterior and inferior gluteal lines; *insertion*, into the great trochanter (anterior border and anterior part of the superior border).

All the fleshy fibers are disposed in a fan-like form converging toward the inferior tendon. This muscle is entirely coverd by gluteus medius.

Action. It abducts the thigh, and rotates it to the inside through its anterior fibers and to the outside through its posterior fibers.

GLUTEUS MEDIUS (PLATE 52, FIGURE 2, 4, and 5)

Attachments: origin, from the outer surface of the ilium between the posterior and anterior gluteal lines, from the anterior three quarters of the external lip of the iliac crest, and from the anterior superior iliac spine by a fascia it shares with the tensor fasciae latae; *insertion*, into the external surface of the great trochanter following a ridge which is oblique from below to the front.

This is a radiating muscle. Its form is fan-shaped like the preceding one, and it is covered at its posterior part by gluteus maximus. It is maintained by a solid aponeurosis which is attached above to the iliac crest and mingles below with the tendon of gluteus maximus and the femoral aponeurosis. The morphological role of this aponeurosis is most important, as we shall see later (see Morphology: Region of the Buttock).

Action. It differs according to the portion of the muscle which comes into play. The middle portion abducts the thigh, the anterior portion rotates it medially and the posterior portion rotates it laterally.

Gluteus medius and minimus, as abductors, support and hold the pelvis on the thigh whenever the trunk rests on the inferior members, for example, when the body is in an upright position or as in the second step of a walk when the weight tends to incline the pelvis to the opposite side.

GLUTEUS MAXIMUS (PLATE 52, FIGURE 2 and 5)

Attachments: origin, from the most posterior part of the ilium, from the external part of the sacrum and the borders of the coccyx, and from the posterior part of the sacrotuberous ligament; *insertion*, into the external bifurcation of the linea aspera from the great trochanter as far as the middle third of the femur, and into the femoral aponeurosis.

Gluteus maximus is a thick muscle of almost equal thickness throughout its entire extent. It is composed of large and distinct fasciculi which together create an irregular quadrilateral shape. Its fleshy fibers, which are directed obliquely from above to below and from within to without, arise, at their origin, from very short tendinous fibers. At their inferior insertion, however, these fleshy fibers join a large aponeurosis which is inserted into the iliotibial band of the fascia lata. The deeper fibers are inserted into the linea aspera.

The fleshy fibers of the superior border are much shorter than the inferior ones. In contrast, the aponeurotic fibers of insertion diminish in length from above to below. A powerful fascia limits the inferior border of the muscle and it is partially inserted into the femoral aponeurosis.

Besides the direct insertion of the fleshy fibers into the femoral aponeurosis, the entire tendon closely adheres to

this same aponeurosis which rises as far as the iliac crest and mingles in front with the tensor of the fascia lata. Entirely subcutaneous, gluteus maximus covers the ischium and the muscles of the deeper layers. It contributes to about half of the size of the buttock and the great abundance of fatty tissue usually accumulated in this region contributes the rest.

Its inferior border, oblique from above to without, has little influence on the crease of the buttock, as we shall explain later.

Action. It extends the thigh powerfully against the pelvis. If the femur is in a fixed position, it extends the pelvis against the thigh. It does not exert much action in an upright stance or horizontal walking position. It only intervenes in action which requires an effort, such as climbing, jumping, running, rising from sitting, etc.

10. Muscles of the Upper Limb

The muscles of the shoulder have been studied together with those of the trunk so we do not have to review them here. We shall now study, in succession, the muscles of the upper arm, the forearm, and the hand.

MUSCLES OF THE UPPER ARM

In front of the humerus, the muscles which compose the fleshy mass of the arm are three in number and they are disposed in two layers. The deep layer is composed of the coracobrachialis and the brachialis; the superficial layer of the biceps brachii.

On the back of the arm there is only a single muscle, the triceps brachii, but it is extremely powerful. It is composed of three distinct fleshy bodies.

CORACOBRACHIALIS (PLATE 56, FIGURE 1)

Attachments: origin, from the summit of the coracoid process (together with the short head of the biceps); *insertion*, into the internal surface of the humerus, at the level of the middle third of the bone.

This small muscle, deeply situated, has little effect on the exterior form when the arm falls alongside the trunk. In vertical elevation of the arm, however, it creates a distinct eminence within the armpit.

Action. It flexes and adducts the arm.

BRACHIALIS (PLATE 56, FIGURE 2)

Attachments: origin, from the two sides and the anterior border of the humerus; *insertion*, into the coronoid process of the ulna.

This muscle, attached directly to the skeleton above the articulation of the ulna, underlies the inferior part of biceps brachii. It can be easily seen on each side of the forearm.

Action. It flexes the forearm against the upper arm.

BICEPS BRACHII (PLATE 56, FIGURE 2)

This is a long muscle divided above into two heads: the long head and the short head.

Attachments: origin, from the superior border of the glenoid cavity of the scapula (by its long head) and from the summit of the coracoid process (by its short head);

insertion, into the posterior half of the bicipital tuberosity of the radius.

The arrangement of the fleshy fibers of this muscle is very simple. Rising from the interior of a hollow tendinous cone (the long head), and from the deep surface of an aponeurosis of insertion (the short head), the fleshy fibers run below to the two surfaces of a central aponeurosis of which the fibers are gathered into a strong and resistant tendon.

Running from the skeleton of the shoulder to that of the forearm, the biceps takes up most of the anterior surface of the upper arm. It is subcutaneous along the inferior two thirds of its length. The superior third is masked by deltoideus and by pectoralis major. The fleshy body of the biceps begins to appear below pectoralis major, at the place where the two heads of the biceps become fused. In some models one is able to see in certain movements of the arm the mark of this division on the superior part of biceps brachii.

The placement of biceps brachii makes it easy to see the changes of form that take place during different phases of the muscle's contraction. In general, it should be noted that the fleshy fibers fall a little lower on the inside than on the outside. At the elbow, its tendon can be seen under the skin, as far as the point where it plunges between brachialis and brachioradialis to reach the radial tuberosity. The tendon is even more visible when the muscle is in action. Its outline varies with the degree to which the arm is flexed. The aponeurotic extension, going toward the medial border of the forearm, leaves a clear outline beneath the skin (Plate 59).

The length of the fleshy body is extremely variable. Its extension takes place at the expense of the inferior tendon, which diminishes in proportion. The modeling of the muscle is considerably changed by the shortness or length of the body of the muscle. In the first case, the anterior part of the upper arm, even in relaxation, takes on a globular aspect, and the planes of brachialis seem to increase its length. In the second case, the arm takes on a much more elongated form. The muscle is fuller and its outline descends almost to the bend of the arm, giving the region more uniformity and harmony.

Action. Biceps brachii is a flexor of the forearm on the upper arm and, at the same time, it is a supinator of the forearm. The tendon of its long head holds the head of the humerus against the glenoid cavity, and thus contributes to the stability of the articulation.

TRICEPS BRACHII (PLATE 56, FIGURE 3 and 4)

This voluminous muscle is divided above into three heads.

Attachments: origin, from the outer border of the shoulder blade below the glenoid cavity (the long head), from the humerus above the groove for the radial nerve (medial head), and from the posterior border and lateral surface of the humerus (lateral head); *insertion*, into the posterior and superior part of the olecranon.

Rising from multiple origins, these fleshy fibers group themselves into three bodies. Their disposition is quite complicated so I will explain it. The fleshy fibers of the long portion and those of the lateral head are at the superior part of the upper arm; they give rise to a large tendon which inserts into the olecranon. The fleshy fibers of the medial head descend further than the lateral head; they are attached to the internal border of the common tendon along its entire deep surface, padding it out, so to speak. These fibers also appear at the exterior border, below the fibers of the lateral head, where they mingle with the most superior fibers of anconeus. The common tendon has an internal part which is attached to the summit of the olecranon and an external part which is prolonged below as far as the posterior border of the ulna. The external part covers the anconeus and blends with the deep fascia of the forearm.

Triceps brachii occupies the whole posterior region of the upper arm where it is subcutaneous, except for the superior part which disappears under the deltoid. A plane created by the tendon of triceps brachii may be easily seen beneath the skin. This plane rises to the middle part of the upper arm and is directed obliquely from below to above and from without to within. It is supported by the deep fleshy fibers of the medial head. The fleshy fibers of the lateral head limit its outline above and on the outside. Within, it is bordered by the much more voluminous swelling of the long and medial heads. The most considerable part of this swelling is due to the long head. The medial head is usually separated from the long head by a slight furrow and it only occupies the most inferior part of the form.

The plane of the common tendon, and the swelling of the muscles which surround it, becomes very clear when the muscle is contracted and the fleshy bodies of the three heads may be easily distinguished. Sometimes each of the three heads is divided into secondary reliefs. These run parallel to the direction of the muscular fibers which are due to distinct fasciculi.

Action. Duchenne de Boulogne has well explained the action of the long head. It somewhat feebly lowers the forearm, although, when the lowering of the forearm is made with an effort, it contracts forcefully. Its purpose is not to interfere with the lowering of the upper arm (an action performed mostly by latissimus dorsi and pectoralis major) and to counteract the tendency that these muscles might have of dislocating the inferior end of the humerus. When the arm is in repose, the long head lifts the humerus and holds the extremity of the bone firmly against the glenoid cavity. Coracobrachialis fulfills an analogous function. The medial and lateral heads extend the forearm on the upper arm.

MUSCLES OF THE FOREARM

The muscles of the forearm divide into two regions, the anteroexternal and the posterior region.

ANTEROEXTERNAL REGION

The anteroexternal region is made up of the following three layers. First, a deep layer—the supinator and the pronator quadratus; second, a middle layer—the flexors; and third, a superficial layer—pronator teres, palmaris longus, flexor carpi ulnaris, and in the external region, brachioradialis, extensor carpi radialis longus, and extensor carpi radialis brevis.

DEEP LAYER.

This layer is composed of the supinator and pronator quadratus.

SUPINATOR (PLATE 57, FIGURE 1)

This is a deep muscle (*supinator brevis*) which is curved around the proximal third of the radius.

Attachments: origin, from the lateral epicondyle of the humerus, from the radial collateral ligament of the elbow joint, from the annular ligament, and from the ulna beneath the radial notch; *insertion*, into the superior third of the radius above the oblique line. This muscle contributes to the superior swelling of the external border of the forearm.

Action. It is a supinator, conjointly with the biceps.

PRONATOR QUADRATUS (PLATE 57, FIGURE 1)

This is a deep, flat, quadrilateral muscle, extending transversely between the two bones of the forearm at their inferior quarter.

Attachments: origin, from the inferior quarter of the anterior surface and internal border of the ulna; *insertions*, into the inferior part of the external border and to the anterior surface of the radius. It accounts for the thickness of the inferior quarter of the forearm at the point where most of the superficial muscles which pass in front of it are reduced to tendons.

Action. It is a pronator.

MIDDLE LAYER

This layer is composed of flexor digitorum profundus, flexor pollicis longus, and flexor digitorum superficialis.

FLEXOR DIGITORUM PROFUNDUS AND FLEXOR POLLICIS LONGUS (PLATE 57, FIGURE 2)

These two muscles are joined together and they cover all the anterior and internal part of the skeleton of the forearm.

Attachments: origin, from the superior two thirds of the internal and anterior surface of the ulna and from the interosseous membrane (flexor digitorum profundus);

from the superior three quarters of the anterior surface of the radius and from the interosseous membrane (flexor pollicis longus). *Insertions*, into the bases of the last phalanges of the fingers, into the third phalange of the four last fingers (flexor digitorum profundus), and into the second phalange of the thumb (flexor pollicis longus). These muscles contribute to the median and anterior swelling of the forearm.

Action. These muscles are flexors of the fingers and especially of the last phalanges where they insert.

FLEXOR DIGITORUM SUPERIFICIALIS (PLATE 57, FIGURE 3)

This muscle is superimposed on the preceding ones.

Attachments: origin, from the median epicondyle (common tendon), from the internal part of the coronoid process of the ulna, from the oblique line of the anterior surface of the radius; *insertion*, into the middle phalanges (on the lateral parts of the anterior surface).

The flexor muscles of the fingers each give rise at their lower parts to four tendons. Each of these tendons goes to one of the four fingers of the hand. They pass together through the carpal canal and each finger receives two flexor tendons. These two tendons, one superimposed upon the other, have a unique arrangement in their inferior parts. The superficial tendon divides itself into two portions which twist about the deeper tendon and attach themselves to the sides of the middle phalange. The deeper tendon continues its course and is attached to the last phalange.

The flexor muscles of the fingers form a voluminous fleshy mass which occupies the whole anterior portion and internal border of the forearm. The fleshy fibers descend far down the tendons, much lower than the fibers of the superficial layer of muscles which we are about to study. When the flexor muscles enter into action, they form a relief which occupies the median internal part of the forearm.

ANTERIOR SUPERFICIAL LAYER

All the muscles of the anterior superficial layer have a common superior insertion at the medial epicondyle of the humerus. They number four: pronator teres, flexor carpi radialis, palmaris longus, and flexor carpi ulnaris.

PRONATOR TERES (PLATE 57, FIGURE 1)

Attachments: origin, from the medial epicondyle of the humerus and slightly from the internal border of the humerus and also from the medial side of the coronoid process of the ulna; *insertion*, into the impression situated toward the middle of the lateral surface of the radius.

The fleshy fibers go into a tendon which appears on the anterior surface of the muscle, and which twists its lower part around the radius before it is inserted.

Toward its inferior part, this muscle is covered by the muscles of the external region. However, its superior part creates a distinct relief on the model on the inside of the crease of the elbow.

Action. It is, above all, a pronator. It also contributes to the flexing of the forearm on the upper arm.

FLEXOR CARPI RADIALIS (PLATE 57, FIGURE 4)

Attachments: origin, from the medial epicondyle (common tendon); *insertion*, into the base of the second metacarpal. The fleshy body descends somewhat obliquely from above to below and produces a flat tendon toward the middle of the forearm. This tendon can be clearly seen under the skin as far as the wrist where it plunges into a special sheath in order to attain its insertion at the second metacarpal.

Action. It flexes and abducts the hand.

PALMARIS LONGUS (PLATE 57, FIGURE 4)

Attachments: origin, from the medial epicondyle of the humerus (common tendon); *insertion*, by a slender, flattened tendon into the palmar aponeurosis, passing over the flexor retinaculum.

This muscle is absent in about one out of ten subjects. Its tendon, clearly visible under the skin, occupies the middle of the anterior surface of the wrist. It is more oblique than the tendon of flexor carpi radialis which is found more to the outside.

Action. It flexes the hand and is a tensor of the palmar aponeurosis.

FLEXOR CARPI ULNARIS (PLATE 57, FIGURE 4)

Attachments: origin, from the common tendon of the medial epicondyle of the humerus, from the olecranon, and from the crest of the ulna by an aponeurosis (Plate 60); *insertion*, into the pisiform bone and into the fifth metacarpal.

This muscle is situated on the internal border of the forearm and it covers the deep flexors. Its anterior border, on which the powerful tendon which forms its inferior attachment appears, is separated from palmaris longus by a triangular space, very elongated along its inferior base. Flexor digitorum superficialis appears in this space.

Action. It is a flexor of the hand and helps to adduct it.

EXTERNAL SUPERFICIAL LAYER

This layer is composed of three muscles: brachioradialis, and the two radial extensors.

BRACHIORADIALIS (PLATE 58, FIGURE 3 and PLATE 61)

Attachments: origin, from the external border of the humerus (inferior third); *insertion*, into the base of the styloid process of the radius.

The fibers of this long muscle (*supinator longus*) undergo a torsion movement of about a quarter of a circle. It is thin above where its fibers go around brachialis but it becomes thicker below at the anterior surface of the forearm where its internal border extends as far as palmaris longus. Brachioradialis covers palmaris longus for a short distance (Plate 59).

It is flat in two different senses. Above, in the upper arm part, it is flattened laterally; at the forearm and lower part, it is flattened from front to back.

Action. It is a flexor of the forearm.

EXTENSOR CARPI RADIALIS LONGUS (PLATE 58, FIGURE 2, and PLATE 61)

Attachments: origin, from the inferior third of the external border of the humerus, below the preceding muscle; *insertion,* into the dorsal surface of the base of the second metacarpal.

The fleshy body, much shorter than that of the brachioradialis, is still much like it in shape. Above, it is flattened laterally, and below it is flat in an anteroposterior sense. The two muscles, superimposed, undergo the same movement of torsion. Above, they touch each other by their borders; below, by their surfaces. Extensor carpi radialis longus is covered by brachioradialis, and, in turn, it covers extensor carpi radialis brevis. On the flayed figure it only shows as a triangular surface of which the inferior summit is between brachioradialis and extensor carpi radialis brevis (Plate 61).

Its form, always distinct from extensor carpi radialis brevis, blends with brachioradialis. It is only under certain strong movements of flexion that the two fleshy bodies can be distinguished from each other under the skin (Plate 104, Figure 1).

Action. It extends and abducts the hand.

EXTENSOR CARPI RADIALIS BREVIS (PLATE 58, FIGURE 1, and PLATE 61)

Attachments: origin, from the lateral epicondyle of the humerus; from the common tendon of the superficial muscles of the posterior surface of the forearm; *insertion,* into the dorsal surface of the base of the third metacarpal on its radial side.

The thick, fleshy body is covered along its anterior half by the preceding muscles. Its posterior superficial part forms, on the external border of the forearm, an extremely distinct elongated relief. It gives rise to a single tendon which descends with that of extensor carpi radialis longus as far as the hand. This tendon passes under the muscles on the posterior surface which go to the thumb.

Action. It extends and may abduct the hand.

MUSCLES OF THE POSTERIOR REGION

These muscles are disposed in two layers, each composed of four muscles. The deep layer includes the extensor indicis and the three muscles of the thumb: abductor pollicis longus, extensor pollicis brevis, and extensor pollicis longus. The superifical layer includes the following: anconeus, extensor carpi ulnaris, extensor digiti minimi, and extensor digitorum.

DEEP LAYER

All the muscles of this layer are directed obliquely from above to below and from within to without. Their influence on the exterior form is apparent only at their inferior extremities.

ABDUCTOR POLLICIS LONGUS (PLATE 58, FIGURE 1)

Attachments: origin, from the posterior surfaces of the ulna and radius; *insertion,* into the superior extremity of the first metacarpal.

Action. It draws the metacarpal obliquely to the outside and to the front.

EXTENSOR POLLICIS BREVIS (PLATE 58, FIGURE 1)

Attachments: origin, from the radius; *insertion,* into the superior extremity of the first phalanx of the thumb. This muscle and the preceding one are coupled together throughout their course and they cross the other tendons on the radius obliquely. Their fleshy bodies descend as far as the region of the wrist and form, at the inferior part of the external border of the forearm, an extremely distinct oblique relief.

Action. It extends the first phalanx of the thumb and by continued action abducts the hand.

EXTENSOR POLLICIS LONGUS (PLATE 58, FIGURE 1)

Attachments: origin, from the ulna; *insertion,* into the base of the second or last phalanx of the thumb. Its tendon, distinct from those of the preceding muscles, passes down an oblique groove on the radius and crosses the radial tendons. On the inside it forms the medial border of a depression (the anatomical "snuff box") which is limited on the outside by the two tendons of extensor pollicis longus and extensor pollicis brevis.

Action. It extends the second phalanx of the thumb and by continued action abducts the hand.

EXTENSOR INDICIS (PLATE 58, FIGURE 1)

This muscle, situated lower than the preceding one, is inserted above it on the ulna. Its tendon blends below with that of extensor digitorum. It has no effect on the exterior form.

SUPERFICIAL LAYER (PLATE 58, FIGURE 2)

This layer is composed of extensor digitorum, extensor digiti minimi, extensor carpi ulnaris, and anconeus.

EXTENSOR DIGITORUM

Attachments: origin, from the lateral epicondyle of the humerus (common tendon); *insertion,* into the bases of the second and third phalanges of the fingers.

The fleshy body is divided into several bundles which prolong themselves into the four tendons which pass under the annular ligament of the wrist and go toward the four corresponding fingers. The tendons form the oblique strips which are so often visible under the skin of the hand. Together with the radial muscles, the fleshy body of extensor digitorum forms a relief under the skin which

crosses the lower and inside part of the posterior surface of the forearm somewhat obliquely.

In contraction, the muscle forms a distinct relief on the superior part of the forearm. On the inferior quarter of the forearm it is no longer visible, but on thin subjects its tendons can be distinguished on the back of the hand.

Action. It extends the phalanges and, by continued action, extends the wrist.

EXTENSOR DIGITI MINIMI (PLATE 58, FIGURE 2)

This slender muscle shares its superior insertion with the other muscles which arise from the lateral epicondyle of the humerus; below its tendon unites with that of extensor digitorum. Its relief blends with the preceding muscle.

EXTENSOR CARPI ULNARIS

Attachments: origin, from the lateral epicondyle of the humerus by a distinct tendon; *insertion,* into the base of the head of the fifth metacarpal (ulna side).

On the nude this muscle forms a distinct elongated relief, bordered within by an oblique groove which corresponds to the crest of the ulna. Its prominent inferior tendon passes through a groove in the head of the ulna and adds to the projection of that bone.

Action. It is an extensor and adductor of the hand.

ANCONEUS (PLATE 58, FIGURE 2)

Attachments: origin, from the lateral epicondyle of the humerus by a distinct tendon; *insertion,* into the external part of the olecranon and to the posterior surface of the ulna (the most superior part). This very short muscle, of triangular aspect, forms a relief which can be clearly seen under the skin.

MUSCLES OF THE HAND

These muscles can be divided into three regions: first, the middle region, or hollow of the hand; second, the external region or thenar eminence; and third, the internal region or hypothenar eminence.

MIDDLE REGION

This region is composed of interossei dorsales and palmares, and lumbricales.

INTEROSSEI DORSALES AND INTEROSSEI PALMARES
(PLATE 58, FIGURE 4 and 5)

Small muscles situated in the intermetacarpal spaces, two in each space, these muscles are divided into dorsal and palmar.

Their superior insertions are on the sides of the metacarpals; below they are attached to the sides of the superior extremities of the first phalanges. The interossei dorsales have a double fleshy body which prolongs itself

Figure 3. Schematic drawing showing the insertions of the interossei muscles. The dotted lines represent the palmar interossei and the continuous lines indicate the dorsal interossei.

below into a single tendon. The bodies are attached above to the two metacarpals which limit the interosseous space. The interossei dorsales can be seen on the dorsal surface of the metacarpus. In particular, the first dorsal interosseous should be studied since it forms the oblong swelling visible outside the second metacarpal on the back of the hand.

The palmar interossei muscles only have single fleshy bodies which are inserted into the metacarpals on the surfaces which are turned toward the palm of the hand. An exception must be made of the first palmar interosseous, which, because of its differences of insertion, should be separately described. It is actually flexor pollicis brevis and it will be described later. All the palmar interossei muscles are on the palmar surface of the metacarpus where parts of the dorsal interossei muscles may also be seen. The different anatomical details that I have described can be easily understood from Figure 3.

Figure 3 also indicates the action of these little muscles, which, because of their position in relation to the axis of the hand, are either adductors or abductors of the fingers. The abductors, which draw the fingers away from the median axis of the hand, are the dorsal interossei. The adductors, which bring them back in the opposite direction, are the palmar interossei.

LUMBRICALES (PLATE 57, FIGURE 2)

The lumbricales are small muscles situated in the region of the hollow of the hand. They run from the lateral side of the tendons of the flexor digitorum profundus, and they insert into the exterior tendons of each finger.

These small muscles do not influence the external form. Together with the tendons of the flexor muscles, they fill the hollow of the hand and the whole area is covered by a strong palmar aponeurosis.

MUSCLES OF THE THENAR EMINENCE

From the point of view of the exterior form we can divide these muscles into two groups: an external group which

forms the swelling at the base of the thumb, and an internal group, much deeper, which underlies the inferior group and raises the thenar eminence.

The first group is composed of three muscles: abductor pollicis brevis, flexor pollicis brevis, and opponens pollicis. The second group is composed of a single muscle, the adductor pollicis.

ADDUCTOR POLLICIS (PLATE 58, FIGURE 4)

Attachments: origin, from the capitate bone, the anterior part of the third metacarpal, and the superior part of the second metacarpal; *insertion,* into the internal tuberosity of the superior extremity of the first phalanx of the thumb.

This triangular muscle, deeply situated, is covered by the tendons of the flexor muscles and the lumbricales. It becomes superficial only at its external extremity where it forms the supporting and inferior part of the thenar eminence.

Action. It is an adductor of the first metacarpal.

OPPONENS POLLICIS (PLATE 58, FIGURE 4)

Attachments: origin, from the anterior part of the trapezium and the ligament of the wrist (flexor retinaculum); *insertion,* into the external border and the anterior surface of the first metacarpal.

Action Deeply situated, this little triangular muscle adducts, flexes, and rotates the thumb.

FLEXOR POLLICIS BREVIS (PLATE 59)

Attachments: origin, from the trapezium and the ligament of the wrist; *insertion,* into the superior extremity of the first phalanx of the thumb. This thick muscle, situated at the internal part of the thenar eminence, is divided into two bundles between which the tendon of flexor pollicis longus passes.

Action. It flexes the first phalanx of the thumb and carries the metacarpal in front and within.

ABDUCTOR POLLICIS BREVIS (PLATE 59)

Attachments: origin, from the tuberosity of the scaphoid, the transverse carpal ligament, and the ridge of the trapezium; *insertion,* into the superior extremity and radial side of the first phalanx. This flat muscle is the most superficial and the most external of the region.

Action. It abducts the thumb.

MUSCLES OF THE HYPOTHENAR EMINENCE (PLATE 59)

The muscles of the hypothenar eminence only need a brief description. They are, to a certain extent, analogous to those of the thenar eminence. They are, starting with the deepest, opponens digiti minimi, flexor digiti minimi brevis, and abductor digiti minimi.

They occupy the internal border of the hand and contribute to the diverse movements of the fifth metacarpal and the little finger. These movements are much more limited than those of the thumb. The muscles of the hypothenar eminence are also much less voluminous than those of the thenar eminence.

I should, however, call attention to the most superficial muscle of the region, palmaris brevis. This muscle is attached, on the outside, to the internal border of the palmar aponeurosis, and, within, to the deep surface of the skin at the ulnar border of the hand. When it contracts, it creates a longitudinal depression in this area which is traversed by extremely characteristic wrinkles over the skin.

11. Muscles of the Lower Limb

We shall study successively the muscles of the thigh, the leg, and the foot.

MUSCLES OF THE THIGH

The muscles of the thigh may be divided as follows: an anterolateral group composed of the quadriceps, the tensor of the fascia lata, and the sartorius; a medial group composed of the adductors and the gracilis; and a posterior group formed of the biceps femoris, of the semimembranosus and of the semitendinosus.

ANTEROLATERAL GROUP.

This group of muscles is composed of quadriceps femoris, tensor fasciae latae and sartorius.

QUADRICEPS FEMORIS (PLATE 63, FIGURE 1)

The quadriceps femoris is composed of four muscles: rectus femoris, vastus lateralis, vastus medialis, and vastus intermedius (crureus). They are united below by a single tendon.

Attachments: origin, for the rectus femoris, from the anterior *inferior* iliac spine (straight tendon) and from a groove above the brim of the acetabulum (reflected tendon); for the vastus lateralis, from the base of the great trochanter and the lateral lip of the linea aspera; for the vastus medialis, from the medial lip of the linea aspera; for the vastus intermedius, from the anterior and lateral surface of the femur, and from the distal part of the lateral intermuscular septum.

Insertion, into the base and the two borders and the anterior surface of the patella, then, through the patella tendon, to the anterior tuberosity of the tibia.

The *rectus femoris,* fusiform in shape, is the most superficial portion of the quadriceps. It occupies the center of the anterior surface of the thigh, and it follows the oblique direction of the femur. Its position makes the relief formed under the skin in contraction very distinct. This relief is marked, at its center, by a longitudinal furrow due to the disposition of the superior aponeurosis of the muscle.

The tendon of rectus femoris plunges above into an upside down V shape. This angle is formed by the sartorius and the tensor of the fascia lata. The rectus femoris runs into the angle in order to gain its insertion at the iliac bone. Because this insertion is made by a double tendon, the muscle is able to act efficiently in two different positions. In extension of the limb, for instance, the straight tendon is in play; in flexion of the thigh, on the contrary, all the strain is carried by the reflected tendon. Below, the tendon of rectus femoris goes to the base of the patella; its fleshy fibers cease almost a hand's breadth above this bone.

The two voluminous fleshy bodies of *vastus medialis* and *vastus lateralis* are situated on either side of the preceding muscle, and join together on the median line below it. Their inferior insertion is made by large aponeurotic surfaces which, closely joined to the tendon of rectus femoris, descend on each side and insert themselves onto the sides of the patella.

The vastus lateralis is the most voluminous of the quadriceps femoris muscles and it occupies almost all of the external surface of the thigh. It is supported on the outside by the band of the fascia lata, but the fibrous bundles of vastus lateralis may, in certain positions of the thigh, be seen running across this band. The fleshy fibers stop at a distance of several fingers' breadth from the patella.

The vastus medialis occupies the inferior and medial part of the thigh. It looks like an ovoid mass. The largest part is turned downwards and the superior point plunges into the angle formed by the rectus femoris and the sartorius. The fleshy body descends very low, as far as a line level with the middle of the patella. There is, therefore, a great difference between vastus lateralis and vastus medialis; this detail is of great importance in modeling the knee.

The *vastus intermedius (crureus)* is the deepest part of the quadriceps. It stretches along the femur and lies partly underneath the vastus medialis although the major part lies underneath the vastus lateralis. Nevertheless, its influence on the exterior form is marked. This is because it projects below the tendon of vastus lateralis and, at the external surface of the knee, it becomes superficial for a short distance. This superficial portion of vastus intermedius is covered by the fascia lata (Plate 70) when the lower leg is extended. When the leg is flexed it forms a distinctly ovoid swelling.

At a distance of three or four fingers' breadth above the patella, the transverse fibers of the aponeurosis become compressed and form a fibrous bundle or band of aponeurosis (*Richer's band*, Plate 68, 70 and 71). These fibers embrace in their curve the superior anterior and medial

part of the knee. The external extremity fans out and blends with the fasciae latae. Within, these fibers converge and cross vastus medialis in a direction perpendicular to the direction of its fleshy fibers. At about two fingers' breadth from its interior border, the band of fibers passes over the medial femoral tuberosity, descends in front of the sartorius, and intermingles with the tendon of this muscle as it turns down at an acute angle.

At the points where the band meets the dividing membranes of the internal and external aponeuroses some of its deep fibers detach themselves and, adhering to the dividing membranes, go to insertions on the divisions of the linea aspera. The band completes an osteofibrous ring around a transverse plane, inclined from above to below and from without to within. This ring may be thought of as enclosing the inferior part of the quadriceps.

Below, the band has a distinct border. The inferior extremities of the vastus lateralis and vastus medialis seem to be covered only by a loose aponeurotic network. The superior limits of the band are less sharp, and its fibers seem to blend almost imperceptibly with the transverse fibers of the femoral aponeurosis.

The band is important from the point of view of form in this region. When the muscles are relaxed, the fleshy extremities of vastus lateralis and vastus medialis swell boldly beneath the band and create distinct reliefs. We will study these forms later.

Action. The quadriceps femoris extends the lower leg. Also, through rectus femoris, it flexes the pelvis against the thigh.

TENSOR FASCIAE LATAE (PLATE 68 and 70)

Attachments: origin, from the outer lip of the iliac crest and from the outer surface of the anterior superior iliac spine; *insertion*, into the iliotibial tract and ultimately into the tibia.

The fleshy body is short and thick and it is situated at the superior and external part of the thigh. In the back it is placed against gluteus medius and its relief blends in with this muscle. It descends as far as the great trochanter to a point in front and somewhat slightly below it. The thick, fibrous band which constitutes its inferior tendon blends with the external investing fascia of the thigh, the *fascia lata.* The fascia lata is closely joined to the tendon of gluteus maximus and rises, passing over gluteus medius, as far as the iliac crest to which it is solidly attached.

Action This muscles is a flexor of the thigh. At the same time it rotates the thigh medially. The medial rotation is counterbalanced by the opposing rotative action of the psoas muscle.

SARTORIUS (PLATE 68 and 71)

Attachments: origin, from the anterior superior iliac spine; *insertion,* into the medial surface of the tibia, near the anterior crest.

This muscle, the longest in the human body, is flat and about two fingers' breadth wide. It descends obliquely across the anterior surface of the thigh and goes down around the internal part of the knee. It thus describes a sort of elongated spiral.

The fleshy fibers terminate below in a point at the posterior part of a flat tendon. These fibers are of various lengths in different individuals, but generally they descend beyond the articular interplane of the knee.

Action. Flexes the thigh and rotates it laterally. Flexes the leg, and, after it is flexed, rotates the lower leg slightly medially.

INTERNAL GROUP

This group is composed of the adductors and gracilis.

ADDUCTOR GROUP (PLATE 63, FIGURE 2 and 3 and PLATE 64, FIGURE 1)

Anatomists are not in agreement about the division of the adductor group into four distinct muscles: pectineus, adductor longus, adductor brevis, and adductor magnus. In fact, these muscles are often mingled together. However, the issue is of no importance to us. The united abductors form, on the living, a powerful mass at the superior and internal part of the thigh. This mass is never subdivided.

Attachments: origins, from the pectineal line and the triangular surface situated in front of this line (pectineus); from the crest of the pubis and below (adductor longus and adductor brevis); and from the tuberosity of the ischium and the ramus of the ischium (adductor magnus). *Insertions,* into the internal bifurcation of the linea aspera, into the whole interstice of the linea aspera, and into the projecting tubercle of the internal condyle of the femur (fascia of adductor magnus).

Action. The adductors are all, as their names imply, adductors of the thigh. The most superior ones are, at the same time, flexors and outward rotators. The lower part of the adductor magnus is an inward rotator.

GRACILIS (PLATE 71)

Attachments: origin, from the pubis and the pubic arch as far as the neighborhood of the ischium; *insertion,* to the crest of the tibia.

This thin, elongated muscle descend vertically down the internal side of the thigh; its relief blends with that of the adductors. The fleshy body, of varying length in different individuals, sometimes descends as far down as the inferior part of the thigh; the inferior tendon is, correspondingly, longer or shorter. Its lower portion follows the posterior border of the sartorius and contributes to the formation of the aponeurotic network which covers the superior part of the medial surface of the tibia and which has been called the *goose foot.*

Action. The gracilis adducts the thigh. It also flexes the lower leg, and, after it is flexed, assists in medial rotation. The first action is the most powerful.

POSTERIOR GROUP

This group is composed of biceps femoris, semimembranosus, and semitendinosus.

BICEPS FEMORIS (PLATE 64, FIGURE 2 and 3)

Attachments: origin, from the ischium by a common tendon with the semitendinosus (long head of the biceps), from the middle part of the linea aspera (short head of the biceps); *insertion*, into the lateral side of the head of the fibula outside, and the lateral condyle of the tibia further to the inside.

The fleshy body of the long head, elongated and fusiform in shape, gives rise at its inferior part to a tendon which rests upon the posterior surface of the muscle. This tendon receives, upon its external border, the fleshy fibers of the short head which come from the femur. The tendon is very strong and covers the fibular collateral ligament of the knee joint.

Action. See discussion of semimembranosus and semitendinosus.

SEMIMEMBRANOSUS (PLATE 64, FIGURE 2 and 3)

Attachments: origin, from the ischium, above and lateral to the semitendinosus and the biceps femoris; *insertion*, into the posterior part of the medial condyle of the tibia where the tendon divides into three fibrous expansions. These expansions are: first, an inferior, which is inserted into the inferior part of this same condyle; second, an external, which moves out and up to reinforce the oblique popliteal ligament; and third, an internal, which is inserted into the horizontal groove of the condyle.

This powerful muscle forms a vertical furrow which receives the semitendinosus. The inferior extremity of its fleshy body forms a rounded swelling above the superior part of the popliteal space. When the muscle contracts, the swelling becomes most pronounced. Its superior tendon arises from the external border of the muscle and it is hidden beneath the semitendinosus. Its inferior tendon, which shows itself on the internal border, is subcutaneous and may be seen behind the tendon of the gracilis (Plate 72).

SEMITENDINOSUS (PLATE 64, FIGURE 2 and 3)

Attachments: origin, from the ischium by a common tendon with the biceps; *insertion,* into the crest of the tibia.

This muscle is the most superficial of the muscles of the posterior region of the thigh. The fleshy body occupies the superior part of the thigh on the medial side of the biceps femoris. At its lower part it produces a slim, rounded tendon which descends to the medial surface of the tibia. This tendon forms, together with the tendons of the gracilis and the sartorius, the aponeurotic network called the *goose foot.*

Action. The semitendinosus and the biceps femoris produce three movements: flexion of the lower limb on the thigh; extension of the thigh on the pelvis; and rotation of the thigh on the pelvis (the first muscle produces medial rotation and the second lateral rotation). The semimembranosus, more powerful than the two preceding muscles, is not a rotator. It is an extensor of the thigh and a flexor of the lower leg.

MUSCLES OF THE LOWER LEG

The muscles of the lower leg are divided into two regions. The anteroexternal region includes five muscles: extensor hallucis longus, extensor digitorum longus, tibialis anterior, peroneus brevis, and peroneus longus. The posterior region also includes five: the popliteus, tibialis posterior, flexor digitorum longus, flexor hallucis longus, and triceps surae (glastrocnemius and soleus).

ANTEROEXTERNAL REGION

This region is composed of extensor hallucis longus, extensor digitorum longus, tibialis anterior, peroneus brevis and peroneus longus.

EXTENSOR HALLUCIS LONGUS (PLATE 65, FIGURE 1 and 2)

Attachments: origin, from the anterior surface of the fibula, from the interosseous membrane; *insertion,* into the base of the second phalanx of the big toe. Completely hidden above, this muscle appears at the inferior part of the leg between the two muscles described below. It passes under the inferior extensor retinaculum, and its tendon can be seen on the dorsum of the foot.

Action. It is an extensor of the big toe and flexes and supinates the foot.

EXTENSOR DIGITORUM LONGUS (PLATE 65, FIGURE 1 and 2)

Attachments: origin, from the lateral condyle of the tibia and from three fourths of the anterior surface of the fibula; *insertion*, into the second and third phalanges of the four lesser toes.

Throughout its length, this muscle occupies the anterior part of the lower leg. Its fleshy body is masked in its superior part by tibialis anterior which is situated medially to this muscle. Below, its four tendons pass together under the retinaculum, and only separate when they reach the dorsum of the foot in order to go to the toes.

The fleshy body is prolonged below by a small muscle called *peroneus tertius.* The tendon of this muscle attaches to the dorsal surface of the base of the metatarsal bone of the little toe.

Action. It extends the proximal phalanges of the four lesser toes. Dorsally it flexes and pronates the foot.

TIBIALIS ANTERIOR (PLATE 65, FIGURE 2)

Attachments: origin, from the lateral condyle of the tibia, and from the upper two thirds of the lateral surface of the body of the tibia; *insertion,* into the medial and plantar surface of the first cuneiform and to the base of the first metatarsal.

This thick muscle, fusiform in shape, creates a relief which projects beyond the crest of the tibia and blunts the sharp anterior border of this bone. Its fleshy body ends about halfway down the border and gives rise to a tendon. This tendon runs obliquely down and to the inside. The projection of the tendon can be easily traced as far as its inferior insertion.

The tendon of the tibialis anterior creates a much more considerable relief than those created by the tendons of

the extensor muscles which are situated to its outside. This is due to a special anatomical arrangement. The inferior extensor retinaculum passes completely above the extensor longus digitorum and the extensor hallucis longus, but it embraces the tendon of tibialis anterior in a sort of a loop. The result is that the tendon of tibialis anterior is less strongly held down to the foot and in contraction it forms a strong relief under the skin when it rises from the bony surfaces on which it otherwise rests.

Action. It flexes, adducts, and inverts the foot.

PERONEUS BREVIS (PLATE 66, FIGURE 1 and PLATE 70)

Attachments: origin, from the lower two thirds of the lateral surface of the fibula; *insertion,* into the tuberosity at the base of the metatarsal of the little toe.

Placed underneath the muscle described below, the fleshy fibers descend in the back as far as the level of the lateral malleolus. Its tendon runs in a groove behind this malleolus along with that of peroneus longus. On the lateral side of the foot, when the muscle is contracted, the tendon becomes clearly visible in the form of a cord. The tendon of peroneus longus, which goes to the bottom of the foot, remains invisible.

Action. It abducts the foot.

PERONEUS LONGUS (PLATE 66, FIGURE 1 and PLATE 70)

Attachments: origin, from the intermuscular septum which separates the neighboring muscles; *insertion,* into the external part of the base of the first metatarsal.

The elongated fleshy body of this muscle ends in a tendon toward the middle of the leg and this tendon covers that of peroneus brevis which lies beneath it. The tendons of these two muscles run together behind the lateral malleolus in a groove that contains the common synovial sheath. Their presence rounds off the lateral malleolus and increases its transverse diameter. At its inferior part, the tendon of peroneus longus leaves the tendon of peroneus brevis and crosses the plantar vault in an oblique line.

Action. It pronates and flexes the foot.

POSTERIOR REGION

The muscles of this region are five in number and they form two layers: a superficial layer composed of a single muscle, and a deep layer which consists of the four others.

DEEP LAYER

The muscles of the deep layer are the popliteus above and the tibialis posterior, the flexor digitorum longus, and the flexor hallucis longus below. The lower muscles descend as far as the foot.

These muscles, directly resting against the skeleton of the lower leg, do not show very much on the surface except behind the internal malleolus. Here, reduced to their tendinous extremities, they enter the groove of the calcaneus and move to the inferior surface of the foot.

Because of their slight influence on the surface form, I shall only point out their attachments and their actions.

POPLITEUS

Attachments: origin, from a depression of the lateral condyle of the femur; *insertion,* into the posterior surface of the tibia above the popliteal line.

Action. It flexes the leg and rotates it medially.

TIBIALIS POSTERIOR (PLATE 65, FIGURE 3 and PLATE 66, FIGURE 1)

Attachments; origin, from the popliteal line of the tibia and the most lateral part of the posterior surface of this bone, from that part of the internal surface of the fibula situated behind the interosseous ligament; *insertion,* into the tuberosity of the navicular bone.

Action. It adducts, inverts, and flexes the foot.

FLEXOR DIGITORUM LONGUS (PLATE 65, FIGURE 3 and PLATE 66, FIGURE 1)

Attachments: origin, from the popliteal line and from the middle third of the posterior surface of the tibia; *insertion,* into the bases of the distal phalanges of the four lesser toes.

Action. Flexor of the terminal phalanges of these toes.

FLEXOR HALLUCIS LONGUS (PLATE 65, FIGURE 1 and 2)

Attachments: origin, from the inferior two thirds of the posterior surface of the fibula; *insertion,* into the base of the terminal phalanx of the big toe.

Action. Flexor of the second phalanx of the big toe.

SUPERFICIAL LAYER

This layer is composed of the triceps surae.

PLANTARIS, SOLEUS, AND GASTROCNEMIUS (PLATE 66, FIGURE 2 and 3)

Attachments: origin, from above the medial condyle of the femur, from a depression on the internal surface and from the femur above (medial or larger head of gastrocnemius); from an impression on the side of the lateral condyle of the femur, and from the posterior part of the femur above the condyle (lateral head of gastrocnemius); from the head and from the superior third of the posterior surface of the fibula, from the popliteal line of the tibia, and from the middle third of its medial border (soleus); *insertion,* into the middle part of the posterior surface of the calcaneus (*Achilles tendon* or *tendo calcaneus*).

The plantaris is a very small and slender muscle. Its fleshy body rises above the lateral head of gastrocnemius. It terminates in a very long tendon which descends as far as the calcaneus, on the inside of the Achilles tendon.

The triceps surae, in its fleshy superior part, is composed of two layers: one deep, the soleus; the other superficial, the gastrocnemius.

The soleus has a flat, fleshy body composed of short muscular fibers. These fibers are obliquely directed and end in a dividing aponeurotic membrane. In the flayed figure only the borders of the muscle show on the corresponding sides of the lower limb. A very strong aponeurosis covers the inferior posterior surface of the muscle and joins onto the tendon of the gastrocnemius with which it forms Achilles tendon. The fleshy fibers of the soleus descend fairly low on each side of this tendon.

The two heads of gastrocnemius arise from each of the condyles of the femur and join each other along the median line. A strong aponeurosis descends from the tendon onto the middle of the posterior surface of each muscle and creates lateral furrows. The inferior extremities of the two heads of gastrocnemius descend more or less low depending on the individual. They terminate abruptly and thus form the well known outline of the calf. The medial head is the most voluminous. It encroaches upon the medial surface of the leg and descends lower than the lateral head. It terminates in a rounded extremity which marks the break in continuity of the calf. The lateral head has less volume and usually has a more pointed inferior extremity.

The common tendon, large above, becomes narrower as it approaches the calcaneus and slightly enlarges again at its point of attachment. The tendon is subcutaneous and its surface projects more in the middle than at the sides. It is joined laterally by the fibers of the soleus which descend more or less low depending on the individual. The fibers contribute to the size of this part of the leg.

Action. Soleus and gastrocnemius are powerful extensors of the foot and, at the same time, they draw the point of the foot to the inside. As flexors of the lower leg on the thigh, their influence is weak.

MUSCLES OF THE FOOT

These muscles are divided into two regions: plantar and dorsal.

DORSAL REGION

This region has a single muscle, extensor digitorum brevis.

EXTENSOR DIGITORUM BREVIS (PLATE 67, FIGURE 1)

Attachments: origin, from the anterior part of the calcaneus, in front of the groove for the tendon of peroneus brevis; *insertion,* this muscle terminates in four tendons. The most medial tendon is attached to the first phalanx of the great toe and the other three are inserted into the lateral sides of the tendons of the extensor digitorum longus of the second, third, and fourth toes.

This muscle is situated under the extensor tendons which cross the dorsum of the foot. The fleshy body of extensor digitorum brevis runs obliquely, and on the outside of the foot near its posterior insertion it forms a relief which is extremely important in modeling the superior surface of the foot.

Action. It is an extensor of the proximal phalanges of the big and adjacent three lesser toes.

PLANTAR REGION

The muscles of the plantar region are of little interest from the point of view of exterior form. They partly fill the bony arch which is principally responsible for the conformation of this region. However, the muscles on the side of the foot sometimes create distinct reliefs which can be seen under the skin.

It is only necessary to indicate the attachments of the muscles of this region. They may be divided, like the muscles of the hand, into three groups: the middle, the external, and the internal.

MIDDLE REGION

This region is composed of the interossei muscles, adductor hallucis, lumbricales, quadratus plantae, and flexor digitorum brevis.

INTEROSSEI

Divided, like the hand, into dorsal and plantar interossei, these muscles have the same disposition as in the hand with this exception: the axis of the foot, instead of passing through the third metatarsal, passes through the second.

ADDUCTOR HALLUCIS (PLATE 67, FIGURE 2)

Attachments: origin, from the bases of the second, third, and fourth metatarsal bones (oblique head), and, *from the outside,* from the transverse ligament of the metatarsus (transverse head); *insertion,* into the lateral side of the base of the first phalanx of the great toe (both heads).

Action. Adducts the big toe. The transverse head of adductor hallucis helps to maintain the vault of the foot in a transverse sense.

LUMBRICALES (PLATE 67, FIGURE 3)

Analogous to the lumbricales of the hand, these little muscles are attached to the internal sides of the tendons of flexor digitorum longus. They go to the first phalanges of the toes.

QUADRATUS PLANTAE (PLATE 67, FIGURE 3)

Attachments: origin, from the inferior surface of the calcaneus; *insertion,* into the lateral border of the tendon of flexor digitorum longus.

Action. Flexes the terminal phalanges of the four lesser toes.

FLEXOR DIGITORUM BREVIS (PLATE 67, FIGURE 4)

Attachments: origin, from the medial and inferior tuberosity of the calcaneus; *insertion,* into the sides of the second phalanges of the lesser toes. Its anterior tendon runs along with those of flexor digitorum longus. It is analogous to the tendons in the hand.

Action. Flexes the second phalange of the four lesser toes.

INTERNAL REGION

This region is composed of flexor hallucis brevis and abductor hallucis.

FLEXOR HALLUCIS BREVIS (PLATE 67, FIGURE 2)

Attachments: origin, from the third cuneiform and the cuboid bone; *insertion,* into the two sides of the base of the first phalange of the big toe.

Divided into two portions, this muscle forms a groove for the tendon of the flexor hallucis longus. It makes its double inferior insertion along with the tendons of the other muscles and its tendons give rise to small bones called the medial and lateral sesamoid bones. These bones augment the relief that the metatarsophalangeal articulation of the big toe forms on the sole of the foot.

The lateral sesamoid bone receives a portion of flexor hallucis brevis together with the two heads of adductor hallucis.

The medial sesamoid bone also receives a portion of the flexor hallucis brevis and it also receives a portion of abductor hallucis, a muscle which we are about to describe.

Action. Flexes the proximal phalange of the great toe.

ABDUCTOR HALLUCIS (PLATE 67, FIGURE 4)

Attachments: origin, from the medial process of the tuberosity of the calcaneus; *insertion,* into the base of the first phalanx of the big toe (medial sesamoid bone). It should be noted that the superior border of this muscle forms a longitudinal relief along the internal border of the foot.

Action. It is an abductor of the big toe.

EXTERNAL REGION

This region is composed of flexor digiti minimi brevis and abductor digiti minimi.

FLEXOR DIGITI MINIMI BREVIS (PLATE 67, FIGURE 3)

Attachments: origin, from the base of the fifth metatarsal; *insertion,* into the lateral side of the first phalange of the little toe.

Action. It is a flexor of the first phalange of the little toe.

ABDUCTOR DIGITI MINIMI (PLATE 67, FIGURE 4)

Attachments: origin, from the lateral process of the tuberosity of the calcaneus; *insertion,* into the base of the first phalange of the little toe (common tendon with the preceding muscle). The tendon of abductor digiti minimi glides over a smooth facet on the plantar surface of the base of the fifth metatarsal bone.

Action. It is an abductor of the little toe in relation to the axis of the foot.

12. Veins

The veins are canals designed to bring the blood that has been distributed to the organs by the arteries back to the heart. In the interior of the tissues the blood is not completely free—it is contained in an infinity of microscopic canals called capillaries. These capillaries are interposed between the veins and the arteries and they establish communication between the two systems. The cutaneous capillaries give the skin its roseate color. The veins contain dark blood which is unfit for nutrition, while the arteries contain red blood which is filled with nutritive qualities.

Veins are disposed both in the deep parts of the body and at the surface. The superficial veins, which alone interest us, arise within the skin. They travel along the cellular subcutaneous tissue and their origin and course are extremely variable. Only their termination, that is to say the place where they communicate with the deep veins, offers a certain consistency. The veins have an irregular cylindrical shape—they are dilated at certain places and contracted in others which gives them a knotty appearance. This knotty quality is due to the valves in their interior which are designed to facilitate the course of the blood. The veins are always of a bluish color because of the blood which they contain and, in people who have a fine and transparent skin, the color of the veins may be seen as they cross the integument.

The veins often communicate with each other and form a most irregular knotty network.

The arteries have resistant walls and are perfectly cylindrical in shape. As they are always deeply situated, I shall not deal with them here. However, the temporal artery is an exception. Its flexuosities may be easily seen under the skin of the temple, as well as its palpitations (arterial pulsations) when it is animated.

In the veins the blood circulates from the periphery to the center, in an inverse direction to that which it follows in the arteries. The blood in the limbs has to overcome the action of gravity, hence the utility of the valves we have just mentioned. Any obstacle in the course of the veinous blood swells the veins; they will show beneath the skin in great detail if the base of a limb is constricted with a band. An analogous result will take place from purely psychological conditions. For example, in the phenomenon of effort, the suspension of respiration and muscular contraction inhibits the course of the blood in the great veins of the neck. These swell and congest, even affecting the face itself. Exercise, by activating the circulation, increases the amount of blood which circulates in the veins.

Finally, muscular contraction compresses the deep veins and forces the blood to flow back into the superficial veins which then become more swollen.

I should like to point out certain superficial veins which artists are often called upon to portray.

EXTERNAL JUGULAR VEIN

When the neck is under muscular strain, a great vein appears which crosses the direction of the fibers of the sternocleidomastoideus obliquely (Plate 73, Figure 1). This is the *external jugular vein*. It arises from the reunion of the superficial veins of the cranium, among which the *temporal* is most apparent. The external jugular runs from the angle of the jaw down to the fossa above the clavicle which it penetrates immediately to the outside of the insertion of the sternocleidomastoideus. The tributaries of this vein are sometimes visible on the face. These tributaries are: the *frontal,* which descends the middle of the forehead; the angular vein, which runs down the outer wing of the nose; and the facial vein, which generally disappears in the tissues of the cheek.

SUPERFICIAL EPIGASTRIC VEIN

This is the only vein that should be noted on the torso. It is sometimes, though rarely, seen. It descends the lower abdomen, crosses the fold of the groin obliquely, and joins the great saphenous vein when the latter goes into the deep veins of the thigh.

SUPERFICIAL VEINS

These are most developed in the projecting limbs of the body. They may be seen, above all, in thin subjects, and in those who are used to violent bodily exercise. The reason for this is easy to see—if the subject is thin, there is no fat to mask the relief of the veins and if the veins are repeatedly congested in exercise, their superficial development becomes exaggerated. Congestion of the veins occurs because the blood is driven from the deeper veins to the superficial ones during muscular contraction, as I explained above.

In the upper limb (Plate 72), the superficial veins originate on a posterior plane at the back of the hand and fingers. They then run obliquely along the borders of the forearm and reach, at the level of the bend of the arm, the anterior plane. Their course is extremely irregular.

The collateral veins of the fingers unite and produce, on the back of the hand, a veinous network which has a form something like an arcade.

The external extremity of this arcade forms the *cephalic* vein of the thumb; the radial vein originates from it and mounts the lateral border of the forearm. From the internal extremity of the arcade the *basilic* vein develops; this vein is situated on the medial border of the forearm. At the anterior part of the wrist, several small veins originate at the thenar and hypothenar eminences. They join the cephalic and basilic veins which rise to the median veins at the middle part of the anterior surface of the forearm.

At the anterior part of the forearm, we find four veins: the basilic, the median antebrachial vein, the accessory cephalic, and the cephalic.

The cephalic and median antebrachial open into two branches which run toward the sides of the arm; the outside branch becomes the median cephalic and the inside branch, the median basilic. After a short path each of these two divisions unites with the veins on the sides of the forearm and gives rise to the two veinous trunks of the upper arm. The disposition of veins at the fold of the arm has been compared to a capital M.

There are two main veins in the upper arm. On the outside, the cephalic vein rises along the anterior border of biceps and the deltoideopectoral furrow, remaining subcutaneous until it reaches the level of the subclavicular depression. On the inside of the arm, the basilic vein rises up and disappears into the deep veins of the arm pit.

VEINS OF THE LOWER LIMB (PLATE 73, FIGURE 2 and 3)

Here two great veinous trunks are visible throughout the length of the leg, medially the *great saphenous vein* can be seen and, at the posterior part of the leg, the *small saphenous vein.*

As on the hand, the collateral veins of the toes join a vein disposed in a more or less transverse fashion, the *dorsal arcade* (dorsal veinous arch). On the inside, this vein passes along the internal border of the foot where it becomes the *medial marginal vein,* and forms the origin of the great saphenous vein. The *great saphenous vein* rises along the medial surface of the lower leg, crossing obliquely the swelling of soleus and the border of the medial head of gastrocnemius. It moves behind the medial condyles of the knee and reaches, following the plane of the sartorius, the internal and superior part of the thigh where it disappears among the deeper veins. At this level it is joined by the integument of the abdomen and the external veins which rise from the genital organs.

The *small saphenous vein* has two origins on each side of the foot. The internal branch comes from the medial border of the foot and the heel. The external branch comes from the external border and dorsum of the foot. Often some of the ramifications of this vein cut transversely across the external malleolus. The two branches converge and join each other at an acute angle on the Achilles tendon. The small saphenous vein then rises directly along the median line until it reaches the back of the knee, where it plunges into the deeper veins.

It must be added that all the principal venous trunks in the upper and lower limbs communicate between themselves by a network of branches. The larger divisions of this network are sometimes apparent. They are often accompanied by smaller branches which run in a parallel direction. At other times, instead of forming a single trunk, the divisions divide themselves into several branches which later unite.

13. Skin and Fatty Tissues

Although the skin and the fatty layer beneath it are really two separate subjects, because of their intimate union I shall treat the two subjects as one in this chapter. But, faithful to the method of moving from the deeper parts to the surface, I shall first describe the fatty tissue.

FATTY TISSUE

Fatty tissue may be found in the organism in two different places. First, it is disposed in a layer between the skin and the general enveloping aponeurosis; this is called the *panniculus adiposus*. Second, it is distributed in the spaces between the deep organs; this is the fatty tissue of interposition.

PANNICULUS ADIPOSUS

However important a role the muscles play in the exterior conformation of the body, we must not forget that between the surface of the muscles and the exterior form of the nude there is a difference, a greater difference, perhaps, than might be expected.

In reality, the skin does not lie directly over the muscles and their aponeurotic envelope. In other words, it is not enough to just cover the flayed form with skin, here and there smoothing out the rough places and not changing anything essential. There is, between the skin and the muscles, an additional layer of special tissue, the panniculus adiposus. Its presence in each region completely modifies the shape of the flayed figure. This is not only true in very plump subjects, whose forms drown in a sea of fat, but it is also true of young, robust, healthy subjects whose bodies seem devoid of superfluous fat.

This layer of fatty cells is throughout most of its extent actually as thick as the skin and adheres closely to it. When the skin is removed it is this layer which slides upon the aponeurosis and the external integument does not attach itself to this subcutaneous fatty layer.

Moreover, the panniculus adiposus varies considerably in thickness in different regions of the body, and on different individuals. It exists on all subjects, even those who are very thin, except in extreme and morbid cases of emaciation. It is important to understand just how much of an influence its greater or lesser development has on the external forms. The forms of the body are most masked in those subjects whose panniculus adiposus is most developed, whereas the exterior forms that seem withered, hard, or sharp appear in subjects who have a very thin fatty layer. Among women and children it is the abundance of the panniculus adiposus which causes the generally rounded form and often almost completely effaces the muscular prominences.

The variations which occur in the fatty layer of different regions in one individual are even more interesting from the morphological point of view. From measurements made on a score of subjects of whom three fourths belonged to the lean category, and of whom none were very fat, we obtained the following results:

The panniculus adiposus is lacking in the skin of the nose, the eyelids, etc. It is very thin at the back of the hand, the foot, and at the level of the clavicles (1 to 2 millimeters). It is thickest on the torso where it is distributed most unequally. The layer of fat is thickest on the buttocks (1 centimeter on the average, and up to 3 centimeters); next in thickness is the fat on the posterior part of the flank (8 millimeters on the average, and up to 1 centimeter and a half); and next is the region of the breast, at its inferior part, around the nipple (6 millimeters on the average, and up to 1 centimeter and a half). At the abdomen the fat is more abundant above than below the navel (6 millimeters and a half on the average above, and 4 millimeters below). Beneath the breast it is less abundant (on the average 3 or 4 millimeters). At the neck its thickest part is in the back, at the nape; this is almost double that which lies in the front at the level of Adam's apple. On the limbs, the fat diminishes in thickness from above to below. On the arms it is much thicker in the back than in front. On the lower limb, there are notable differences in the disposition of the fat; it becomes thickest in the middle going from above to below.

It is evident from these measurements that the panniculus adiposus plays a considerable part on the external form. It is not just a veil which attenuates the abrupt outlines of the flayed figure, it also directly influences the forms of the body. In fact it should be given the same status as the muscles and the bones with respect to its effect on exterior from. The panniculus adiposus accentuates certain prominences which already exist on the flayed figure, and at times it creates its own prominences. There are certain regions of the body where, through its persistence and abundance even in thin subjects, it acquires a sort of autonomy. Without anticipating the detailed descriptions of the different regions of the body which I shall give later, I should like to point out here certain regions where the fatty tissue plays a special morphological role.

First, let us consider the region of the buttocks. The fat is mostly accumulated around the center and the inferior border of this region and accounts for most of the volume especially in women. The panniculus adiposus gives the buttocks the firmness and elasticity that can be seen in young subjects. Its exaggerated development constitutes the steatopygia of the female Bushmen, which can also be seen, if I may say so, in different degrees of attenuation among European females(Figure 4).

Equally related to steatopygia is the fatty accumulation at the superior and external part of the thigh (Figure 5). The body of the female Bushman shows this at its maximum development. There is almost always a trace of this among European women, to a very variable degree, it is true (Figures 6 and 7).

On the back part of the flanks, above the small of the back there is always a sort of fatty cushion which fills an area which on the flayed figure is a void left between the

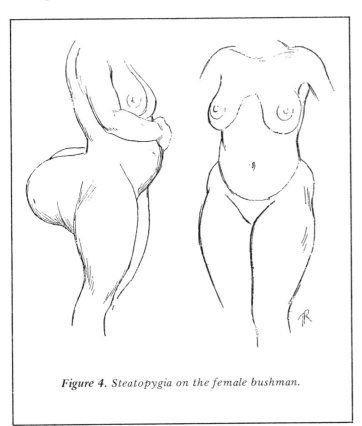

Figure 4. Steatopygia on the female bushman.

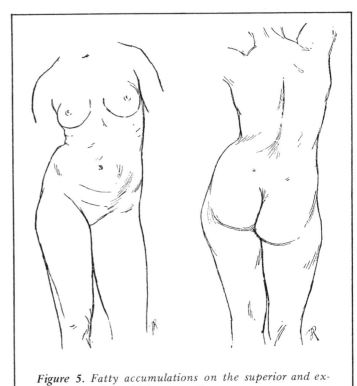

Figure 5. Fatty accumulations on the superior and exterior part of the thigh on two European women.

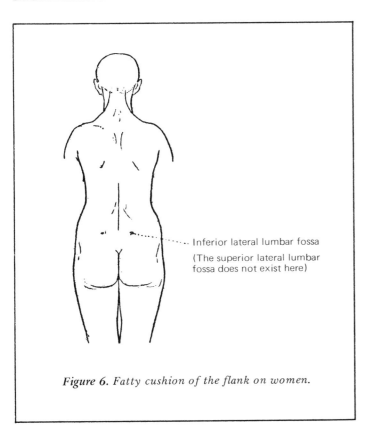

Inferior lateral lumbar fossa

(The superior lateral lumbar fossa does not exist here)

Figure 6. Fatty cushion of the flank on women.

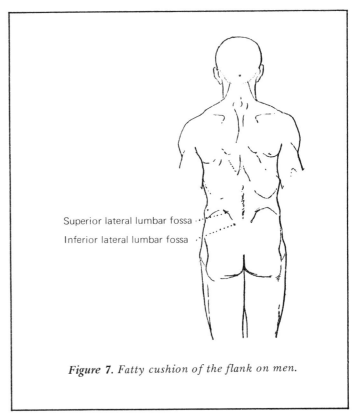

Superior lateral lumbar fossa

Inferior lateral lumbar fossa

Figure 7. Fatty cushion of the flank on men.

common mass of the spinal muscles and the posterior border of obliquus externus abdominis. This fatty cushion makes a most distinct swelling. As far as I know, its morphological role has not yet been pointed out. It has the effect of prolonging the surface of the flank in the back, and it creeps, diminishing, around to the side and front. The result of this is that the relief formed by the flank is muscular in front and fattish in the back. (This can be clearly seen in antique statues.) Among subjects who are just starting to put on weight, this cushion of fat all at once takes on a remarkable development. Among women it blends with the fatty tissue of the buttock behind the flank to such an extent that it seems to rise as far as the ribs which should limit the superior edge of the flank and mark the waist. The result of this disposition is that the furrow of the haunch, which can be seen so clearly in men, disappears almost completely in the back in women. However, this furrow remains visible in women along the whole anterior part, despite the enlargement of the iliac crest.

I should also mention the fatty tissue of the region of the chest. In women, besides the presence of the mammary glands, it is the fat which determines the volume and form of the breasts. Voluminous breasts are formed, above all, of fat; doctors know well that large breasts are but a poor indication of the quality of a wet nurse.

It is interesting to note that men only have rudimentary mammary glands but the fatty tissue still plays an important role in the morphology of the region. It augments the swelling of all the inferior part of the chest above the submammillary furrow. It is important to know that the relief in this region is due not only to the fleshy fibers of pectoralis major, but also to the fatty tissue. Even among the very lean, it plays a certain part. A considerable furrow can often be seen in subjects who are not at all muscular. This constitutes a favored place for the accumulation of fat on people who are just starting to put on weight.

Finally, let me bring to your attention the fatty tissue of the palm of the hand and especially that of the sole of the foot. On the sole of the foot there is a special disposition of cells in the elastic conjunctive tissue which confines the fatty tissue. This forms a sort of elastic cushion that adapts itself exactly to the surface of objects and withstands different pressures.

FATTY TISSUE OF INTERPOSITION

The fatty tissue of interposition is that tissue which is situated under the general enveloping aponeurosis. It is much less important than panniculus adiposus and, even in fat subjects, does not change their proportions. It fills the muscular interstices, accompanies the vessels, and fills the voids around the ligaments and the muscular insertions, etc.

From the point of view of exterior form, it has an effect in several regions. It fills the popliteal space and the armpit. Below the patella, it forms two lateral reliefs, a most important thing to know in understanding the morphology of the knee. Finally, on the face, it fills the void on the skeleton below the cheekbones.

SKIN

The skin, or external integument, is a solid, resistant, and elastic membranous envelope which stretches over the surface of the body. It is continuous and moves without interruption into the mucous membrane at the natural orifices.

The thickness of the skin varies, according to different regions. On most of the body, it is about 1 millimeter thick. It becomes about 3 millimeters thick on the palm of the hand, the sole of the foot, and toward the upper part of the back and the nape of the neck.

The skin is elastic and, in its normal state, it will spring back to the body if it is stretched. This is true of the skin even in cases of emaciation, if the emaciation is accompanied at the same time, as in old age, by a dimunition of the skin's elasticity, the contraction of the skin will produce wrinkles.

Along most of its extent, the skin, together with the panniculus adiposus, is united to the parts it covers only by an extremely loose cellular tissue. Therefore, it can glide over the deeper parts of the body and undergo considerable displacement under the influence of outside action or simply because of the movement of various parts of the body. But the mobility of the skin is not the same in all regions. On the limbs, it is generally less mobile on the side of the flexion than on the side of extension; it is less mobile on the inside of the limbs than the outside.

The skin adheres completely to the body on the scalp, on the nape of the neck, on the palms of the hands, and on the soles of the feet. On the rest of the body there are a few places where the skin adheres more closely and causes certain wrinkles and depressions which are remarkable for their consistency.

In this category let me point out the depression of the skin on the anterior and the posterior median lines of the trunk; the depression around the dorsal spine of the seventh cervical vertebra; the depression at the level of the inferior tendon of the deltoid; etc.

The following wrinkles are among those due to the close adherence of the skin to the deeper parts. The flexion wrinkles at the wrist; the flexion wrinkles of the hand and the fingers; the fold of the groin; the wrinkle of the armpit; and the fold of the buttocks. I shall not go into details here as all these parts of the skin will be studied with the regions to which they belong.

Other wrinkles in regions where the skin does not adhere to the deeper parts are just as constant. For example, the extensor wrinkles of the fingers; the wrinkle of the bend of the arm; the wrinkle at the back of the knee; the flexion folds of the trunk; the semicircular wrinkle of the abdomen; and the flexion wrinkles of the anterior region of the neck (the necklace of Venus).

All the wrinkles just mentioned are due to articular displacements; they could be called *wrinkles of locomotion.*

Other cutaneous wrinkles, especially on the face, are produced by muscular contraction. These are *skin wrinkles.* They are caused because the muscles of the face are, in fact, skin muscles. Attached to the skeleton by one of their extremities, they are inserted into the skin at their other extremity. When they draw the skin back, they create wrinkles on it perpendicular to the direction of

their fibers. By the changes they make on the character of the face, they contribute to the expression of different emotions.

Finally, we must mention the wrinkles of old age. They appear on all parts of the body. They result from the fact that the skin, having lost its elasticity, cannot contract itself enough to cover the tissues which have become atrophied by the progress of age. It doubles upon itself, therefore, and forms folds which are bordered by wrinkles of the most varied directions.

Besides the wrinkles which we have just studied, and which disappear when the skin is detached from its subjacent parts, there are others which are dependent upon the structure of the skin itself. First, there are the papillary wrinkles of the sole of the foot, and of the palm of the hand. Other parts of the skin, when viewed through a magnifying glass, show a multitude of small eminences separated by lozenge shaped wrinkles. These make the skin look like the rough grainy surface of an orange. There are also the little rounded swellings at the base of the hairs that become more prominent under the influence of strong emotion, and constitute the phenomena known as goose pimples.

It is this irregularity of the surface that gives the skin its matte quality. It is only when it is stretched that it becomes smooth and shiny.

The skin itself is composed of two superimposed layers. The epidermis, the most superficial layer, is very thin and does not have nerves or vessels. This layer adheres closely, and molds itself exactly, to the surface of the deeper dermis where there are small elevations caused by the nerves and the vessels. The sudoriferous and sebaceous glands open at the surface of the skin in microscopic orifices.

The color of the skin varies according to races, individuals, the different parts of the body and also with age. But on such a subject I have little to teach to artists.

Part Two
MORPHOLOGY

We have now reached a point of culmination in this work. All that preceded has been but a preparation for what is to follow. Now, we shall first explore each separate part of the body at rest in the attitude chosen for study. Then I shall point out the changes that occur in these forms during various specific movements. This study of exterior forms in action will be accompanied by information on the mechanism of the joints involved and of the musculature brought into play.

14. Exterior Forms of the Head and Neck

In this chapter I shall not go into the many different developments of the exterior forms on the head. I do not want to stray from the original plan of this book which was to discuss anatomy exclusively and its relation to the exterior form. For this reason I will not discuss the infinite morphological varieties that occur in individuals, as well as the differences which distinguish races. Nor shall I discuss the numerous expressions of the face, in movement or in repose. All these interesting issues deserve to be treated separately, and this is not the place. Moreover, the essential quality of the face is not, like the rest of the body, masked by the effects of certain climates or by social conventions. In fact, the overall problem of the face may be overcome in an instant by the penetrating observation of an artist. It is here, therefore, that personal observation must supercede scientific data, just as, in earlier civilizations, day by day observation of the nude athlete in a gymnasium supplied all the information needed for anatomical study.

At the superior and posterior part of the head, the oval shape of the cranium reveals its form under the hair, although the hair masks its details. On bald heads the marks of the diverse sutures which traverse the surface of the cranium may be observed (see Plate 2).

The whole anterior portion of the head makes up the face, which looks toward the front. Its summit, formed by the forehead, belongs to the cranium.

The head rests on the neck and projects beyond it, unequally, on all sides. The greatest projection is in front, so much so that, at the level of the chin, there is a small area below the head which is free (submaxillary region). This area is crescent shaped and its concavity embraces the superior part of the neck in its anterior half. Projecting from the median line, this region is hollowed out laterally into two depressions; these are extremely distinct in thin subjects (submaxillary depressions) (Gerdy). Although from the point of view of morphology I do not think this region should be separated from the head, anatomically it is part of the neck, and the reader will find the anatomical details concerning it in the chapter on the anatomy of the neck. It will be seen that the mylohyoideus muscle is inserted on the internal surface of the maxillary, well above its lower border. The submaxillary gland does not completely fill the space left void between the muscle and the bone and this results in the lateral depression I have just described.

In the description of the face, I shall study in succession the forehead, the eyes, the nose, the mouth, and the chin.

FOREHEAD

The forehead is delimited above by the hair, or by the line of its implantation when it has disappeared. On the sides, it is limited by the temples, and at its lower part, it is limited by the bridge of the nose and the eyebrows.

The form of the forehead is divided into two planes, joined at a more or less obtuse angle at the level of the frontal eminences. The forehead generally reproduces almost exactly the form of the frontal bone. However, if the lateral frontal eminences of the skeleton show clearly beneath the skin, the nasal eminence, in certain subjects, lies at the bottom of a depression caused by the lateral projection of the eyebrows. The skin of the forehead is furrowed by wrinkles which play a large part in the expression of emotions.

The superciliary arch should not be confused with the orbital arch. Although superimposed on the inside, they become separated on the outside in certain individuals. The reason for this is that the superciliary arch is directed obliquely upward and out, while the orbital arch, as we have seen in the skeleton, is directed outward and down.

EYE

The eyeball is lodged in the interior of the orbit and only its anterior segment, together with the muscular apparatus that moves it, shows on the exterior. It is framed by the eyelids and inserted into the quadrilateral bony frame which forms the circumference of the orbit. This part of the skeleton makes itself felt all around the eye and plays an essential role in the exterior form of the whole region. The superior border of the orbit is the most prominent; it belongs to the forehead and supports the eyebrow. The lower border, formed by the corresponding borders of the zygomatic and the maxillary bones, is depressed on the outside. The internal side blends with the lateral plane of the nose. The external border turns back to expose the eye which, less sheltered on this side, appears in full view on the profile.

It should be remembered in fact that on the skeleton the orbit does not open directly to the front, and that its base lies within a vertical plane which is inclined slightly downward and at the same time turns strongly to the outside. This last direction, to the outside, is followed to some extent by the transverse axis of the eye (meaning the straight line that passes through the two commissures of the eyelids). The internal angle of the eye, therefore, is very slightly in front of the external angle of the eye. The

transverse axis of the eye does not usually appear to be completely horizontal—it is usually raised a little on the outside. This disposition of the eyes, when exaggerated, constitutes one of the characteristics of the yellow races.

The eyeball, as I have said, only appears partially between the buttonhole created by the eyelids. When the eye shuts, the two free borders of the eyelids touch. The greatest part of the closing motion is performed by the superior lid which descends in front of the eyeball, molding itself over its form; the lower lid only rises very slightly. The surface of the upper lid is marked by two wrinkles which follow, more or less, the same curve as that of the free border. When the upper eyelid is lifted, it disappears under a fold of skin and leaves only a border of skin visible on the outside. This border varies in size according to the individual, and it is generally larger at the middle, above the pupils, than at the edges of the eyes at either side of the commissures. On the lower lid there are several light wrinkles which start at the internal angle of the eye and run obliquely below and to the outside.

The free borders of the eyelids are quite different from each other. The eyelashes on the upper border are longer than those on the lower border. Above, the down plane of the upper border disappears under the shadow of the lids; below, on the contrary, the upper plane of the lower border is inclined to the front and often the light falls on it in such a way that it seems like a luminous line between the eyeball and the dark line formed by its eyelashes. Finally, the border of the upper lid describes an arc which is much more extreme than that of the lower border.

Above the upper lid there is a depression which varies in depth, although it is always deeper on the inside than on the outside. This depression separates the eyelid from the prominence formed at the supraorbital margin. Below, the lower lid is separated from the inferior border of the orbit by the so called tear bag.

The two angles of the eye, whose direction and relative position we have described above, are also very different one from the other. The internal angle is marked by a sort of long indentation and at the interior of this there is a small pinkish mass, the *caruncula lacrimalis*. From this angle a small, elongated prominence departs and moves within and slightly upwards; it is the tendon of the orbicularis oculi muscle and it reflects light strongly. The external angle of the eye is marked by a wrinkle that travels down and to the outside; it appears to prolong the free border of the superior lid.

We still have to examine that part of the eyeball which is visible between the lids. At the center there is a segment of a sphere; it is transparent as glass, and its curve forms a prominence analogous to the crystal of a watch. This is the *cornea*. It is set within a white membrane which coats all the rest of the eyeball and is called the *sclera*. The projecting form of the cornea is clearly visible under the upper lid when the eyes are closed.

Only a small portion of the sclera can be seen because it is covered by a thin yellowish-white membrane called the *conjunctiva*. This membrane travels over the eye under the eyelids and reaches to the limits of the cornea. The white of the eye is more or less pure. Its whiteness depends on the conjunctiva which is sown with small blood vessels, more or less injected with blood. It is bluish-white, as it is in children, when the sclera is thin and the conjunctiva is less vascular. This allows the black tint of the internal membrane of the eye to show through and contributes to the bluish color.

The cornea covers the colored iris and at the center of the iris there is a circular aperture called the pupil. The pupil appears to be dark because it opens into the eyeball, the interior of which is covered with a dark membrane, except among albinos.

NOSE

The nose, in its most superior part, directly continues down from the forehead. A hollow usually marks the root of the nose, although at times the transition on the profile is a straight line. The latter form was adopted by the sculptors of ancient Greece.

The base of the nose is free and turned downward; it is pierced by two openings separated by a medial partition which forms the nostrils. The openings swell on the sides and produce the *wings of the nose*; they also possess a anterior prominence (*lobes of the nose*).

The wings of the nose are circumscribed, above and in back, by a curvilinear wrinkle which separates them from the rest of the nose and the cheeks. The nostrils open below and also to the outside, which means that the medial partition descends lower than the inferior borders of the nostrils. This is why the opening of the nostril is apparent in profile.

The lobes are sometimes completely round, and sometimes they reveal the various planes which are created by the shapes of the cartilage with which they are partly constructed. It is not unusual therefore, on a lean subject, to see the end of the nose divided in two swellings, separated by a slight vertical groove. This groove is formed by the two cartilages which partly surround the openings of the nostrils on the insides. The line of the nose on the profile, which is usually either straight, convex, or concave, is at other times marked by a light break at the point where the nasal bones meet the cartilages.

MOUTH

The mouth is encircled by the two lips which lie on the convex projection of the dental arches. The meeting of the teeth above with those below maintains the height of the lips; thus, when a person loses his teeth, which often happens in old age, the height of the lips diminishes and at the same time they become gathered within the mouth.

The only teeth which actually meet together are the molars in the back. The teeth in front cross over each other like the two blades of a pair of scissors, the upper teeth descending in front of, and circumscribing, the lower teeth. When the mouth is closed, the upper and lower teeth contact each other in back, and cross each other in front. The interstice of the lips, when the lips are closed without effort, corresponds to about the middle part of the front upper teeth.

The red edges of the two lips have a sinuous form which is well known. They are composed of mucous membrane, and the place where they meet the skin is marked by a small lighter band which defines their shape. The commissures are protected on the outside by an oblique relief.

CHIN

The chin terminates the lower part of the face. Its protuberance varies considerably, depending on the individual. It is uniformly rounded on some, and marked by a median depression on others. The protuberance of the chin is due, on one hand, to the body of the inferior maxillary on which the chin rests, and on the other hand, to a dense accumulation of fatty tissue which doubles the thickness of the skin. This fatty tissue can, in certain individuals, considerably modify the forms of the skeleton and may well slightly change the proportions of the face, mostly from the point of view of height.

The chin is rounded below and it encroaches slightly upon the inferior surface of the jaw. It is separated from the submaxillary region by a transverse furrow of which the depth varies, but which is always visible. In fact, it is never effaced, regardless of the amount of the fat; it can even be seen on faces surcharged with fat. This line always neatly delineates the chin and it is absolutely distinct from the other transverse reliefs that develop at the expense of the inferior region of the face. These other reliefs are commonly known as the second or third chin.

On the sides of the head we will study the temples, the cheeks, and the ears.

TEMPLE

The temples prolong the forehead to the side. They correspond to the temporal fossae on the skeleton, but the excavated form of the bone can be seen only in exceptional cases and in subjects who are very thin. In fact, on the living, the temporal depression is filled by a powerful muscle which forms a considerable projection, especially when the lower jaw moves. In front, the temple blends into the forehead and the summit of the head. Sometimes there is a curved line separating these forms running from the superior insertions of the temporal muscle to the front of the external orbital process. At this place, and below, the limits of the temple are always quite distinct. In fact, the temple is separated from the eye by the relief of the external border of the orbit, the form of which, though depressed, can always be felt. At its lower part the temple is bordered by the transverse relief of the projection of the zygomatic arch which also serves as the superior limit of the cheek.

CHEEK

The cheek extends from the nose to the opening of the ear, and from the eyes and temples to the chin and the region beneath the chin; it blends completely into these different parts of the face. The cheekbone, or zygomatic bone, unites with the maxillary bone. On the line of their union the most prominent point of the cheek is situated, slightly below and sometimes a little to the outside of the orbit.

In front of this point the cheek rises obliquely underneath the eye to join the lateral surface of the nose. It is sometimes separated from the nose by a large shallow groove. In the back it becomes slightly depressed as it moves to the front of the ear and to the angle of the jaw where it meets the quadrilateral surface of the masseter muscle. The cheek is limited in front both by the lateral plane of the nose and the curvilinear line which separates it from the wing of the nostril and by another oblique line running downward and to the outside (*nasolabial fold*) which separates the cheek from the upper lip and the skin above. In back, the cheek touches the ear. Below, it runs into the submaxillary region and blends more or less with it, depending on the development of the subject's fat and the degree to which the inferior maxilla projects. Above, the cheek joins the temple from which it is separated by the transverse prominence of the zygomatic arch. This relief, very visible in thin subjects, merges into the cheekbone in front. In the back, the prominence of the zygomatic arch terminates at the base of the tragus of the ear. However, it is separated from the ear by a small hollow and by the slight prominence of the condyle of the inferior maxillary. When the mouth is open, this prominence moves to the front and below, leaving a marked cavity in its former place.

EAR

The funnel of the ear lies on the limits of the face, cranium, and neck. Altogether it is ovoid in form and its thickest extremity faces above, a little to the back and a little more to the outside. The funnel of the ear adheres to the surface of the head along about a third of its anterior part. The rest has an internal surface which generally lies about a centimeter and a half away from the cranium, although this distance is greater in certain individuals.

The ear resembles the flattened mouth of a trumpet of which the inner side is folded several times upon itself (Figure 8). It presents a number of individual forms. These forms vary according to the individual but in general they may be described as follows. At the center, there is a kind of anti-chamber for the external auditory passage which it introduces; this is the *concha*. At the periphery, a fold borders all the most superior and posterior part of the funnel; this is the *helix*. At its anterior extremity the helix rises from the bottom of the concha, above the external auditory passage. The posterior extremity of the helix terminates below in a fleshy ovoid mass (the *lobe*), of which the two surfaces are free. The lobe is attached to the cheek by the most elevated part of its anterior border.

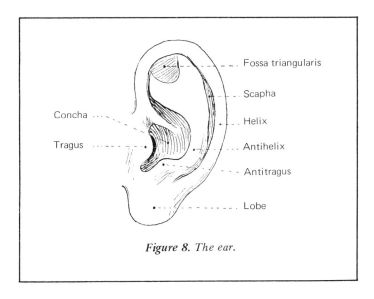

Figure 8. The ear.

The cavity of the concha is bordered in back by the *antihelix* which terminates above in two branches with a depression (*fossa triangularis*) between them. The helix and the antihelix are often separated by an elongated depression (the *scapha*). Finally, two projections, one below and one in front, restrict the entrance to the concha making it into a kind of opening which is extremely characteristic. In front there is the *tragus*, which shelters the entrance of the auditory passage, and in back and below, the *antitragus*, which prolongs the antihelix.

Beneath the ear, and behind the jaw, there is the *subauricular depression*, limited in the back by the mastoid process and by the anterior border of the sternocleidomastoideus muscle. The mastoid process is separated from the ear by a deep groove which limits the part of the ear which adheres there and leads it below to the subauricular fossa.

EXTERIOR FORM OF THE NECK

The neck is that part of the body which supports the head and unites it with the trunk.

Its limits are as follows. From the surface of the head, the neck starts, in the back, at the level of a curved horizontal line from one mastoid process to the other. This line follows the direction of the superior nuchal line of the occipital. In front, the neck is separated from the face by a line which, also running between the mastoid processes, descends below the lower jaw.

From the surface of the trunk, the limits of the neck which are extremely precise in front, are more indefinite in the back. In front, the neck ends naturally at the projections of the clavicles. On the sides, it stretches out to reach as far as the external extremities of the clavicles. In back, it is limited by a totally artificial line which runs from the points of the shoulders to the dorsal spine of the seventh cervical vertebra.

The cervical column, which forms the skeleton of the neck and maintains its proportions, is susceptible, depending on the individual, to only very slight changes in height. We have seen that the vertebral column as a whole is the part of the skeleton that presents the most fixed dimensions, and in fact any increase in height of the figure is due mostly to the development of the inferior members.

Therefore, the length of the neck, which seems so variable, depends almost always on its inferior limit, which is formed by the bony scapuloclavicular girdle. The long neck, in fact, is accompanied by low shoulders; the short neck, on the other hand, is formed by high shoulders. In the first case, the clavicle runs in an oblique line downward and to the outside; in the second case, it runs obliquely upward toward the outside.

I shall now describe successively the anterior region of the neck, or the throat; the anterolateral surface of the sternomastoid; the posterior region of the neck, or nape; and the supraclavicular hollow.

ANTERIOR REGION OF THE NECK AND THE THROAT (PLATE 74 AND 77)

On the front view, the anterior borders of the sternocleidomastoideus muscle (on the inside of which there is a slight linear depression) limit a triangular space of which the narrow point is at the sternum and the base at the mastoid processes. The superior part of this triangle is occupied by the inferior part of the face and the projection of the lower jaw. The angle of the jaw is a short distance in front of the anterior border of the sternocleidomastoideus. In its superior part this muscle is separated from the lower jaw by a depression situated below the ear, which we have discussed above (subauricular depression).

Below the chin, all the space included between the two sternocleidomastoideus muscles is filled by a rounded surface. This surface is separated from the submaxillary region above by a curved groove (hyoid depression), and ends below in an extremely narrow depression at the pit of the neck.

This surface is marked by the irregularities of the following forms. Above and on the median line, there is an angular projection formed by the thyroid cartilage of the larynx. Commonly called the *Adam's apple*, this projection varies considerably depending on the individual. The hyoid bone, situated above the larynx, at the level of the angle created by the meeting of the submaxillary region and the neck, cannot be seen except in extreme extension of the neck. However, there is a depression on each side of the hyoid bone at the center of which one can sense the projection of the greater cornu of the hyoid. Gerdy calls this the *hyoid fossa*. The depression is an equal distance from the body of the hyoid bone and the angle of the lower jaw. It becomes obvious in forced extension.

Below the Adam's apple the neck becomes rounder and owes its form not only to the thyroid gland, but also to the small flat muscles of the region.

Often, the thyroid gland, always more developed in women than in men, raises the interior extremity of sternocleidomastoideus and creates a marked enlargement at this point. Below the thyroid gland, the skin is depressed between the insertions of two inferior tendons of the sternocleidomastoideus into the manubrium and forms the hollow of the pit of the neck.

SURFACE OF THE STERNOCLEIDOMASTOIDEUS (PLATE 76 AND 79)

The sternocleidomastoideus is subcutaneous throughout its whole extent; the external surface betrays the same forms as the muscle itself (see page 57).

Above, this muscle is inserted into the mastoid process and the superior nuchal line of the occipital. From there it descends to the front, turning upon itself as it approaches the median line. It divides, at its inferior insertion, into two fasciae; the internal one rounded, and attached to the sternum; the exterior one flat, and attached to the clavicle. These two fasciae leave a triangular space between them which becomes a small depression (sternoclavicular fossa) on the outside.

The surface of sternomastoideus is crossed obliquely by the anterior jugular vein.

POSTERIOR REGION OF THE NECK (PLATE 75 AND 76)

On the median line of the posterior surface of the body there is, at the junction of the neck and the cranium, a depression which corresponds to the external occipital protuberance on the skeleton. It is usually hidden by the

hair. A depressed line, caused by the meeting of two rounded planes, descends from this point toward a slightly depressed oval surface. In the middle of this oval depression there is a protuberance caused by the dorsal spine of the seventh cervical vertebra.

On the lateral sides of the neck there are two muscular reliefs which correspond to the superior part of the trapezius muscle. The trapezius is entirely subcutaneous, like the sternocleidomastoideus. It is a very flat muscle, moulding itself exactly on the deep parts. These deeper parts play a considerable role in the forms of the region. In other words, the two elongated longitudinal masses on each side of the neck are due to the deep muscles covered by splenius capitis and finally by the superior extremity of the trapezius. The form of the nape is created by the insertions of the deep muscles into the occipital bone. The depressed surface along the median line is due to the meeting of the rounded planes of these muscular masses and, above all, to the union of the two splenius muscles, the insertions of which meet each other on the median line. However, the oval depression, with the protuberance of the seventh cervical at its center, corresponds to the oval form of the aponeurosis of the trapezius.

Below and on the outside, the trapezius is raised, in the region above its clavicular insertion, both by the deeper muscles (*scalenus muscles*) and the *levator scapulae*. This produces that enlargement of the neck below and behind which on the front view can be seen outlined by two curved outlines descending from the middle of the neck towards the points of the shoulders. Also, I should point out that in this region there is a considerable, though varying, thickening of the trapezius, and in muscular subjects this causes certain accentuations of form (see page 56).

The thin anterior edge of the trapezius shows through the skin. Above, it allows the insertion of the muscle to be traced as far as the occipital, where it almost touches the posterior border of the sternocleidomastoideus. Towards the outside, this edge descends to the clavicle, to the point of the union of the external third of the clavicle with its internal two thirds.

POSTERIOR TRIANGLE OF THE NECK
(PLATE 77 and THE FOLLOWING)

Between the posterior border of the sternocleidomastoideus and the internal border of the trapezius, there is an elongated space. The superior part of this space has a rounded surface; the inferior part, which is larger and descends to the clavicle, is depressed. The whole space is called the posterior triangle of the neck.

Above, the deep muscles of the neck completely fill the area between the sternocleidomastoideus and the trapezius. However, as these two muscles run toward their insertion at the clavicle, which moves away from the thoracic cage, they separate from the deeper muscles and occasionally alter the size of the depression itself. This depression is much more accentuated on the outside than on the inside, and more accentuated on the side of the trapezius than on the side of the sternocleidomastoideus.

The posterior triangle of the neck corresponds to the middle part of the clavicle which borders its lower portion. The hollow varies depending on the individual. It

is pronounced in lean models, less so in fatter ones. The position of the shoulders also influences its degree of accentuation. It is deep when the shoulders are high and almost flat when they slope down. At its internal angle the anterior jugular vein rises and moves toward its insertion crossing the sternocleidomastoideus obliquely.

MOVEMENTS OF THE HEAD AND THE NECK

We have seen in the chapter on anatomy that the movements of the head on the vertebral column take place in the articulations of the first two cervical vertebrae (atlas and axis), and between them and the occipital bone (see Plate 24 and Plate 4). These movements are of three sorts. First, movements of rotation, which take place in the articulation of the atlas and axis; second, movements of flexion and extension; and third, movements of lateral inclination. The last two kinds of movement take place in the articulation between the atlas and the occipital.

We have seen, elsewhere, how the cervical column is the most movable part of the whole backbone, and how it is able to execute movements of three types: rotation, flexion and extension, and lateral inclination. I should point out that these movements are the same as those of the head.

I have already explained the mechanism of the diverse articulations described above. The movements of the head are rarely isolated from those of the neck; they work together as accomplices, almost always acting in the same way. Therefore, in the study which follows, we shall not separate the movements of the head and the neck.

ARTICULAR MECHANISM

In its movements around the transverse axis (flexion and extension), the head, on the condyles of the occipital bone, rolls upon the superior articular surfaces of the lateral masses of the atlas. From the side view, in flexion, the inferior maxillary bone can be seen meeting the anterior convexity of the cervical column; in extension, the occipital bone is lowered in the back. This movement is more extended.

When the cervical column enters into the same movements of flexion and extension these movements become considerably amplified. The head not only rolls upon itself but undergoes, at the same time, a movement of translation in the anteroposterior plane. In flexion, the chin approaches the sternum which it touches in front, and, in extension, the back of the head comes within a few centimeters of the dorsal spine of the seventh cervical vertebra.

In flexion, the cervical column, which is convex in front, straightens out and may even curve in the opposite direction. This takes place in such a manner that the cervical column continues the curve of the dorsal region, the two regions thus forming a single curve inclined toward the same direction. In extension, on the contrary, the normal curve of the cervical column is accentuated. In the movement of rotation the head and neck are entirely interdependent. The rotation of one cannot take place without the rotation of the other, however little the movement may be. At the limit of rotation, from a front view of the trunk, one may see the profile of the face.

Lateral inclination is hardly ever an isolated movement. When it is performed for purposes of study, the movement is restricted and looks forced. Usually, lateral inclination is accompanied by a movement of rotation which lifts the face upward and turns it toward the opposite side.

We have seen the anatomical reasons for this in the special disposition of the articular surfaces of the region (see page 28).

MUSCULAR ACTION

The movements of the head on the spine are reinforced, in every sense, by the small deep muscles which surround the articular surfaces of the occipital, the atlas, and the axis. However, they do not act alone, and other more powerful muscles whose more superficial disposition influences the exterior form, are also brought into play.

If we now consider the muscles whose contraction influences the exterior form, we have *for flexion*: the suprahyoid and the infrahyoid muscles, the scalenus muscles, and the sternocleidomastoideus; *for extension*: the large muscles of the neck, the trapezius, the splenius, the semispinalis capitis and the levator scapulae; *for lateral inclination*: the trapezius, the splenius capitis, the semispinalis capitis, and the sternocleidomastoideus; *for rotation*: the splenius capitis, the sternocleidomastoideus, the trapezius, and the semispinalis capitis.

However, one need not conclude from the above list that, in any given movement, all the muscles enumerated necessarily enter forcefully into the action, or reveal themselves on the exterior form.

First of all, slight movements can be performed exclusively by the action of the small deep muscles. The effect of gravity should also be considered since it plays a most important part in muscular interaction. Thus, for example, when the head is thrown forward, the displaced center of gravity tends to push it in that direction. This movement, which amounts to the movement of flexion, is thus produced by the influence of gravity alone. To prevent the complete descent of the head in front, the contraction of the extensor muscles becomes absolutely necessary. This results in a seeming paradox: the contraction of the extensors in a movement of flexion.

In fact, a general law might be formulated as follows. When the displacement of a part of the body is produced by the influence of its own weight, the muscles that ordinarily produce this displacement become unnecessary; it is their antagonists which contract to counterbalance and regulate the action of gravity.

MODIFICATIONS OF EXTERIOR FORMS:
MOVEMENTS OF THE NECK (PLATE 87, FIGURE 2)

In the bending back of the neck into a forced position, the external occipital protuberance approaches within several centimeters of the seventh cervical vertebra and thus reduces the back of the neck to its shortest length.

At the same time, the anterior regions are extended and acquire their greatest dimensions in a vertical sense. The inframaxillary region tends to become a prolongation of the region beneath the hyoid, but the reentering angle which lies between these two areas is never completely erased. However, the hyoid depression becomes wider.

In this movement the mouth tends to open and at the same time the neck undergoes a lateral enlargement due to the displacement of the sternocleidomastoideus muscle.

The exterior forms become modified as follows. On the median line, the hyoid bone shows prominently at the bottom of the widened hyoid depression. On the sides, the hyoid fossae become hollowed out.

The angular form of the larynx projects under the skin and can be clearly seen. The superior border of the thyroid cartilage, with its anterior V-like angle, is also visible. Below the larynx the rounded form of the thyroid gland projects. The double prominence of the larynx and the thyroid gland shows great variety in form in different individuals.

The anterior border of the sternocleidomastoideus becomes clearly defined. The same is true of the sternal and clavicular attachments of the muscle and this augments the hollow of the pit of the neck.

The two spiral forms of sternocleidomastoideus muscle glide over the sides of the column of the neck while their posterior borders are lifted to the outside of the spinal attachments of the deep muscles. This causes the lateral enlargement of the neck which we have mentioned. The sternocleidomastoideus muscles, held within an aponeurotic covering which is attached by special fibers to the angle of the jaw, closely follow the curve of the neck. The posterior triangle is traversed obliquely by the cord of the omohyoideus.

During extension several strong cutaneous wrinkles, running transversely, appear at the nape of the neck.

Flexion (Plate 87, Figure 1). In flexion of the neck, the chin approaches the sternum and actually touches it in some individuals. The anterior regions of the neck disappear under transverse cutaneous wrinkles which are smaller and more numerous than those on the nape in extension. This is because of the difference in the thickness of the skin in the two regions.

The sternocleidomastoideus, pushed back by the angle of the jaw, forms a swelling in that area while the inferior extremities of the muscle disappear. The nape becomes rounded and elongated. The prominence of the dorsal spine of the seventh cervical vertebra is accentuated and surmounts the reliefs of the spinal processes of the first and second thoracic vertebrae.

On the sides, the distended anterior border of the trapezius can be seen, and the forms of the deep muscles become enlarged. The posterior triangle diminishes in height.

Rotation (Plate 88, Figure 1). If we examine the side of the neck which is most exposed, that is to say the part which is on the opposite side to that of the face, we will see that the oblique direction of the sternocleidomastoideus has become vertical. Its relief indicates the part which it plays in this movement. However, the relief is not due to an equal contraction in all the parts of the muscle. The relief created by the fleshy body is fusiform, and this shape is brought about mainly by the tendon of the muscle which projects strongly at the sternum, while the clavicular insertion almost disappears.

In front of the sternocleidomastoideus, the hyoid depression becomes hollowed out and it moves nearer to the angle of the jaw.

The posterior triangle tends to disappear. However, on the opposing side, that is to say the side towards which the face is turning, it becomes deeper. On this same side, the relaxed sternocleidomastoideus disappears under the wrinkles of the integument.

Lateral inclination (Plate 88, Figure 2). In this movement the ear is brought closer to the shoulder, without ever actually making contact with it (unless the shoulder is raised). In fact, the ear can be moved only within about four or five fingers' breadth of the shoulder.

On the side of the inclination, numerous cutaneous wrinkles are formed. On the other side, the integument is stretched. I should like to point out an extremely accentuated relief which has a cord-like form. It crosses the upper part of the posterior triangle, and it is due to the tension of the levator scapulae muscle. This cord becomes more and more apparent as the shoulder is lowered.

15. Exterior Forms of the Trunk

To make the description of the exterior forms of the trunk clear, I will divide each of these forms into several regions. On the whole, we shall follow the scheme adopted by Gerdy, with certain modifications for the sake of simplicity (Figure 9).

First, the trunk, or torso, may be divided into three large, natural segments determined by the skeleton: the thorax, which corresponds to the thoracic cage; the abdomen, which occupies all the space between the thoracic cage and the pelvis; and finally, the pelvis. Each

of these segments is subdivided in the following way. The thoracic segment comprises: in front, the chest, which itself includes the sternal region, the mammary region, and the inframammary region; in back, the back, which subdivides itself into the spinal region, the scapular region, and the infrascapular region (Figure 10). The abdominal segment includes: in front, the belly; on the sides, the flanks; and in back, the loins. Finally, the pelvic segment includes: in front, the pubic region, the groin or the inguinal surface; in back, the buttocks.

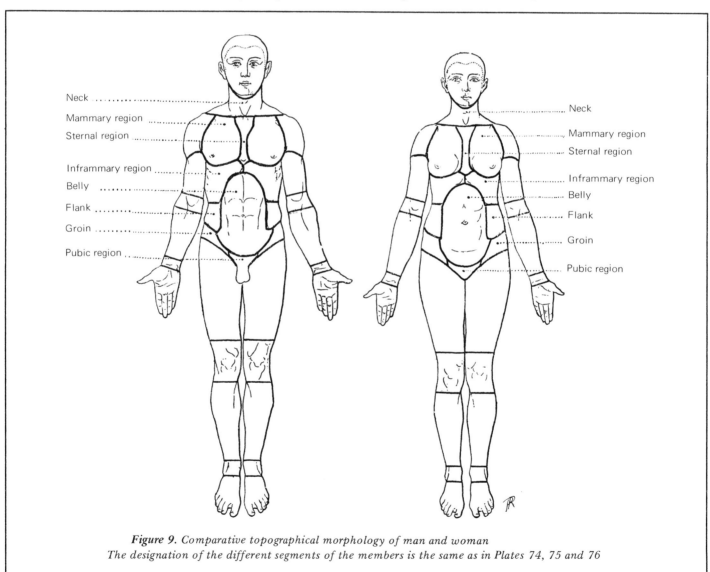

Figure 9. *Comparative topographical morphology of man and woman*
The designation of the different segments of the members is the same as in Plates 74, 75 and 76

CHEST

The chest occupies the whole anterior part of the thorax. It can be subdivided into several natural regions. These regions are: in the middle, the sternal; and on the sides, the mammary region and the inframammary region.

STERNAL REGION (PLATE 77)

Situated on the median line, the sternal region rests on the sternum bone. It stretches from the pit of the neck to the epigastric depression. It is bordered on the sides by the muscular relief of pectoralis major which makes the region into a sort of furrow. The depth of this furrow varies according to the development of the pectoralis major. It is more depressed along its inferior half as pectoralis major contains more fat in its lower part.

The sternal region has two distinct planes: a superior one, shorter and wider than the inferior, which corresponds to the manubrium; and a narrower inferior one which is composed of the body of the sternum or gladiolus. At their articulation these two pieces are marked by a transverse meeting of planes which is called the sternal angle.

At its inferior part the sternal furrow becomes enlarged and forms a triangular plane which is caused by the increasing distance between the muscular fibers at this level. This disposition of the fibers can be understood easily if one remembers that the insertion of pectoralis major on the sides of the sternum follows a curved, not a straight, line and that the convex curve of this line is towards the median line of the body.

Finally, because the xiphoid process is so deeply situated it causes a depression, called the epigastric depression.

This depression is bordered, above, by an arch-like ligament which unites the cartilages of the last ribs in front of the xiphoid process. On the sides of the depression, the costal cartilages themselves project. Below, the borders of the depression are more indefinite. They are formed by the spreading fibers of the superior extremity of the rectus abdominis muscle. The epigastric depression is maintained by the disposition of the muscular fibers which border it; therefore, its form varies with the variations in the volume of the muscles.

The inferior extremity of the xiphoid process curves to the front and, at times, causes a small eminence at the inferior part of the epigastric depression which can be clearly seen under the skin.

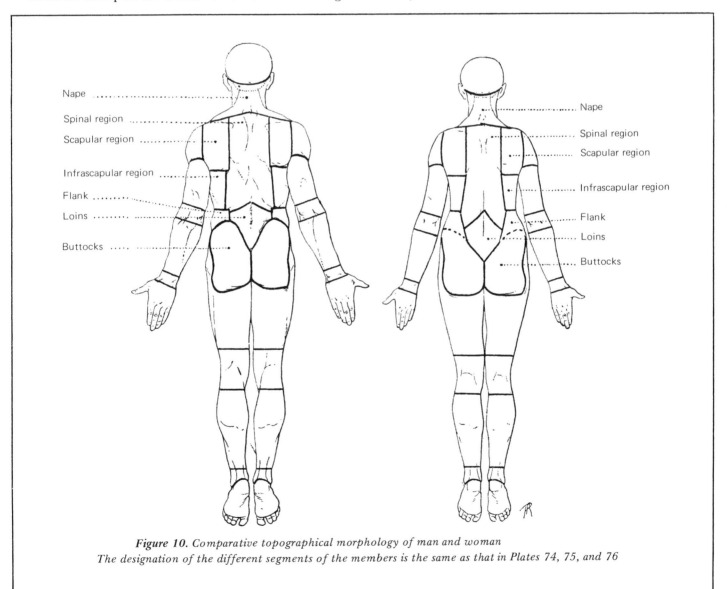

Figure 10. Comparative topographical morphology of man and woman
The designation of the different segments of the members is the same as that in Plates 74, 75, and 76

The mammary region is bordered on the inside by the sternal region which we have just studied. Its upper border is formed by the clavicle, and the region extends from there to a deep groove which forms its inferior border. On the outside, it touches the shoulder. This region corresponds exactly to the pectoralis major, although the fascia of this muscle extends somewhat below it.

Its outline is thus more or less the same as that of pectoralis major, and it necessarily varies according to the degree of muscular emaciation or development.

Above and to the inside, the clavicle makes a strong projection on the surface of the region. This projection is caused by the thinness of the muscle at this point and by the strong forward curve of the bone to which the muscle is inserted, along the whole internal part of its anterior border. A triangular depression, the *infraclavicular fossa*, separates the insertions of pectoralis major and those of deltoideus. This depression is caused by the separation of these two muscles which were previously coupled together. They separate just before they reach upwards to the clavicle but the juxtaposition of these two muscles is in no sense a fusion. A slight groove (*deltoideopectoral line*) departs from the infraclavicular fossa and descends, towards the outside, as far as the inferior angle of the deltoideus. It fixes a line of demarcation between the two muscles, and at the same time establishes the limits of the pectoral region and the limits of the region of the shoulder. The cephalic vein, which comes from the arm, runs within this groove.

On all the other sides, the mammary region projects onto the areas next to it. Within, it swells slightly onto the sternal region; below, it swells strongly as it approaches the arm at the place where pectoralis major, leaving the thoracic cage to reach its insertion at the humerus, creates the anterior border of the armpit.

The anterior border of the armpit, which is very thick because of the disposition of the muscle fibers, which we have described (see page 58), does not run directly towards the outside. Even when the arm is lowered, it runs clearly upwards and disappears between the relief of the biceps brachii and the deltoideus. It forms an acute angle with the inferior extremity of the deltoideopectoral line. The inclination of the anterior border of the armpit is caused by the direction of the inferior fibers of pectoralis major. These fibers originate at the cartilages of the false ribs and the abdominal aponeurosis, and they are forced to rise upwards to reach their insertion at the humerus which lies on a much higher plane. The anterior border of the armpit also forms an angle with the inframammary furrow which borders the region below. But this angle is obtuse and rounded. At this level we find the nipple, which is always situated on the inside of a vertical line dropped from the infraclavicular fossa.

The inframammary furrow is not horizontal. It is oblique from below to above and from the outside to the inside. It usually follows a very slight curvilinear direction, but sometimes it is almost straight. It is large, shallow, and not very accentuated on the inside. It becomes much more definite as it approaches the armpit where it disappears. It is usually exaggerated on antique statues. Its situation corresponds to the cartilage of the fifth rib, across which it cuts in a very oblique direction. The crease is caused by the relief of the fleshy fibers upon the fibers of the aponeurosis of insertion, which themselves descend as far as the cartilage of the sixth or seventh rib. On the outside, the fleshy fibers of pectoralis major descend much lower to insert into the abdominal aponeurosis. The obliquus externus mounts as high as these fibers, which mask its superior digitation.

When pectoralis major is inactive, and the arms are falling naturally beside the body, its mass, provided that the muscle is somewhat developed, is drawn down below and to the outside by the action of gravity. This augments the anterior relief of the region and deepens the furrow which borders it.

The internal border of the pectoral region is marked by the projection of the fleshy fibers of pectoralis major which originate from the side of the sternum. These projections are usually slight and more marked below than above. They are irregularly disposed in groups along a curved line and the fibers of the muscle are gathered into several bundles which form about three or four digitations, all of which are reasonably distinct. On lean subjects the prominences caused by the chondrosternal and chondrocostal articulations can be seen near this internal border.

The arched surface of the whole region often presents linear depressions, which follow the direction of the muscular fibers of pectoralis major and separate its various muscular bundles. One of these lines is constant, the one which leaves the internal extremity of the clavicle and loses itself towards the external angle of the muscle. It separates the muscular bundle called the clavicular portion from the rest of the fleshy body of the muscle. These lines can be distinguished only on subjects with well developed muscles and a fine skin which is only slightly encumbered with fat. On the same type of subject, towards the external angle of the region one finds, at a slight distance from the deltoideopectoral line, a depression which is enlarged when the arm is extended to the outside and which corresponds to the crossing of the superior fibrous bundle over the inferior bundles.

Among subjects with slight muscular development, one can easily see, across pectoralis major, the prominences formed by the costal arches. These prominences are separated by depressions which correspond to the intercostal spaces. Finally, the forms on a subject who is not really fat but whose muscles are well developed are full and smooth due to a dense and firm fatty panniculus. Under these circumstances the pectoral surface takes on the simple and uniform quality which it has in antique statues. It is easy to demonstrate, therefore, that the fatty panniculus is not distributed in a layer of equal thickness throughout the region. It becomes thicker as it descends and its greatest thickness is at the level of the nipples and throughout the whole inferior part. Thus, the swelling of the mammary region is partly due to muscular development, and partly due to the accumulation of a certain amount of fat. The differences in thickness of the fatty panniculus are found even in thin subjects.

In women, the presence of the mammary gland gives the region its particular characteristics. I shall not discuss

in detail a form as variable as the female breast. Its relief is due both to the mammary gland, and to a considerable amount of fatty tissue. However, the exact position of the breast should be determined. It occupies the inferior and external part of the pectoral region, leaving the superior part free. The breast faces towards the front and slightly to the outside; the nipple lies on the most salient part, at the point where the upper and lower surfaces meet each other. The inferior border of the breast projects beyond the limits of pectoralis major and encroaches upon the inframammary region, which is narrow in women. In youth, when the breast is not very developed, its demi-globe seems clearly differentiated from the plane on which it rests. The anterior border of the armpit shows above it on the outside, and on the inside a space of several fingers' breadth separates the two breasts. However, when the breast is larger, because of the fat accumulated there, its limits are much less clear. Above, it blends with the pectoral region, which is also enlarged by fat. As it falls lower down under the influence of gravity, the crease which marks its lower border becomes much deeper. Finally, the two breasts almost join at the middle line.

INFRAMAMMARY REGION (PLATE 77 and PLATE 79)

The inframammary region is limited as follows: above, by the mammary region; on the outside and in back, by the somewhat vertical line of the anterior border of latissimus dorsi; below and on the side, by the superior line of the flank; below and in front, by the line which follows the border of the cartilages of the false ribs and by the line due to the first aponeurotic intersection of the rectus abdominis; and finally, within, by the epigastric depression and the median line which separates the two sides of the rectus abdominis.

This region, which seems to be circumscribed on the outside in such a manner, does not possess a single muscle which might be called its own. In fact, the region is composed of portions of three separate muscles: the anterior and inferior part of the serratus anterior, the superior half, more or less, of the obliquus externus, and the superior extremity of the rectus abdominis.

As a whole the region is convex because it is formed by muscular bundles which lie directly upon the ribs which form its skeleton. However, these bundles give it an undulating quality and a great number of small and differing planes. First of all, there is the series of digitations of the serratus anterior, created by the insertions of this muscle on the lower ribs. These digitations show on the exterior surface as a series of angular projections pointing towards the front, and they end along a curved line, convex below and to the front. Resting on the costal swelling and enlarging it, the muscle takes its origin on the external surface of the ribs. The visible digitations are four in number, and they differ in size. The first appears at the level of the inferior border of pectoralis major; the last seems to lose itself under the projection of latissimus dorsi. The digitations of the obliquus externus interlock with those of the serratus anterior, but these digitations are less prominent because they are formed of thinner muscular bundles. They are attached to the inferior borders of the ribs, resting on the depressed surface of the intercostal spaces.

The first visible digitation of the obliquus externus originates below the first visible digitation of the anterior serratus. Above this there is a muscular prominence which touches the inferior line of the mammary region, and which seems to be a new digitation of the obliquus externus. It is not. The prominence is created by the fasciculus of the pectoralis major which leaves the pectoral region to reach its insertion in the abdominal aponeurosis.

The obliquus externus arises from different muscular bundles and it follows the form of the part of the thoracic cage which it covers, until it detaches itself and descends to the flank. Because the muscle molds itself upon the thoracic cage, various forms arise. These vary, depending upon the thickness or thinness of the muscle. They also depend on the projections of the ribs, separated by the intercostal depressions, and on the series of tuberosities on the ends, formed by the chondrocostal articulations which are often confused with the muscular digitations. Finally, the forms are influenced by the unevenness of the cartilages of the false ribs along the costal border.

Among the forms of this region there are, therefore, three kinds of reliefs: the muscular reliefs, the digitations of the obliquus externus, the bony reliefs due to the ribs themselves or to their chondrocostal articulations, and the reliefs of the costal cartilages.

Of all these prominences, the most important is the one that forms the lower end of the costal border. Gerdy calls it the costoabdominal protuberance. It is due to the relief formed by the cartilage of the tenth rib. Usually, it can be easily seen. The lateral line of the belly begins beneath it.

The most internal part of the region has more uniformity. Moreover, it is much narrower and it is on a level with the first division of the rectus abdominis. The muscle is usually thick enough at this level to mask the relief of the cartilaginous border, and it fills the void which exists to the inside on the skeleton. Sometimes certain muscular bundles can be seen at the point of their superior insertions into the costal cartilages. The furrow which forms the lower edge of the costal border does not rise towards the epigastric depression (as it does in very lean subjects) but diverges at the external border of the rectus abdominis and continues transversely with the depression formed by the first aponeurotic intersection of the muscle. It thus cuts off the top of the anterior cartilaginous arch of the chest; this arch is always more or less angular in the skeleton.

BACK

The back consists of the whole posterior part of the thorax. Above, on the median line the limit of the back is formed by the prominence of the seventh cervical and the line which runs from this point to the external extremity of the clavicles (these are the inferior limits of the neck). Below, the back is limited by the two oblique lines which depart from the median line, run below and to the outside as far as the back of the flanks, and form the upper limits of the loins. Finally, on the outside, the oblique vertical line formed by the anterior border of latissimus dorsi separates the region of the back from the inframammary region.

The back may be subdivided into three regions. Within and near the vertebral column there is the spinal region; on the outside there is the scapular region and the infrascapular region.

SPINAL REGION (PLATE 78)

The back is traversed from top to bottom by a median vertical furrow which extends to the loins and disappears in the sacral region. The depth of this furrow, which corresponds to the projection of the spinal crest on the skeleton, depends on the development of the muscles which border it. It is the only place where the vertebral column is subcutaneous. By no means uniform, the regions of the vertebral column vary notably.

In the region of the back, the column follows the projections of the spinous processes of the first and second thoracic vertebrae which can be seen after that of the seventh cervical. The furrow, which is broad at the top, gets narrower and deeper as it descends. It also becomes more uniform and the dorsal spinal processes do not project except in very thin subjects and in flexion movements of the trunk. Of course, there are exceptions. At the lowest part of the back in some subjects the prominences of two or three spinous processes can be seen. This seems to be due to a special conformation of the spinal column, and an accentuation, in the dorsal region, of the normal curve.

At the loins, the median furrow offers interesting details which we will discuss later.

The spinal region, which occupies the entire extent of the part of the back closest to the vertebral column, is limited on the outside by the interior border of the scapula which separates the superior half of this region from the scapular region. Below, the lateral line of the back, which delimits the infrascapular region, forms the external border. The lateral line of the back corresponds to the angle of the ribs and it is not particularly accentuated in the upright position.

Superficially one sees only two muscles: the inferior extremity of the trapezius and the most internal part of latissimus dorsi. These two muscles are flat and not very thick and thus the general form of the region is due to the deeper muscles—the rhomboids above and the mass of the spinal muscles below.

The surface of the trapezius occupies the whole superior part of the region. One can easily see, even on lean subjects, the triangular form of the inferior extremity of the muscle. This muscle arises as far down as the last thoracic vertebra. However, the external relief of the muscle does not go as far as this. Its fleshy fibers stop at some distance from the inferior extremity in a small aponeurotic triangle, so thin that it is not visible under the skin. The result of this is that, on the nude, the inferior termination of the trapezius appears to be at the end of its fleshy fibers and looks like two points, just a little to each side of the median line.

There is another aponeurotic part of the muscle which greatly influences the exterior form. All the fleshy fibers of the inferior extremity of the trapezius (some of which cover the internal border of the scapula) insert into a small triangular aponeurosis and attach themselves to the inter-

nal extremity of the spine of the scapula. This aponeurosis is the cause, at this point, of a cutaneous depression which has a constant relationship with the skeleton on which it rests. I shall designate it, after Gerdy, the *scapular depression.*

Finally, let me refer again to the superior median limit of this region where there is an oval aponeurotic depression. In the center of this depression the dorsal spine of the seventh cervical vertebra projects.

The whole inferior extremity of the trapezius forms a clear triangle on the flayed figure. But the form of this triangle is raised by the powerful rhomboid muscles beneath. In fact, these are the muscles which create the ovoid relief which can be seen clearly on muscular subjects inside of the internal border of the scapula in the conventional attitude we are studying.

When persons of ordinary musculature stand with their shoulders in a normal position with their arms falling naturally beside the body, the lower part of the relief of the rhomboids is limited by an oblique linear depression. This depression ascends from the inferior angle of the scapula towards the vertebral column and corresponds to the inferior border of the lower rhomboid. I should also point out here a depression to the inside of the inferior angle of the scapula. It corresponds, on the flayed figure, to the only point where the posterior part of the thoracic cage is completely uncovered. This restricted space is triangular in form—it is limited by the latissimus dorsi below, the trapezius within, and the lower rhomboid without. Its size varies with the movements of the scapula and it disappears completely when the shoulder is pushed back. It is, however, accentuated by an opposite movement because its exterior limit, which is formed by the relief of the inferior extremity of the lower rhomboid muscle, becomes displaced.

The inferior part of the spinal region is occupied entirely by the relief of the fleshy bodies of the spinal muscles. They are very prominent here, although they are covered by the latissimus dorsi, and by the inferior extremity of the trapezius which lies on top of the most internal part of the latissimus dorsi. The external limit of the prominence due to the spinal muscles is usually not very distinct in the conventional attitude but it becomes clearer when the arms are raised vertically. During this action the slight linear depression, called the lateral line of the back, becomes most distinct. This depression corresponds, on the skeleton, to the internal angle of the ribs. On certain subjects, with well developed muscles, the external limits of the spinal region are different. They are pushed more towards the outside by the digitation of the serratus posterior muscle which inserts well to the outside of the angle of the ribs.

SCAPULAR REGION (PLATE 78)

The limits of the scapular region are: on the inside, the spinal region; above, the inferior limit of the neck; and below, the superior border of the latissimus dorsi (which also serves as the upper limit of the infrascapular region).

This region offers the following details. The projecting surface of the deltoideus divided by a strong aponeurosis that draws it in around the middle part; the surface of the infraspinatus, which does not project very much because

it is bound by a strong aponeurotic sheath; and the rounded surface of the teres major (projecting in a ball-like manner when the model is in the conventional attitude), of which the lower part is bound by latissimus dorsi.

The spine of the scapula, which projects in thin individuals, becomes a groove in muscular ones. This is due to the volume of the muscles which insert there. The superior muscle, the trapezius, projects the most.

The internal border of the scapula, covered by the rising fibers of the trapezius, forms a prominent blunt edge on thin subjects. In muscular individuals when the muscles attached to the edge are contracted, the internal border becomes a furrow.

When the arms fall naturally alongside the body, the inferior angle of the scapula forms a prominence blunted by the latissimus dorsi which passes over it.

The posterior border of the armpit, which does not really show in the conventional attitude, is formed by teres major and latissimus dorsi. The latter twists around the former in order to reach its insertion in the humerus.

INFRASCAPULAR REGION (PLATE 78)

The infrascapular region is limited by the following: above, by the scapular region; on the inside, by the lateral line of the back (which separates it from the spinal region); on the outside, by the projection of the anterior border of the latissimus dorsi; and below, by the superior line of the flank.

A single superficial muscle fills the whole region—the latissimus dorsi. This flat muscle follows the forms of the parts which it covers allowing them to appear on the surface. Above and to the outside, the serratus anterior lifts it and causes a large oblique furrow which runs from the inferior angle of the scapula, down and to the outside, towards the flank. This furrow is sometimes interrupted about halfway down. The lower half lies on a slightly lower plane because the last bundles of the serratus anterior are disposed in a different direction.

Between this furrow and the lateral line of the back, which is the internal limit of the infrascapular region, there is a small triangular space. Its summit is near the angle of the scapula and its base is turned down and to the outside. In this space the thoracic cage is covered only by the latissimus dorsi. The dimensions of this triangle vary in different individuals, and it usually quite small in the conventional attitude. However, it is worth pointing out because the triangle becomes much more developed when the arm is lifted and the serratus anterior is displaced. It allows that portion of the thoracic cage to which it corresponds to show under the latissimus dorsi.

On very thin subjects, the prominent form of the ribs and the depressed intercostal spaces are visible throughout the whole of the infrascapular region because of the thinness of the muscles.

ABDOMEN

The abdomen is that part of the trunk between the chest and the pelvis. It can be divided into three regions: in front, the *belly*; in back, the *loins*; and on the sides, the *flanks*.

The belly is circumscribed by the following landmarks: above, by the anterior furrow of the chest; below, by the anterior line of the pelvis; and on the sides, by the vertical lines (lateral furrows of the belly) which separate it from the flanks.

It is traversed, on the median line, from top to bottom, by a groove of varying depth which disappears a few fingers' breadth below the navel. This groove is created by the relief of the rectus abdominis on either side. It disappears at the inferior part because the fleshy parts of the two sides of the muscle come together at this point.

The navel can be located at an equal distance between the xiphoid process and the pubis.

On each side of the median line one finds the surfaces of the rectus abdominis and its aponeurotic intersections may be easily seen on muscular subjects. The number of intersections varies in different subjects, although there are usually three. In classical times these intersections were given a regular form and the surface of the muscle was divided into quadrilateral planes.

The lowest intersection is at the level of the navel; the highest is just below the epigastric depression; and the middle intersection is at an equal distance between the two others. The highest intersection, the most important from the point of view of exterior form, reaches the level of the anterior furrow of the chest. The superior part of the rectus abdominis muscle thus fills the summit of the angle formed by the cartilaginous border of the ribs. The result is that on the model the anterior opening of the thoracic cage appears as a rounded arch, while on the skeleton it is clearly angular. However, the shape of the anterior opening varies, and on very thin individuals, the skeletal forms predominate.

Below, the line which limits the belly is curved, in an inverse direction to that of the anterior furrow of the chest. It extends laterally to the anterior border of the iliac bones and forms the superior line of the groin. In the middle, the line limits the upper part of the pubis. Its form is regularly rounded on subjects whose abdomens are very fat. However, on thinner subjects and adolescents, its form is angular with a truncated summit; it straightens out on each side and the line across the top of the pubic area becomes equally straight.

The lateral line, which separates the belly from the flanks, starts at the costoabdominal prominence of the cartilage of the tenth rib. As it descends towards the groin it becomes a furrow bordered laterally by the projecting form of the rectus abdominis on the inside, and by the fleshy fibers of obliquus externus on the outside. Below this line, it becomes larger and ends above the groin in a plane that follows the curve and separation of the two neighboring muscles. The rectus abdominis bends downward to the inside, while the line of insertion of the fleshy fibers of the obliquus abdominis bends upward to the outside towards the anterior superior iliac spine.

The volume and projection of the belly varies with the fatness of the subject. Even in thin subjects the maximum projection may be found above the navel. We have already pointed out that the fatty pannicule is usually thicker above the navel than below it.

A little above the navel, there is a transverse cutaneous

wrinkle caused by the forward flexion of the trunk.

The infraumbilical region is marked by a semicircular cutaneous line of which the concavity faces above. It is situated several fingers' breadth above the pubic region. The line is not necessarily due to the amount of fat in this region, as it is found on thin subjects.

LOINS (PLATE 78)

The region of the loins has the quality of a lozenge. The superior inverse V is formed by the union of the two superior lumbar lines which also form the lower border of the spinal region. The branches of the inferior V follow the exterior border of the sacrum and the posterior part of the bony projections of the iliac crest. These borders become transformed into linear depressions by the relief of the gluteal muscles which are attached to them. The inferior angle corresponds to the superior space between the buttocks, and the broader lateral angles approach the flanks.

The appearance of the region of the loins is extremely variable and its superior limits, often indefinite, differ a great deal from individual to individual.

The superior lumbar grooves, attributed by Gerdy to the relief formed by the fleshy fibers of the latissimus dorsi at its aponeurotic origin, are rarely accentuated. When they are evident, they run from the inferior angle of the trapezius, below and to the outside, towards the region of the flanks (Figure 11). In many subjects, they are not readily distinguishable. In some subjects, because their skin is slightly thicker, it is impossible to see them.

The spinal muscles give rise to another oblique line which goes in the same direction, but lower down. It is so often present that, in my opinion, it should fix the upper limit of the loins. This line is caused by the relief of the fleshy fibers of iliocostalis lumborum and longissimus dorsi upon their aponeurosis of insertion (see Plate 40). The situation of this line varies, depending on the length of these fibers. It is often the same as the line caused by the fleshy fibers of latissimus dorsi. The varying appearance of the upper limits of the lumbar region depends on whether the latissimus dorsi or the spinal muscles are of the short or long type. The different types of the two muscles create different lines and they may be near or far apart or they may fuse through superimposition.

On the other hand, the inferior limit of the loins is constant because it rests on the skeleton which varies so little. It is marked on each side by two small depressions, the *lateral lumbar fossets*, one superior and one inferior. Gerdy points out only one, the superior lateral lumbar fosset. This corresponds to a sinus opening towards the outside which exposes the iliac crest at the level of the posterior third of its length. It is near the external angle of the region and immediately below the origin of the iliocostalis lumborum at this part of the bone. The second notable fosset is situated a little lower, towards the middle of the inferior border of the region. It corresponds to the bony projection of the posterior superior iliac spine which is transformed into a depression by the relief of the fleshy masses which are attached to it. The superior fosset is sometimes erased by the presence of excess fat (we will discuss this later in relation to the flanks). Sometimes, for the same reason, the depression becomes slightly com-pressed below. The inferior fosset is much more fixed. Moreover, it is the only one that can be seen on women.

In the middle of the lumbar region, one finds the lumbar furrow which prolongs the furrow of the back. This furrow is large and deep. It corresponds to the spinal crest on the skeleton, although it appears as a groove because of the powerful muscles which border it on each side. Nevertheless, the lumbar vertebrae often appear as a series of nodular prominences at the bottom of the furrow. Of these prominences, generally only three or four show. They are often irregular and hardly show at all in an upright position. When the trunk is forcibly flexed to the front, they are much more evident.

The lumbar furrow descends as far as the inferior half of the sacrum where it disappears completely. Near its termination, it is generally marked by a depression (*median lumbar fosset*), situated a little above the level of the inferior lateral fossets. It corresponds to the union of the lumbar column with the sacrum.

The whole surface of the lumbar region is filled by the powerful relief of the spinal muscles, covered at this point by their own aponeurosis and by that of the latissimus dorsi. I shall not describe again here the projection (in the superior part of the region) of the fleshy fibers on the aponeurotic part. Below the line of this projection (superior lumbar line), one can see in an upright position, when the lumbar curve is exaggerated, several transverse wrinkles. At first sight, they appear to be cutaneous wrinkles, but they are actually due to the wrinkling of the fleshy portion of the spinal mass under the aponeurosis. This occurs only when the spinal muscles are completely relaxed and the wrinkles disappear at once when they are contracted. By manipulating the skin of this region, it is easy to demonstrate that these wrinkles have nothing to do with the skin itself.

Outside the mass of the spinal muscles, there is a line which becomes visible during flexion of the trunk. It is the lateral lumbar line. Beyond this the region of the loins is depressed, and extends towards the flanks.

FLANK (PLATES 77, 78 and 79)

The flanks form the sides of the abdomen and they fill the space left between the base of the chest and the iliac crest. They correspond to the inferior half of the obliquus externus.

The superior limit of the flank (generally not very distinct) is marked by a superficial transverse line due to a change in direction of the obliquus externus. Above, the obliquus externus follows the direction of the ribs to which it is joined; below, it detaches itself to insert at the iliac crest. This line invariably ends in the back in a depression which corresponds to the inferior extremity of the thorax, at the point where the ribs cease.

In front, the flank is bordered by the relief of the fleshy fibers of the rectus abdominis on the abdominal aponeurosis. In the back, it delimits the lumbar region.

Below, it is circumscribed by the furrow of the hip, or *iliac line*. The name of this line is derived from the relationship of the hip to the iliac bone, a relationship often falsely interpreted.

Actually, approximately only the anterior third of the iliac line rests upon the corresponding part of the iliac

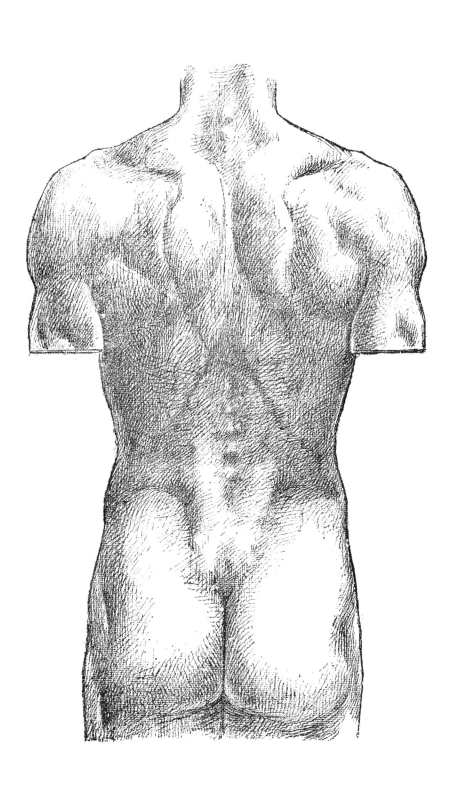

Figure 11. Torso on which the superior limit of the loins is formed by the fleshy fibers of the latissimus dorsi, because of the slight development of the spinal muscles. The contrary to this would be the torso on Plate 78, in which the superior limit of the loins is formed by the fleshy fibers of the spinal muscles.

crest, the posterior two thirds of this line are situated much lower. This may be easily observed if one compares the profile of the skeleton with the nude. There are many anatomical reasons for this, which remain to be explained (Figure 12).

I pointed out before that the lowest fibers of the obliquus externus are attached, by very short aponeurotic fibers, to the external lip of the iliac crest in such a way that the cutaneous fold formed by their relief is not situated at the level of the crest but just below. The gluteal muscles are sheathed in such a strong aponeurosis that they project only slightly from the crest. Their projection does not counteract the downward line of the cutaneous fold which, at this level, describes a slight curve of inferior convexity. Besides, the presence of a certain amount of fat at the back part of the flank accentuates this form.

In the front, however, at the anterior third of the crest, the fleshy fibers of the obliquus externus tend to separate from the line of the crest. These fibers are thinner and, therefore, their relief is less bulky than in the back. From the point where the fibers separate, the iliac line follows the bony prominence of the crest exactly and both describe curves of superior convexity. The anterior superior iliac spine forms a small projection at the anterior extremity of this line.

The surface of the flank is always convex from front to back. In very muscular subjects, it is convex from above to

Figure 12. Schematic figure showing the difference in direction of the hip and the line of the iliac crest.

below. However, in thin subjects it becomes concave from above to below and the iliac crest can be seen.

In relation to the morphology of the back part of the flank the subcutaneous pannicule of fat plays an important role in certain circumstances. This has been verified in all subjects we have observed, even in the thinnest. At the posterior part of the flank, there is a thickening of the fatty layer, necessarily varying with different subjects, but nevertheless constant. When this thickening is not particularly marked, it softens the relief of the posterior border of the obliquus externus and fills the void which, on the flayed figure, exists in the back between the obliquus externus and the latissimus dorsi at its insertion into the iliac bone. But, in many cases, the fat collects in this region and becomes localized to the point where it forms a veritable pad, prolonging the relief of the obliquus externus in the back. I am not necessarily referring to fat models because in them this pad is always greatly developed. It may also be found in thin subjects where it forms a swelling in back which reaches to the superior lumbar fosset, often partly filling it. Finally, an understanding of this fatty pad is important in modeling the female hip. It fills the iliac furrow to such an extent that only a superficial trace remains and it also fills the superior lateral lumbar fosset, erasing it completely. It hides the indications of the divisions between the flank and the buttock in such a way that the buttocks seem to rise as far as the line of the waist which, in fact, is the superior limit of the flank. These forms, characteristic of women, are often found, though attenuated, in men. On the other hand, certain women, in this respect, seem to have the masculine shape. Nature, in other words, in the infinite variety of individual forms, offers all the intermediate degrees between the male and female types.

PELVIS

The pelvis consists in front of the narrow median region of the pubis and groin. In back there is a region consisting of the prominence of the buttocks. (On the sides lie the joints of the hips.)

PUBIC REGION

The pubic region rests on the bone of the same name. The skin is usually thickened by the fat which attenuates the bony forms. It is shaded with hair. This region tends to project more in women. It is limited above by a transverse line which joins the lines of the groin and forms, with them, the front indentation of the pelvic area. On the sides, the region is bordered by the lines of the thighs, which move towards the groin. The region is somewhat triangular, and its base supports the reproductive organs.

GROIN

The line of the groin separates the thigh from the abdomen. It runs obliquely from the anterior superior iliac spine to the pubis. In an upright position, when the thigh is extended beneath the trunk, the line of the groin appears as a wide, superficial furrow. But in flexion, it becomes a deep fold. The line of the groin corresponds to Poupart's ligament and follows the same direction. It is

maintained by fibrous fasciculi which unite with the deep surface of the skin in this area, and with the adjacent ligaments. Above the line of the groin, the round form of the lower median surface of the belly projects. Beneath the line, there is a surface, often sharply defined, which corresponds to the psoas major muscle on its way to its insertion in the lesser trochanter of the femur (Figure 12).

The line of the thigh is very accentuated in fat subjects, and generally extremely clear in women. It starts, on the inside, from the line which separates the thigh from the pubic region; then it rounds the leg and ascending slightly it terminates, on the outside, a few fingers' breadth below the anterior superior iliac spine (Figure 13). At this point, it is marked by a depression which corresponds to the separation of two muscles: the sartorius and the tensor fasciae latae. This is the femoral fosset, which we will consider when we study the thigh. There is often, although less frequently on women, an accessory transverse wrinkle, at an equal distance between the anterior superior spine and the femoral fosset, which runs to the line which marks the superior limit of the pubic region.

BUTTOCKS

Behind the pelvis, there is the prominence of the buttocks. The buttocks are limited by the following: on the inside, by the line between the buttocks; below, by the curved lines which separate them from the thighs; on the outside, by the projection of the great trochanter; and above, by the inferior lumbar line and the flank line.

These boundaries enclose an area much higher than wide and it is filled by the sloping relief of the buttocks. This relief projects most at the inferior internal part where it is rounded and corresponds to the gluteus maximus. Above, on the outside, the projection of the gluteus medius is firmer and flatter. A superficial, oblique depression sometimes separates these two areas of muscle.

On the buttocks, the fat plays an important morphological role. It is thickest in the inferior, internal area. In fact, the projection of the whole region is much more often due to the accumulation of fat than to the development of muscle. This is most evident in women, whose muscular system is usually less developed and whose buttocks are, nevertheless, quite prominent. The firm buttocks of young subjects are due to a dense and resistant fatty tissue. The flat buttocks of older subjects are the result, for the most part, of the disappearance of this tissue. Models whose muscles are extremely well developed usually have a sparse fatty pannicule, and thus the projection of the buttocks is relatively slight. They are quite flat, and unless the muscle is in contraction, they have a soft and undulating quality quite different from the quality of accumulated fat (Figure 14).

As I have said, the steatopygia of the female Bushman is

Demicircular line of the abdomen

Furrow of the flank

Accessory line which continues from the superpubic line

Line of the groin

Femoral fosset

Fold of the thigh

Figure 13. Fold of the groin on women.

Figure 14. *Fold of the buttocks in the standing position. The left part of figure shows the relationship of the gluteus maximus to the surface. Its limits above and below are indicated by the dotted line.*

nothing but an exaggerated development of the fatty pannicule. It is interesting to note that, in Europeans, the relief of the buttocks is extremely variable in shape, and it offers examples of every degree of attentuation of this curious anatomical development.

On the outside, the buttock is separated from the great trochanter by a depression due to the manner in which the fleshy fibers insert into a large aponeurosis of insertion (Figure 15).

Below, the buttock is bordered by a fold which is deep on the inside and fades away on the outside. This is due to the inferior fleshy fibers of gluteus maximus which descend to the thigh, to which the lowest part of the muscle really belongs. This fold has a horizontal direction which crosses the oblique direction of the inferior border

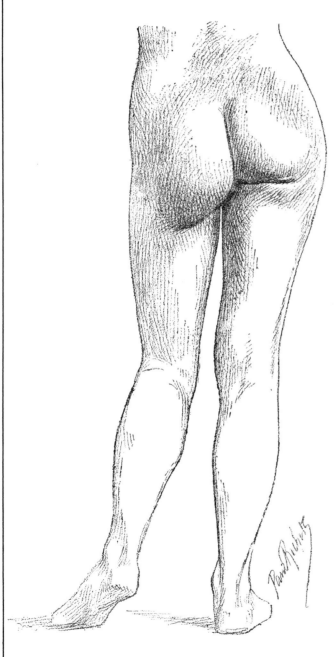

Figure 15. Fold of the buttocks with weight on one side (female).

of the muscle. This has not always been clearly understood.

A simple examination of the nude will show that the fold of the buttock is solidly attached to the deeper parts. For example, when the weight is on one side, the fold of the buttock on the standing side will be deeply creased, forming a kind of band which encircles the internal part of the top of the thigh. However, on the other side, the fold will follow the movement of the tilted pelvis—it will descend lower and will not be as pronounced.

Anatomy offers an explanation for this. As we have seen in the anatomical sections, the deep surface of the skin at the level of the fold of the buttocks adheres to the femoral aponeurosis, which itself inserts into the ischium. However, it is important to remember that this surface attaches to the femur directly, by solid fibrous fasciculi. This was pointed out to me by my friend Paul Poirer, Chef des Travaux Anatomiques à la Faculté.

As a result, there is an intimate connection between the cutaneous fold of the buttocks and the pelvis, and the one follows the movements of the other. In effect, one can state that if the pelvis is lifted on one side, it carries with it the fold of the buttock on that side, and the fold will be higher than that of the other side.

Another consequence is that the fat of the region is in some way contained in a kind of pocket formed below by the fibers which go from the skin to the ischium, and which, since they are unable to descend to the thigh, increase the projection of the buttock. It is in this same pocket that a part of the fleshy mass of the muscle is retained and during complete relaxation this mass falls down towards the inside under the influence of gravity.

When the trunk is flexed to the front, the fold of the buttock tends to disappear, and the contracted muscle shows its form most exactly under the skin with its inferior border moving obliquely out and down (Plate 94).

The fold of the buttock is attached to the ischium only at its internal part, where it is deep. On the outside, the fold disappears before it reaches the external surface of the thigh. It is replaced by an inclined surface which descends towards the thigh, creating the transition between the region of the buttock and that of the thigh. This surface is due to the gluteus maximus.

Sometimes, there is a second fold of the buttock a little underneath and to the outside of the preceding.

At the articulation of the hip there is a projection caused by the great trochanter. The reason for this can be easily understood upon examination of the skeleton.

The projection of the great trochanter is greater than that of the iliac bone.

MOVEMENTS OF THE SHOULDER

The shoulder has great freedom of movement—it can move forwards, backwards, and upwards. Necessarily, it moves the arm at the same time. The shoulder cannot be lowered very much unless it is already in a raised position.

ARTICULAR MECHANISM

The skeleton of the shoulder is composed of two bones, the clavicle in front, and the scapula behind. These bones

form a complete half girdle which embraces laterally the summit of the thoracic cage (see Plate 31, Plate 16 and the following plates). The anterior extremity of this bony arc is closely connected to the thoracic cage at the sterno-clavicular articulation. Laterally, the center of the arc moves some distance away from the thoracic cage and articulates with the bone of the arm (scapulohumeral articulation). Finally, the posterior portion of the arc again approaches the thoracic cage, but it is not attached to the cage, it is only in contact with it. Actually, the scapula, much thickened by the muscles which cover its surface, is held against the thoracic cage simply by atmospheric pressure and by the muscles that regulate its movements.

The movements of the shoulder can be broken down into the gliding of the scapula against the thoracic cage, and the slight movement that takes place in the articulations of the clavicle with the sternum (sternoclavicular articulation) and with the scapula (acromioclavicular articulation). These articulations have been described (see page 32 and Plate 11).

In the upright position, with the arms falling freely alongside the body, the vertebral border of the scapula is almost vertical. Its distance from the median line is about half its length.

In the elevation of the shoulder, the scapula does not just describe a simple upward movement, but undergoes at the same time a slight movement of rotation on itself. Because of this, the axillary border becomes oblique and the inferior angle withdraws slightly from the cage and moves to the outside.

If one considers the solid attachment of the clavicle to the sternum and the transverse direction of this bone towards the outside, it is easy to understand that movement of the shoulder directly to the front is extremely limited. It is only possible if it is accompanied at the same time by a movement of elevation.

In the back, however, nothing stands in the way of the scapula. Also, the backward movement of the shoulders is itself very easy to perform. It is usually accompanied by a slight lowering of the point of the shoulder.

MUSCULAR ACTION

Elevation of the point of the shoulder directly upwards is produced by the contraction of the superior part of the trapezius which is attached to the clavicle, to the acromion process, and to the adjoining part of the spine of the scapula.

When this movement is performed with effort, as in the act of lifting a burden on the shoulder, other muscles enter into action as well as the trapezius. These muscles are: the rhomboids, the levator scapulae, the teres major, and the superior portion of the pectoralis major. The serratus anterior does not really participate.

The shoulder is drawn back by the inferior third of the trapezius and by the rhomboids which, while drawing the scapula towards the median line, lift the point of the shoulder. This latter movement is counterbalanced by the latissimus dorsi—through the medium of the head of the humerus, it moves the scapula from above to below and from front to back. At the same time, the latissimus dorsi straightens the trunk.

When this movement is violent, as in the act of drawing towards oneself a heavy weight, other muscles join the preceding. These muscles are the teres major and the posterior third of the deltoid.

The movement of the shoulder upwards and to the front is brought about by the superior third of pectoralis major. It expresses fear or apprehension. If it is done with violence, as in pushing the shoulder against a resistant obstacle, the serratus anterior contracts at the same time.

NORMAL POSITION OF THE SCAPULA

From the preceding details we can better understand the reasons for the normal position of the scapula. It arises naturally from the combined tonic forces of all the muscles which insert there.

Therefore, if the superior part of the trapezius and of the levator scapulae become weakened, the point of the shoulder drops down and, at the same time, the neck appears longer. If these muscles are unusually powerful, the opposite effect is produced.

Further, if the inferior part of the trapezius and of the latissimus dorsi are weak, the back becomes rounded transversely and the chest tends to become hollow. This condition also pushes the clavicles forwards and draws forward the point of the shoulder. The predominance of the tonic action of the pectoralis major and the serratus anterior will produce the same effect.

EXTERIOR FORM OF THE TRUNK DURING MOVEMENTS OF THE SHOULDER (PLATE 89 and 90)

In a direct upward movement of the shoulder, the middle part of the trapezius becomes extremely prominent. Above, this part compresses the integument of the neck, and several large wrinkles are formed there. The superior angle of the scapula approaches the median line of the back, while the inferior angle moves away from it and projects. In front, the exterior extremity of the clavicle is raised and the clavicle itself becomes oblique and the posterior triangle of the neck becomes deeper.

Movements of the shoulder to the front and back create a number of notable morphological modifications throughout the whole torso.

If the shoulder is carried to the front, the action rounds the back, tends to hollow the chest, and exaggerates the curve of the dorsal column. The modeling of the whole back part of the trunk undergoes changes which Plate 89 should clarify. On this figure, the right shoulder alone is advanced, while the left shoulder, remaining in the normal position, serves as a point of comparison. It may be easily seen that the scapular region, displaced to the outside and to the front, exhibits a few small changes in relation to the muscles teres major, infraspinatus, and the posterior third of the deltoid. The spinal region, in the upper part, is enlarged transversely and at that part the surface of the trapezius is flattened and extended. Below the trapezius, the inferior extremity of the rhomboideus major may be observed at its insertion into the inferior angle of the scapula.

But the most important modifications are in the infrascapular region. Actually, a whole new region is uncovered between the posterior border of serratus an-

terior and the spinal region. We have discussed this region in the conventional attitude but now it is much enlarged. It has become a rounded surface on which the reliefs of the ribs can be seen more or less easily. On certain subjects, on the lower part of this surface, the projections of the different muscle bundles of the serratus posterior inferior can also be seen. On the inside, the relief of the spinal muscles shows very clearly and the external limit of this form is distinctly marked (*lateral line of the back*).

It should be noted that the latissimus dorsi has not entered into the forms we have just described. As a matter of fact, this muscle, whether extended or relaxed, always molds itself exactly over the deeper forms and these alone influence the morphology of the region. On the outside, however, the anterior border of the latissimus dorsi would form in this movement a distinct relief which would almost completely cover the contracted digitations of the serratus anterior.

The backward movement of the shoulders (Plate 89, Figure 2) is always accompanied by a flattening of the back, a thrusting forward of the chest, and a throwing back of the torso. The movement of the shoulder blades towards each other is limited only when they come into contact with the adjacent muscular masses. The spinal region is reduced each side to its minimal size. Its superior part shows the strong muscular relief created by the trapezius and the rhomboids—these reliefs touch each other at the median line. In the scapular region, the swelling of several muscles is accentuated—the teres major, infraspinatus and the posterior third of the deltoid. As for the infrascapular region, its details are hidden beneath the contraction of latissimus dorsi. However, in the back the line where the fleshy fibers of latissimus dorsi originate from the aponeurosis becomes most apparent. The whole region of the loins becomes traversed with striations which follow the direction of the fibers of latissimus dorsi. These striations are caused by the pull of the fibers upon the aponeurosis from which they originate.

Laterally, the anterior border of latissimus dorsi becomes oblique above and to the back and it uncovers the flattened digitations of the serratus anterior which are not contracted.

MOVEMENTS OF THE ARM

The movements of the arm take place through the articulation of the scapula and the humerus. Because of the shape of the articular surfaces at this joint, the arm has extraordinary mobility and it is capable of moving in any direction. At the same time, the arm cannot achieve and complete these movements without a certain displacement of the scapula. Thus, when the arm is raised, the scapula undergoes a movement of rotation and its inferior angle is drawn forwards and to the outside, while its superior angle is lowered. If the arms are outstretched horizontally, or moved to the front or rear, the scapula follows the direction of the arms.

The movements of the arm fall into three categories. First, movements in a plane that is vertical and parallel to the body. These movements are produced around an anteroposterior axis of rotation, the arm moving in a half circle around the shoulder joint which is its center. The arm starts by moving out, away from the trunk forwards and to the outside, soon becomes horizontal (horizontal elevation of the arm), and then continues its course until it reaches the vertical (vertical elevation of the arm).

Second, when the arm is placed in the position of horizontal elevation, it may describe extended movements within the horizontal plane by moving around a vertical axis. In front, the hand can move well beyond the median plane of the body. In the back, this movement is much more limited and the arm can only reach a position where it makes an obtuse angle with the back.

Third, the arm can undergo movements of rotation upon itself.

MECHANISM AND MUSCULAR ACTION

The initial elevation of the arm is brought about by the supraspinatus and the deltoideus. The first, a deep muscle, has very little effect on the exterior form, because of the thickness of that portion of the trapezius which covers it and makes its shape. The deltoideus, on the contrary, is entirely subcutaneous and is very important to the morphology of the region. However, by contracting the deltoideus can lift the arm only to the horizontal; that is the limit of its action. The complete elevation of the humerus is brought about by the contraction of serratus anterior, which rotates the scapula at its external angle.

We have observed that, from the anatomical point of view, the deltoideus is formed of three portions which are easily separated in dissection; physiologically, the deltoideus may be thought of as being formed of three separate muscles: the anterior, the middle, and the posterior. Each muscle portion may act alone and may become an antagonist to the other. When elevation is carried out without effort, each portion contracts independently in order to produce the elevation, whether it is to the front, to the back, or to the outside. Thus the three portions act as antagonists between themselves in movements to the front and back. Finally, the posterior portion acts as an antagonist to the two others in the movement of vertical elevation. This portion has very little power as an elevator. When the arm is raised vertically, it appears to be relaxed, whereas the two other portions are manifestly contracted. However, when the arm is lowered, the contraction of the posterior portion becomes definitely emphasized.

According to the authorities, the serratus anterior contracts in order to complete the action of elevation only after the arm has been extended horizontally. However, it is easy to see, simply by an examination of the forms, that the serratus anterior contracts from the very beginning of the movement of elevation. It contracts, as Duchenne de Boulogne has observed, not only in order to attach the spinal border of the scapula firmly against the thorax, but also to initiate the movement of rotation which is characteristic of its action upon the scapula. Nevertheless, it is important to distinguish this from what happens when the hand is moved together with the arm to the front, or to the back, since in this case the serratus anterior enters into the action, but in a totally different manner. The action of serratus anterior may be supplemented by the middle portion of the trapezius. When the arm is in horizontal extension and carried to the front, a strong contraction

of the serratus anterior may be clearly seen and its digitations appear in strong relief. In proportion to the extent to which the arm is moved back and to the outside, in the same horizontal plane, the contraction of serratus anterior becomes weaker and the middle portion of the trapezius becomes harder. Finally, when the arm is moved to its extreme limit in the back, the digitations of the serratus anterior appear flattened and relaxed and the middle third of the trapezius contracts violently.

Lateral rotation of the humerus is brought about by the supraspinatus, the teres minor, and the infraspinatus. Only the last muscle is subcutaneous but, because it is sheathed by a strong aponeurosis, its relief is always subordinated. As rotators of the humerus these muscles play an important role in supination of the hand, as we shall see later.

When the arm is lifted vertically it may return to its normal position simply through its own weight. Under these circumstances it is the muscles of elevation that enter into action in order to moderate and restrict the arm's descent. The depressor muscles only intervene to determine the direction of the movement, or to produce it with force.

Lowering of the arm to the front and within is performed by the pectoralis major. If this movement is in a horizontal direction, the whole muscle enters into the action. Below this level only the inferior portion is involved.

Lowering to the back is produced by the posterior third of the deltoideus, though only as far as the horizontal position. Then the teres major and the rhomboids take over, and finally the latissimus dorsi and the long head of triceps brachii.

The action of lowering the arm directly to the outside is dependent upon all the depressor muscles with the exception of the superior third of pectoralis major.

EXTERIOR FORM OF THE TRUNK DURING MOVEMENTS OF THE ARM (PLATES 91, 92 and 93)

Plates 91, 92, and 93 should allow us to avoid long and tedious descriptions. When the arms are moved modifications of form occur principally within the scapular region in the back, and the pectoral region in front. Laterally and to the front, the elevation of the arm discloses a new region, the arm pit, which is morphologically extremely important. We shall study this separately.

Vertical elevation of the arm produces notable changes in the form of the back. They are the result not only of the muscular action itself but of the see-saw movement of the scapula. For instance, the spine of the scapula, which is marked by a clear depression in well muscled subjects, pivots, so to speak, at its external extremity. Accordingly, the spine moves from an almost transverse position to an almost vertical position. The scapular fosset which marks the internal extremity of the spine is carried below and to the outside, and the surface of the trapezius becomes considerably enlarged. The modeling varies with the different regions. For instance, the middle portion of the trapezius, which is attached to the acromion process and to the adjacent part of the spine of the scapula, forms a very distinct relief in contraction. The inferior portion of

the trapezius becomes flat and stretched out in the direction of its fibers. The spinal border of the scapula, released from underneath the inferior part of the trapezius which covers it in the normal attitude, forms an accentuated relief directed obliquely from above to below and from within to without. This spinal border seems thickened because of the infraspinatus muscle which fills the infraspinatus fossa. Beneath the spinal border of the scapula a triangular depression appears. This depression is limited within by the relief of the spinal muscles and below by the superior border of latissimus dorsi. In the superior angle of this depression the lower border of the rhomboideus major becomes apparent. The inferior angle of the scapula, drawn to the outside and thickened by teres major, makes a marked prominence under the latissimus dorsi which embraces it. The superior border of latissimus dorsi may be followed as far as the arm pit because of the elongated relief of teres major. From the inferior angle of the scapula the triangular relief of the serratus anterior, covered by the latissimus dorsi, may be seen moving to the outside. The infrascapular region also changes, for, between the swelling of the spinal muscles and the inferior border of serratus anterior, the thoracic cage itself is now covered only by latissimus dorsi.

The deltoideus now seems like a heart on a playing card, the point directed above and the three portions of the deltoideus becoming reasonably clear. The integuments, forced back, create a wrinkle across the external extremity of the clavicle and the acromion process.

In front, when the arm is raised vertically, there are significant changes in the pectoral region. It seems to lose in breadth what it gains in height. The relief formed by its inferior border is practically effaced and the whole portion which supports the nipple is flattened. The external angle of the pectoral region is carried very high.

The inframammary region is marked by the digitations of the serratus anterior; their reliefs jut out sharply in front of the vertical swelling of the anterior border of the latissimus dorsi. When the arm is raised the latissimus dorsi is relaxed and models itself exactly over the hard digitations of the serratus anterior.

However, if the model raises his arm and attempts to pull down a resistant object or attempts to raise his own body, the latissimus dorsi becomes hard and smooth. Its muscular bundles stand out and their insertions into the sides of the thoracic cage become apparent. At the same time the serratus anterior becomes somewhat limp and compressed above and its digitations become less distinct and more oblique.

If the arms are extended horizontally to the outside they bring about modifications in the trunk which should be easily understood from the preceding study. Horizontal elevation is, after all, but the intermediate position between repose and vertical elevation—we find all the same types of modification in the forms but they are less accentuated. Note, however, that when the arm is raised to the horizontal the shoulder blade has already begun to rotate and the synergetic action of the serratus anterior is under way. This muscle does not follow the action of the deltoideus in the elevation of the arm but, as I have already pointed out, it accompanies the action from the beginning. In the front the pectoral region becomes an irregular quadrangle and when the arm is in horizontal

elevation the deltoideopectoral dividing line takes its place as a prolongation of the clavicle.

If the arm is moved to the front or to the back it carries the scapula with it. The scapula glides over the thoracic cage approaching or drawing away from the vertebral column. Certain modifications of form occur then which I shall describe only briefly because they are much like those brought about when the shoulder is moved to the front or to the back.

ARM PIT

When the arm hangs naturally alongside the body the arm pit is hardly more than a fold running from front to back. It is only when the arm is separated from the body that the hollow of the arm pit appears. As the humerus moves to the outside the muscles of the trunk that are inserted into it are carried with it. Three muscles form the walls of the hollow of the arm pit—the pectoralis major is responsible for the wall in front and latissimus dorsi and teres major for the one behind. The hollow of the arm pit is limited above by the fasciculi of the biceps and the coracobrachialis, and within it is bordered by the thoracic wall covered by the serratus anterior. It is upon this quadrangular space that the skin sinks in, due to atmospheric pressure. The skin is also maintained in this position by the resistant aponeurotic fasciae which are attached to the skeleton of the region (summit of the coracoid process, neck of the humerus, inferior surface of the articular capsule, neck of the scapula). They form a sort of vertical compartment.

The top and bottom surfaces of the arm pit seem to continue with no line of demarcation between them and the neighboring areas; the top rises into the arm and the bottom runs into the thorax. But the front and back walls of the arm pit form clear borders. The front wall is thick and rounded; it is formed by the deep and superficial fasciculi of the pectoralis major. The rear wall, which descends lower than the other, is composed of two surfaces—above by the surface of teres major, and below by the latissimus dorsi which at this level turns about the inferior border of the teres major. As a result the rear wall is longer than the front wall. This should be borne in mind on a back view of the model as the difference in length is not visible from this position.

In vertical elevation the hollow of the arm pit changes form. It then appears as a great vertical furrow bordered in the front by pectoralis major, and in the back by latissimus dorsi and the teres major. Above, the coracobrachialis forms a prominence which is usually most distinct in lean subjects. At this level the furrow divides in two. Its anterior branch, straight and deep, twists around the coracobrachialis and the biceps and follows the border of pectoralis major as far as its meeting with the deltoideus. The posterior branch, which is more superficial, mounts towards the internal surface of the arm where it becomes continuous with the furrow that separates the biceps from the triceps. We should also point out the oblique furrow on the outside which, as it leaves the hollow of the arm pit, rounds the base of the arm. It separates the teres major from the adjacent muscles—the triceps brachii on one side, and the posterior third of the

deltoideus on the other. When the arm is raised vertically the hollow of the arm pit is directed vertically from above to below and from the outside to the front. It encroaches upon the anterior surface of the torso.

There is no region more variable than the arm pit because it is modified at every moment by the varied movements of the arm. But it is not too difficult to recognize the muscular elements that I have pointed out. Certainly, they are the best guides for understanding and representing this region.

MOVEMENTS OF THE TRUNK

Let us now examine the changes of the form that follow the movements of the trunk itself. When the model is in the conventional position the torso may carry out movements upon itself or upon the lower limbs. We shall take up here the movements of the torso upon itself, since the movements of the torso upon the limbs are a matter of the movements of the thigh on the pelvis. However, these movements, because of their particular nature, are often associated—they complement each other and are often confused with each other—and they can be distinguished only by minute analysis.

ARTICULAR MECHANISM

The diverse movements of the trunk take place in the dorsal and lumbar sections of the spinal column, but the movements are not equally divided between these two sections.

Although the movements are, in fact, quite limited in the dorsal region, they are not absent. It is an error to think that the presence of the ribs transforms the column into a rigid and immovable stalk, and that the thoracic cage can only be moved as a whole. In reality all extensive movements of the lumbar column affect the thoracic cage and it tends to increase or correct these movements by compensatory displacement.

The lumbar region of the spine, though not as mobile as the cervical region, may nevertheless perform extensive movement in every direction. It directs the movements of the torso which may be reduced to three principal ones: movements around a transverse axis (flexion and extension); movements around an anteroposterior axis (lateral inclination); movements around a vertical axis (rotation).

In *flexion* the thoracic cage approaches the pelvis, the vertebral column curves to the front, the normal curve of the thoracic column is accentuated and the normal curve of the lumbar column is effaced and replaced by an inverse curve. All this takes place in such a way that the whole thoracic-lumbar column follows a curvilinear direction of anterior convexity. The most mobile point may appear to be in the superior part of the lumbar region but there are great differences among individuals.

This movement is limited by the resistance to compression of the anterior parts of the intervertebral disks and by the distension of spinal ligaments (see Plate 7).

Extension is produced by a straightening of the thoracic region and through an exaggeration of the normal curve of the lumbar region. The limit of extension is more rapidly attained than that of flexion.

In *lateral inclination* the ribs almost come into contact with the iliac crest. The vertical direction of the articular surfaces of the lumbar column renders this movement independent of the movement of rotation (this is not the case in the cervical column). These two movements of rotation and lateral inclination often take place together. It is only for purposes of description that we separate them.

By itself the movement of rotation of the vertebral column is quite limited—much more than students imagine. This is because the movement is usually accompanied by a movement of rotation of the pelvis on the femurs, and by a twisting of the shoulders which makes the movement of the vertebral column seem more extensive.

MUSCULAR ACTION

When we recall the role that gravity plays upon muscular action and the sort of paradox that results we can understand why the extensors contract in flexion of the trunk and the flexors contract in extension. But we must also remember that this is true only in accentuated movements and in those where there is no resistance to overcome.

Flexion is caused by muscles of the abdomen—the rectus abdominis, the obliquus internus, and the obliquus externus abdominis. *Extension* is caused by the spinal and lumbar dorsal muscles, and by the transversospinal muscles beneath them. The action of these last is not revealed on the exterior.

Lateral inclination is caused by the iliocostalis lumborum, the quadratus lumborum, the intertransversarii of the lumbar region and the obliquus internus and externus.

In movements of *rotation*, two muscles, obliquus internus and longissimus dorsi, turn the anterior surface of the trunk to the side where they are situated. The obliquus externus and the transversospinal muscles turn the trunk to the opposite side.

EXTERIOR FORM DURING MOVEMENTS OF THE TRUNK
(PLATE 94 and 95)

Flexion of the trunk. Since we have given a detailed description of the trunk in the upright figure, we shall only mention briefly the changes that take place in the regions we have studied.

In front the forms of the chest change very little. The belly, however, diminishes greatly in height. It is divided by a deep fold which crosses it either at the level of the navel, or a little above. On the sides this wrinkle touches a deep depression at the bottom of which one senses the costoabdominal prominence which has now disappeared. The fold is often accompanied by several other less pronounced wrinkles which are below, at the level of the navel or slightly above it. The inframammary region is slightly altered by the flexion wrinkles of the compressed integument. Finally, the demicircular line of the abdomen, which is four or five fingers' breadth below the navel, becomes a deep fold. The region below the belly tends to stand out and the lines which border it below, the transverse line of the pubis and the line of the groin, are accentuated.

The flank diminishes in height in the front where it forms a sort of cushion which effaces the lateral line of the belly. The iliac line descends a little, its posterior part tends to disappear.

On the sides the anterior borders of the latissimus dorsi form a strong relief.

The forms of the back change considerably since they depend greatly on the position of the arms and the resulting displacement of the scapula. The infrascapular region is in clear view. In its inferior part the ribs may be seen between the reliefs formed by the inferior border of the serratus anterior and the spinal muscles.

Important modifications take place in the lumbar region. It becomes longer and its muscular and bony reliefs undergo changes. But, since these changes differ according to the degree of flexion, we should study this region in two positions: light flexion and forced flexion.

All the modifications of form of which we are now speaking depend on the degree of contraction or distension of the spinal muscles. In fact, at the beginning of the flexion produced by the powerful anterior muscles of the trunk the spinal muscles, although they are extensors, enter into the action. This is because of the law of synergy which applies to antagonistic muscles: their aim is to maintain the trunk and to prevent it from giving way to any action which might impel it to the front and which might be assisted by gravity. At all times, when there is flexion in front, the spinal muscles are in contraction until the movement reaches its limit and the contraction becomes useless. When this happens these muscles are in a state of extreme distension which does not allow them to contract again without bringing the trunk towards extension.

Light flexion. In the upright position, when the trunk is balanced upon the femurs, the spinal muscles are not at all contracted, nor are the gluteal muscles. But as soon as the trunk falls to the front, all of them contract.

The lateral lumbar fossets become modified; the superior ones tend to disappear, while the inferior ones become more evident because of the contraction of the adjacent muscles, which, as we have seen, are the sole reason for their existence.

On each side of the median lumbar furrow, at the bottom of which the prominence of the lumbar spinous processes are evident, the spinal muscles offer several prominences which differ in form and volume.

On each side, rising from the sacrum, there is a considerable linear prominence. It starts at the level of the inferior lateral fosset and forms a cord-like relief bordered by the lumbar line. It ascends in a vertical direction until its fibers disappear under the aponeurotic fibers of the latissimus dorsi. The prominence is due to the contraction of the muscular and aponeurotic fibers of longissimus dorsi. At its external border, a little above the superior lateral lumbar fosset, there is a second prominence, stronger than the first and globular at its base. This second prominence rises into the dorsal region where it may be clearly seen underneath the fleshy body of the latissimus dorsi.

The second prominence is due to the fleshy fibers of the iliocostalis lumborum which run over the spinal aponeurosis. Its internal border ascends obliquely

towards the vertebral column and reaches different heights on different subjects. On those whose spinal muscles are well developed, this relief joins the median line lower than the relief of the latissimus dorsi and below this point it creates a second line running in the same direction. This second line follows the insertion of the fleshy fibers of iliocostalis lumborum and longissimus dorsi to their spinal aponeurosis.

On the outside of the relief of iliocostalis lumborum there is a line which descends to the superior lateral fosset, the lateral *line of the loins* (according to Gerdy). This is usually invisible in the upright position.

The buttocks are narrow, globular, touching on the median line, and the depression behind the great trochanters is marked. All these forms become distinct morphologically if the gluteal muscles contract.

Forced flexion. The forms which we have just described change considerably. The inferior lumbar fossets are replaced by the prominences of the posterior superior iliac spines because of the flattening of the muscles which surround them. For the same reason the median lumbar furrow is replaced by the prominences of the sacral vertebrae. However, there is always a depression on the median line at the point of junction of the sacrum and the vertebral column.

The median lumbar furrow sometimes disappears completely; it is replaced by a medial fusiform swelling caused by the prominence of the lumbar crest. This projection is never uniform; it is marked by protuberances that correspond to the summits of the spinous processes of which there are usually five. They vary greatly, however, as to number and regularity. At the junction of the dorsal column and the lumbar column, there is usually a depression; above it the dorsal crest often projects. So much for the forms caused by the bones. The muscular reliefs are much simpler. There is one on each side, a short distance from the median line. Each one is somewhat ovoid, developed in proportion to the development of the spinal muscles. These reliefs originate between the lumbar fossets and rise above the confines of the lumbar region.

The buttocks are large and flat because of the distension of the gluteal muscles. The muscular and aponeurotic fibers are clear beneath the skin.

Extension. The movement of extension of the trunk seems to have its center at the inferior part of the lumbar column. It is at this level, the level of the superior lateral lumbar fosset, that the summit of the angle between torso and pelvis is created. It is here that transverse cutaneous wrinkles appear.

Thus the lumbar region is greatly modified. The lateral reliefs of the spinal muscles form two rounded masses, soft to the touch and marked by big transverse wrinkles due to the fact that the fleshy bodies of the muscles themselves are relaxed. In fact, the spinal muscles enter into contraction only if the movement of extension is produced with effort or if it encounters resistance (see page 107). The lumbar fossets hollow out and the lateral superior fossets disappear in the bottom of a fold which continues on the outside with the iliac line and ends a little below it.

The width of the flanks diminishes in the back in the neighborhood of the loins. The superior part of the space between the ribs and pelvis is marked by a transverse depression. This space contains the fatty cushion which is at times distinct from the relief formed by the obliquus externus abdominis. The obliquus externus abdominis is depressed in front and enlarged on the sides. It is extended in its anterior part, where its fasciculi may be seen, and it is relaxed in the back.

The anterior superior iliac spine becomes most prominent. The iliac line is effaced at its anterior part, whereas, in the back, it becomes deeper and descends slightly.

The belly is flat and stretched throughout. Its costal borders are clear under the skin. The chest undergoes no modifications worthy of notice, unless these are brought about by the movements of the arms which we have studied.

Lateral inclination (Plates 97 and 98). The lumbar column may curve laterally. If this is the case the summits of the spinous processes are often visible curving in the same direction at the center of the median lumbar furrow. The curve of the median lumbar furrow varies among individuals. Usually it is uniform, disposed equally throughout the region as it continues above with the column of the back. But occasionally it is more angular, and the vertebral column follows a broken line, the break corresponding to about the middle of the lumbar region.

On the side of the convexity, that is to say on the side opposing the inclination, there is a relief in the lumbar region which mounts as far as the dorsal region. It is due to the contracted spinal muscles. On the opposing side these muscles are relaxed and the prominence they form is crossed by transverse wrinkles which reach the region of the flank. If, however, the movement is made with effort or encounters resistance, the spinal muscles tend to contract on the side of the inclination.

The flanks are the region of the trunk where the results of lateral inclination are most apparent. The two sides are greatly modified in an inverse sense. On one side the flank is lengthened, flattened and stretched, on the other it is diminished, gathered upon itself and swollen. These changes of form are a natural consequence of the approach on one side of the thoracic cage toward the pelvis, and the separation on the other side of these two bony pieces one from the other.

Thus, on the side of the flexion, the flank forms a sort of swollen cushion marked by several transverse wrinkles. These are not particularly distinct in the back in the region of the loins, but they become more delineated in front. They are bordered below by the iliac line which now becomes transformed into a deep furrow. The flank is limited above by a fold which corresponds to the top of the space between the ribs and the pelvis, and which, depending on the relaxation or contraction of intervening muscles, stops on the side or continues to the vicinity of the navel.

On the side opposite the flexion there is a feeling of flatness about the whole region. The iliac line is effaced, as well as the relief of the iliac crest, and the costoabdominal prominence. The two lateral lines which limit the flanks in the front and back are hardly visible.

There are no appreciable modifications in the abdomi-

nal region below the navel. The center of the movement evidently exists above, and it is in the region above the navel that the median abdominal line curves laterally, responding in front to the curve of the median lumbar furrow in back. From this result obvious modifications in the modeling of the surface of the rectus abdominis.

Rotation of the trunk (Plates 99 and 100). In the upright position the rotation of the trunk is almost always accompanied by a movement of rotation of the pelvis on the femoral heads. At the same time there is a movement of the shoulders, one moving to the front, the other to the rear.

It is in the region of the belly and the loins that modifications appear due exclusively to rotation of the torso. These are, however, very slight as the movement itself is always of small extent. We must remember that the two sides of the spinal lumbar muscles do not contract at the same time except in pure flexion. If the movement of rotation is made without effort the contraction of the spinal muscles takes place to oppose the direction of this movement. But if the movement encounters resistance the spinal muscles on both sides contract. Although the oblique muscles of the abdomen are also rotators, a comparison with the spinal muscles is hardly possible. We have, on each side, two superimposed oblique muscles of which the fibers are directed inversely and which act in opposition. Whatever the direction of the rotation there is always a muscle contracted on each side, either the superficial muscle or the deep one.

The most important changes that take place in rotation of the trunk occur at the superior part of the torso and they are influenced by the associated movements of shoulders and hips (Figure 16). We have already studied the forms which result when the shoulders are moved either to the front or back (see page 103).

As for the movements of rotation of the pelvis on the femurs, they are brought about by the rotators of the thigh. The fixed point of these muscles is accordingly displaced from the pelvis to the femur. Rotation of the thigh is brought about by the concurrence of antagonistic muscles acting on each side of the body.

It is because of concurrence that we find great differences between one side and the other on the hips and the buttocks. On the side opposite that to which the movement is directed the posterior part of the gluteus medius makes a distinct relief above the buttock, the gluteus maximus itself contracts and the hollow behind the great trochanter is accentuated. At the same time on the side to which the action is directed the anterior part of gluteus medius, raised by the anterior part of gluteus minimus, makes a marked relief.

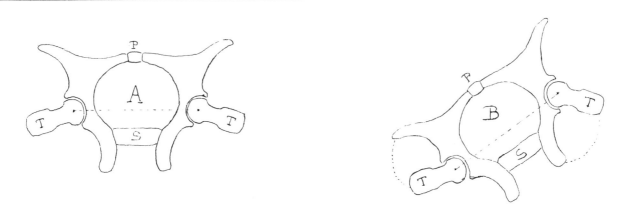

Figure 16. (left) These two schematic figures show the movements of the pelvis during rotation of the trunk. In A the pelvis is in its normal position. (P) Pubis. (S) Sacrum. (T) Great trochantor.

(right) In B, the pelvis is shown during rotation to the left. (P) Pubis. (S) Sacrum. (T) Great trochantor. Note: when the pelvis is drawn in the same direction as the trunk, it pivots on the two femoral heads. This movement is brought about by the rotator muscles of the femur, and the fixed point of these muscles is transported from the pelvis to the femur.

16. Exterior Form of the Upper Limb

We should remember that in the conventional attitude used for study the arm is placed in extension with the palm turned to the front (supination). We shall take up successively the shoulder, the upper arm, the forearm, the wrist, and the hand.

SHOULDER (PLATES 80, 81 and 82)

So far we have only studied the most prominent part of the shoulder, commonly called the point of the shoulder. As far as anatomy is concerned, the scapula region belongs to the arm, but from the point of view of morphology, it belongs to the trunk. Thus we have already studied it as part of the trunk.

Rounded in form, the shoulder projects beyond the acromion process. A single muscle, the deltoideus, supported by the head of the humerus, occupies the region which is limited in the front by the deltoideopectoral line. In the back the limits are not so precise; the posterior third of the deltoideus more or less blends with the scapular region. The surface of the deltoideus swells out in the front, it is flat in the back, and it is depressed on the outside and below towards the level of its insertion. Actually, in the living model the deltoideus is much like that on a flayed figure, though the outline is much softer. The skin around the insertion of the deltoideus is thickened by an accumulation of fat which accentuates the depth of the deltoid impression.

UPPER ARM (PLATES 80, 81 and 82)

The upper arm has a cylindrical form in lean subjects and in women. However, if the muscles are developed, it becomes flat on the sides. It is wider from front to back than from side to side.

The whole anterior part of the upper arm is occupied by the elongated relief of the biceps brachii (see page 64). This muscle is bordered by two long lateral lines which become accentuated when the muscle is contracted and the biceps brachii takes on a globular form. When the arm is rotated to the inside, the lateral line is effaced and a new one appears. This new groove runs obliquely below and to the outside and it is due to a particular disposition of the aponeurosis which sheaths the muscle. The medial line, which separates the biceps brachii from the triceps brachii, is filled in by vessels and nerves which join each other at this point.

The posterior part of the upper arm has less uniformity than the anterior part because the detail of the triceps brachii is much more considerable than that of the biceps brachii. When the triceps is relaxed, the form is full and rounded but in contraction the various parts of the muscle are very clear (see page 65). The large plane of the common tendon becomes very distinct below. It is oblique from above to the inside and is surrounded by a number of fleshy masses. The most voluminous mass, situated above and to the inside, is due to the long head of the triceps. On the outside there is slightly smaller relief which is created both by the lateral head, and, at the bottom, by the median head which is not as large as the long head. The three heads of the muscle are separated by more or less distinct lines.

On the external surface of the upper arm, the biceps brachii and triceps brachii, separated above by the insertion of the deltoideus, draw even further away from each other as they descend. The space remaining is occupied by a slightly raised triangular surface, separated from the neighboring muscles by a superficial groove, which corresponds to the brachioradialis and the extensor carpi radialis longus. The line between these last two muscles is not evident except in forced flexion (Plate 104, Figure 1) or in pronation (Plate 101, Figure 3).

Two veins mount the upper arm. On the inside there is the basilic, which is hidden in the internal groove, and the outside, the cephalic, which rises along the external border of the biceps brachii until it reaches the detoideopectoral line.

ELBOW (PLATES 80, 81 and 82)

The anterior region of the elbow is known as the bend of the arm. The elbow corresponds on the skeleton to the articulation of the humerus with the radius and ulna. It is flattened in the anteroposterior sense.

BEND OF THE ARM (PLATE 80)

The following three muscular reliefs can be seen here. One, median and superior, is formed by the inferior extremity of the biceps brachii whose fleshy fibers descend more or less down the tendon, depending on the individual model. Two others on each side and further down surround the base of the median tendon of the biceps brachii.

Of these two reliefs, the internal one, which is rounded and elevated, is formed by the superior extremity of

pronator teres. The external relief, situated on a surface further back, corresponds to the brachioradialis. Between this last surface and the median projection of the biceps brachii there is another somewhat extended plane over which the biceps brachii itself descends. This corresponds to the brachialis muscle.

As a result of these forms the wrinkle of the bend of the elbow travels over three muscular reliefs. In extension of the arm it has the shape of a V opening to the front, the external branch being the deepest. Towards the point of the V one senses the cord formed by the tendon of the biceps brachii, but this cord becomes most apparent in flexion. When the flexion is extreme the bend of the elbow has a deep transverse fold.

The veins which travel over the anterior surface of the elbow take the shape of an M, the central V being formed by the union of the median cephalic on the outside and the median basilic on the inside. This last is usually the most voluminous and the most apparent. The lateral branches correspond to the accessory cephalic vein on the outside and the basilic on the inside (Plate 72).

The region is crossed transversally by several cutaneous flexion wrinkles which run fairly close together and are situated at the level of the tendon of the biceps.

Just outside this tendon there is a depression which is usually about the size of a finger tip but it is accentuated in fat subjects and in women. On the outside there are two other superficial wrinkles which are directed transversely and which become evident in slight flexion. These wrinkles are concave and their concavity is directed towards the center of the region. They are situated some distance above the others. One, the superior, crosses the swelling of the biceps brachii above the tendon. The other, the inferior, meets the anterior surface of the forearm.

POSTERIOR PART OF THE BEND OF THE ARM (PLATE 81)

The word *elbow* can be thought of as applying to the back of the region under discussion. Towards the middle of this part, but nearer the internal than the external border, the prominence of the olecranon is situated. This prominence is surmounted in extension by a transverse cutaneous wrinkle. In fat people and often in women, the transverse fold becomes so pronounced that it effaces the prominence of the olecranon and it may, in fact, dominate the morphology of the whole region.

The olecranon is bordered medially by a depression which separates it from the medial epicondyle. At the bottom of the depression the ulnar nerve is situated. On the outside there is a depression which is remarkable for its constancy. It is bordered above by the relief of the extensor carpi radialis longus. This depression lies at the level of the lateral epicondyle and it is called the condyloid depression. One can see, in fact, at this point both the medial epicondyle and the head of the radius, and even the interarticular line which separates them. In women and children the condyloid depression is known as the dimple of the elbow.

Between the olecranon and the condyloid depression there is a triangular surface turned to the inside. Its base blends with the external border of the olecranon and its summit blends into the depression. This surface corresponds to the anconeus muscle.

The internal border of this region is prominent, and the point of the medial epicondyle is easily seen. Above the point in lean subjects there is a projection of the form of a cord due to the intermuscular dividing membrane.

The external border is formed by the strong relief of the brachioradialis and the extensor carpi radialis longus which combine to fill the obtuse angle on the skeleton between the upper arm and the forearm.

FOREARM (PLATES 80, 81 and 82)

The forearm is flat in the anteroposterior sense, contrary to the upper arm which is flat laterally. It follows that in the lateral profile the maximum width of the arm is at the upper arm (Plate 82), while from the anterior or posterior views (Plates 80 and 81), the maximum width is at the superior part of the forearm. At its inferior part the forearm diminishes in volume and becomes rather block-like, though still cylindrical in form.

These changes in the volume of the forearm are dependent on the structure of the muscles of the region. For the most part these muscles are composed of a superior fleshy mass and a long inferior tendon. The proportion between the fleshy part of the muscle and the tendinous part varies with individuals. We have already observed that there are subjects with long muscles and others with short muscles. In the forearm this general observation has consequences that are important. Among subjects with short muscles the inferior tendinous portion dominates and forms a striking contrast with the superior part which is fleshy and massive. However, among subjects with long muscles it is the superior part which dominates, and even encroaches on the tendinous portion, thus giving the whole forearm a fusiform shape.

The anterior or palmar surface of the forearm is flat throughout and at its superior portion there are two muscular reliefs separated by a median surface. The external relief is made up of the fleshy body of the brachioradialis which is supported by the extensor carpi radialis longus, projecting a little on the outside. The internal relief is created by a group of muscles which form several distinct masses. The swelling of the pronator teres, which we have noted at the fold of the arm, occupies the superior part. This muscle is separated by a superficial line, running obliquely from below to the outside from a second swelling which is due to the palmar and the flexor muscles and continues to the outer border of the forearm.

The fibrous expansion of the tendon of the biceps brachii cuts obliquely across the internal muscular swellings, it constrains them, and is sometimes the cause of a furrow which runs perpendicular to the fleshy fibers.

These two masses (the external and the internal reliefs) divide the anterior and superior part of the forearm. In lean subjects they are separated by a large and superficial furrow parallel to the axis of the forearm. In well developed subjects this furrow is much less obvious. This is because the two muscular groups may join at the

middle and even cover each other partially, while the internal border of the brachioradialis may cover a muscle of the other group (see Plate 117).

The palmar surface of the forearm narrows at its inferior part. It has a somewhat round surface which is traversed along the middle by the tendons which appear at the wrist.

The posterior surface of the forearm has several distinct muscular swellings. It is naturally divided into two parts by the crest of the ulna, which becomes a furrow due to the adjacent muscles. On the inside there is a somewhat uniform surface traversed by veins and continuous with the internal border of the forearm. This corresponds to the flexor digitorum profundus covered by the flexor carpi ulnaris. This last through the intervention of an aponeurosis takes its insertion from the crest of the ulna. On the outside, there are muscles which appertain especially to the posterior surface of the arm. As a whole their reliefs are directed obliquely from above to below and from outside to within and these become most distinct when the hand is forcefully extended. There is, first of all, parallel to the ulnar furrow, the relief of the extensor carpi ulnaris, which seems to blend with the relief of the anconeus above. Next is the relief of the extensor digitorum, generally blending into that of the extensor digiti minimi. The swelling of the extensor digitorum starts at the condyloid depression and is at first quite narrow. A different furrow separates it from the muscles of the external border, which we shall now study.

The external border of the forearm has three muscular reliefs, each of which describes a distinct curve. First of all there is the curve of extensor carpi radialis longus. Then, far below in the tendinous portion of the forearm a new curve appears. It is formed by the two small fleshy bodies of the abductor pollicis longus and the extensor pollicis brevis blended together. The elongated relief of these two muscles starts, on the posterior surface of the forearm, from under the swelling of the extensor digitorum and descends obliquely towards the external border of the arm to fade away at the wrist. At that point we can see the two tendons of these muscles. Above them we find the relief of extensor carpi radialis brevis. This is clearly fusiform, it terminates in an inferior point and as a whole its direction is parallel to the axis of the forearm. It is contiguous, in the back, to the extensor digitorum and is separated above from the extensor carpi radialis longus by an oblique furrow which appears as a depression on the profile. The fleshy body of this latter muscle blends with the brachioradialis to form a mass which, although external in the neighborhood of the elbow, then descends obliquely towards the anterior surface of the forearm. This has been described above.

As to the internal border of the forearm it offers a uniform transition through its rounded surface between the front and back of the arm.

The veins obliquely crossing this region mount from the posterior surface of the wrist towards the anterior surface of the elbow. There are several on each side but they form two groups. Outside, there are the radial or cephalic veins, on the inside the basilic. There is also a median group on the anterior surface of the forearm. At the bend of the arm this group forms an M, the middle strokes of which accentuate the relief above them.

WRIST (PLATES 80, 81 and 82)

The wrist is situated between the hand and the forearm, though its precise limits are difficult to define. Like the forearm it is generally flat, thus it has an anterior or palmar surface, a posterior surface and two sides.

The palmar surface is crossed by flexion wrinkles, which are usually three in number. They are slightly oblique, their internal extremities being somewhat higher than their external extremities. The inferior wrinkle is the strongest, it borders the heel of the hand and undulates somewhat. The middle wrinkles, about a centimeter above, describe a simple curve of inferior convexity. The superior wrinkle is the same and is less marked. These wrinkles are accentuated even in light flexion of the forearm.

Besides these cutaneous wrinkles, the most notable reliefs on the anterior surface of the wrist are the longitudinal cords formed by the palmaris longus and the flexor carpi radialis. They do not exactly follow the axis of the forearm but they are directed very slightly from above to below and from the inside to the outside. It is important to note that the tendon of the palmaris longus, the thinner but the most projecting tendon, passes outside of the anterior ligament of the carpus. It is almost in the middle of the wrist. On the inside of this tendon there is a depressed surface corresponding to the tendons of the flexor muscles. This leads to the relief of the tendon of flexor carpi ulnaris, the muscle that creates the internal border of the wrist. Outside of the tendon of palmaris longus there is a depression where the inferior extremity of the radius may be sensed. Bordering it on the extreme outside is the tendon of the abductor pollicis longus.

A little to the outside of the tendon of palmaris longus there is a prominence on the wrist due to the scaphoid bone. This prominence blends below and towards the outside with the thenar eminence. It is separated from the hypothenar eminence by a slight depression. Isolated beneath the hypothenar eminence, very near the internal border of the region, the pisiform bone projects.

The dorsal surface of the wrist owes its principal morphological traits to the skeleton of the region. On the outside, the inferior extremity of the radius forms a large projecting surface. On the inside and on a slightly raised surface, the prominence of the styloid process of the ulna forms a smaller prominence. Finally, in the middle, the tendons of the extensor muscles are gathered together. It is not until they reach the hand that they form separate and distinct reliefs.

The two side views of the wrist each reveal a slight depression. The depression on the inside is quite flat and extends from the tendon of flexor carpi ulnaris in the front to that of extensor carpi ulnaris in back.

The external side of the wrist is traversed, at its middle and in the direction of the axis of the forearm, by the two united tendons of the abductor pollicis longus and extensor pollicis brevis. Posterior to these tendons,

below the styloid process of the radius, there is a depression limited by the tendons just mentioned and by that of the extensor pollicis longus. This is commonly known as the snuff-box.

HAND (PLATES 80, 81 and 82)

Strictly speaking, the hand is composed of the hand itself and the fingers.

The details of the hand are too well known for me to undertake a tedious description. I shall only describe the relationship of the exterior form to the underlying anatomy.

Body of the hand. Flattened from front to back, the hand has an anterior surface or palm, a posterior surface or dorsum, and two sides. The inferior border gives rise to the fingers.

The *palm of the hand*, depressed at the center, has at its borders several eminences of different shape and volume. The most prominent is at the outside and it corresponds to the base of the thumb. It is called the thenar eminence and is composed of two surfaces. The superior one, ovoid and projecting, rests on the bony prominences of the scaphoid and the first metacarpal; it corresponds to a muscular group of which the uniform relief is never divided. The lower one, depressed and of minor extent, corresponds to the external extremity of a single muscle, the abductor pollicis, which is superficial at this place.

At the internal side of the hand, the hypothenar eminence, due to a group of muscles of the same name, extends along the whole length of the hand, running without precise limitations within the hollow of the palm and the ulnar border of the hand. Above, the thenar and the hypothenar eminences come together without actually touching, and form the heel of the hand. Lower down the two eminences separate and, swerving away from the axis of the arm, they circumscribe the hollow of the palm. The hollow of the palm is limited below by an elongated transversal eminence which corresponds to the metacarpophalangeal articulations. This last eminence is not uniform. It reproduces the anterior concavity of the curve of the metacarpus itself which is created on either side of the hand by the projection of the bases of the index and the little finger. This eminence is also marked, when the fingers are extended and touching, by rising folds which correspond to the interdigital spaces. These are caused by small layers of fat which become folded by the tension brought about by the aponeurotic parts that adhere intimately to the deep surface of the skin of each finger.

The palm of the hand passes well below the inferior limits of the metacarpus and includes in its bony framework the superior extremities of the first phalanges.

Finally, the central depression which constitutes the hollow of the hand is maintained by the adherence of the skin to the palmar aponeurosis.

The palm of the hand is crossed by numerous wrinkles or lines, but they may be reduced to four — two principal and two accessory. They are caused by the movements of flexion of the fingers and adduction of the thumb (Figure 17).

The thenar eminence is encircled, within and below, by a long curved line which is accentuated in adduction. It is the *line of the thumb,* or life line. In flexion of the fingers a transverse line may be seen some centimeters from their base. Slightly curved, it starts at the internal border of the hand and fades away in the interdigital space between the index and middle fingers. It is created by flexion of the last three fingers and is called the *line of the fingers.* The flexion line of the index finger is actually the same as the lower extremity of the line of the thumb or life line. These are the two principal lines of the hand, but they give rise to two accessory lines that are not as profound. Thus, to the inside of the line of the thumb, there is a line which starts at the top of the hypothenar eminence and goes directly towards the space between the index finger and the middle finger. It is accentuated when the thumb is brought towards the little finger. Gerdy has called this line the *longitudinal line.* Finally there is the *oblique line* which starts at the

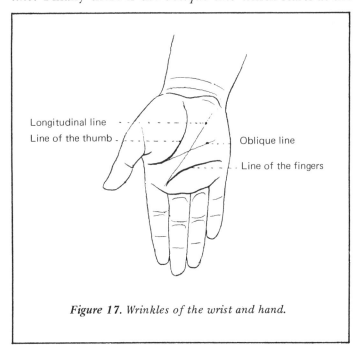

Longitudinal line
Line of the thumb
Oblique line
Line of the fingers

Figure 17. Wrinkles of the wrist and hand.

inferior extremity of the line of the thumb and goes towards the middle of the ulnar border of the hand. This is, of course, an accessory line to the flexion line of the fingers. It has been observed that the different lines of the hand form a capital M. The outside lines are the line of the thumb and the line of the fingers; the inside lines are the accessory lines that form the central V.

The dorsal surface or *dorsum of the hand* considered as a whole reproduces the general transverse convex form of the skeleton. The most prominent part corresponds to the second metacarpal. The surface of the region is the result of the combined forms of the anatomical elements of which it is composed — they are many. Let me mention the metacarpals and the muscles which project in the spaces between them; the lumbricales and the interossei. Also, the first dorsal interosseous running between the first and second metacarpal; the tendons of the muscles, which divide and diverge from the center of the wrist towards each finger; and the meandering and capricious veins, which come from the fingers and describe an irregular arcade of inferior convexity.

The internal side of the hand is rounded and thicker above than below. It is formed by the fleshy mass of the muscles of the hypothenar eminence which descend to embrace the inner side of the fifth metacarpal.

The external side of the hand is divided into two parts: an upper part which carries the thumb, and a lower part which corresponds to the metacarpophalangeal articulation of the index finger. The first metacarpal is situated on a plane anterior to that of the other metacarpals which is directed obliquely below and to the outside. Its anterior surface faces to the inside while its dorsal surface is directed to the back and to the outside. This dorsal surface is traversed by two tendons. First, there is the tendon of the extensor pollicis brevis, which is parallel to the metacarpal bone and is inserted into the superior extremity of the first phalanx. Second, there is the oblique tendon of the extensor pollicis longus. Above, this tendon runs some distance behind the preceding one but they join together at the level of the metacarpophalangeal articulation and run as far as the last phalanx. These two tendons are most visible during extension with abduction of the thumb.

In relation to the inferior border of the hand the longitudinal palmar folds mentioned above occupy a portion of the palmar surface inferior to metacarpophalangeal articulation. The inferior palmar line (see page 113) corresponds to the middle of the first phalanx of each finger. On the back of the hand the space between the fingers is modeled in such a way that it mounts up from the inferior palmar line to the level of the metacarpophalangeal articulation.

This inferior border is convex. On the back, when the fingers are flexed, it is most convex from the knuckle of the little finger to the middle finger, much less from there to the knuckle of the index.

The fingers. The remarks I have just made concern the relationship of the fingers to the hand itself. All the fingers (except the thumb) seem longer when seen from the back than from the front. On the dorsal surface the fingers seem to start at the metacarpophalangeal articulation. On the palmar surface, however, the palm of the hand descends almost as far down as the middle of the first phalanx of each finger and covers the metacarpophalangeal articulation so that the length of the finger is diminished.

The middle finger descends the lowest, the index scarcely reaches the root of the nail of the middle finger, and the so-called ring finger reaches about halfway down the nail of the same finger. The thumb reaches to the end of the first phalanx of the index, and the little finger to the end of the second phalanx of the ring finger.

Irregularly cylindrical, the fingers have four distinct surfaces, an anterior or palmar, a posterior or dorsal, and two sides. The backs of the fingers correspond almost exactly to the form of the bony phalanges. They are rounded, and marked at the articulations by transverse wrinkles which create an elipse. There are also a few wrinkles between the articulations.

The palmar surface of each finger is divided into three parts by flexion wrinkles. The superior one separates the fingers from the palm of the hand and this wrinkle is doubled for the two middle fingers (the middle finger and the ring finger). These two fingers seem somewhat narrowed at this level. Of the three segments into which the flexion wrinkles divide the fingers the middle one is the shortest. The wrinkle which limits the superior extremity of the middle segment is usually double, that which limits the inferior extremity is single. The skin of the palmar surface is doubled by a dense and elastic cellular tissue which is most abundant upon the last phalanx. The sides of the fingers are quite simple, save for the presence of the terminations of wrinkles coming from their dorsal and palmar surfaces.

All the fingers have three phalanges except the thumb which has two.

ROTATION OF THE ARM

The movements that occur during elevation of the arm have been studied with the trunk, as well as the modifications these movements cause in the upper part of the body. However, we have reserved until now a study of rotation of the arm because there is an intimate connection between rotation of the humerus and the movements of supination and pronation of the forearm.

Mechanism. The head of the humerus, which is almost spherical, turns upon itself in the glenoid cavity of the scapula. This movement is performed about an axis which passes through the head of the humerus and continues below with the axis about which the movements of pronation and supination are made. The amount of rotation allowed to the humerus does not exceed 90° and this may be checked on the living model by observing the medial epicondyle. This prominent landmark will be seen to scarcely describe a quarter of a circle. Although the movement of rotation starts at the upper arm through the rotation of the humerus, it may be continued at the forearm through the movements of pronation and supination.

These last movements take place in the articulations which unite the two bones of the forearm at their superior and inferior extremities. In the superior articulation, the head of the radius turns upon itself in the annular ring which surrounds it. In the inferior articulation, the inferior extremity of the radius describes an arc around the head of the ulna of almost 120 degrees. The ulna remains supposedly immobile and the radius carries the hand with it.

In rotation of the forearm the radius is not, as is generally supposed, the only bone which is displaced. The ulna contributes an inverse movement as we have already seen (see page 38). If we wish to really study the movements of the radius and ulna by themselves, the forearm must be flexed. It must be understood that this flexion in no way hinders the rotation of the two bones of the forearm; they are absolutely independent of the rotation of the humerus. If one considers the relative positions of the two bones of the forearm in various degrees of rotation, one observes the following. In the attitude of supination the two bones are side by side and parallel, but not altogether in the same plane, the radius being situated in a plane anterior to that of the ulna. As soon as the movement of pronation starts

the head of the radius turns in its fibrous ring and the inferior extremities of the two bones are displaced in inverse directions; the radius moves to the front and the ulna to the back. To the extent to which pronation is increased these movements become proportionately accentuated. Finally, at the limit of pronation, the inferior extremity of the ulna becomes external and the inferior extremity of the radius becomes internal, yet the two bones are not in the same transverse plane they were when they started. They are now in a plane slightly oblique to the initial plane. The result is that the movement of each extremity is no more than a demicircumference.

If the rotation of the humerus and the rotation of the forearm take place together the combined rotation is about three quarters of a circle.

The amount of rotation may be clearly understood by a study of the forms and the figures in Plates 101, 102, and 103. The hand is shown first in supination, the palm turned to the front; second, in demipronation, the palm turned within; and third, in pronation, the palm turned to the back. In forced pronation, which is the limit of the movement of rotation, the hand is turned to the outside. However, the hand can never turn so much that it faces the front again.

MUSCULAR ACTION

The movement of rotation of the arm is produced to a great extent by deep muscles. Thus rotation of the humerus to within is brought about by the subscapularis, a muscle situated under the shoulder blade. Its action is complemented by the teres major, which constitutes part of the scapular region, and by two other muscles which influence the exterior form considerably—the latissimus dorsi and pectoralis major. However, the last two muscles only intervene when the movement is violent. Rotation to the outside is produced by the infraspinatus and teres minor, both muscles of the scapular region.

In the forearm, supination is produced by the supinator and the biceps brachii; pronation, by pronator quadratus which is buried in the deep layers of the anterior inferior region of the forearm, and by pronator teres.

MODIFICATION OF EXTERIOR FORM (PLATES 101, 102 and 103)

When the arm is extended the movements of supination and pronation of the forearm never take place independently of the rotation of the humerus. If the arm is in supination, as soon as pronation starts the humerus begins to rotate. This rotation is very slight at the beginning of the movement. It is only when the pronation of the forearm reaches its limit that the rotation of the humerus becomes clearly accentuated, continuing and complementing the rotation of the lower arm.

We therefore cannot separate, in the study that follows, the rotation of the upper arm from that of the forearm. We have to study the morphological modifications down through the whole extent of the arm. Four stages of the movement of rotation of the arm—supination, demipronation, pronation, and forced pronation —are illustrated in Plates 101, 102, and 103.

It should be observed that the forms of the trunk are modified by these movements. In the front the pectoralis major, relaxed in supination, contracts according to the amount of rotation it produces. In forced rotation it becomes hard and projects. It is then almost spherical in form and the fasciculi appear on the surface. In the back the two scapulae, at first close together, separate. The point of the shoulder tends to be carried to the front, although this is most marked at the end of the movement. The deltoideus, at first in repose, undergoes a movement of torsion upon itself; beneath the skin its distinct fasciculi undergo a sort of twisting around the head of the humerus. The muscles of the arm, the biceps and triceps brachii, undergo the same sort of twisting and this is expressed on the exterior form by an obliquity, or spiraling almost, of the muscular eminences and the depressions which separate them.

The forearm also shows a number of changes in its general shape. Flat in supination, it becomes rounded in pronation; this is because of the superimposition of the two bones which fall across each other. Plates 101, 102, and 103 perhaps explain this better than a long and difficult verbal description. The artist should be able to follow easily the displacement of the different muscles by studying the anatomical sketches. It should be noted that the wrist retains its somewhat block-like form and it will always seem longer in supination than it does in pronation.

MOVEMENT OF THE ELBOW

Mechanism. Let me restate here that the articulation of the elbow is an actual hinge that only permits a single sort of movement (see page 38)—a movement of flexion and extension around a transverse axis passing through the inferior extremity of the humerus. This axis is not perpendicular to that of the arm but is a little oblique from above to below and from outside to within. Due to this fact the forearm does not flex directly upon the arm. Instead of meeting the shoulder, the hand is carried somewhat to the inside.

In flexion, the anterior surfaces of the forearm and the upper arm only touch near the elbow joint.

This movement is limited by the meeting of the coronoid process of the ulna with the coronoid fossa of the humerus. Extension brings the two segments of the arm into the same plane. However, sometimes the limit is passed and the forearm forms an obtuse angle opening to the back with the upper arm. I have observed this disposition, which should be classified as an acquired deformation, among certain subjects who have often performed the movement of extension with violence, such as boxers.

MUSCULAR ACTION

Extension is produced by two superficial muscles, the anconeus and the triceps brachii. Their action strongly affects the exterior form.

The lateral and medial heads of the triceps act with equal force during extension. The long head is, however, only a feeble extensor—its principal function is to fix

the head of the humerus solidly against the glenoid cavity when the arm is lowered.

Flexion of the forearm on the upper arm is produced by three flexor muscles and one of them has an additional function, the biceps brachii is not only a flexor but a supinator.

As I have pointed out, movements of supination and pronation may be executed perfectly even though the arm is flexed. If these movements are made with effort, the adductors and abductors of the arm enter into contraction. That is why, during supination, the elbow approaches the body, while during pronation it moves away.

MODIFICATION OF EXTERIOR FORMS (PLATE 104)

We have already described the forms of the arm when the arm is extended because full extension is part of the conventional attitude used for study. In this position the triceps brachii only becomes contracted when the extension is carried to its extreme limit or when it is forced. As a matter of fact, when the arm falls naturally alongside the body extension is maintained by gravity. This extension, however, is never complete.

When the arm is flexed, the triceps brachii is distended and the posterior surface of the arm becomes quite flat. In the front, the biceps becomes globular, forming a swelling which grows larger according to the effort made and the degree of flexion. As the brachialis is also contracted, its superficial relief becomes distinct and is bordered by deep grooves.

If flexion is produced (the lower arm being in demi-pronation) so that the forearm is at a right angle with the upper arm, and if action is performed with muscular effort as in the act of lifting a weight (Plate 104), then the brachioradialis will create a relief distinct from that of the extensor carpi radialis longus. In all other positions these two muscles seem to blend together. During the action described above the tendinous expansion of the biceps brachii, stretched by the muscle's contraction, will cut a deep furrow across the internal mass of the forearm.

Flexion of the forearm may at all times be accompanied by any degree of pronation or supination. I should like to point out that this produces rather complex forms which I do not think it necessary to describe.

Finally, if flexion is carried to its furthest limit, the back of the elbow takes on an angular form, its point being the olecranon.

MOVEMENTS OF THE HAND

The movements of the hand on the forearm are of two types. They take place about two axes. Movements of flexion and extension take place around a *transverse* axis and movements of adduction and abduction take place around an *anteroposterior* axis.

Flexion and extension take place in the radiocarpal articulation.

Flexion is more extended than extension and it easily attains a right angle, that is to say the hand may be placed in a plane perpendicular to the plane of the fore-arm as long as the fingers are completely extended. As a matter of fact if the hand is clenched, the movement of flexion allowed is much less and the hand can only make an obtuse angle with the forearm. This is due to the fact that the extensor muscles of the fingers, already extended by the flexion of the fingers, restrict the hand from any further flexion.

In extension the hand always forms an obtuse angle with the forearm opening to the back. But the simultaneous flexion of the fingers augments the extension of the hand—the reason for this is analogous to the inverse movement I have just mentioned.

The movements of adduction and abduction take place in the radiocarpal articulation. Adduction is extensive; abduction is somewhat limited.

MUSCULAR ACTION

There are three extensor muscles and they each have a special action.

The extensor carpi radialis longus is an extensor and an abductor, and the extensor carpi ulnaris is an extensor and an adductor.

If the extension of the hand is made with effort, the three muscles contract simultaneously. Flexion of the fingers is always accompanied by the synergetic contraction of the extensors of the wrist.

There are three flexors: the palmaris longus, the flexor carpi radialis, and the flexor carpi ulnaris.

These muscles are synergetic with the extensors of the fingers. When they contract they make an easily visible relief because of their superficial situation on the forearm.

Lateral inclination. In abduction the hand inclines away from the body, in adduction, towards the body. Abduction is largely induced by the extensor carpi radialis longus and by the abductor pollicis longus. Adduction is produced mostly by the extensor carpi ulnaris.

MODIFICATION OF EXTERIOR FORM

In flexion of the wrist the heel of the hand is pushed within and numerous cutaneous wrinkles appear. The tendons of the flexor muscles make strong cord-like prominences on the anterior surface of the wrist. These prominences vary depending on whether the muscles are being used to move the fingers or the wrist. Therefore, the modeling of the anterior surface of the forearm depends on whether the flexors of the fingers or the flexors of the wrist have gone into action. When the hand is flexed the posterior surface of the wrist becomes rounded. The rounded upper surface of the capitate bone becomes prominent medially and above it the two lateral prominences of the inferior extremities of the bones of the forearm appear.

Extension of the hand effaces the flexion wrinkles on the anterior surface of the wrist. The relief of the scaphoid becomes exaggerated and tendons of the distended flexor carpi radialis and palmaris longus disappear at the vicinity of the wrist. On the back the summit of the angle formed by the hand and forearm is filled by a sort of intermediate inclined plane situated

close to the radial border. Beneath this surface the tendons of the extensor carpi radialis longus and brevis muscles run to their insertion in the metacarpus. Several cutaneous wrinkles limit the surface above and below.

On the forearm the fleshy bodies of these two muscles can be clearly seen.

MOVEMENTS OF THE FINGERS

Mechanism and muscular action. In flexion the different sections of the fingers form right angles between themselves, though this angle may be surpassed in the articulation between the phalanges. An exception must be made for the thumb, where the angle of flexion is less. In extension the phalanges arrange themselves in a straight line. However, this movement is usually more extended at the metacarpophalangeal articulation, and the fingers may form an obtuse angle with the back of the hand.

However, in this regard, there are many individual variations. The movements of the index finger are free; those of the last three fingers are interdependent.

Only the movements of flexion and extension can take place between the phalanges. However, at the metacarpophalangeal articulation lateral movements occur. There the fingers may withdraw from the axis of the hand (abduction) or approach it (adduction).

The thumb owes its varied and extended movements mostly to the mobility of the first metacarpal and from this mobility varying movements of apposition result. Normally the thumb lies on an anterior plane, the palmar surface of the thumb being directed a little to the inside. In movements of apposition the palmar surface of the final phalange of the thumb may touch successively the extremities of each of the other fingers. This movement is accentuated by the great mobility of the last two metacarpals and above all by that of the fifth. This last may move in an analogous action to meet the metacarpal of the thumb.

The muscular action which controls the movements of the fingers is most complex. Though an understanding of this is necessary for doctors, I do not think it is necessary for artists. It is sufficient to remember that a certain number of the muscles that move the fingers have their fleshy bodies on the forearm and their forms naturally undergo changes even when the fingers are moved but slightly.

I should also like to point out the synergetic action of the flexors of the fingers and the extensors of the thumb when the fist is clenched, as well as that of the extensor carpi ulnaris during abduction of the thumb.

MODIFICATIONS OF EXTERIOR FORM

I shall be brief in my description of the exterior forms of the hand as everyone has them directly under his eyes. In flexion, the dorsal wrinkles of the fingers are effaced and the angular bony projections which replace them are due to the inferior extremities of the bones which occupy the superior parts of the articulations. In the metacarpophalangeal articulation, the head of the metacarpal is surmounted by the tight cord of the extensor tendon and as a result the exterior form does not correspond to the rounded surface of the head of the metacarpal but takes on an angular aspect. On the palm the lines of the hand are best understood if they are simply thought of as flexion wrinkles of the fingers and flexion wrinkles of the thumb. In movements of apposition of the thumb to the other fingers, the hollow of the hand becomes deeper, while the dorsal surface becomes more rounded.

17. Exterior Form of the Lower Limb

We shall study successively the thigh, the knee, the lower leg, and the foot.

THIGH (PLATES 83, 84, 85 and 86)

The thigh is rounded and fusiform in shape only on fat subjects and on most women. As soon as the musculature is slightly developed, the thigh is seen to be formed of the three distinct muscular masses we have studied above. They are disposed this way: in the front and to the outside there is the mass of the quadriceps femoris; within and above, the mass of the adductors; and in the back, the hamstring group.

The anteroexternal mass fills the whole external surface of the thigh and only a part of the anterior surface. On the outside this mass starts beneath the great trochanter and descends to the knee. Its surface corresponds to the relief of the vastus lateralis restrained by the strong aponeurosis of the fascia lata. The tensor muscle makes a distinct eminence beneath this aponeurosis which runs from the iliac crest in front of the great trochanter. The relief of the vastus lateralis is limited in the back by a deep furrow—the *external lateral furrow*. In the front the relief blends with the swelling of the rectus femoris and the vastus medialis. The quadriceps femoris occupies the anterior and inferior part of the thigh and it is limited on the inside by the oblique surface of the sartorius. It starts above with the depression previously referred to as the femoral depression. This depression is caused by the separation of the two muscles which fall from the anterior superior iliac spine—the sartorius and the tensor of the fascia lata.

The bottom of this depression rests on the tendon of rectus femoris which disappears upwards towards the anterior inferior iliac spine where it takes its origin. The fleshy body of this same muscle, which is situated at the middle of the anterior surface of the thigh, reproduces on the side view the curve of the femur on which it rests. On the whole the rectus femoris does not form a distinct relief unless it is contracted; this relief is fusiform and is marked at its superior middle line by the superior aponeurosis of the muscle.

Below and to the inside of the thigh the vastus medialis creates a sort of ovoid mass the point of which is lost, above, between the rectus femoris and the sartorius. The larger portion descends as far down as the middle of the patella. There is often a distinct relief

formed at that point by the muscle's most inferior fibers. We shall study these with the knee.

The surface of the sartorius scarcely merits a special description. It cuts obliquely across the thigh, passing from the anterior surface to the internal surface and it corresponds exactly to the description of the muscle we have already given (see Plate 127). Above, the surface of the sartorius is reduced to a minor furrow. The whole mass of the adductors is situated above and behind it and fills the angle described by the sartorius and the fold or line of the groin. As the adductor mass descends, increasing in volume, it fills the whole internal and superior part of the thigh. It is made up of all the adductors including the gracilis, but no particular muscle stands out individually. In the back the adductors blend into the posterior mass of the thigh without leaving a line of demarcation. The posterior surface is traversed by the saphenous vein.

In the back the thigh forms a rounded relief at its superior part which extends from the internal border to the external lateral line or furrow. Above, this rounded relief is separated from the buttock by the fold of the buttock and at that point it forms a slight swelling. This swelling of the thigh becomes narrower as it descends. Lower down it is bordered by two furrows — one on the inside, which is limited by the surface formed by the tendons of the gracilis, the semitendinosus, and the semimembranosus, and one on the outside, which is a continuation of the lateral line of the thigh.

In fat subjects these muscular reliefs become minimized and the thigh, as I have said, takes on a rounded and fusiform aspect. This is usually characteristic of women. Let me bring to your attention the fact that women have a veritable parcel of fat at the external and superior part of the thigh (see page 79). This disposition is found at its highest degree of development, along with steatopygia, among the female South African Bushmen and the African Hottentots. It may also be observed frequently in the white race in various degrees of attenuation.

KNEE (PLATES 83, 84, 85 and 86)

The knee, situated between the thigh and the lower leg, corresponds to the articulation of the femur and tibia. Considered together the condyles of the femur surmounting the tuberosities of the tibia constitute a quad-

rangular mass. The patella projects in front of this mass and the inferior extremity of the patella almost descends to the articular interplane. The knee, therefore, offers four surfaces: an anterior surface, two sides, and a posterior surface, or bend of the knee.

Important changes are caused in the morphology of the anterior region of the knee through the contraction of the muscles of the thigh. The upright position is not necessarily accompanied by a contraction of the quadriceps, the extensor muscles of the thigh. But if the muscles do contract, the patella is raised, it is applied more directly against the bony surfaces, the integument stretches, and certain reliefs disappear.

Let me describe the knee both in extension and in muscular repose.

The patella dominates the middle of the region. Its upper border or base presents two rounded angles. On its posterior surface there are two facets. Its anterior surface juts forward further on the model than on the skeleton because of the serous bursa beneath it. Its inferior angle, which continues into the patellar ligament (ligamentum patellae), is ordinarily masked by a light transversal swelling of the skin that joins the two lateral prominences formed by the infrapatellar pad of fat. These prominences jut out on each side of the patella. On the median line below the patella, the patella ligament only shows on the exterior when the quadriceps is contracted. During muscular relaxation this region is often cut by a transverse cutaneous furrow which becomes deeper the more the muscle is relaxed. This furrow is very deep on the leg of the standing side of the Doryphoros of Polycleitus (see Figure 20 page 121).

When this furrow is not present, the region below the patella has a heart-shaped relief, the point of the heart descending to the anterior tubercle of the tibia where the patella tendon is inserted. The top of the heart corresponds to the two lateral fatty prominences embracing the downward point of another smaller prominence created by the inferior angle of the patella itself.

Above the patella there is a surface which corresponds to the inferior tendon of the rectus femoris. This is bordered laterally by the unequal swellings of the inferior extremities of vastus medialis and vastus lateralis.

The region above the patella should be studied in some detail (Figure 18). There is a furrow well above the patella formed by a portion of the lowest part of the fleshy body of the vastus medialis. The most inferior part of this muscle forms a swelling which is distinct from the rest of the muscle under certain conditions and under the influences of a special anatomical disposition. The most inferior fibers of the vastus lateralis often produce an analogous relief.

These forms, which might be called the inferior protuberances of the vastus medialis and of the vastus lateralis, appear clearly when the leg is extended and the model is standing at ease. They coincide with muscular relaxation and are even more evident when relaxation is complete. If the muscle contracts (the leg being in extension), they are less evident and in certain subjects disappear altogether. The separate inferior protuberance of the vastus medialis, even in slight flexion, sometimes remains distinct among subjects with extremely well developed muscles. Generally, however, this protuberance

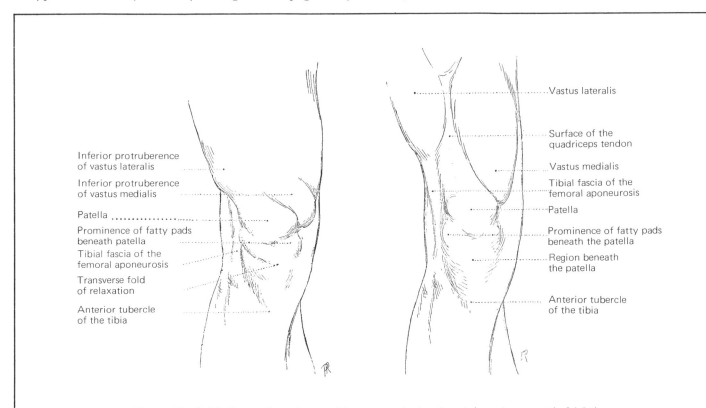

Inferior protruberence of vastus lateralis

Inferior protruberence of vastus medialis

Patella

Prominence of fatty pads beneath patella

Tibial fascia of the femoral aponeurosis

Transverse fold of relaxation

Anterior tubercle of the tibia

Vastus lateralis

Surface of the quadriceps tendon

Vastus medialis

Tibial fascia of the femoral aponeurosis

Patella

Prominence of fatty pads beneath the patella

Region beneath the patella

Anterior tubercle of the tibia

Figure 18. (left) Knee when the quadriceps muscle is relaxed (anterior aspect). (right) Knee when the quadriceps muscle is contracted (anterior aspect).

disappears, as does that of the vastus lateralis, because these are distended due to the increased flexion of the leg (Figure 19). These forms often exist among young subjects and also among women (see page 121), but they are not as clear as those on well developed subjects and sometimes they are more or less masked by subcutaneous fatty tissue.

Artists, both ancient and modern, have represented these muscular reliefs with remarkable frankness and exactitude.*

From the morphological point of view, these reliefs have the following characteristics. The vastus lateralis forms the most superior relief, and it is a more or less suppressed rounded mass. Vastus medialis forms a sort of bulge directed obliquely from above to below and from without to within. Its lower portion descends to about the level of the middle part of the patella.*

The inferior part of the vastus medialis moves to the back as a rounded extremity and reaches the elongated prominence of the sartorius (Plate 86). Above and in front of this it mounts towards the median line of the thigh where it terminates.

* Among the classical works that might be mentioned, the *Achilles*, the *Doryphoros* of Polycleitus, and the *Apollo Sauroctonus* by Praxiteles; among the modern works, *David* by Mercie and *St. John the Baptist* by Rodin.

* The inferior fibers of the vastus medialis descend lower than is generally thought. In relaxation and on the cadaver it is easy to ascertain that they pass beyond the superior border of the patella usually as far down as the level of its middle part.

Sometimes a swelling of the skin makes a sort of bridge obliquely crossing the surface of the patella. This unites the two reliefs.

I have pointed out the anatomical reason for these partly muscular reliefs (see page 71). At the inferior part of the femoral aponeurosis there is a veritable aponeurotic band. It terminates below in the resistant aponeurotic sheath which maintains the muscles of the anterior part of the thigh (Figure 20). In relaxation of the quadriceps the fleshy extremities of the vastus medialis and the vastus lateralis swell out below it. The constriction which the fibers of the band exert upon the fleshy body of the vastus medialis determines the furrow which limits the upper part of the inferior relief and separates it from the relief above. This furrow varies in depth among individuals, the variations depending on the tension of the band and upon the amount of condensation, in this area, of the aponeurotic fibers which compose the band.

This separate relief of the inferior portion of the vastus medialis is a natural form, related directly to muscular development. It appears in models of all ages but it is extremely variable and becomes apparent only in certain positions of the leg. It should be classed among the incessant modifications of form which movement imparts to different parts of the human body. The importance of studying this relief lies in the fact that it not only reveals muscular contraction, but it indicates the physiological state of the muscle, and occurs essentially in the living model (Figure 21).

Sometimes a cutaneous furrow becomes apparent

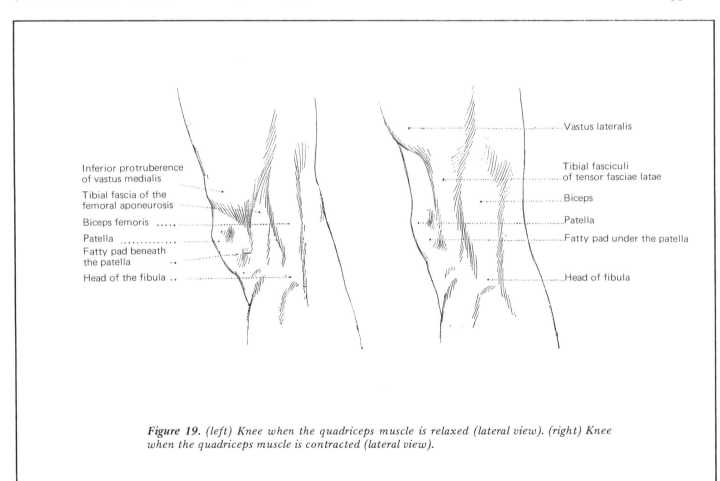

Inferior protruberence of vastus medialis

Tibial fascia of the femoral aponeurosis

Biceps femoris

Patella

Fatty pad beneath the patella

Head of the fibula

Vastus lateralis

Tibial fasciculi of tensor fasciae latae

Biceps

Patella

Fatty pad under the patella

Head of fibula

Figure 19. *(left) Knee when the quadriceps muscle is relaxed (lateral view). (right) Knee when the quadriceps muscle is contracted (lateral view).*

above the patella. I have observed it on elderly models. It is situated immediately above the patella and covers the inferior extremity of the tendon of the rectus femoris. The cutaneous origin of this furrow is indicated by the fact that it is produced by the extension of the knee and that it becomes deeper when the quadriceps is contracted because of the elevation of the patella. The muscular relief itself is lessened or, at times, even effaced, when the muscle is in action. At certain times and on certain subjects the two furrows, one muscular, one cutaneous, may both appear at the same time.

Let us now take up the two sides of the knee.

The external or lateral surface is depressed because of the muscles of the thigh above it and those of the lower leg below it. The internal or medial surface, on the contrary, seems to project.

The lateral surface of the knee is traversed towards its center by the termination of the lateral furrow of the thigh. On each side of this furrow there are two longitudinal prominences. They differ in size and shape but they both terminate below in a bony eminence. The anterior prominence is restrained and flattened. It corresponds to the tibial fasciculi of the tensor fasciae latae. It is continuous above with the relief of vastus lateralis which partly masks the larger relief of the fleshy fibers of vastus intermedius. This latter muscle only appears in flexion. The anterior prominence terminates at the external tuberosity of the tibia. The posterior longitudinal prominence, rounded and larger, is formed by the tendon of the biceps femoris and by the fleshy fibers of this muscle's short head. It starts above,

contiguous to the lateral furrow of the thigh, and descends towards the back of the knee. It terminates below at the head of the fibula.

The medial surface of the knee is more or less divided into two equal parts by the furrow which runs along the anterior border of the sartorius. In the anterior part it should be noted that the posterior border of vastus medialis is situated very far back. Below the relief of the vastus medialis there is a rounded surface corresponding to the two contiguous condyles of the femur and the tibia. These are at times divided from each other by a depression at the level of the interarticular plane. Further to the front there are the prominences due to the internal angle of the patella, to its fatty cushion, and to the lower patellar tendon.

The back part of the medial region of the knee is more uniform. The inferior extremity of the sartorius can be clearly seen; its fleshy fibers descend and sometimes pass down through the interarticular plane. Further back there is a surface which corresponds to the union of the tendons of the gracilis, the semimembranosus and the semitendinosus. The lower part of the internal surface of the knee blends into the surface of the tibia. This, however, is part of the lower leg and will be described later.

Back or bend of the knee (Plate 84). The back of the knee is somewhat hollow in flexion. In extension, however, it forms a longitudinal relief which extends above and below the limits of the region of the knee well into the posterior muscle masses of the thigh and lower leg. This relief is fairly near the middle of the back of the

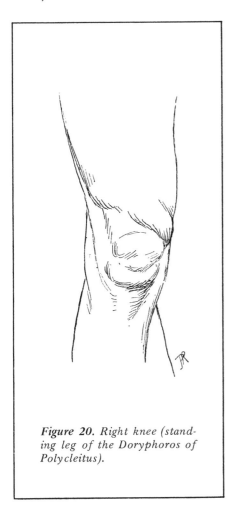

Figure 20. Right knee (standing leg of the Doryphoros of Polycleitus).

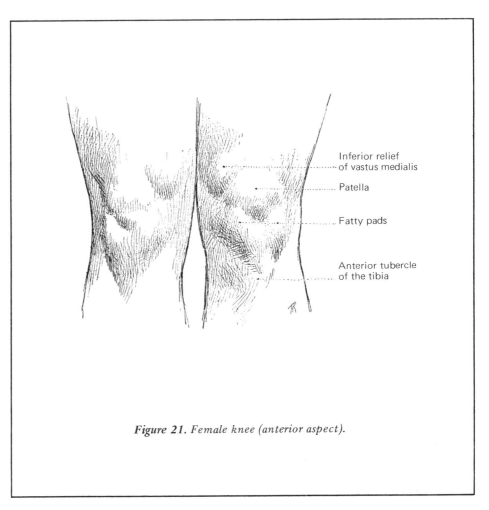

Inferior relief of vastus medialis

Patella

Fatty pads

Anterior tubercle of the tibia

Figure 21. Female knee (anterior aspect).

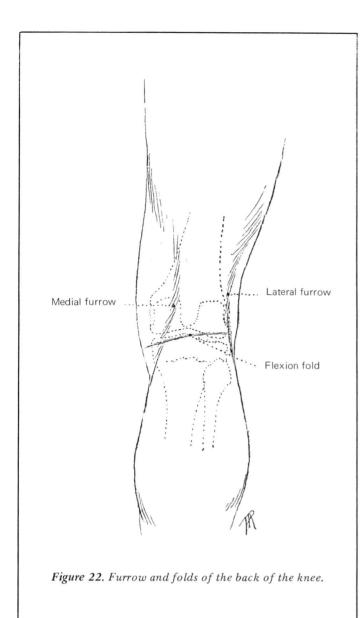

Figure 22. Furrow and folds of the back of the knee.

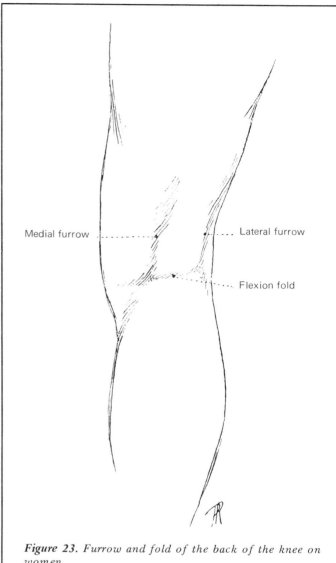

Figure 23. Furrow and fold of the back of the knee on women.

knee. It is formed, above, by the internal border of the biceps femoris on one side and the inferior extremity of the semimembranosus on the other and, below, by the medial and lateral heads of the gastrocnemius. It is filled with vessels, nerves, and fat, although these cannot be seen on the surface.

Two longitudinal furrows or lines border the median relief of the back of the knee. The external one is the deepest and it follows the tendon of the biceps, mounting obliquely as if to join the lateral external furrow of the thigh. It extends below to the head of the fibula. The more shallow internal furrow or line rises above, towards the surface of the sartorius; below, it describes a curve which embraces the knee in a concavity turned to the front, thus separating itself from the gastrocnemius (Figure 22). This line is often more distinct on women than on men because of the fat which usually accumulates on the whole internal region of the knee. On its course it is marked by several depressions, the most inferior being where it meets the flexion fold.

The fold lies on the inferior part of the region, it extends transversely, though somewhat obliquely, from below to above and from inside to outside. It corres-

ponds to the deeper articular interplane of the leg, which it crosses in an oblique direction. Although it is usually clear on models who are fat and on women, it is scarcely visible on lean subjects and it is never apparent when the leg is extended.

The back of the knee is thus framed by the two longitudinal prominences I have already described in relation to the external and internal surfaces of the knee—that is to say, by the longitudinal prominence of the biceps femoris on the outside, and by the tendinous and rounded surface which rises towards the sartorius on the inside (Figure 23). In flexion this surface shows the cord-like prominences of the various tendons of which it is composed: the tendon of the gracilis in front and in the back the united tendons of the semimembranosus and semitendinosus. These tendons form the internal border of the hollow of the back of the knee. The external border, which does not descend as low, corresponds to the biceps femoris.

LOWER LEG (PLATES 83, 84, 85 and 86)

The skeleton of the lower leg is composed of two bones of unequal size placed side by side. These are sur-

rounded by muscles which group themselves into two distinct masses, an anteroexternal mass and a much more important posterior mass. On the inside of the lower leg the internal surface of the tibia is subcutaneous throughout its whole length.

Swollen at its middle, the lower leg becomes gradually thinner below because, at this point, the muscles which compose it become tendinous. This attenuation may or may not be abrupt and it may be high or low, it depends on how far down the fleshy fibers descend upon the tendons, which in turn depends on whether the muscles are the short or long type.

The anteroexternal mass, which is completely convex, has three surfaces: that of the tibialis anterior, that of the extensors and that of the peroneal muscles.

The internal and most anterior surface runs from the anterior tuberosity of the tibia and it corresponds to the tibialis anterior. The fusiform fleshy body of this muscle directed obliquely down a little to the inside overlaps the crest of the tibia. As a result the upper anterior border of the lower leg is soft to the touch and on the profile it describes a curve which is more accentuated than that on the skeleton. About halfway down the lower leg the fleshy body of tibialis anterior is succeeded by its tendon which follows the same direction as the muscle. The tendon is important; we shall take it up when we discuss the ankle.

The surface of the *extensors* is well developed only on the inferior part of the lower leg. On the superior part it is reduced to a sort of furrow, more or less large, which runs between the two neighboring surfaces of the tibialis anterior and peroneus longus and brevis.

The surface of the peroneal muscles, completely turned to the outside, is several fingers' breadth in width. This surface starts above beneath the prominence of the fibula and it is only when the muscles are relaxed that it is uniform. In contraction, it is marked below by a median longitudinal surface due to the superimposed tendons of the two muscles. As this surface descends, it divides obliquely to the front and to the rear exposing the inferior extremity of the fibula a few fingers' breadth above its lateral malleolus. As the fibula is situated on a plane behind that of the muscles, it creates a constant depression at the level where the peroneal surface divides.

The whole posterior mass of the leg is formed by the gastrocnemius (see page 73). Its two heads are superficial and form the relief of the calf. The gastrocnemius rests on the soleus, which is well hidden except for its borders which appear on the surface of the leg on each side.

At the top of the lower leg, descending towards each other, the two heads of the gastrocnemius form longitudinal prominences on each side of the median line. The medial head of the gastrocnemius is larger and descends somewhat lower than the lateral head. It forms a strong relief on the internal surface of the leg whereas the lateral head does not extend beyond the swelling of the soleus. The result is, on the superior front view of the lower leg, the medial head of the gastrocnemius alone is visible. The rounded inferior borders of the two heads form the bottom of the calf and create a strong relief on the tendo calcaneus. The height of this relief depends on the individual.

Beneath the two heads of the gastrocnemius there is the tendo calcaneus which becomes narrower as it descends. Its sides blend with the borders of the soleus. On the outside view the external border of the soleus forms a narrow plane which mounts to the level of the head of the fibula. On the inside the swelling of this muscle may be noted on the center third of the length of the lower leg. The soleus maintains the gastrocnemius and the degree of development of the soleus has a lot to do with the thinness or thickness of the lower part of the lower leg.

On the medial surface of the leg a relief is formed by the medial head of the gastrocnemius and the internal border of the soleus. This double relief is limited in front by a curved line of anterior convexity which continues above in an inverse curve to embrace the knee as far as its internal furrow or line at the back. The entire depressed anterior part of the lower leg is occupied by the interior surface of the tibia which is subcutaneous throughout its whole length. This surface is more rounded than it is on the skeleton because of cellular tissue which thickens the skin. It is traversed by the great saphenous vein which rises to the interior border of the gastrocnemius.

ANKLE (PLATES 83, 84, 85 and 86)

The ankle forms the junction of the lower leg and the foot. They unite at a right angle. The region is made up of the skeleton which consists of the inferior extremities of the leg bones and the talus and the tendons of the muscles. The skeleton appears on the sides, the tendons in the front and back. On the inside the large internal malleolus is situated well to the front; on the outside the external malleolus is narrower, lower, and occupies the middle of the region. In the front the tendons are not too distinct but in the back a strong long tendon (tendo calcaneus), removed some distance from the leg bones, is attached at a right angle, to the calcaneus, forming a most prominent relief. We will consider successively these four surfaces of the ankle.

From the front the ankle presents a transverse rounded surface facing to the outside and the tendons stand out prominently only during violent movement. This surface ends on the medial side in the front with a relief formed by the tendon of the tibialis anterior which is always distinct. This tendon descends obliquely from within to without and terminates as far down as the base of the first metatarsal. The prominence of the tendon is due to an anatomical disposition which we have already discussed (see page 73).

On the medial side of the ankle, immediately behind the tendon of tibialis anterior, the prominence of the internal malleolus takes up the whole anterior half. The posterior half is traversed by a wide furrow running over the deep muscles of the lower leg which fill the groove of the calcaneus on their way to the sole of the foot. This retromalleolar furrow is bordered in the back by the tendo calcaneus. It descends below and to the front decreasing in depth but rounding out the malleolus.

The middle of the external side of the ankle is occupied by the lateral malleolus which blends in front with the surface of the extensors. This malleolus is

formed by the inferior extremity of the fibula and further developed by the tendons of the peroneal muscles which embrace it in the back. These tendons decrease the angular form of the bony extremity and at the same time increase its volume. They only become distinct in certain movements of the foot.

A retromalleolar furrow, narrower than that on the internal side of the ankle, borders the malleolus in the back and extends under it (the inframalleolar furrow). This furrow is cut by an oblique cord which, from the summit of the malleolus, runs down and to the front, to the tuberosity of the fifth metatarsal. This cord is due to the tendon of the peroneus brevis.

Finally, at the back part of the region of the ankle, the tendo calcaneus is situated. It is the strongest tendon in the whole body. It describes from the lateral and medial points of view a slight curve of posterior concavity. From the posterior aspect it appears smallest at the height of the lateral malleolus, and at its insertion into the calcaneus it presents a slight swelling.

FOOT (PLATES 83, 84, 85 and 86)

The foot is divided into two distinct parts: the foot, so called, or vault of the foot, and the toes.

Vault of the foot. It is the skeleton, which is composed of the tarsus and the metatarsus, that dominates the general form of the region. We shall consider the foot as having two surfaces, a superior and an inferior; two borders, an external and internal; and two extremities. The vault which forms the foot is arched on the inside, depressed on the outside. It is supported by the calcaneus in back, by the heads of the toes in front, and by the fifth metatarsal at the external border. The bones of the leg do not rest on the middle of the vault but on a point of culmination situated more in back and formed by the talus (see Plates 29 and 31).

Superior surface or dorsum of the foot. The leg rests on the posterior half, more or less, of the vault, thus the inferior surface of the foot is much longer. The dorsum of the foot corresponds to the form of the skeleton, its rounded surface inclines to the front and to the outside. Its point of culmination corresponds to the articulations of the first and second cuneiforms with the first and second metatarsals. It is traversed by a number of tendons which diverge from the middle of the ankle to the anterior circumference of the foot. Proceeding from within to without these are: the tendon of the tibialis anterior which goes to the internal border of the foot; the tendon of the extensor hallucis longus; the tendons of the extensor digitorum longus; finally the tendon of the peroneus tertius, which descends towards the styloid process of the fifth metatarsal.

It should be noted that, on the outside, the relief of the extensor digitorum brevis muscle is situated below and well in front of the lateral malleolus. Also, before reaching the internal border, the surface of the dorsum of the foot is sometimes depressed into a sort of valley. (This is apparent on many ancient statues.) Finally, under the skin of the region there are numerous veins, particularly the venous arcade of the metatarsals.

Sole of the foot. This really designates that part of the foot which rests on the ground. It is composed of the hollow of the vault and opens on the inside. It is closed on the outside, in the back and front, where the foot touches the ground.

The skin of the sole of the foot is thick and filled inside with a thick deposit of fat which has a cushioning effect. The result is that no muscular detail appears in this region. The morphology, as on the dorsum of the foot, is dominated by the skeleton. At the level of the points of support the skin has certain notable characteristics. There is a thick cushion in front stretched under the metatarsophalangeal articulations and its thickest part corresponds to the big toe. This cushion is caused by the volume of the anterior extremity of the metatarsal of the big toe and the two sesamoid bones at the inferior surface of the articulation. Since this cushion encroaches upon the toes, they seem very short when seen from the plantar aspect. We have seen that the fingers are disposed in an identical manner. The skin along the whole external border of the foot has the same characteristics. In the back, beneath the calcaneus, there is a large surface of support in the form of an oval. At the summit of the vault the skin is finer and has oblique wrinkles which become exaggerated when the foot is arched.

The points of support upon the ground, which consist of the heel, the external border and the base of the toes, when considered together take up three quarters of the circumference of the foot.

The internal border, thickset and raised, takes up the transition between the plantar vaults and the internal retromalleolar furrow. The relief of the abductor hallucis appears and, right in the front, the voluminous articulation of the big toe. This region is traversed by the venous network of the medial marginal vein of the foot.

The external border is thinner and rests entirely on the ground. It is marked, in the center, by the relief of the posterior extremity of the fifth metatarsal.

The toes. The toes (except for the big toe) have all the characteristics of the fingers of the hand although they are more rounded, smaller, and end in an extremely large extremity which rests on the ground.

The big toe is much bigger than the others and is separated from them by an interval which in classical times was augmented by the thong of the sandal. Modern shoes tend to change the direction of the toes. They are squeezed together and are so compressed they become flattened on each side. These acquired deformities must be kept in mind when the direction of the toes is studied. The big toe does not follow the direction of its metatarsal which forms the internal border of the foot. It is slightly inclined to the inside, towards the median axis of the foot. This disposition, though it is certainly exaggerated by our shoes, may still be noted on classical statues. The second and third toes are more or less parallel to the first. Their axis, prolonged to the back, touches the medial malleolus. The last or fifth toe follows an inverse direction. Its axis, if prolonged to the front, converges with the axis of the other toes at a distance of about half the length of a foot. As for the fourth toe its direction is variable. Sometimes it is the

same as that of the first and second, sometimes it is parallel to the fifth. The last disposition is the one most often encountered in classical statues. One notices also, on these same statues, that the little toe is raised and does not rest on the ground.

Like the fingers, the toes are of unequal length. Sometimes the big toe is the longest, sometimes the second toe. Both these dispositions can be seen on classical statues. The third toe is shorter than the second by the length of a nail. The fourth scarcely reaches the nail of the third and the fifth is situated even farther in the back.

The dorsal surface of the toes is rounded and light wrinkles traverse the phalangeal articulations. On the inferior surface of the foot there are deep furrows separating the enlarged extremities of the toes from the sole, but the extent of the inferior surface of the toes is clear only when they are extended. In extension two flexion wrinkles become apparent and these correspond to the articulations.

MOVEMENTS OF THE HIP

Mechanism. The coxal articulation, or hip joint, presides over the movements of the thigh upon the pelvis and details have been given (see page 43). We should note here that, although the femoral head is deeply situated, the great trochanter is subcutaneous and undergoes in its different movements of articulation displacements which are of great interest to artists.

These movements are of three sorts: first, flexion and extension; second, abduction; and third, rotation.

Flexion and extension take place about a transversal axis. The great trochanter, because of its inclined neck, is situated on a plane inferior to that of the femoral head so it follows that it rises in flexion and draws itself slightly nearer to the iliac crest.

In rotation the great trochanter describes an arc of an anteroposterior circle. Thus it moves to the front in inward rotation and to the back in outward rotation.

In abduction the great trochanter rises and approaches the pelvic crest; in adduction it descends and draws away from the crest.

MUSCULAR ACTION

Rotation. All the rotators that rotate the femur to the outside are deep muscles. They are: the piriformis, the gemelli, the obturator internus and the quadratus femoris.* Their action is powerful, despite their small size, because the direction of their fleshy fibers is more or less perpendicular to their point of leverage.

The action of these muscles is counterbalanced, though incompletely, by the less energetic action of the muscles which rotate the thigh to the outside. These are the gluteus minimus and gluteus medius but solely in their anterior parts. It is because the action of these muscles is less energetic that the point of the foot is naturally directed to the outside during muscular repose. Of all these muscles, gluteus medius alone is superficial and greatly influences the exterior form. Even in rotation to the outside its relief is greatly accentuated.

Flexors and extensors. The flexor muscles are the psoas major and minor, the iliacus, the tensor of the fascia lata, the sartorius, the pectineus and, to a certain extent, the rectus femoris.

The psoas muscles, the iliacus, and the pectineus are deep muscles and their action is not obvious on the exterior. But this is not true for the tensor of the fascia lata, the sartorius, and the rectus femoris.

The psoas-iliacus muscle is a flexor and at the same time a rotator to the outside. Its action is counterbalanced by an inverse rotational action of the tensor of the fascia lata. The pectineus is a rotator and at the same time an adductor. The sartorius is a rotator and also flexes the leg. The rectus femoris is above all an extensor; as a flexor of the pelvis on the thigh it is most limited. However, this muscle intervenes in forceful movements when the leg has been previously flexed.

The extensor muscles of the thigh against the pelvis are gluteus maximus and the posterior muscles of the thigh. The gluteus maximus is a most powerful muscle but it only intervenes when the movement demands a large deployment of force.

Abduction and adduction. Abduction of the thigh is produced by the gluteus medius and minimus. These two muscles, taking their fixed point from the femur, maintain the pelvis. They come into play, for example, in walking when the leg on the opposite side leaves the ground.

Adduction. This is brought about by the powerful adductor group of the thigh. Some of these are partly flexors and at the same time rotators of the thigh to the outside. The exception is the inferior part of adductor magnus which is a rotator of the thigh to the inside. Duchenne de Boulogne has given this muscle an important role in the attitude of the horseman.* The same movement is produced by accessory muscles, the psoas major, the adductors, etc.

MODIFICATION OF EXTERIOR FORM (PLATES 105, 106, and 107)

Extension. The attitude of extension has already been studied. It takes place in the erect position, though it should be noted that the extensor muscle *par excellence,* gluteus maximus, is not contracted in this position. Paradoxical as this may seem, it is easily explained (Figure 24). In the upright position the line through the center of gravity of the trunk passes behind the articulation of the hip joint. In this position the pull of gravity is enough to maintain extension which is limited by the distension of the strong fibrous bundle situated at the anterior part of the articulation (the iliofemoral

* The same movement is produced by accessory muscles, the psoas major, the adductors, etc.

* "This rotative action to the inside of the adductor magnus," Duchenne de Boulogne states, "is most useful in certain movements of the legs. For instance, the horseman who wishes to avoid pricking his horse with his spurs when he is squeezing its belly with his thighs may avoid this difficulty if he is aware of the rotative action to the inside of the inferior portion of adductor magnus." *Physiologie des Mouvements,* page 360.

ligament). Gluteus maximus intervenes only to reestablish the equilibrium when, through a displacement of some superior part of the body, the trunk has a tendency to fall to the front. The gluteus maximus will also contract in all violent movements of the torso. When it takes its point of support from the pelvis, the gluteus maximus carries the leg to the back. This contraction of gluteus maximus brings great changes in the region.

Consider, for example, the model in the position we have chosen for study (see Plate 78). The gluteus maximus is not contracted. But if the model moves his right leg to the back we will see at once that the buttock on this side becomes narrow, globular, and elongated, the furrow behind the great trochanter becomes exaggerated, and the whole muscle looks reniform or kidney-shaped (see the drawings below). The fold of the buttock almost disappears, and the inferior border of the muscle reveals its natural obliquity. The secondary muscular fasciculi sometimes appear on the surface. The contrast is striking in relation to the buttock on the opposite side which is large and flat.

But if, instead of moving his leg to the back, the model moves his leg slightly to the front, the forms of the region become completely changed. Now it is the opposite buttock that enters into contraction. This is because the trunk must be maintained in an upright position despite the weight of the forward leg which has a tendency to pull the trunk forward. The buttock on the side of the forward leg is now large, distended and flat. In light flexion of the trunk to the front the two buttocks contract simultaneously (see Plate 94).

Flexion. We shall now study flexion of the thigh on the pelvis produced without effort. This will enable us to clarify the role of the flexors on the exterior forms of the region (see Plates 105 and 106). It will be observed that two flexor muscles, the sartorius and the tensor

fasciae latae, reveal themselves clearly under the skin. Their tendons, preparing to join each other at the level of the anterior superior iliac spine, make a marked protrusion which augments the depth of the femoral depression. The fascia lata, the long tendon of the tensor muscle, somewhat retains the mass of the vastus lateralis in the front. The rectus femoris is not contracted.

In the back the enlarged flat buttock blends into the posterior surface of the thigh. The fold of the buttock is suppressed. On the outside, at the level of the articulation of the hip, important new forms appear. The great trochanter becomes less visible. In fact, it almost disappears under the tendon of the gluteus maximus which leads to an enlargement of the buttock. The gluteus medius, which is not contracted, is divided into two parts by the fasciculi of the femoral aponeurosis which go from the iliac crest to the tendon of the gluteus maximus (see page 61). The tension of the fasciculi limits the movement and creates a furrow at this level. The back part of gluteus medius blends with the gluteus maximus; its front part forms an elongated relief which includes the striking prominence of the contracted tensor muscle.

In the front the fold of the groin is accentuated, and several new cutaneous wrinkles appear. In further flexion the same morphological characteristics appear.

Abduction. The relief of the gluteus medius becomes most apparent under two conditions; when the leg is abducted to the outside, and when the pelvis must be inclined or maintained in its position, because, for example, the leg on the opposite side is raised from the ground. In this last case the fixed point of the gluteus medius is below on the femur.

Adduction. Adduction augments the prominence of the great trochanter.

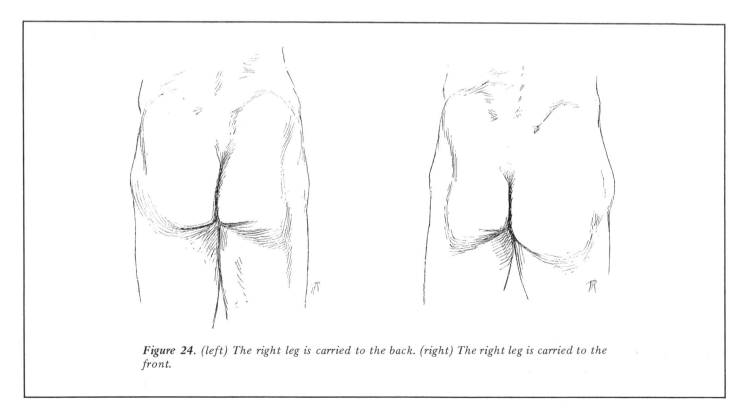

Figure 24. *(left) The right leg is carried to the back. (right) The right leg is carried to the front.*

MOVEMENTS OF THE KNEE

Mechanism. The movements of the lower leg on the thigh take place at the knee joint. They are of two kinds: first, movement around a transverse axis (in the manner of a hinge), *flexion and extension;* and second, movements of the lower leg around a vertical axis, *rotation.* (The point of the foot may be carried to the inside or to the outside; more rotation is possible to the outside than to the inside.)

This last movement is not possible except in the intermediate positions between flexion and extension of the knee.

MUSCULAR ACTION

Extension of the lower leg on the thigh. This movement is dominated by the powerful quadriceps femoris muscle which occupies the whole anterior part of the thigh. Its different heads all have a slightly different action. Those which are attached to the femur (vastus lateralis, vastus medialis, and vastus intermedius) are only extensors of the leg. The rectus femoris is also a flexor of the pelvis.

Flexion. Flexion is brought about by the following superficial muscles: the sartorius, which is at the same time a rotator to the inside; the vastus medialis, which is also an adductor of the thigh and a rotator of the lower leg to the inside; the semitendinosus and the biceps femoris, which are at the same time rotators of the lower leg; the semimembranosus, a flexor exclusively; and the gastrocnemius, which is an extensor of the foot.

The popliteus, a deep muscle, is a feeble flexor and a rotator to the inside.

Rotation. The rotating muscles are at the same time flexors of the lower leg on the knee. This may explain why rotation takes place only during flexion of the lower leg.

The rotators to the inside are: the semitendinosus, the vastus medialis, and the sartorius, the two last being the strongest. It should be pointed out that the popliteus, though a feeble flexor, is a powerful rotator to the inside. With the preceding muscles it counterbalances the powerful action of the biceps femoris which is a rotator to the outside.

MODIFICATION OF EXTERIOR FORM (PLATES 105, 106, and 107)

Extension. Extension has already been studied in the description devoted to forms in repose. In the conventional position the knee is extended, but it should be pointed out that the great extensor muscle, the quadriceps femoris, is more or less in relaxation. This is explained by the fact that the line from the center of gravity of the trunk passes behind the hip joint but in front of the knee joint. Thus the thigh, like the hip, maintains its position only through the weight of gravity in passive extension and movement is limited by the resistance of the distended ligaments. Under these circumstances the different parts of the quadriceps blend together into a uniform mass. However, two unequal swellings, the reliefs of the inferior extremities of the vastus medialis and lateralis, appear below. In contrast,

when the quadriceps is contracted, everything changes. The rectus femoris becomes apparent at the middle of the thigh and, on each side, the vastus medialis and vastus lateralis are clearly visible. The inferior reliefs disappear completely. The region below the patella becomes simpler, the transverse wrinkles are suppressed and the lower patellar ligament is accentuated.

Flexion. In flexion of the knee the patella, which is applied against the trochlea of the femur, sinks into the wide opening in front between the femur and the tibia. Thus the prominence the patella makes in extension becomes less the more the knee is flexed.

The ligamentum patellae is stretched and on each side the infrapatellar fat becomes more prominent as the flexion increases. In extreme flexion the fatty pads project beyond the ligament so that the ligament itself is indicated by a mild furrow.

Slightly behind this the two condyles of the femur form two appreciable reliefs under the skin. These reliefs are unequal and each has its distinct character. Within, the medial condyle shows only slightly and it is covered by the inferior extremity of the fleshy body of the vastus medialis which gives this side of the knee a rounded form. On the external side of the knee, the border of the trochlea becomes clearly visible and forms a sharp angle, though it is continuous with the lateral malleolus. The vastus lateralis retreats in flexion and the prominence of the vastus intermedius appears because it is no longer covered by the sheath of fascia lata, which is now lower down. On the outside, the articular interline is visible (Plate 105).

In the back the hollow of the knee is limited laterally by the tendons of the posterior muscles of the thigh which border it. When the knee is bent, the internal border is lower so that the hollow behind the knee does not point directly to the back but to the back and to the outside. The internal border is made up of the tendons of the semimembranosus and the semitendinosus, thickened by the exterior extremity of the sartorius. The external border is formed by the strong tendon of the biceps femoris which goes to the head of the fibula.

The hollow at the back of the knee is deepest near the lower leg; it fades away towards the thigh. It consists of a sort of excavation which receives, in forced flexion, the superior extremities of the two heads of the gastrocnemius.

MOVEMENTS OF THE FOOT

Mechanism. The movements of the foot are of two kinds. First, those which take place around a transversal axis, for instance, when the point of the foot is raised. When the point of the foot is raised it is flexion; when it is lowered it is extension (or plantar flexion). These movements take place in the tibiotarsal articulation. Second, movements which take place around an anteroposterior axis. When the point of the foot is directed within it is adduction; without, it is abduction.

Adduction is accompanied by a movement of torsion which makes the internal border of the foot rise some-

what. The external border falls and the plantar arch becomes hollow.

In abduction it is the opposite. The internal border is lowered, the external is raised, and the plantar arch is somewhat suppressed. This last movement is less powerful and more limited than adduction. All of this takes place within the articulations of the tarsus.

MUSCULAR ACTION

Extension. As Duchenne de Boulogne has demonstrated, two muscles acting simultaneously are necessary for direct extension: the triceps surae (which is the soleus and gastrocnemius considered as one) and the peroneus longus which is also an abductor. The flexor digitorum longus and the flexor hallucis longus are powerless as extensors of the foot on the lower limb.

Flexion. As in extension, direct flexion entails two muscles acting at the same time: the tibialis anterior, also an adductor, and extensor digitorum longus, also an abductor.

Abduction and adduction. The peroneus brevis abducts the foot and the tibialis posterior adducts it.

MODIFICATION OF EXTERIOR FORM

Flexion. In flexion the heel falls and the dorsum of the foot makes an acute angle with the lower leg.

In direct flexion the tendon of the tibialis anterior and those of the extensor digitorum longus make distinct prominences at the ankle. If the foot is at the same time carried within, the tendon of the tibialis anterior is augmented. If it is carried to the outside the tendon of the peroneus brevis becomes visible below the ankle.

On the leg the fleshy body of the tibialis anterior stands out and its relief blends with the extensor digitorum longus.

Extension. In extension the dorsum assumes almost the same direction as the lower leg; the heel is lifted and the projection of the back of the foot is accentuated. On the front of the lower leg the superior relief of the tibialis anterior and the extensor digitorum longus is replaced by a depression. A little to the outside, under and behind the head of the fibula, a new prominence created by the peroneus longus appears. This very interesting relief accentuates, on the front view, the curve of the lower leg at its superior part. This form also appears on a subject standing on his toes. At the same time the tendon of the peroneus longus appears below in the form of a long lateral prominence behind the lateral malleolus.

The modeling of the back of the leg differs according to whether the foot is extended or flexed.

When the subject is standing on his toes the relief of the triceps surae is very strong. All its forms stand out—the prominences and planes of the two heads of gastrocnemius, the lateral reliefs of the soleus and those of the tendo calcaneus or Achilles tendon. This last describes, on the side view, a stronger curve above the heel.

If the leg is extended and the foot does not touch the ground, the entire triceps surae will be contracted but to a lesser degree.

Finally, if the knee has been flexed and extension of the foot is produced, the whole calf together with the tendo calcaneus will be flaccid.

MOVEMENTS OF THE TOES

The toes undergo movements of flexion and extension as well as limited lateral movements. In flexion the toes press one against the other, in extension they have a tendency to separate.

In flexion the rounded extremity of the toe touches the anterior pad of the sole which becomes, except under the big toe, creased with numerous wrinkles going in varying directions. On the dorsal surface of the foot the articulations of the phalanges between themselves, and above all, the articulations of the phalanges with the metatarsals become very visible.

Extension effaces the wrinkles on the sole of the foot and brings into relief a thick cord which fills the summit of the vault. This cord runs from the heel towards the big toe and it is due to the tension of the plantar aponeurosis.

Certain cutaneous wrinkles appear on the dorsal surface at the metatarsophalangeal articulation of the big toe. The tendon of the extensor hallucis longus becomes very visible.

On the inferior surface of the foot the relief of this same articulation becomes more pronounced as extension continues.

18. Proportions

Artists through the ages have been fascinated by the proportions of the human body. They have tried to standardize them and have attempted to lay down rules or canons which could be followed in the production of works of art. Works of this nature, made by artists of ancient times, have not been passed on to us.*

Such texts as we have on the subject of proportion are categorical but more or less circumstantial. They are usually filled with conjectures drawn from works of art executed under those particular rules. Without entering too deeply into a subject which has occupied the sagacity of artist and archeologist for so long a time, it might be useful to discuss the situation as it exists today.

CANONS OF PROPORTION

The oldest text on proportion is an Egyptian canon, and Blanc believed he had discovered its key—the length of the middle finger was equal to one nineteenth the total height of the body.

The Greeks had several canons, all totally different from those of the Egyptians. The most celebrated was that of Polycleitus. This canon defined the type of athlete that so fascinated the Greeks, and above all the Dorians. This type was the strong healthy male who was excellent at gymnastics and skilled in the handling of weapons of war. Typical examples are the *Doryphoros* and the *Borghese Achilles*. According to Guillaume, the palm of the hand, or the length of the hand to the level of the root of the fingers, was the unit of measurement chosen by Polycleitus. This measurement does not apply to the canon of Lysippus, who introduced more elegance into figure. He made the heads smaller and the body less squared thus giving the whole a more graceful quality. The *Apollo Belvedere* is representative of this type.

"In all probability," states Guillaume, "it is this canon of Lysippus, maintained by Vitruvius, followed by the Byzantines, and recognized by Cennino Cennini, which the modern artists have partially adopted. In it not only the palm of the hand, but the head and its subdivisions, serve as a module."

Artists pursue a double purpose in tracing these rules of proportion. First, they seek to illuminate the reasons for the harmonies of the human body, to determine its "symmetry" in the Greek sense of balancing diverse parts with the whole. All their efforts are aimed towards the realization of a certain ideal of beauty.

But as the author of the article *Canon* has written in the *Dictionnaire de l'Academie des Beaux-Arts,* "The abstract idea of proportion is superior to proportion in reality. Proportion, like beauty itself, is a noble torment of the mind, a powerful incentive to achievement. However, it can only be realized in principle. The greatest artists have sought its key, but each one was only capable of rendering proportions that had been imprinted with the artist's own taste."

In other words, in formulating a canon, artists have never contemplated the idea of executing all their figures to correspond to a specific set of rules. The proof of this can be seen in their works. In classical times the rules varied according to the subject to be represented. These subjects were certainly very different, a mortal, perhaps, or a god, and among the gods there were Apollo, Mars, Mercury, or Eros. One can safely say that the canon varies according to the subject, otherwise the exact relationship between physical character and moral and intellectual character could not be expressed.

Such was the aim of Polycleitus when he created his famous Doryphoros. In a sense one could say that Polycleitus put the whole of art in that single work of art.

The second reason why artists, and especially modern artists, seek rules of proportion is perhaps less exalted and more a matter of technique. They want to have at hand a simple method which will allow them to construct figures in proportion. This allows them, once they are given the full size of the model, to determine the measurement of each part, or conversely, once they are given a part, to determine the size of the whole. In this way the rules become a sort of guide—they may be altered according to the taste of the artist, and their single aim is to help the artist in his work.

All the modern research seems to be derived from a somewhat obscure passage of Vitruvius. It is constantly commented upon, explained, and attempts are made to carry it to a conclusion. It is said, among other things, that the height of a figure is eight heads or ten faces, that the width is equal to the dimension of the outstretched arms, and that the figure may be placed in a circle of which the center corresponds to the navel.

* The marble statue of the *Doryphoros* in the Museum of Naples, according to a statement authorized by M. Guillaume, was only a reproduction of the celebrated work of Polycleitus; the original was of bronze. The original was accompanied by a written work explaining the proportions. This, unfortunately, has been lost.

Leonardo da Vinci demonstrated Vitruvius' ideas on proportion in the well known double figure of the man within the square and circle.

In this drawing a man, his arms outstretched and his hands opened, has first been inscribed within a square. His head, his feet, and the extremities of his middle fingers touch the sides of the square. The arms being raised a little and the legs separated, he has then been inscribed within a circle with its center at his navel. His feet and the extremities of his middle fingers touch this circle. However, Leonardo also indicated many other proportions of the body as one can see in the drawing itself. We shall return to some of these later (Figure 25).

One can study proportions in the voluminous and obscure memoirs of Albrecht Durer, in the works of Lomazzo, in those of Christopher Martinez or of Rubens, and in many other works which might be considered to be merely curiosities. But there are, of course, several works which review and summarize all the others. Of all the authors who have written on this subject, the clearest, the most precise and consistent is undoubtedly Jean Cousin.

COUSIN'S CANON OF PROPORTIONS

In his book on proportion the head is taken as a unit of length; it is measured from the summit of the cranium to the inferior limit of the chin. The head itself is subdivided into four parts.

The first section divides the forehead, the second runs

Figure 25. Facsimile of a drawing by Leonardo da Vinci.

through the eyes, the third cuts through the base of the nose, and the fourth the bottom of the chin. A fifth part could be added which would determine the length of the neck.

The horizontal middle line (on the front view) is divided into three parts, the center part being occupied by the iris. The opening of the eye is one third of its width. The greatest width of the nose is equal to the space between the eyes. The mouth has the width of an eye and a half. The ears are placed between the line of the eyes and that of the base of the nose.

The height of the body from the summit of the head to the ground is divided into eight parts, each part being equal to the head. The first, of course, is the head itself. The second extends from the chin to the nipples, the third from the nipples to the navel, the fourth from the navel to the genital organs, the fifth from the genital organs to the middle of the thigh, the sixth from the middle of the thigh to below the knee, the seventh from below the knee to the calf, and finally the eighth, from the calf to the sole of the foot. The middle of the body is thus placed at the level of the genital organs.

The principal measurements of width are: two heads at the level of the shoulders; two faces, or six lengths of the nose, at the level of the hips.

The arm is three lengths of the head thus divided: from its attachment at the shoulder to the articulation of the wrist, two heads; from the wrist to the extremity of the middle finger, one head.

As a result, on a figure with outstretched arms, the measurement from the extremities of the middle fingers would equal eight heads or the total height of the individual.

The hand equals a face or three noses, the foot is one head long.

Jean Cousin's canon is extremely simple—it relates all the dimensions of the body to the length of the head, it subdivides the head into four equal parts, and it gives each of these the length of the nose. It is a system which may be applied very easily and it is simple to understand the favor in which it has been held.

However, this system is not completely accurate and it contains a number of obscurities. For example, the fourth division, which marks the center of the body, corresponds to the genital organs, but at what particular level on these organs? And exactly where is "below the knee"? Where, "below the calf"? In a discussion of the measurements of the trunk the text mentions in one part that the second division corresponds to the nipples, but in another place that it appears that this same division corresponds to beneath the pectoral muscles.

One might expect that the plates and drawing that accompany the text would clarify the obscurities and omissions of the text. However, the drawings that relate to diverse parts of the body do not correspond to the drawings of the figure as a whole. For example, on the drawings devoted especially to the proportions of the torso, the divisions from the points of the shoulders to below the pectoral muscles, and those from the navel to the genital organs, are not the same divisions as those given in the figure as a whole. Comparable inconsistancies are present in the drawings of the leg.

GERDY'S CANON OF PROPORTIONS

The measurements adopted by Gerdy do not differ greatly from those of Jean Cousin. He uses the same measurements of height, except for the neck, to which he gives a nose and a half to two noses. He keeps the measurements of width. But at least Gerdy moves towards a greater precision by introducing various prominences created by the skeleton as points of measure. Among these are the vertebral prominences, the costoabdominal prominence and the spine of the tibia.

Gerdy's canon, like that of Jean Cousin, gives eight heads as the height of the figure. This proportion is rarely encountered in nature but artists, of course, have always known this fact. There are certain Greek statues which are eight heads high, but there are others which measure seven and three quarters heads, seven and a half, and even seven heads.

THE CANON DES ATELIERS

The proportion of seven and a half heads has been set down in a canon offered by Blanc under the name of *Canon des Ateliers*. This differs appreciably from the canon of Jean Cousin. Let us pause for a moment and examine it.

The figure in this canon is seven and a half heads high. The neck is half a head, which appears to be excessive, and the trunk five half heads from the pubis to the pit of the neck, which seems short. The trunk is further subdivided into three equal parts the length of a face. One from the pit of the neck to beneath the pectoral muscles, a second to the navel, and a third to the pubis.

The position of the knee is as vaguely indicated as it is in the canon of Jean Cousin. There are six parts from the pubis to above the knee, one part and a half to the knee, six parts from above the knee to the ankle, and a part and a half from the ankle to the ground. But the question is, where does the knee start? Where does it finish? That is what Blanc does not tell us.

ARTISTIC CANONS IN GENERAL

To sum up, the amazing thing about these artistic canons is their lack of precision as to the exact position of the points of reference. Because of this, it becomes possible to construct, following the same canon, types of varying proportions. Although it is true that this is not a matter of much importance because a canon is but a guide which the artist should be able to modify according to his taste, it does seem that if there is to be such a guide it should be most precise so that the artist may make comparisons and be aware of exactly how far he is departing from the guide when he wishes to make modifications he feels would be more fitting. An exact knowledge as to the whereabouts of landmarks is of great value in the construction of figures.

In regard to the artistic canon that follows, it might well be asked how far its proportions conform to the reality of things as they are. This question is raised because art tends to strive towards a presentation of truth and nature and it is natural for an artist to try to verify measurements drawn from different artistic traditions on the model (Figures 26 and 27). However, there is such a variety in individual proportions that to conform to things as they are it would be necessary to measure a great number of individuals and then take the average. At the same time one would have to distinguish between the different ages, the different sexes, and the different races. Happily this has become one of the functions of a rapidly developing science. I refer, of course, to the science of anthropology.

ANTHROPOLOGY AND HUMAN PROPORTIONS

Anthropology has revived the study of the proportions of the human body but from a point of view that is essentially different from that of the artist. Anthropology admits that there are as many canons as there are individuals of the human race. It relies on statistics and proceeds by averages. Instead of seeking a module as a point of departure and reproducing it over and over again along with each of the parts of which it is composed, anthropology simply states that there are certain relationships between the parts and that these relationships are necessarily elementary.

This method of approach has been aptly studied by Dr. Topinard. He has clearly indicated the path to be followed in the determination of the different human canons, although he realizes that there is still much work to be done—an enormous number of individuals must be measured with method and precision, their age and sex

*Figure 26. (left) Figure taken from **A Treatise on Painting** by Leonardo da Vinci. This figure shows that the distance from the point of the shoulder to the olecranon equals the distance from the olecranon to the metacarpophalangeal articulation of the middle finger.*

Figure 27. (right) This figure shows that the width of the shoulders equals the forearm measured from the tip of the middle finger to the olecranon.

must be clearly determined, and above all their race. This last, because of the great mixing of races, is not easily done. However, Dr. Topinard began by using the already considerable work which exists on the measurements of Europeans. Drawing on the facts of anthropology as they exist, and using the most comprehensive and trustworthy measurements, he has established the average canon for the adult male European (Figure 28).

The measurements are formulated in scientific terms, that is to say that they are all brought down to figures of which the total is 100. Although they are not really of much use to artists, it is interesting to compare them to the artistic canons and to note the many resemblances between this scientific canon and the artistic canons. As Dr. Topinard says, "This bears witness both to the excellent eye of the artist and to the value of the measurements taken by the anthropologists." Nevertheless, there are a number of divergences.

The canon of eight heads comprising the height of the body is only true for very tall people. For short people, the measurement is seven heads. In the scientific canon seven and a half heads makes up the height of the body as in the *Canon des Ateliers* of Blanc. However, the width across a figure with outstretched arms is equal to its height only one time out of ten. The rule of the artist in this regard is thus an exception. In the scientific canon the width of the outstretched arm is 104, the height of the figure being considered 100. The arm is somewhat short in the artistic canon, the neck too short in the canon of Jean Cousin, too long in that of Blanc, etc. . . . I shall pass over the other comparative details which are no of great importance.

In the face of these very interesting results, it seems to me that, since there is little room for new artistic canons, one might be able to introduce a little scientific precision especially in regard to points of reference which determine the partial measurements. This has been my aim in designing the three plates 108, 109 and 110. I have tried, besides, to simplify the measurements and to do away, as much as possible, with fractions.

RICHER: CANON OF PROPORTIONS

This canon which I am submitting to artists preserves most of the traditions which are taught in the studios; it contains besides, particularly in regard to the legs, new points of reference derived from the skeleton (Figure 29). These are of great advantage because they are fixed and hold their relative position despite the different movements. What is more, they correspond to the principal measurements of the scientific canons.

In the scientific canon the height of the figure is seven and a half heads. The width through the outstretched arms is greater than the height. The middle of the body is a little above the pubis. As in the canon of Jean Cousin, the length of the head serves as the unit of measurement.

The trunk and the head together measure four heads. The divisions fall at points of reference on the front and back of the body. The first division is at the chin; the second corresponds to the nipples; the third corresponds to the navel, or a little above, and in the back it corresponds to the superior limit of the gluteal muscles;

the fourth cuts through the inferior part of the genital organs in front and in the back it is at the level of the gluteal fold.

The leg measures four heads, from the sole of the foot to the fold of the groin which corresponds to the level of the hip joint. However, these two measurements, placed one above the other, overlap each other by one half a head. This gives a height to the figure of seven and a half heads. It places the middle of the figure at mid-distance between the inferior limit of the trunk and the superior limit of the leg. This point is slightly below the pubis.

The subdivisions of the leg are as follows: from the sole of the foot to the articular interline of the knee, two heads; from this point to the great trochanter and then to the height of the fold of the groin, two heads (Figure 30). These points of reference seem to be quite precise, because they are fixed and belong to the bony system. Also, they serve equally well when the leg is flexed and when it is extended. The articular interline of the knee is always easily found. The chapter that discusses the exterior form of the knee covers all the necessary details. The length of the thigh does not vary because the points of reference belong to the bone. If the length of the lower leg is taken from the superior limit of the tibia to the sole of the foot it is always easy to make the necessary changes that result from the movements of the foot.*

It could be said that, seen from the inside, there are three and a half heads from the ground to the perineum. The center of the patella is the middle point between the anterior superior iliac spine and the ground. The arm measures three heads, from the arm pit to the extremity of the middle finger.

The superior limit of the arm lacks a fixed point, it is below the shoulder joint, a little less than half a head from the superior border of the clavicle. A more precise determination of the length of the arm can be found by an indirect method which I shall explain. From the inferior extremity of the middle finger to just above the olecranon is two heads. The first of these heads falls well up the wrist, the hand itself measures three quarters of a head from the extremity of the middle finger to the heel. The middle finger together with the head of its metacarpal measures a half head.

The olecranon is at the middle of the distance between the point of the shoulder and the metacarpophalangeal articulation of the middle finger. This last measurement is useful in fixing the length of the arm (Figure 31).

The measurement should be taken from the acromion. However, its summit is often difficult to find because of the insertion of the deltoid. It is important to note that this measurement is only true when the arm is extended. When the arm is flexed, the descent of the olecranon causes a proportional lengthening of the upper part of the arm. The reference point of the olecranon can easily be replaced by the epicondyle, which in flexion does not change its place. It must be noted in this case that the length of the arm from the acromion to the epicondyle is changeable. For instance, if the arm is raised horizontally

* Colonel Duhousset (*Revue d'Anthropologie*, No. 4, 1889) gives approximately the same measurement and he points out that the length of the femur is equal to the tibia plus the height of the foot.

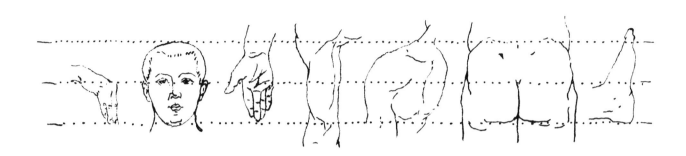

Figure 28. Parts of the body having a common measurement of a head or two half heads.

Figure 29. Parts of the body measuring one and a half heads.

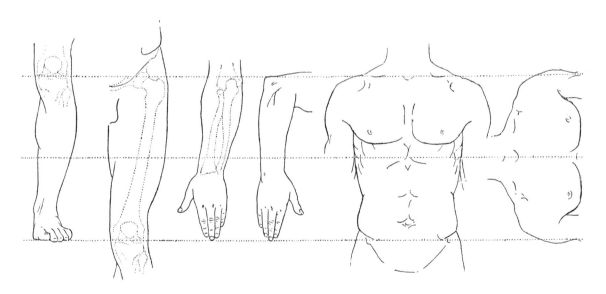

Figure 30. Parts of the body having a common measurement of two heads.

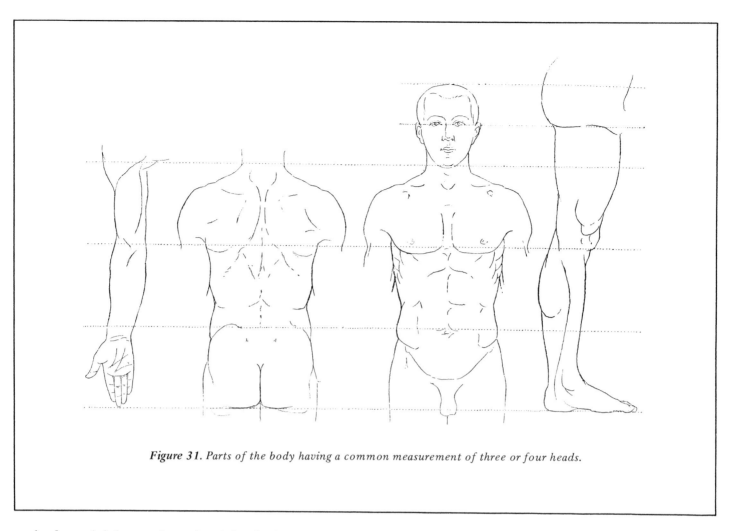

Figure 31. *Parts of the body having a common measurement of three or four heads.*

to the front, it is longer than when it is raised horizontally to the side.

The head is divided in half by the line of the eyes. The other subdivisions given by Cousin may be helpful although it does seem that the nose, which takes up the third division, might be too long, and that the fourth division is too narrow to include both the chin and the mouth. Leonardo da Vinci offers another measurement which appears to be more exact—that the base of the nose marks the middle point between the ridge of the eyebrows and the base of the chin.

The distance from the chin to the pit of the neck is one third of a head.

The principal measurements of the trunk are as follows: the greatest width of the shoulders is two heads; the distance between the two fossets under the clavicles is one head; the width of the chest at the level of the arm pits is a head and a half; and the distance between the two nipples is a head. The greatest width of the pelvis is more than a head and the distance between the great trochanters is a head and a half.

Among the measurements for the height of the trunk, the following are the easiest to remember. From the anterior superior iliac spine to the clavicle, two heads. From the clavicle to the costoabdominal prominence in front and to the upper part of the space between the ribs and pelvis in back, one head and a half. These places indicate the superior limits of the flank. The flank should be given a height of a half head in front and much less in back. From the superior border of the trapezius to the inferior angle of the scapula, one head.

The twelfth dorsal vertebra is situated at the middle of the third division of the torso (when the head is included in the torso).

Finally, the distance from the pit of the neck to the pubis is equal in the back to the distance between the dorsal spine of the seventh cervical vertebra and the summit of the sacrum.

The length of the foot exceeds the height of the head by about one seventh.

Let me summarize certain parts of the body that have a common measurement:

½ HEAD

From the inferior extremity of the middle finger to the top of the head of the third metacarpal.

The height of the flank in front.

The line between the buttocks.

1 HEAD

From the chin to the line of the nipples.

From the nipples to the navel.

From the arm pit to just above the point of the elbow.

The hand, including the wrist.

The height of the buttocks.

The distance in front that separates the two subclavicular fossets.

The height of the scapular region from the superior border

of the trapezius to the inferior angle of the scapula.

(The bi-iliac diameter, measured on the iliac spines, surpasses one head.)

1 ½ HEADS

The height of the thorax from the top of the shoulder to the top of the flank.

The distance that separates the centers of the two shoulder joints.

The distance between the great trochanters.

The distance from the perineum to the articular interline of the knee.

2 HEADS

The lower leg, from the sole of the foot to the articular interline of the knee.

The thigh, from the articular interline of the knee to just above the great trochanter or to the line of the groin.

The forearm and the hand, from the extremity of the middle finger to slightly above the olecranon.

From the clavicle to the anterior superior iliac spine, and in the back from the dorsal spine of the seventh cervical vertebra to the iliac tuberosity which is marked by the lateral inferior lumbar fosset.

3 HEADS

From the chin to the gluteal fold.

From the summit of the head to the navel, or to the superior limit of the buttocks.

The arm, from the arm pit to the extremity of the middle finger.

Finally, let us recall two instances of equal measurement. Though these have nothing to do with measurements in terms of heads, they are nevertheless quite important. On the arm there is an equality of measurement between the distance from the olecranon to the top of the shoulder and the distance from the olecranon to the metacarpophalangeal articulation of the middle finger. On the leg there is an equality of measurement between the distance from the center of the patella to the anterior superior iliac spine and the center of the patella to the ground.

In offering ideas on the proportions of the human body I have had no other aim than to put at the disposition of artists certain useful and precise measurements. They represent no more than a sort of average which should be changed at will according to the artist's esthetic conception, his fantasy, or his genius.

PLATES

All the plates are made from half-life size drawings of a model one meter, 72 centimeters tall. However, because there were great advantages in devoting somewhat larger reproductions to the smaller bones of the sketelon and to anatomical details, not all the drawings have been reduced the same amount. But each plate is internally consistent; all the parts of the body shown in that plate have been reduced to the same scale. The various sizes in which the drawings have been reproduced are indicated below.

SCALE OF PROPORTIONS OF ANATOMICAL DRAWINGS

OSTEOLOGY AND ARTHROLOGY

2/5 LIFE SIZE:
Vertebrae (Plate 3, 4 and 6)
Bones of the Wrist and Hand (Plate 12)
Bones of the Foot (Plate 28, 29, and 31)

1/3 LIFE SIZE:
Head (Plate 1 and 2)
Vertebral Column (Plate 5 and 7)
Sternum, Ribs (Plate 8)
Thoracic Cage (Plate 9 and 10)
Clavicle and Scapula (Plate 11)
Coccyx (Plate 12)
Pelvis (Plate 13, 14 and 15)
Humerus (Plate 19)
Bones of the Forearm (Plate 17)
Femur (Plate 26)
Bones of the Leg (Plate 27 and 28)

1/4 LIFE SIZE:
Trunk (Plate 16, 17 and 18)
Upper Limb (Plate 23, 24 and 25)
Lower Limb (Plate 32, 33, 34 and 35)

MORPHOLOGY

1/3 LIFE SIZE:
Head (Plate 36 and 37)
Neck (Plate 35, 46 and 47)
Hand (Plate 58, Figures 4 and 5)
Foot (Plate 67)

1/4 LIFE SIZE:
Torso (Plate 38, 39, 40, 41, 42, 243,
 44, 45, 48, 49, 50, 51 and 52)
Arm (Plate 56)
Forearm (Plate 57 and 58)
Thigh (Plate 63 and 64)
Leg (Plate 65 and 66)
Full figures (Plate 53, 54, 55, 59, 60,
 61, 62, 68, 69, 70 and 71)

Plate 1: THE SKULL

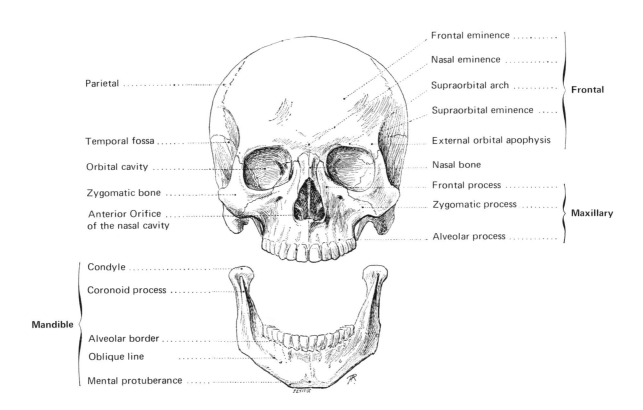

Frontal eminence
Nasal eminence — **Frontal**
Supraorbital arch
Supraorbital eminence
External orbital apophysis

Parietal

Nasal bone
Frontal process
Temporal fossa
Zygomatic process — **Maxillary**
Orbital cavity
Zygomatic bone
Anterior Orifice
of the nasal cavity
Alveolar process

Mandible —
Condyle
Coronoid process
Alveolar border
Oblique line
Mental protuberance

FIGURE 1: ANTERIOR ASPECT

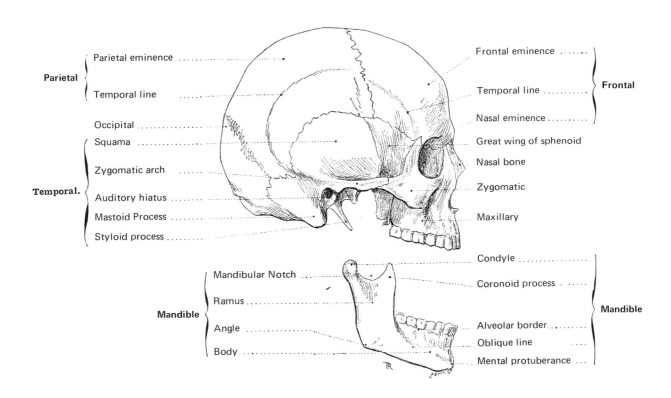

Parietal —
Parietal eminence
Temporal line

Frontal eminence
Temporal line — **Frontal**
Nasal eminence

Occipital
Squama
Zygomatic arch
Temporal. —
Auditory hiatus
Mastoid Process
Styloid process

Great wing of sphenoid
Nasal bone
Zygomatic
Maxillary

Mandible —
Mandibular Notch ...
Ramus
Angle
Body

Condyle
Coronoid process
Alveolar border — **Mandible**
Oblique line
Mental protuberance ...

FIGURE 2. LATERAL ASPECT

Plate 2: THE SKULL

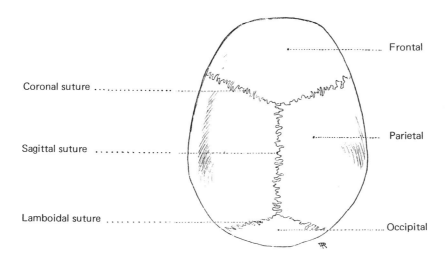

Frontal

Coronal suture

Sagittal suture

Lamboidal suture

Parietal

Occipital

FIGURE I: SUPERIOR ASPECT

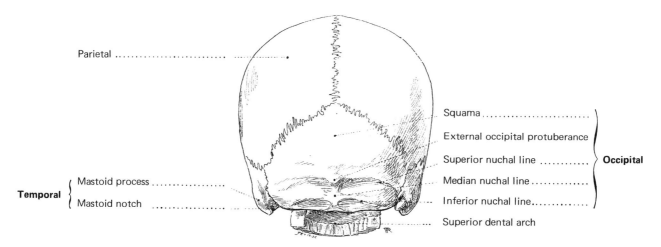

Parietal

Squama

External occipital protuberance

Superior nuchal line

Median nuchal line

Inferior nuchal line

} **Occipital**

Temporal { Mastoid process

Mastoid notch

Superior dental arch

FIGURE 2: POSTERIOR ASPECT

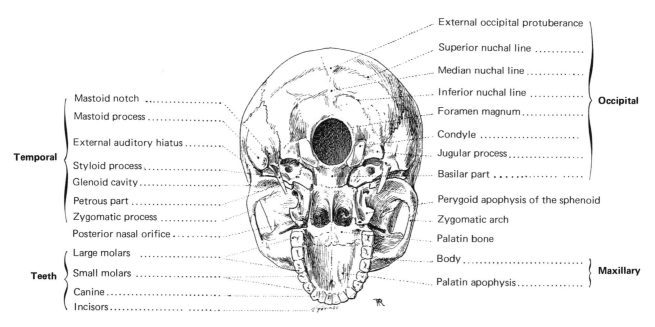

External occipital protuberance

Superior nuchal line

Median nuchal line

Inferior nuchal line

Foramen magnum

Condyle

Jugular process

Basilar part

} **Occipital**

Temporal {
Mastoid notch

Mastoid process

External auditory hiatus

Styloid process

Glenoid cavity

Petrous part

Zygomatic process

Posterior nasal orifice

Perygoid apophysis of the sphenoid

Zygomatic arch

Palatin bone

Body

Palatin apophysis

} **Maxillary**

Teeth {
Large molars

Small molars

Canine

Incisors

FIGURE 3: INFERIOR ASPECT,
BASE OF CRANIUM

PLATE 3: VERTEBRAE

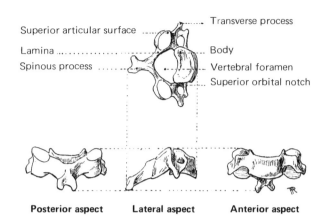

Superior articular surface — Transverse process

Lamina — Body

Spinous process — Vertebral foramen

— Superior orbital notch

Posterior aspect **Lateral aspect** **Anterior aspect**

FIGURE 1: SUPERIOR ASPECT,
FOURTH CERVICAL VERTEBRA

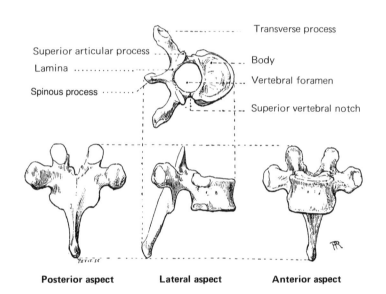

Transverse process

Superior articular process — Body

Lamina — Vertebral foramen

Spinous process — Superior vertebral notch

Posterior aspect **Lateral aspect** **Anterior aspect**

FIGURE 2: SUPERIOR ASPECT
SEVENTH DORSAL VERTEBRA

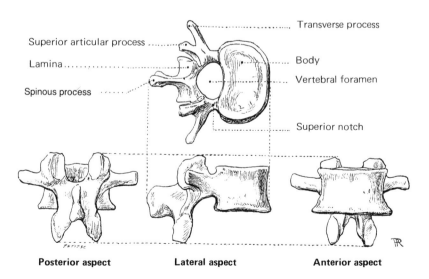

Transverse process

Superior articular process — Body

Lamina — Vertebral foramen

Spinous process — Superior notch

Posterior aspect **Lateral aspect** **Anterior aspect**

FIGURE 3: SUPERIOR ASPECT
THIRD LUMBAR VERTEBRA

Plate 4: VERTEBRAE

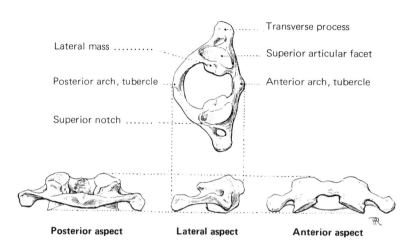

Transverse process

Lateral mass

Superior articular facet

Posterior arch, tubercle

Anterior arch, tubercle

Superior notch

Posterior aspect **Lateral aspect** **Anterior aspect**

FIGURE 1: SUPERIOR ASPECT,
FIRST CERVICAL VERTEBRA OR ATLAS

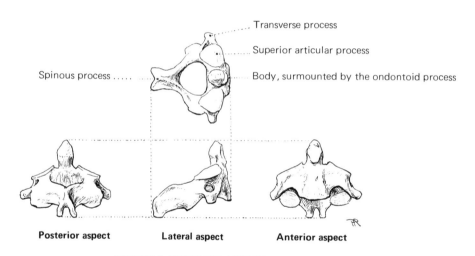

Transverse process

Superior articular process

Spinous process

Body, surmounted by the ondontoid process

Posterior aspect **Lateral aspect** **Anterior aspect**

FIGURE 2: SUPERIOR ASPECT,
SECOND CERVICAL VERTEBRA OR AXIS

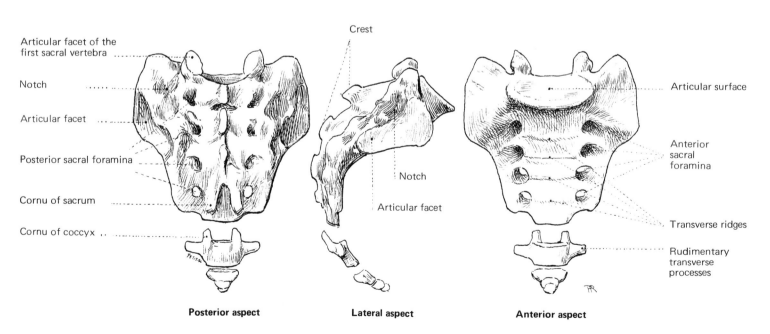

Crest

Articular facet of the
first sacral vertebra

Notch

Articular facet

Articular surface

Posterior sacral foramina

Anterior
sacral
foramina

Cornu of sacrum

Notch

Cornu of coccyx ..

Articular facet

Transverse ridges

Rudimentary
transverse
processes

Posterior aspect **Lateral aspect** **Anterior aspect**

FIGURE 3: SACRUM AND COCCYX

Plate 5: VERTEBRAL COLUMN

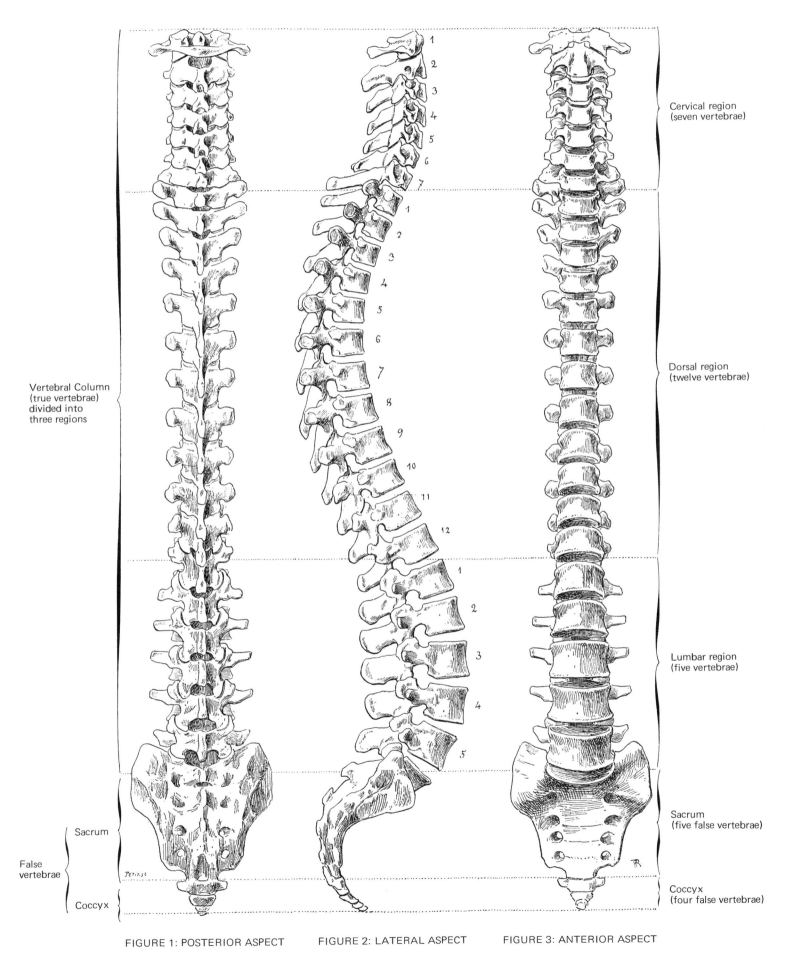

Cervical region
(seven vertebrae)

Dorsal region
(twelve vertebrae)

Vertebral Column
(true vertebrae)
divided into
three regions

Lumbar region
(five vertebrae)

Sacrum
(five false vertebrae)

Sacrum

False
vertebrae

Coccyx

Coccyx
(four false vertebrae)

FIGURE 1: POSTERIOR ASPECT FIGURE 2: LATERAL ASPECT FIGURE 3: ANTERIOR ASPECT

Plate 6: LIGAMENTS OF THE HEAD AND THE VERTEBRAL COLUMN

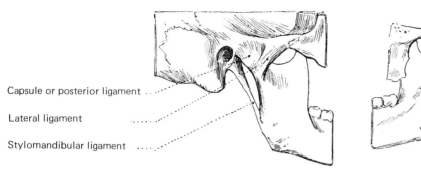

Capsule or posterior ligament

Lateral ligament

Stylomandibular ligament

FIGURE 1: TEMPOROMANDIBULAR ARTICULATION,
EXTERNAL ASPECT

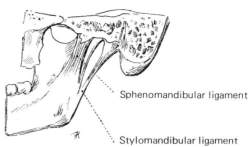

Sphenomandibular ligament

Stylomandibular ligament

FIGURE 2: TEMPOROMANDIBULAR ARTICULATION,
INTERNAL ASPECT

Posterior
longitudinal
ligament

FIGURE 6: DETAIL OF THE ARTICULATION OF
THE VERTEBRAE BETWEEN THEMSELVES;
posterior view of the anterior part
of the vertebral canal

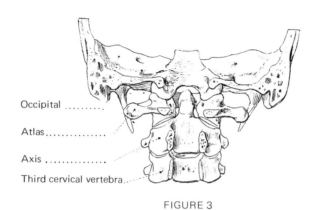

Occipital

Atlas

Axis

Third cervical vertebra.....

FIGURE 3

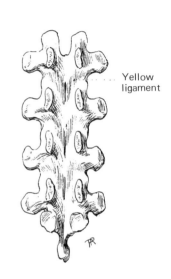

Yellow
ligament

FIGURE 7: DETAIL OF THE ARTICULATION OF
THE VERTEBRAE BETWEEN THEMSELVES
anterior view of the posterior part
of the vertebral canal

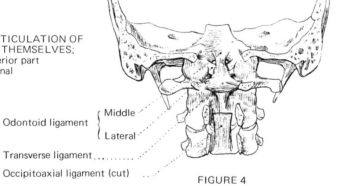

Odontoid ligament { Middle

{ Lateral

Transverse ligament

Occipitoaxial ligament (cut)

FIGURE 4

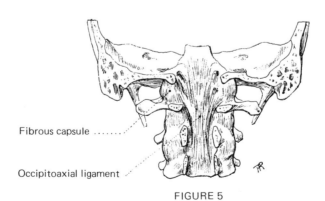

Fibrous capsule

Occipitoaxial ligament ...

FIGURE 5

FIGURE 3, 4, and 5: ARTICULATION OF THE OCCIPITAL, ATLAS, AND AXIS;
posterior aspect, vertebral canal is open

Plate 7: LIGAMENTS OF THE VERTEBRAL COLUMN

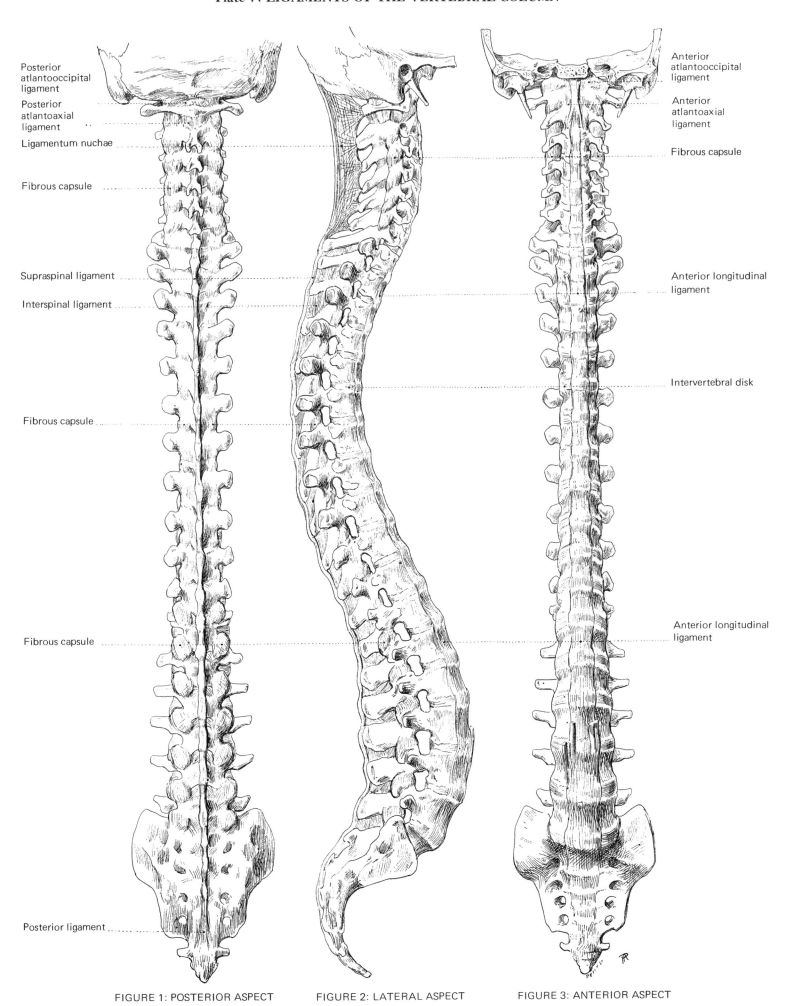

Posterior atlantooccipital ligament

Posterior atlantoaxial ligament

Ligamentum nuchae

Fibrous capsule

Supraspinal ligament

Interspinal ligament

Fibrous capsule

Fibrous capsule

Posterior ligament

Anterior atlantooccipital ligament

Anterior atlantoaxial ligament

Fibrous capsule

Anterior longitudinal ligament

Intervertebral disk

Anterior longitudinal ligament

FIGURE 1: POSTERIOR ASPECT

FIGURE 2: LATERAL ASPECT

FIGURE 3: ANTERIOR ASPECT

Plate 8: THE SKELETON OF THE THORAX

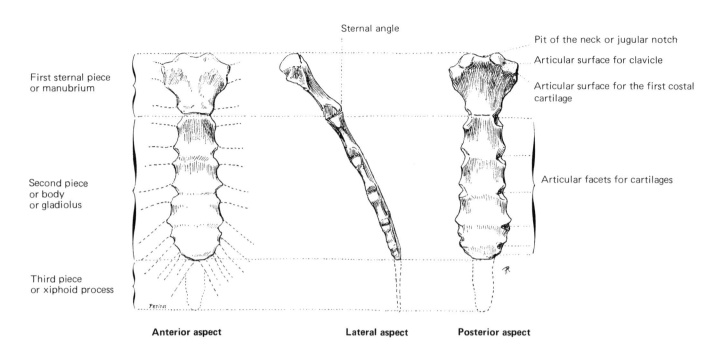

First sternal piece
or manubrium

Second piece
or body
or gladiolus

Third piece
or xiphoid process

Sternal angle

Pit of the neck or jugular notch

Articular surface for clavicle

Articular surface for the first costal
cartilage

Articular facets for cartilages

Anterior aspect

Lateral aspect

Posterior aspect

FIGURE 1: STERNUM

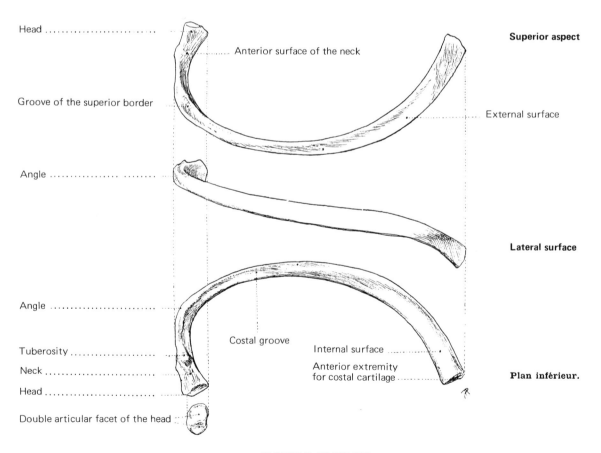

Head

Groove of the superior border

Angle

Angle

Tuberosity

Neck

Head

Double articular facet of the head

Anterior surface of the neck

Costal groove

Internal surface

Anterior extremity
for costal cartilage

Superior aspect

External surface

Lateral surface

Plan inférieur.

FIGURE 2: SIXTH RIB

146

Plate 9: THORACIC CAGE

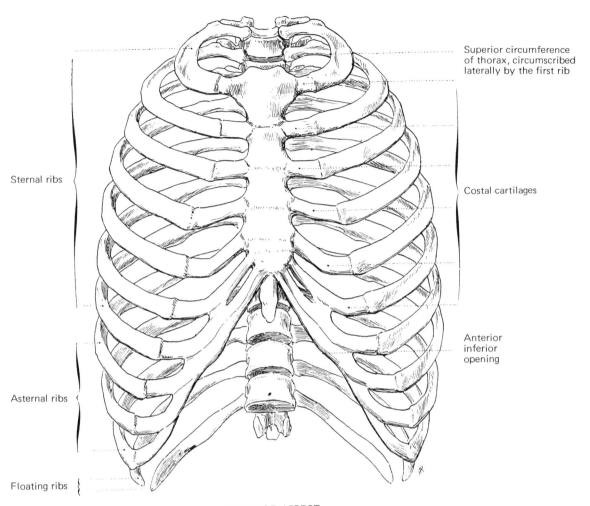

Superior circumference of thorax, circumscribed laterally by the first rib

Sternal ribs

Costal cartilages

Anterior inferior opening

Asternal ribs

Floating ribs

ANTERIOR ASPECT

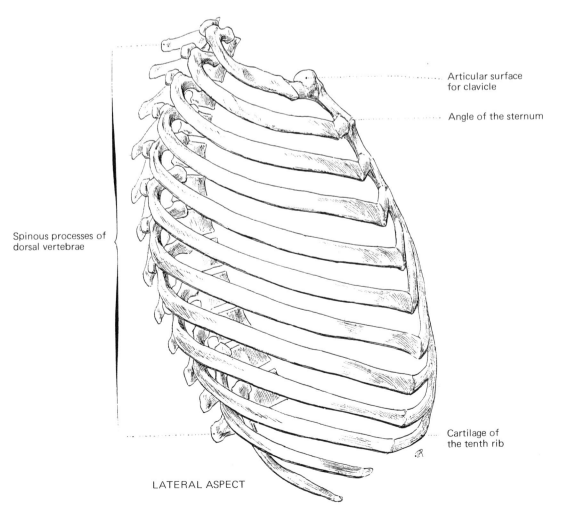

Articular surface for clavicle

Angle of the sternum

Spinous processes of dorsal vertebrae

Cartilage of the tenth rib

LATERAL ASPECT

147

Plate 10: THORACIC CAGE

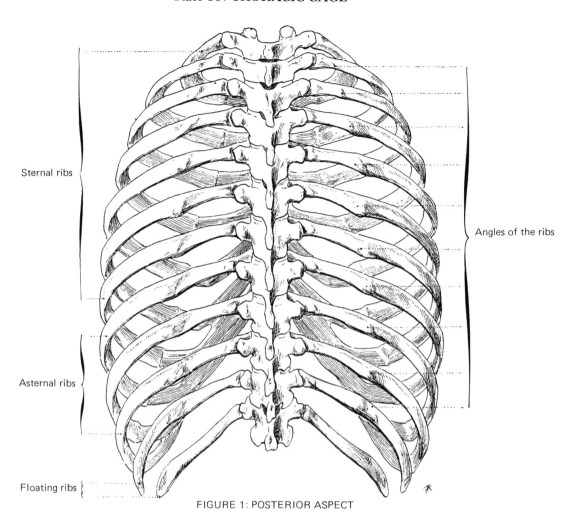

Sternal ribs

Asternal ribs

Floating ribs

Angles of the ribs

FIGURE 1: POSTERIOR ASPECT

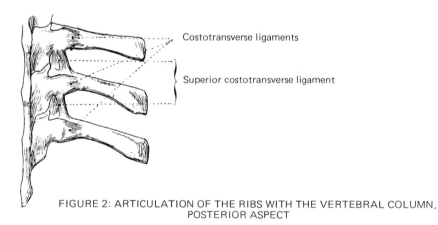

Costotransverse ligaments

Superior costotransverse ligament

FIGURE 2: ARTICULATION OF THE RIBS WITH THE VERTEBRAL COLUMN,
POSTERIOR ASPECT

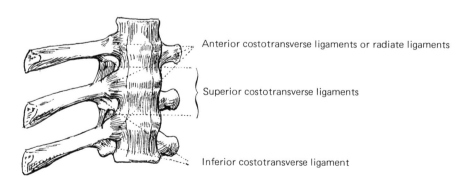

Anterior costotransverse ligaments or radiate ligaments

Superior costotransverse ligaments

Inferior costotransverse ligament

FIGURE 3: ARTICULATIONS OF THE RIBS WITH THE VERTEBRAL COLUMN,
ANTERIOR ASPECT

148

Plate 11: BONES OF THE SHOULDER

Articular facet for the acromion

Superior aspect

Anterior aspect

Articular surface

Inferior aspect

Roughened surface for the insertion of the coracoclavicular ligament

Subclavian groove

Tuberosity

FIGURE 1: CLAVICLE

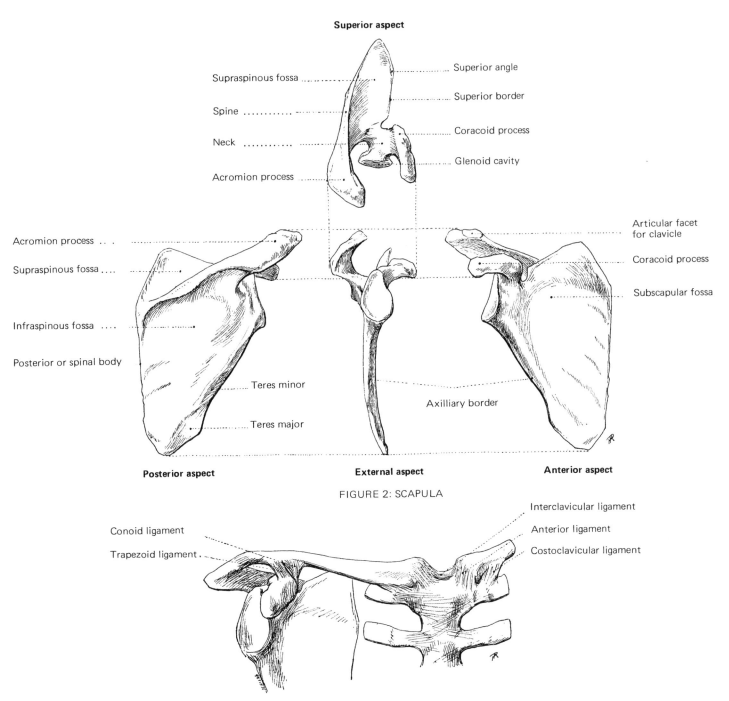

Superior aspect

Supraspinous fossa

Spine

Neck

Acromion process

Superior angle

Superior border

Coracoid process

Glenoid cavity

Acromion process

Supraspinous fossa

Infraspinous fossa

Posterior or spinal body

Teres minor

Teres major

Articular facet for clavicle

Coracoid process

Subscapular fossa

Axilliary border

Posterior aspect

External aspect

Anterior aspect

FIGURE 2: SCAPULA

Conoid ligament

Trapezoid ligament

Interclavicular ligament

Anterior ligament

Costoclavicular ligament

FIGURE 3: ARTICULATIONS OF THE CLAVICLE

Plate 12: THE HIP BONE

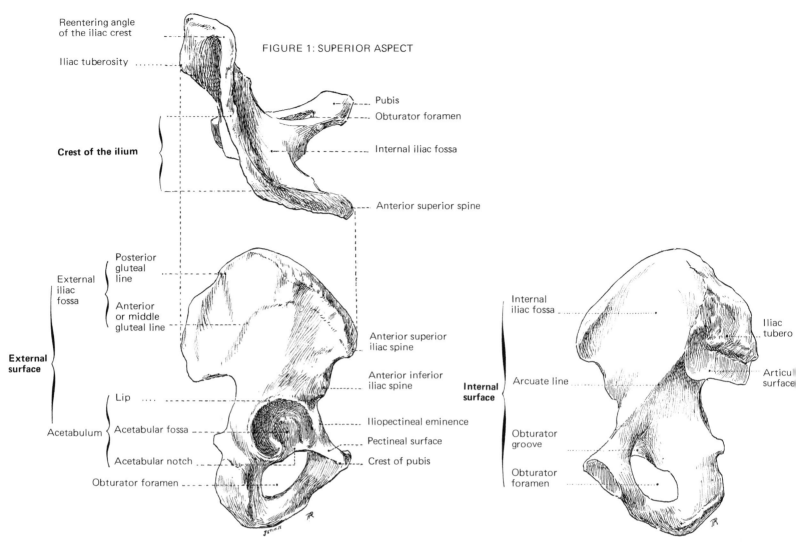

Reentering angle of the iliac crest

Iliac tuberosity

FIGURE 1: SUPERIOR ASPECT

Pubis

Obturator foramen

Internal iliac fossa

Crest of the ilium

Anterior superior spine

External surface

External iliac fossa — Posterior gluteal line

Anterior or middle gluteal line

Anterior superior iliac spine

Anterior inferior iliac spine

Lip

Acetabular fossa

Acetabulum — Iliopectineal eminence

Pectineal surface

Acetabular notch

Crest of pubis

Obturator foramen

FIGURE 2: LATERAL ASPECT

Internal iliac fossa

Iliac tubero

Internal surface — Arcuate line

Articu surface

Obturator groove

Obturator foramen

FIGURE 3: MEDIAL ASPECT

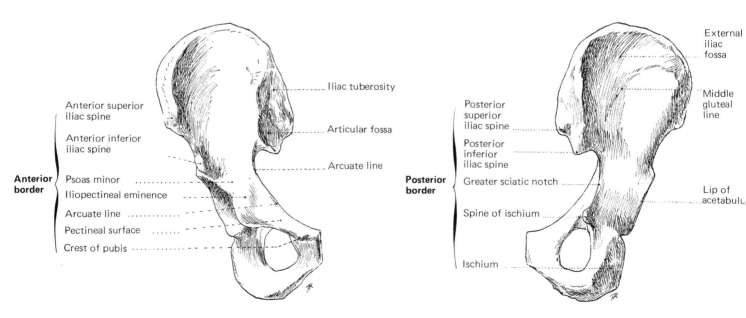

Iliac tuberosity

Articular fossa

Arcuate line

Anterior border

Anterior superior iliac spine

Anterior inferior iliac spine

Psoas minor

Iliopectineal eminence

Arcuate line

Pectineal surface

Crest of pubis

FIGURE 4: ANTERIOR ASPECT

External iliac fossa

Middle gluteal line

Posterior border

Posterior superior iliac spine

Posterior inferior iliac spine

Greater sciatic notch

Spine of ischium

Lip of acetabulu

Ischium

FIGURE 5: POSTERIOR ASPECT

Plate 13: MALE PELVIS

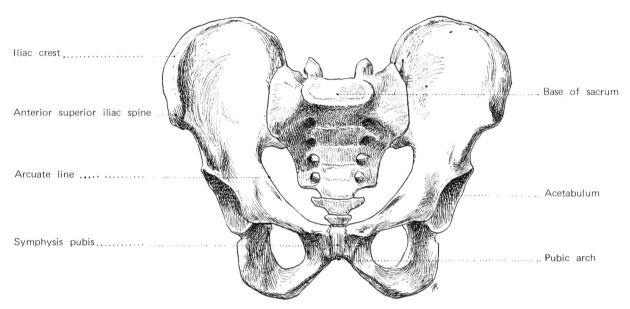

Iliac crest

Anterior superior iliac spine

Arcuate line

Symphysis pubis

Base of sacrum

Acetabulum

Pubic arch

FIGURE 1: ANTERIOR ASPECT

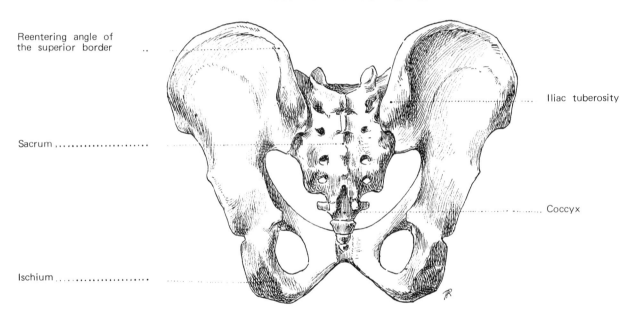

Reentering angle of
the superior border

Sacrum

Ischium

Iliac tuberosity

Coccyx

FIGURE 2: POSTERIOR ASPECT

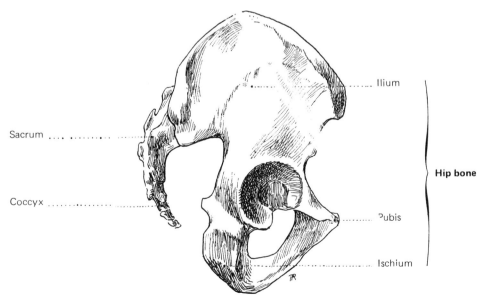

Sacrum

Coccyx

Ilium

Hip bone

Pubis

Ischium

FIGURE 3: LATERAL ASPECT

Plate 14: FEMALE PELVIS

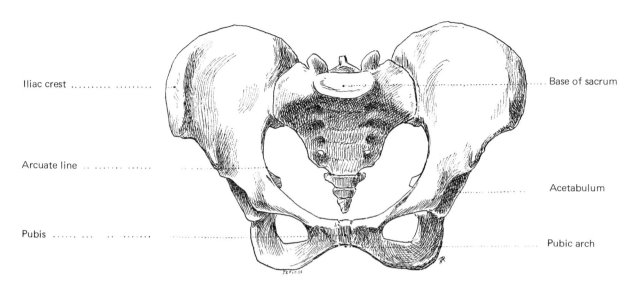

Iliac crest

Arcuate line

Pubis

Base of sacrum

Acetabulum

Pubic arch

FIGURE 1: ANTERIOR ASPECT

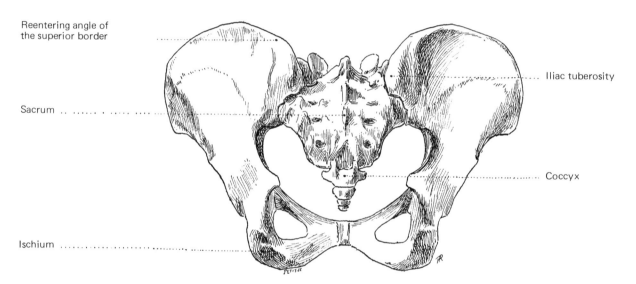

Reentering angle of
the superior border

Sacrum

Ischium .

Iliac tuberosity

Coccyx

FIGURE 2: POSTERIOR ASPECT

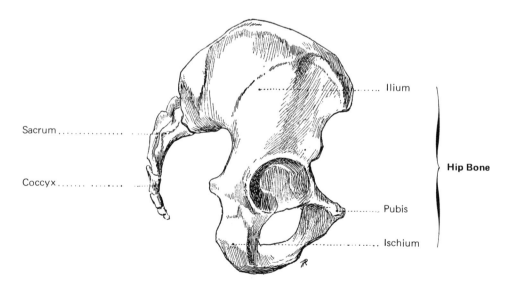

Sacrum

Coccyx

Ilium

Hip Bone

Pubis

Ischium

FIGURE 3: LATERAL ASPECT

152

Plate 15: LIGAMENTS OF THE PELVIS

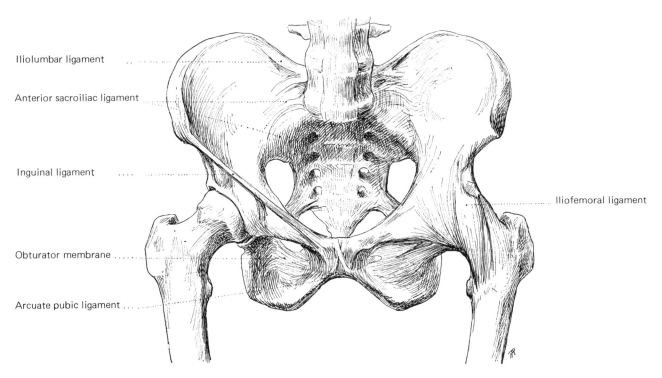

Iliolumbar ligament

Anterior sacroiliac ligament

Inguinal ligament

Obturator membrane

Arcuate pubic ligament

Iliofemoral ligament

FIGURE 1: ANTERIOR ASPECT

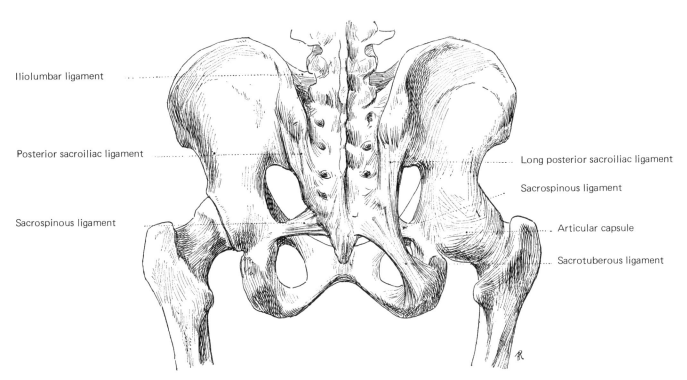

Iliolumbar ligament

Posterior sacroiliac ligament

Sacrospinous ligament

Long posterior sacroiliac ligament

Sacrospinous ligament

Articular capsule

Sacrotuberous ligament

FIGURE 2: POSTERIOR ASPECT

Plate 16: SKELETON OF THE TRUNK

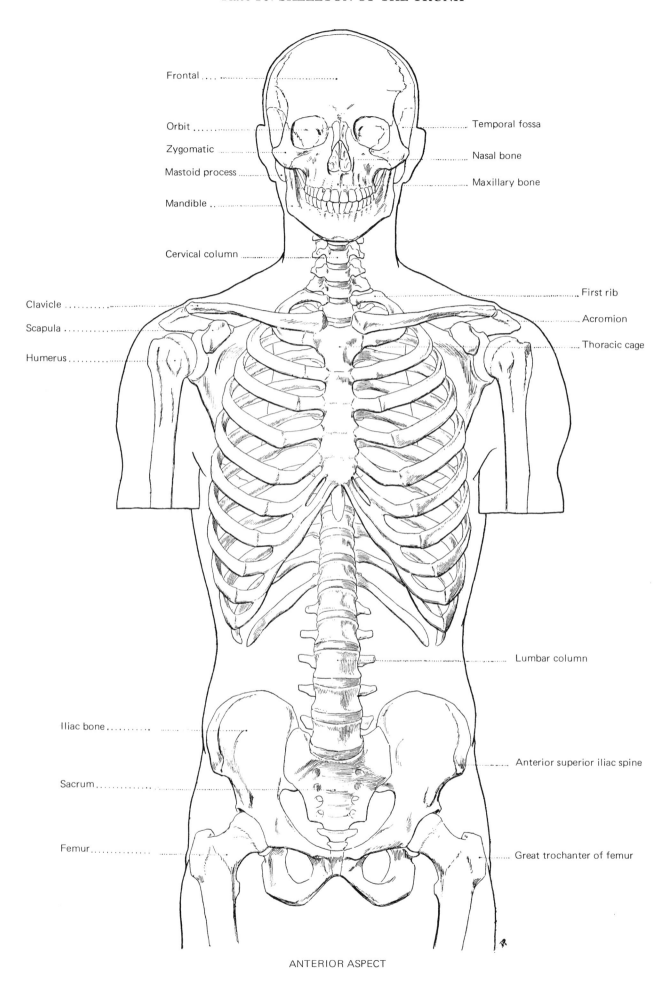

Frontal

Orbit

Zygomatic

Mastoid process

Mandible

Cervical column

Clavicle

Scapula

Humerus

Temporal fossa

Nasal bone

Maxillary bone

First rib

Acromion

Thoracic cage

Lumbar column

Iliac bone

Sacrum

Femur

Anterior superior iliac spine

Great trochanter of femur

ANTERIOR ASPECT

Plate 17: SKELETON OF THE TRUNK

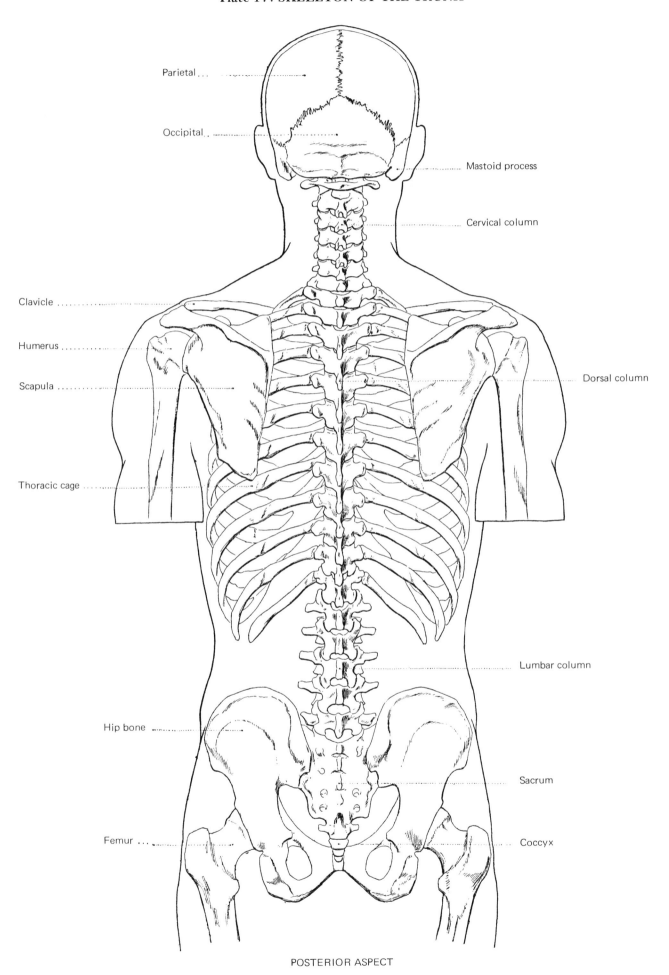

Parietal

Occipital

Mastoid process

Cervical column

Clavicle

Humerus

Scapula

Dorsal column

Thoracic cage

Lumbar column

Hip bone

Sacrum

Femur

Coccyx

POSTERIOR ASPECT

Plate 18: SKELETON OF THE TRUNK

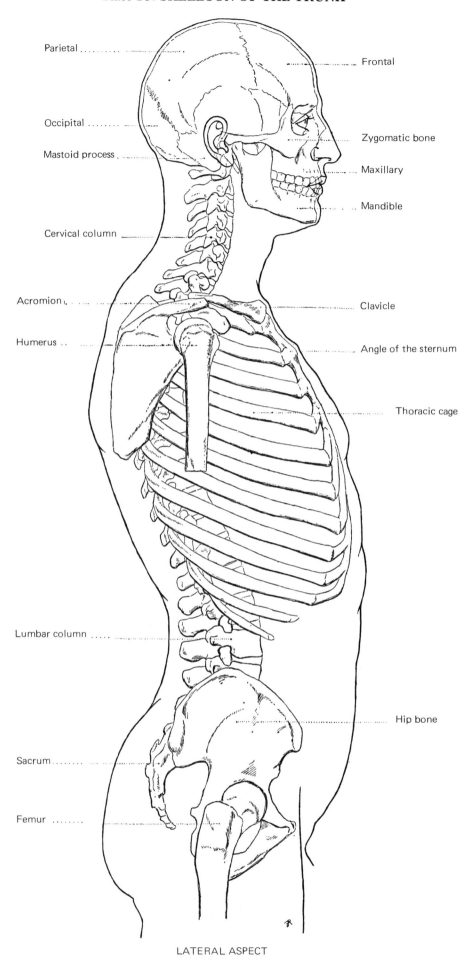

Parietal

Frontal

Occipital

Zygomatic bone

Mastoid process

Maxillary

Mandible

Cervical column

Acromion

Clavicle

Humerus . .

Angle of the sternum

Thoracic cage

Lumbar column

Hip bone

Sacrum

Femur

LATERAL ASPECT

Plate 19: SKELETON OF THE ARM

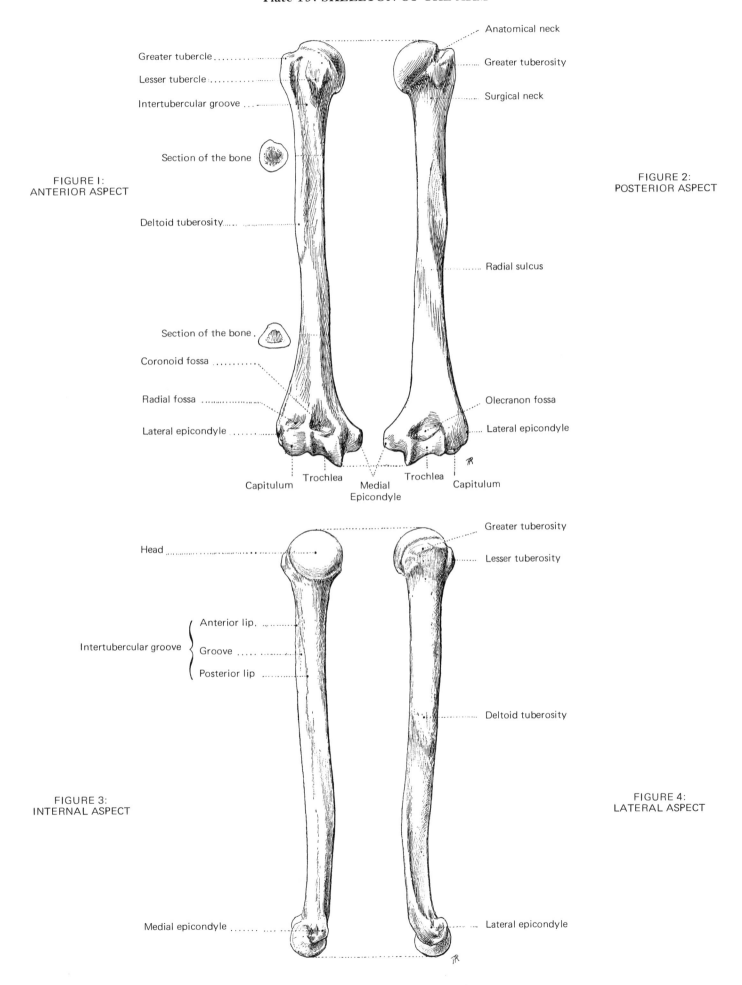

Greater tubercle

Lesser tubercle

Intertubercular groove

Section of the bone

Deltoid tuberosity

Section of the bone

Coronoid fossa

Radial fossa

Lateral epicondyle

Capitulum

Trochlea

Medial Epicondyle

FIGURE I:
ANTERIOR ASPECT

Anatomical neck

Greater tuberosity

Surgical neck

Radial sulcus

Olecranon fossa

Lateral epicondyle

Trochlea

Capitulum

FIGURE 2:
POSTERIOR ASPECT

Head

Intertubercular groove

Anterior lip

Groove

Posterior lip

Medial epicondyle

Greater tuberosity

Lesser tuberosity

Deltoid tuberosity

Lateral epicondyle

FIGURE 3:
INTERNAL ASPECT

FIGURE 4:
LATERAL ASPECT

Plate 20: BONES OF THE FOREARM

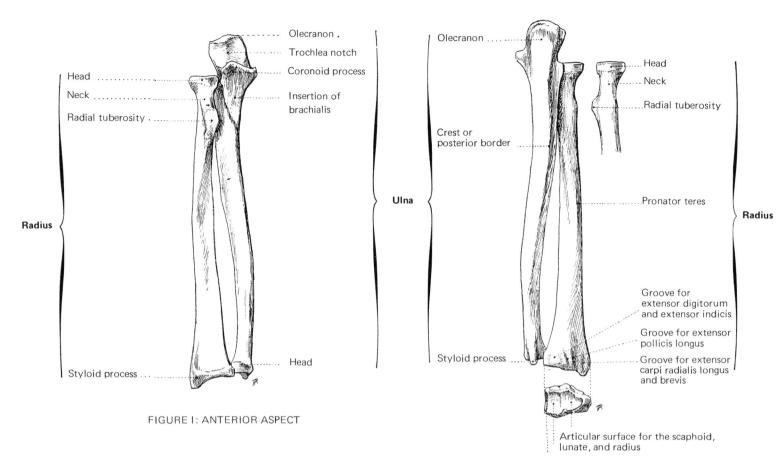

Olecranon

Trochlea notch

Coronoid process

Insertion of brachialis

Head

Neck

Radial tuberosity

Head

Styloid process

Radius

FIGURE I: ANTERIOR ASPECT

Olecranon

Head

Neck

Radial tuberosity

Crest or posterior border

Pronator teres

Ulna

Radius

Groove for extensor digitorum and extensor indicis

Groove for extensor pollicis longus

Groove for extensor carpi radialis longus and brevis

Styloid process

Articular surface for the scaphoid, lunate, and radius

FIGURE 2: POSTERIOR ASPECT

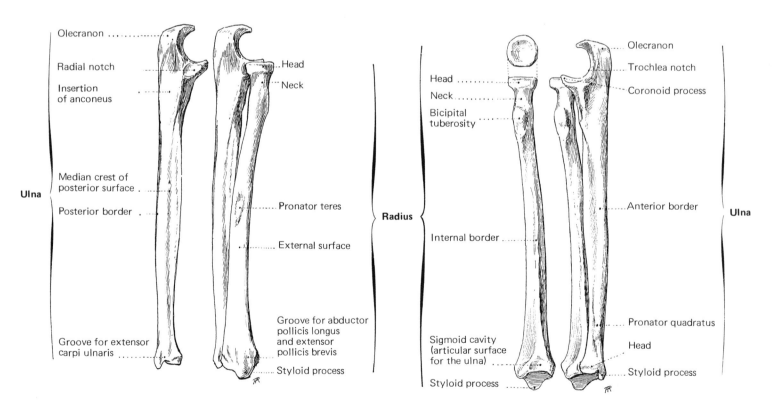

Olecranon

Radial notch

Insertion of anconeus

Head

Neck

Median crest of posterior surface

Posterior border

Pronator teres

External surface

Ulna

Groove for abductor pollicis longus and extensor pollicis brevis

Groove for extensor carpi ulnaris

Styloid process

FIGURE 3: LATERAL ASPECT

Head

Neck

Bicipital tuberosity

Olecranon

Trochlea notch

Coronoid process

Anterior border

Radius

Internal border

Ulna

Pronator quadratus

Head

Sigmoid cavity (articular surface for the ulna)

Styloid process

Styloid process

FIGURE 4: MEDIAL ASPECT

Plate 21: BONES OF THE WRIST AND HAND

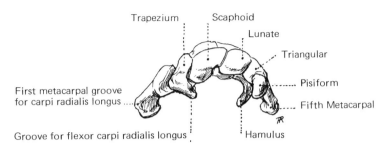

Trapezium
Scaphoid
Lunate
Triangular
Pisiform
Fifth Metacarpal
Hamulus

First metacarpal groove
for carpi radialis longus

Groove for flexor carpi radialis longus

FIGURE 1: SUPERIOR ASPECT

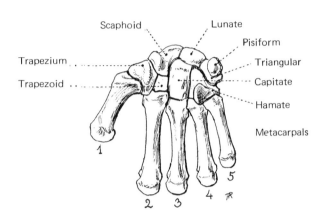

Scaphoid
Lunate
Pisiform
Triangular
Capitate
Hamate
Metacarpals

Trapezium
Trapezoid

1
2 3 4 5

FIGURE 2: ANTERIOR ASPECT

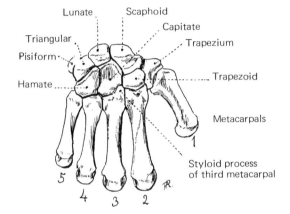

Lunate
Scaphoid
Capitate
Trapezium

Triangular
Pisiform
Hamate

Trapezoid

Metacarpals

Styloid process
of third metacarpal

5
4 3 2
1

FIGURE 3: POSTERIOR ASPECT

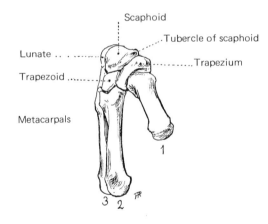

Scaphoid
Tubercle of scaphoid
Trapezium

Lunate
Trapezoid

Metacarpals

1
3 2

FIGURE 4: LATERAL ASPECT

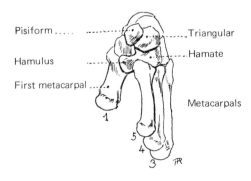

Pisiform
Triangular
Hamulus
Hamate
First metacarpal
Metacarpals

1
5
4
3

FIGURE 5: MEDIAL ASPECT

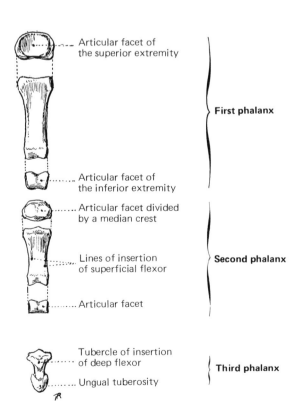

Articular facet of
the superior extremity

First phalanx

Articular facet of
the inferior extremity

Articular facet divided
by a median crest

Lines of insertion
of superficial flexor

Second phalanx

Articular facet

Tubercle of insertion
of deep flexor

Third phalanx

Ungual tuberosity

FIGURE 6: BONES OF THE FINGERS,
ANTERIOR ASPECT

159

Plate 22: LIGAMENTS OF THE ARM

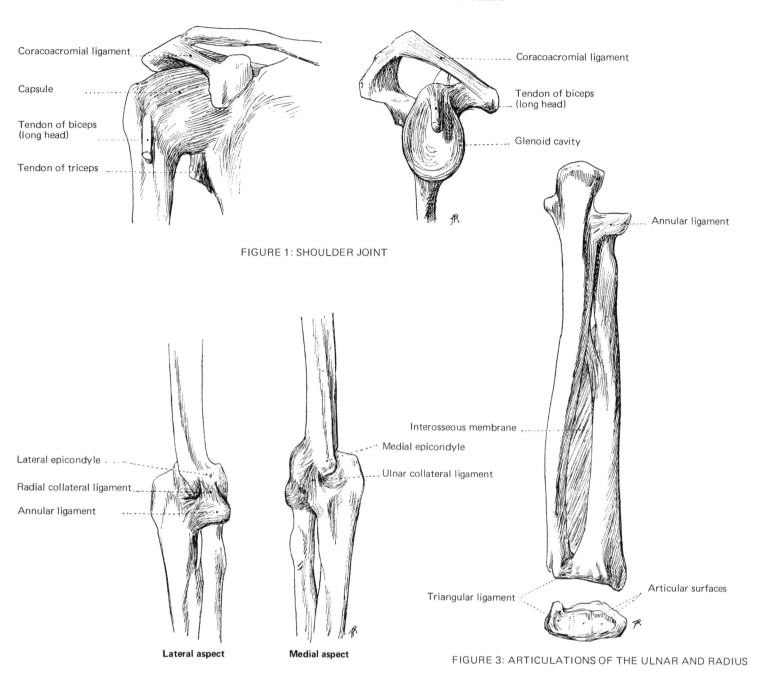

Coracoacromial ligament

Capsule

Tendon of biceps
(long head)

Tendon of triceps

Coracoacromial ligament

Tendon of biceps
(long head)

Glenoid cavity

FIGURE 1: SHOULDER JOINT

Annular ligament

Lateral epicondyle

Radial collateral ligament

Annular ligament

Medial epicondyle

Ulnar collateral ligament

Interosseous membrane

Triangular ligament

Articular surfaces

Lateral aspect **Medial aspect**

FIGURE 2: ARTICULATION OF THE ELBOW

FIGURE 3: ARTICULATIONS OF THE ULNAR AND RADIUS

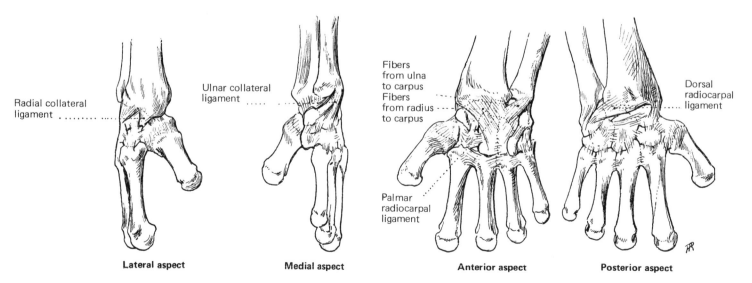

Radial collateral
ligament

Ulnar collateral
ligament

Fibers
from ulna
to carpus
Fibers
from radius
to carpus

Dorsal
radiocarpal
ligament

Palmar
radiocarpal
ligament

Lateral aspect **Medial aspect** **Anterior aspect** **Posterior aspect**

FIGURE 4: ARTICULATIONS OF THE WRIST

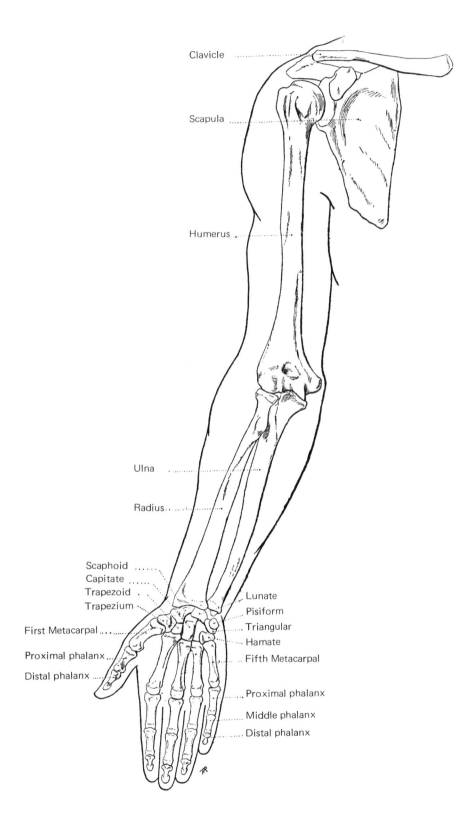

Clavicle

Scapula

Humerus

Ulna

Radius

Scaphoid
Capitate
Trapezoid
Trapezium

First Metacarpal

Proximal phalanx

Distal phalanx

Lunate
Pisiform
Triangular
Hamate
Fifth Metacarpal

Proximal phalanx
Middle phalanx
Distal phalanx

ANTERIOR ASPECT

Clavicle

Scapula

Humerus

Radius

Ulna

Scaphoid

Capitate

Trapezoid

Lunate

Trapezium

Pisiform

Triangular

First metacarpal

Hamate

Fifth metacarpal

Proximal phalanx

Distal phalanx

Proximal phalanx

Middle phalanx

Distal phalanx

POSTERIOR ASPECT

Clavicle

Scapula

Humerus

Radius

Ulna

Scaphoid

Lunate

Trapezium

Capitate

First metacrapal

Trapezoid . . .

Metacarpal

Proximal phalanx

Distal phalanx

Proximal phalanx

Middle phalanx

Distal phalanx . . .

Clavicle

Scapula

Humerus

Ulna

Radius

Scaphoid

Lunate

Pisiform

Triangular

Trapezium

Hamate

First metacarpal . . .

Capitate

Fifth metacarpal

Proximal phalanx . . .

Proximal phalanx

Distal phalanx . . .

Middle phalanx

Distal phalanx

FIGURE 1: LATERAL ASPECT

FIGURE 2: MEDIAL ASPECT

Plate 26: THE THIGH FEMUR

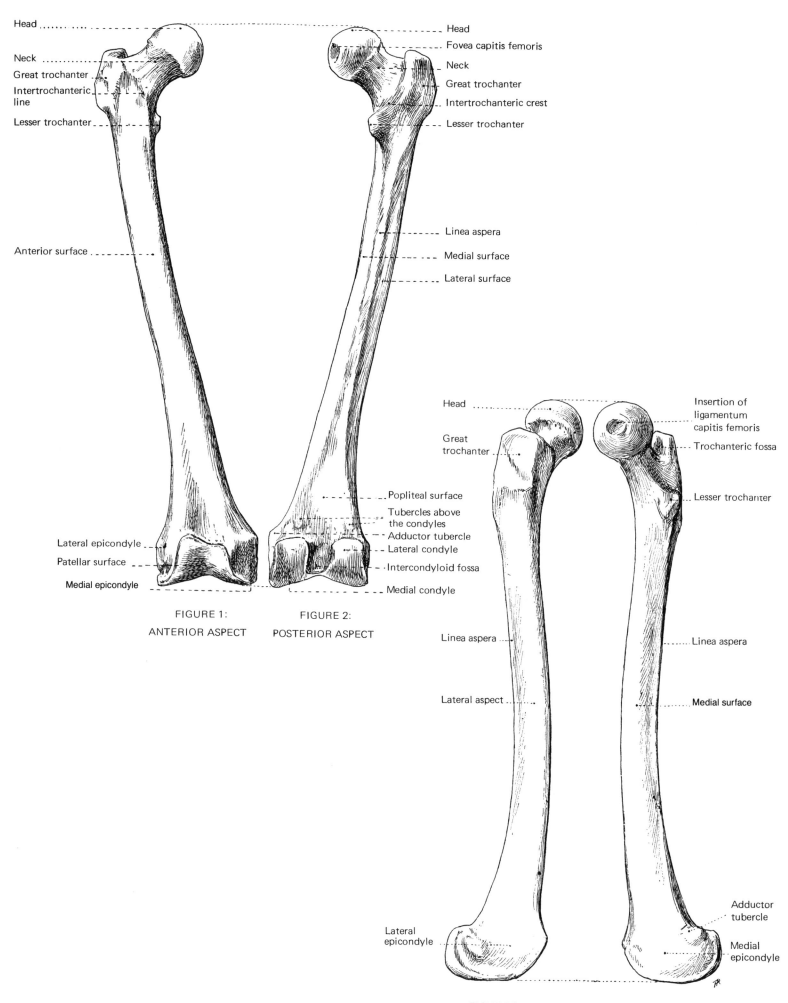

Head

Neck

Great trochanter

Intertrochanteric line

Lesser trochanter

Anterior surface

Lateral epicondyle

Patellar surface

Medial epicondyle

Head

Fovea capitis femoris

Neck

Great trochanter

Intertrochanteric crest

Lesser trochanter

Linea aspera

Medial surface

Lateral surface

Popliteal surface

Tubercles above the condyles

Adductor tubercle

Lateral condyle

Intercondyloid fossa

Medial condyle

FIGURE 1:
ANTERIOR ASPECT

FIGURE 2:
POSTERIOR ASPECT

Head

Great trochanter

Linea aspera

Lateral aspect

Lateral epicondyle

Insertion of ligamentum capitis femoris

Trochanteric fossa

Lesser trochanter

Linea aspera

Medial surface

Adductor tubercle

Medial epicondyle

FIGURE 3:
LATERAL ASPECT

FIGURE 4:
MEDIAL ASPECT

Plate 27: BONES OF THE LOWER LEG

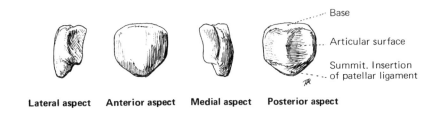

Base

Articular surface

Summit. Insertion
of patellar ligament

Lateral aspect **Anterior aspect** **Medial aspect** **Posterior aspect**

FIGURE 1: PATELLA

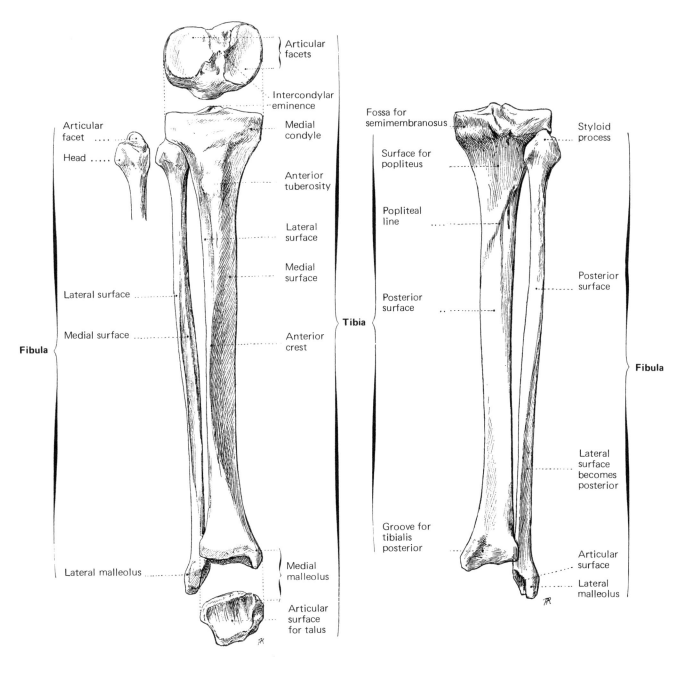

Articular
facets

Intercondylar
eminence

Medial
condyle

Anterior
tuberosity

Lateral
surface

Medial
surface

Anterior
crest

Articular
facet

Head

Lateral surface

Medial surface

Fibula

Lateral malleolus

Medial
malleolus

Articular
surface
for talus

Tibia

Fossa for
semimembranosus

Surface for
popliteus

Popliteal
line

Posterior
surface

Groove for
tibialis
posterior

Styloid
process

Posterior
surface

Lateral
surface
becomes
posterior

Articular
surface

Lateral
malleolus

Fibula

FIGURE 2: ANTERIOR ASPECT FIGURE 3: POSTERIOR ASPECT

165

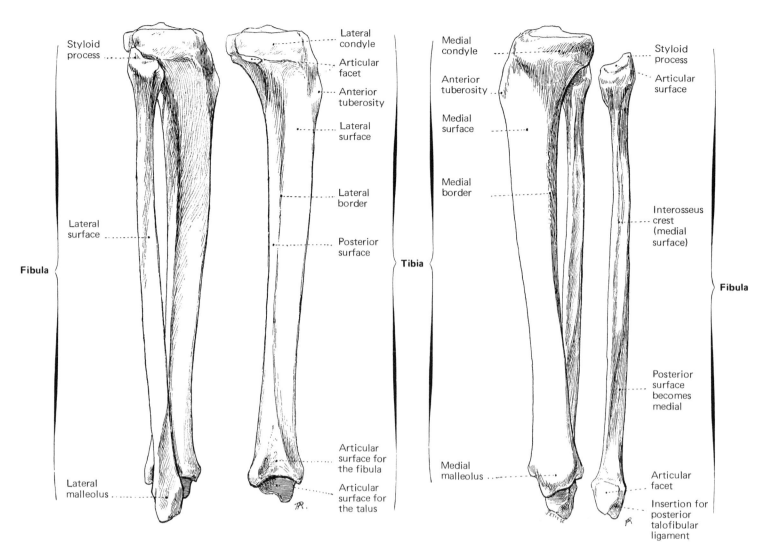

Styloid process

Lateral surface

Fibula

Lateral malleolus

Lateral condyle

Articular facet

Anterior tuberosity

Lateral surface

Lateral border

Posterior surface

Tibia

Articular surface for the fibula

Articular surface for the talus

FIGURE 1: LATERAL ASPECT

Medial condyle

Anterior tuberosity

Medial surface

Medial border

Medial malleolus

Styloid process

Articular surface

Interosseus crest (medial surface)

Fibula

Posterior surface becomes medial

Articular facet

Insertion for posterior talofibular ligament

FIGURE 2: MEDIAL ASPECT

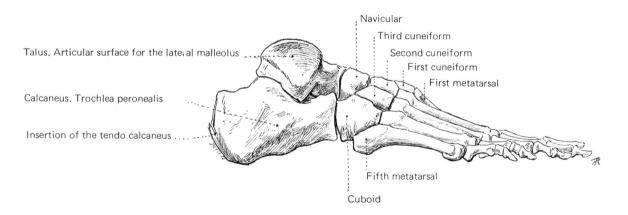

Talus. Articular surface for the lateral malleolus

Calcaneus. Trochlea peronealis

Insertion of the tendo calcaneus

Navicular

Third cuneiform

Second cuneiform

First cuneiform

First metatarsal

Fifth metatarsal

Cuboid

FIGURE 3: BONES OF THE FOOT,
LATERAL ASPECT

166

Plate 29: BONES OF THE FOOT

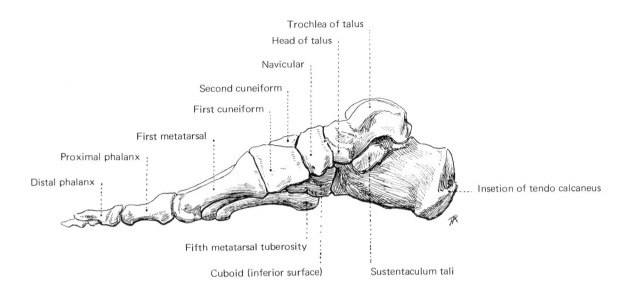

Trochlea of talus

Head of talus

Navicular

Second cuneiform

First cuneiform

First metatarsal

Proximal phalanx

Distal phalanx

Insetion of tendo calcaneus

Fifth metatarsal tuberosity

Cuboid (inferior surface)

Sustentaculum tali

FIGURE 1: MEDIAL ASPECT

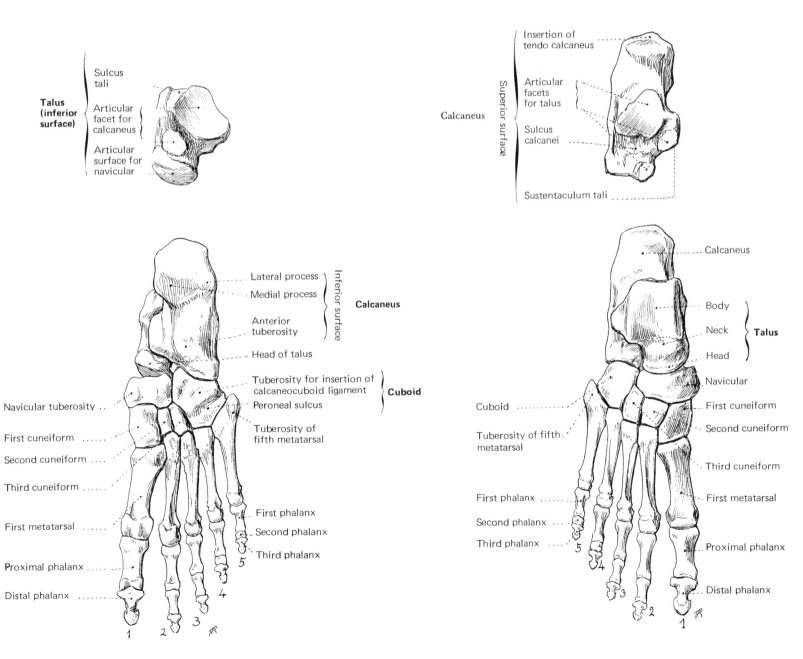

Talus (inferior surface)

Sulcus tali

Articular facet for calcaneus

Articular surface for navicular

Insertion of tendo calcaneus

Articular facets for talus

Sulcus calcanei

Sustentaculum tali

Calcaneus

Superior surface

Lateral process

Medial process

Anterior tuberosity

Head of talus

Inferior surface

Calcaneus

Tuberosity for insertion of calcaneocuboid ligament

Peroneal sulcus

Cuboid

Navicular tuberosity

First cuneiform

Second cuneiform

Third cuneiform

First metatarsal

Proximal phalanx

Distal phalanx

Tuberosity of fifth metatarsal

First phalanx

Second phalanx

Third phalanx

FIGURE 2: INFERIOR ASPECT

Calcaneus

Body

Neck

Head

Talus

Navicular

First cuneiform

Second cuneiform

Third cuneiform

First metatarsal

Proximal phalanx

Distal phalanx

Cuboid

Tuberosity of fifth metatarsal

First phalanx

Second phalanx

Third phalanx

FIGURE 3: SUPERIOR ASPECT

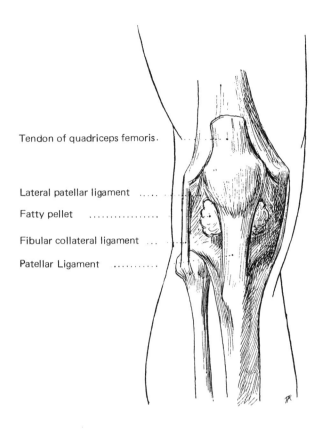

Tendon of quadriceps femoris.

Lateral patellar ligament

Fatty pellet

Fibular collateral ligament

Patellar Ligament

FIGURE 1: ANTERIOR ASPECT

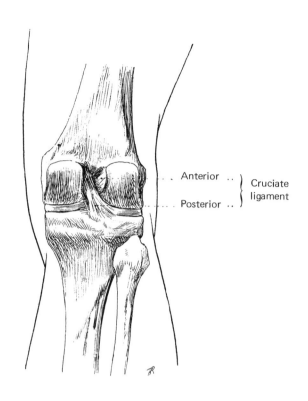

Anterior
Posterior

Cruciate ligament

FIGURE 2: POSTERIOR ASPECT

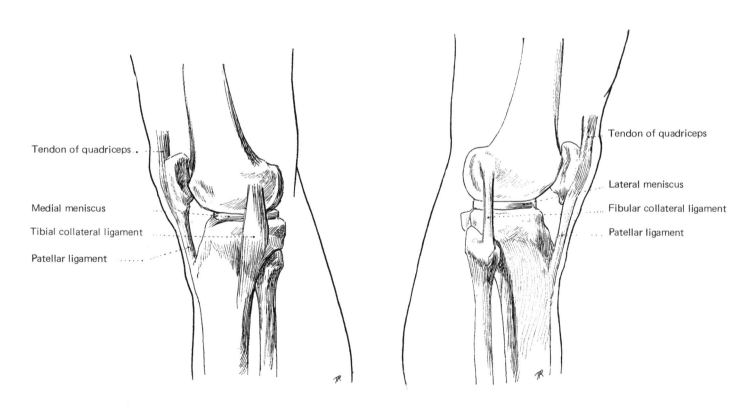

Tendon of quadriceps

Medial meniscus

Tibial collateral ligament

Patellar ligament

FIGURE 3: INTERNAL ASPECT

Tendon of quadriceps

Lateral meniscus

Fibular collateral ligament

Patellar ligament

FIGURE 4: MEDIAL ASPECT

Plate 31: LIGAMENTS OF THE ANKLE AND FOOT

Articulations of the Ankle

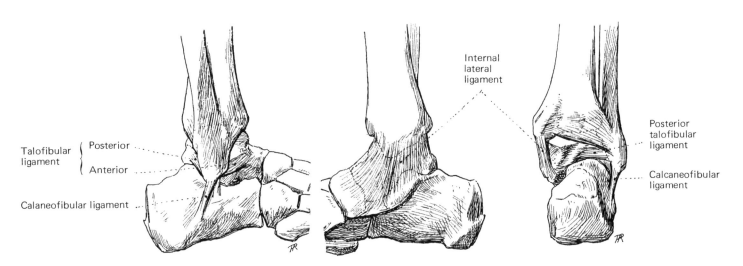

Talofibular ligament { Posterior / Anterior

Calaneofibular ligament

Internal lateral ligament

Posterior talofibular ligament

Calcaneofibular ligament

FIGURE 1: MEDIAL ASPECT FIGURE 2: LATERAL ASPECT FIGURE 3: POSTERIOR ASPECT

Articulations of the Foot

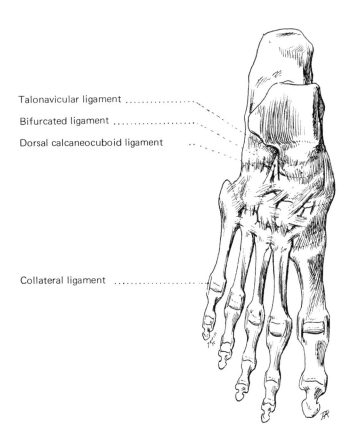

Talonavicular ligament

Bifurcated ligament

Dorsal calcaneocuboid ligament

Collateral ligament

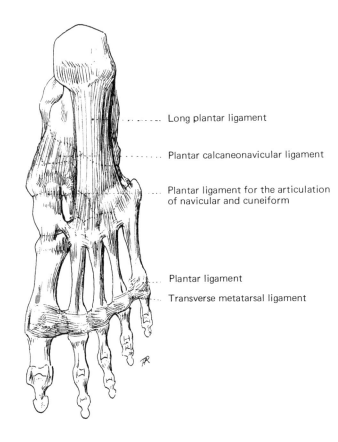

Long plantar ligament

Plantar calcaneonavicular ligament

Plantar ligament for the articulation of navicular and cuneiform

Plantar ligament

Transverse metatarsal ligament

FIGURE 4: SUPERIOR ASPECT FIGURE 5: INFERIOR ASPECT

PLATE 32: BONES OF THE LOWER LIMB

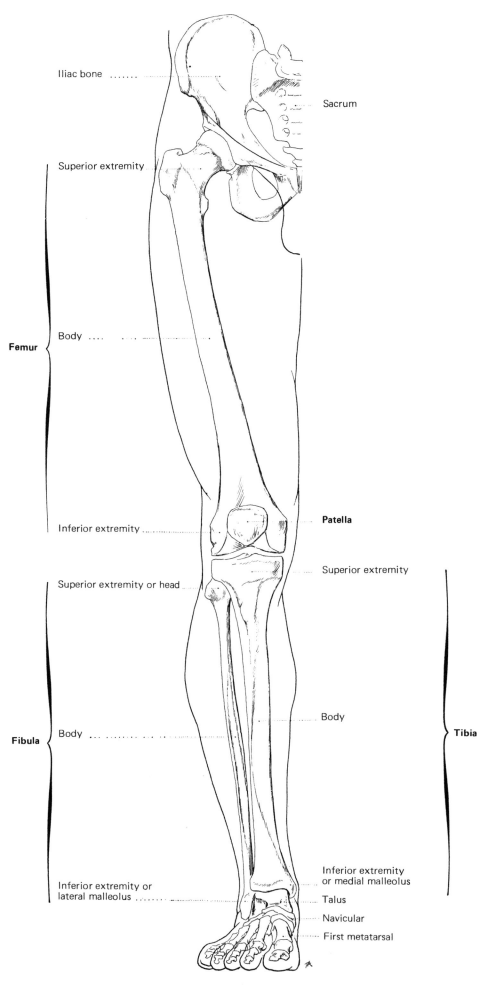

Iliac bone

Sacrum

Superior extremity

Body

Femur

Inferior extremity

Patella

Superior extremity

Superior extremity or head

Body

Body

Fibula

Tibia

Inferior extremity
or medial malleolus

Inferior extremity or
lateral malleolus

Talus

Navicular

First metatarsal

ANTERIOR ASPECT

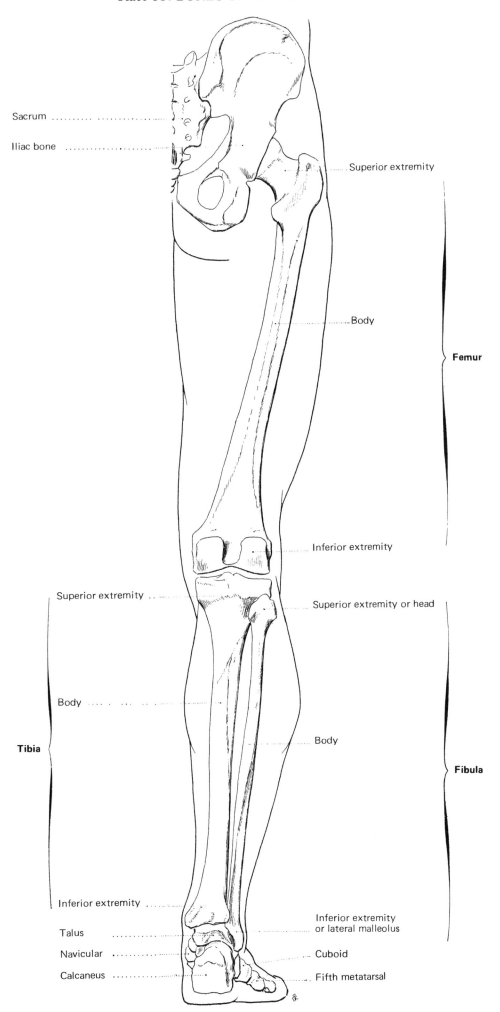

Sacrum

Iliac bone

Superior extremity

Body

Femur

Inferior extremity

Superior extremity

Superior extremity or head

Body

Body

Tibia

Fibula

Inferior extremity

Inferior extremity
or lateral malleolus

Talus

Navicular

Cuboid

Calcaneus

Fifth metatarsal

POSTERIOR ASPECT

171

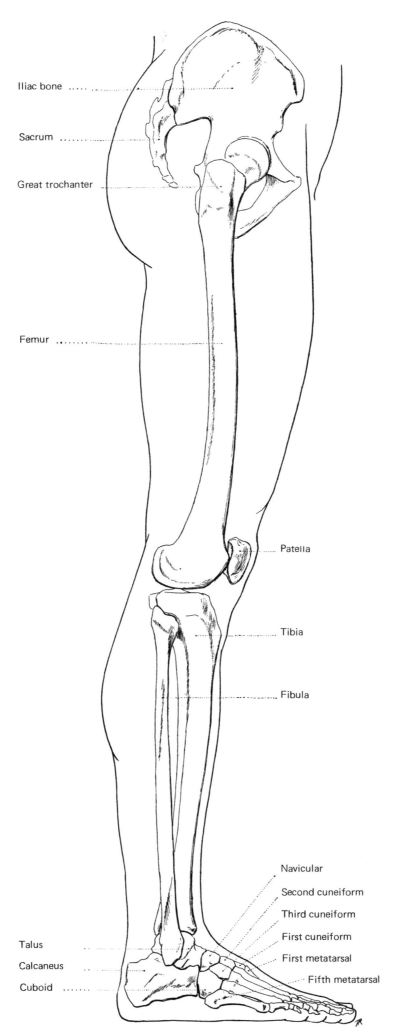

Iliac bone

Sacrum

Great trochanter

Femur

Patella

Tibia

Fibula

Navicular

Second cuneiform

Third cuneiform

First cuneiform

First metatarsal

Talus

Fifth metatarsal

Calcaneus

Cuboid

LATERAL ASPECT

Plate 35: BONES OF THE LOWER LIMB

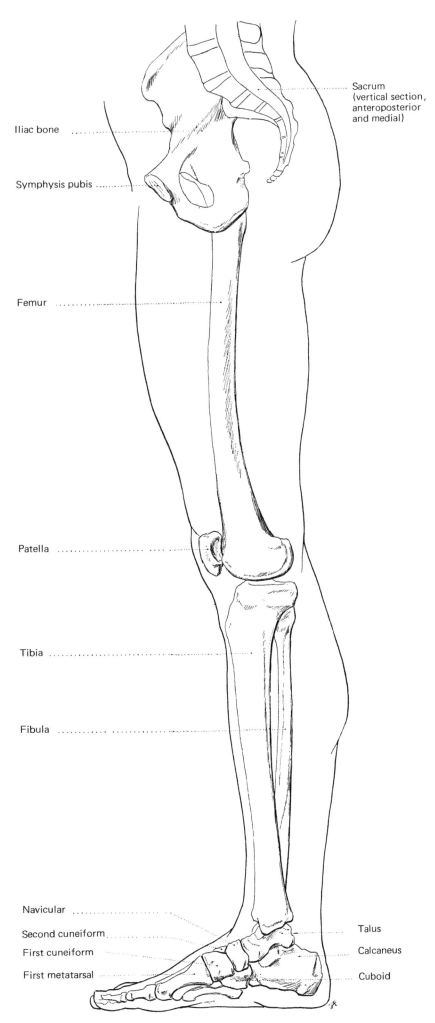

Iliac bone

Symphysis pubis

Femur

Patella

Tibia

Fibula

Navicular

Second cuneiform

First cuneiform

First metatarsal

Sacrum
(vertical section,
anteroposterior
and medial)

Talus

Calcaneus

Cuboid

MEDIAL ASPECT

Frontalis

Temporal aponeurosis

Orbicularis oculi

Levator labii superioris
 alaeque nasi

Levator labii superioris

Levator anguli oris

Zygomaticus minor

Zygomaticus major

Masseter

Buccinator

Orbicularis oris

Depressor anguli oris

Depressor labii inferioris

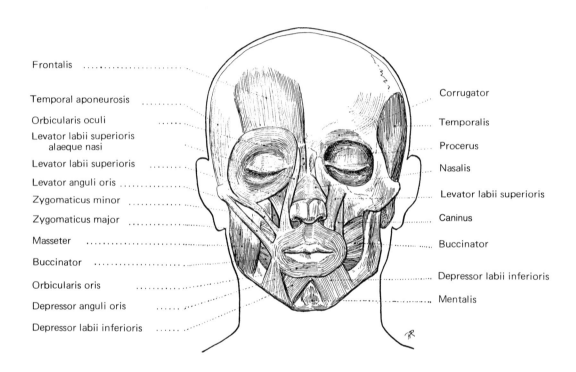

Corrugator

Temporalis

Procerus

Nasalis

Levator labii superioris

Caninus

Buccinator

Depressor labii inferioris

Mentalis

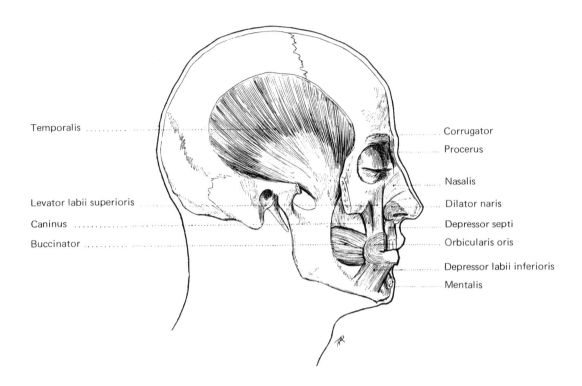

Temporalis

Levator labii superioris

Caninus

Buccinator

Corrugator

Procerus

Nasalis

Dilator naris

Depressor septi

Orbicularis oris

Depressor labii inferioris

Mentalis

FIGURE 1: DEEP LAYER

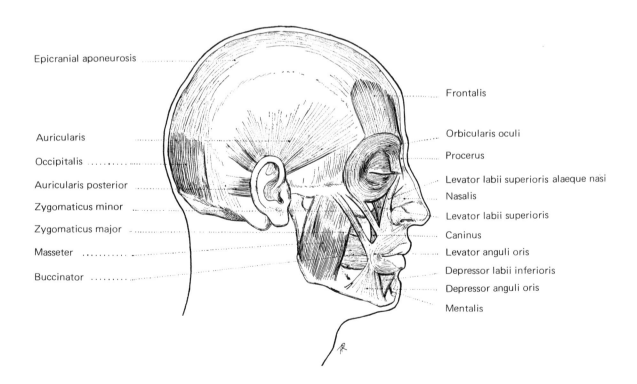

Epicranial aponeurosis

Auricularis

Occipitalis

Auricularis posterior

Zygomaticus minor

Zygomaticus major

Masseter

Buccinator

Frontalis

Orbicularis oculi

Procerus

Levator labii superioris alaeque nasi

Nasalis

Levator labii superioris

Caninus

Levator anguli oris

Depressor labii inferioris

Depressor anguli oris

Mentalis

FIGURE 2: SUPERFICIAL LAYER

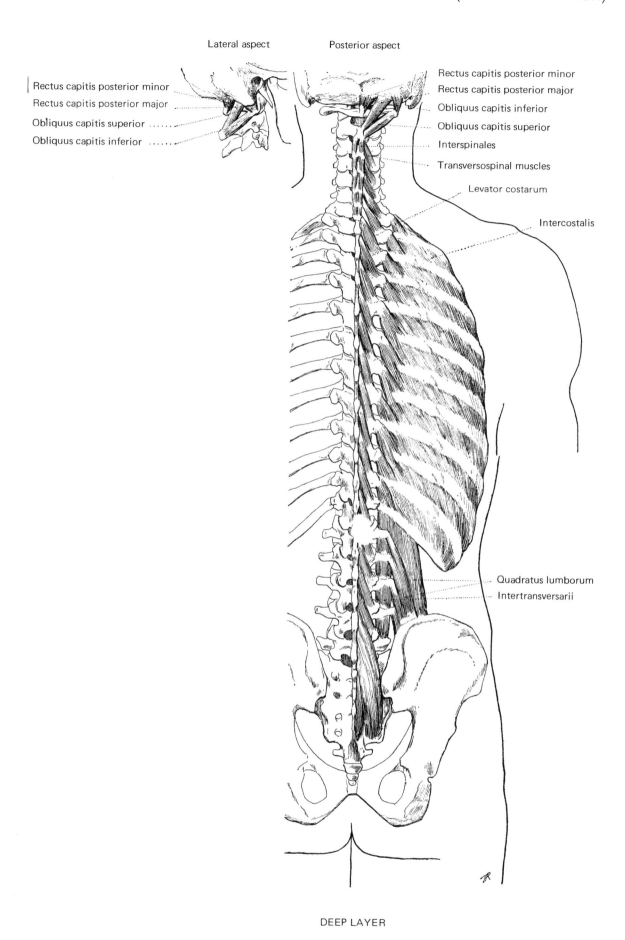

Lateral aspect

Posterior aspect

Rectus capitis posterior minor

Rectus capitis posterior major

Obliquus capitis superior

Obliquus capitis inferior

Rectus capitis posterior minor

Rectus capitis posterior major

Obliquus capitis inferior

Obliquus capitis superior

Interspinales

Transversospinal muscles

Levator costarum

Intercostalis

Quadratus lumborum

Intertransversarii

DEEP LAYER

Plate 39: MUSCLES OF THE TRUNK AND NECK (POSTERIOR REGION)

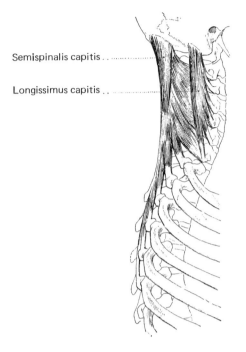

Semispinalis capitis

Longissimus capitis

FIGURE 1: LATERAL ASPECT

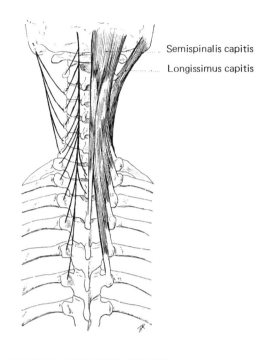

Semispinalis capitis

Longissimus capitis

FIGURE 2: POSTERIOR ASPECT

on the left side, the dark lines show
the muscular origins and insertions

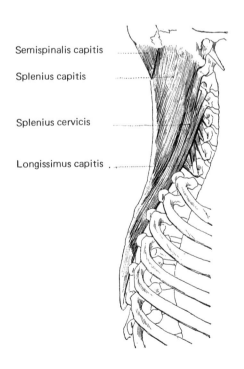

Semispinalis capitis

Splenius capitis

Splenius cervicis

Longissimus capitis

FIGURE 3: SPLENIUS, LATERAL ASPECT

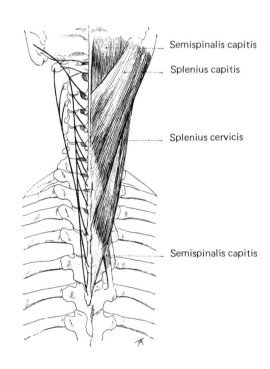

Semispinalis capitis

Splenius capitis

Splenius cervicis

Semispinalis capitis

FIGURE 4: SPLENIUS, POSTERIOR ASPECT

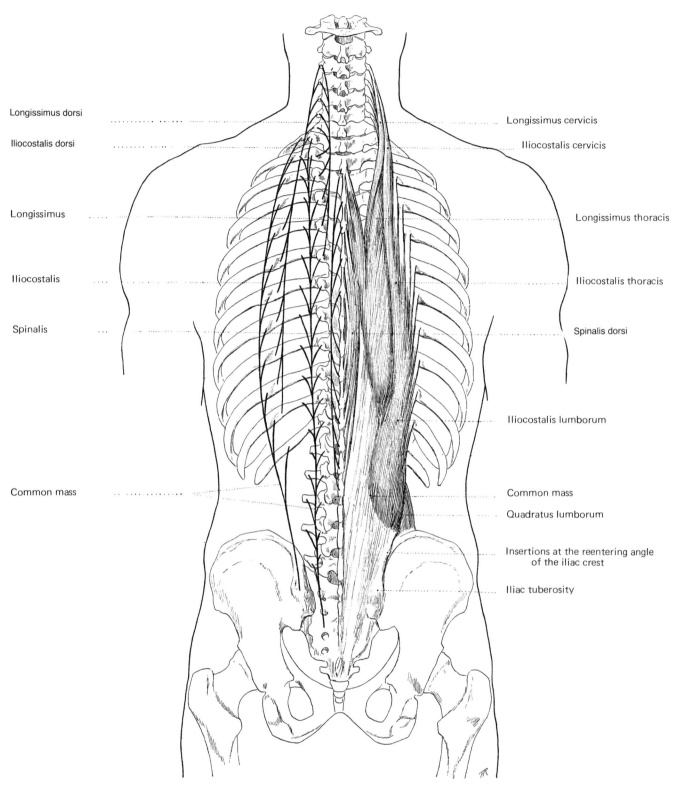

Longissimus dorsi

Iliocostalis dorsi

Longissimus

Iliocostalis

Spinalis

Common mass

Longissimus cervicis

Iliocostalis cervicis

Longissimus thoracis

Iliocostalis thoracis

Spinalis dorsi

Iliocostalis lumborum

Common mass

Quadratus lumborum

Insertions at the reentering angle
of the iliac crest

Iliac tuberosity

SPINAL MUSCLES

on the left side of the figure, the darker
lines show the origins and insertions of the muscles

178

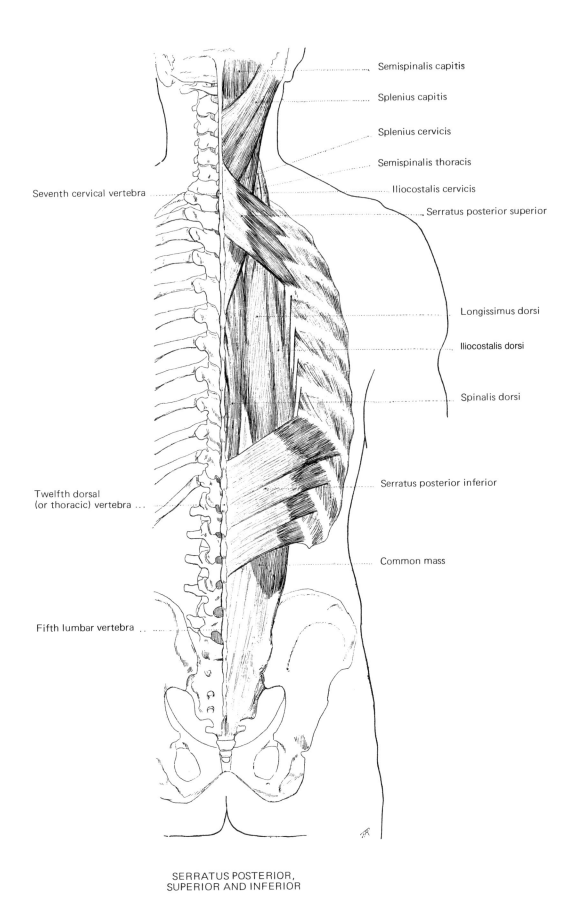

Semispinalis capitis

Splenius capitis

Splenius cervicis

Semispinalis thoracis

Iliocostalis cervicis

Serratus posterior superior

Seventh cervical vertebra

Longissimus dorsi

Iliocostalis dorsi

Spinalis dorsi

Serratus posterior inferior

Twelfth dorsal
(or thoracic) vertebra

Common mass

Fifth lumbar vertebra

SERRATUS POSTERIOR,
SUPERIOR AND INFERIOR

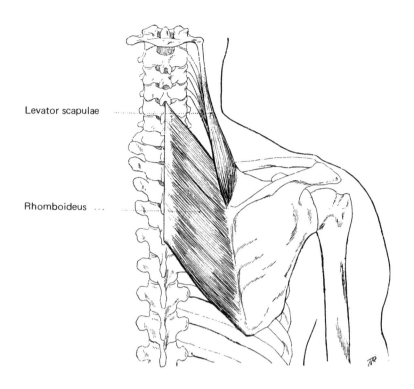

Levator scapulae

Rhomboideus

FIGURE 1: RHOMBOIDEUS AND LEVATOR SCAPULAE

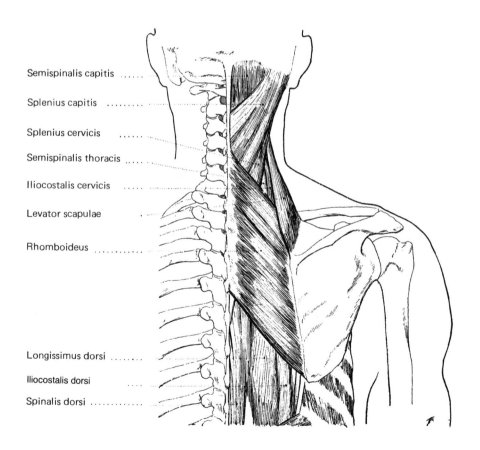

Semispinalis capitis

Splenius capitis

Splenius cervicis

Semispinalis thoracis

Iliocostalis cervicis

Levator scapulae

Rhomboideus

Longissimus dorsi

Iliocostalis dorsi

Spinalis dorsi

FIGURE 2: RHOMBOIDS AND LEVATOR SCAPULAE WITH THE ADJACENT MUSCLES

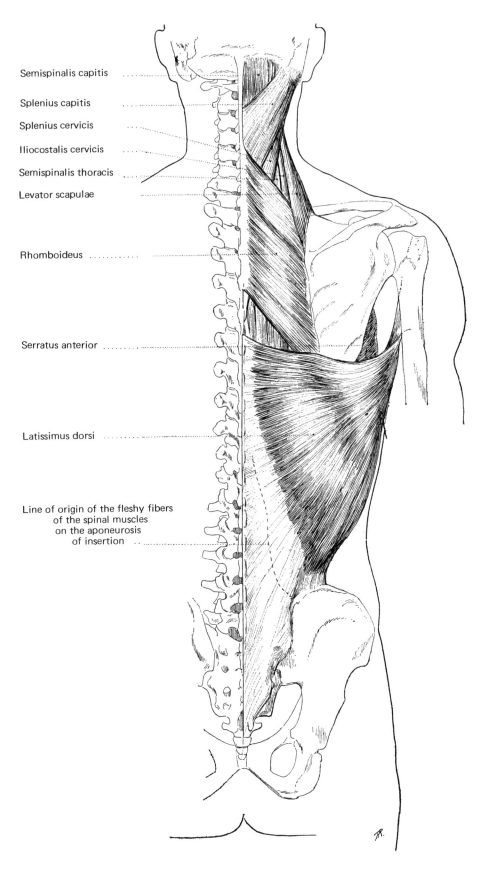

Semispinalis capitis

Splenius capitis

Splenius cervicis

Iliocostalis cervicis

Semispinalis thoracis

Levator scapulae

Rhomboideus

Serratus anterior

Latissimus dorsi

Line of origin of the fleshy fibers
of the spinal muscles
on the aponeurosis
of insertion

LATISSIMUS DORSI

Plate 44: MUSCLES OF THE TRUNK AND NECK (POSTERIOR ASPECT)

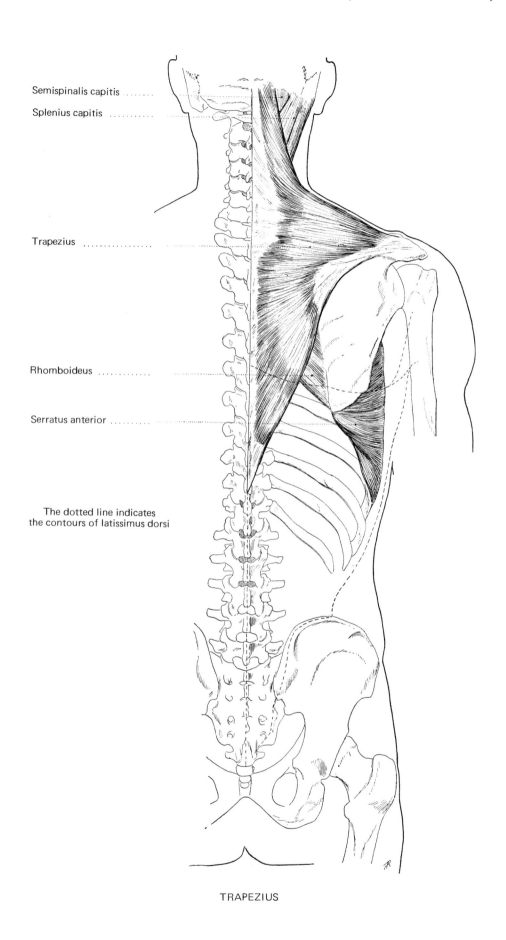

Semispinalis capitis

Splenius capitis

Trapezius

Rhomboideus

Serratus anterior

The dotted line indicates
the contours of latissimus dorsi

TRAPEZIUS

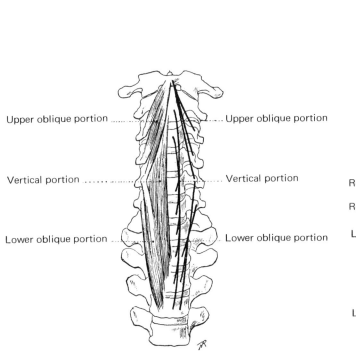

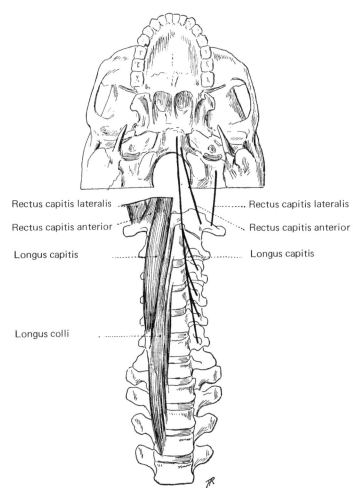

Upper oblique portion Upper oblique portion

Vertical portion Vertical portion

Lower oblique portion Lower oblique portion

Rectus capitis lateralis Rectus capitis lateralis

Rectus capitis anterior Rectus capitis anterior

Longus capitis Longus capitis

Longus colli

FIGURE 1: LONGUS COLLI

(the lines on the right show the
muscular origins and insertions)

FIGURE 2: ANTERIOR DEEP LAYER

(the lines on the right show the
muscular origins and insertions)

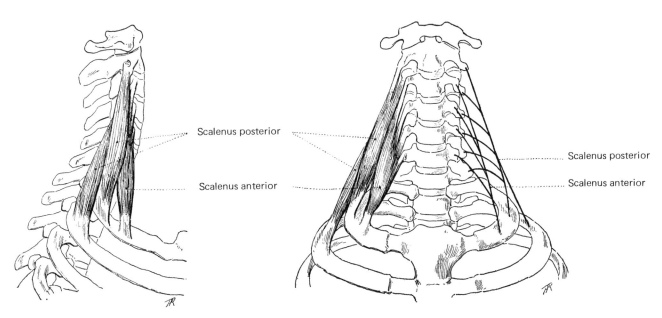

Scalenus posterior

Scalenus anterior

Scalenus posterior

Scalenus anterior

FIGURE 3: SCALENUS, LATERAL ASPECT

FIGURE 4: SCALENUS, ANTERIOR ASPECT

(the lines on the right show the
muscular origins and insertions)

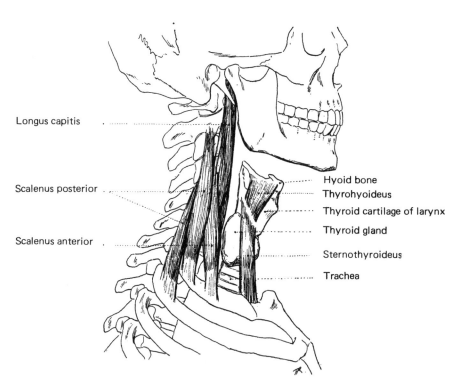

Longus capitis

Scalenus posterior

Scalenus anterior

Hyoid bone
Thyrohyoideus
Thyroid cartilage of larynx
Thyroid gland
Sternothyroideus
Trachea

FIGURE 1

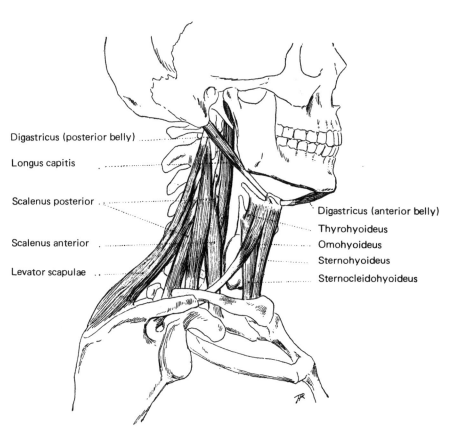

Digastricus (posterior belly)

Longus capitis

Scalenus posterior

Scalenus anterior

Levator scapulae

Digastricus (anterior belly)
Thyrohyoideus
Omohyoideus
Sternohyoideus
Sternocleidohyoideus

FIGURE 2

Plate 47: MUSCLES OF THE NECK

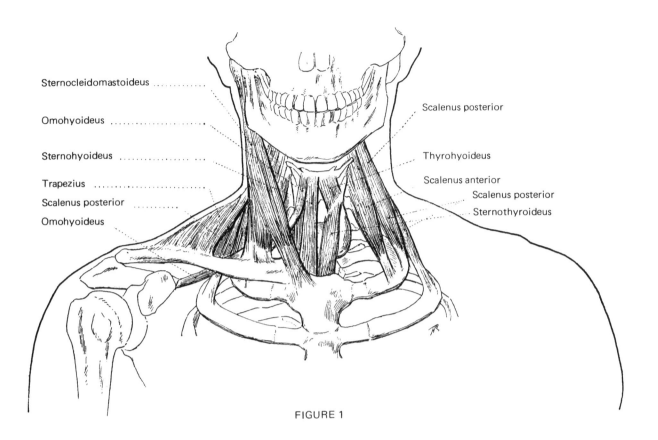

Sternocleidomastoideus

Omohyoideus

Sternohyoideus

Trapezius

Scalenus posterior

Omohyoideus

Scalenus posterior

Thyrohyoideus

Scalenus anterior

Scalenus posterior

Sternothyroideus

FIGURE 1

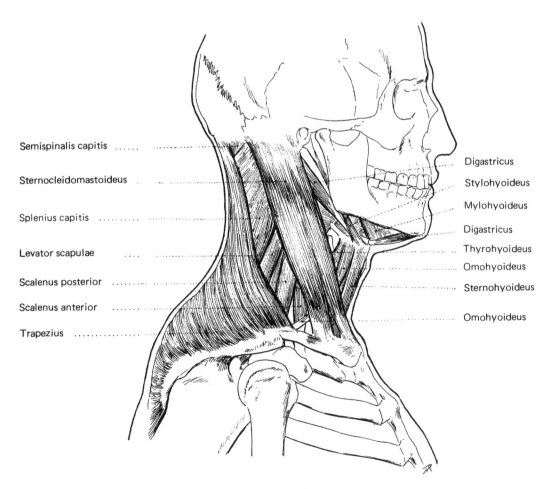

Semispinalis capitis

Sternocleidomastoideus

Splenius capitis

Levator scapulae

Scalenus posterior

Scalenus anterior

Trapezius

Digastricus

Stylohyoideus

Mylohyoideus

Digastricus

Thyrohyoideus

Omohyoideus

Sternohyoideus

Omohyoideus

FIGURE 2

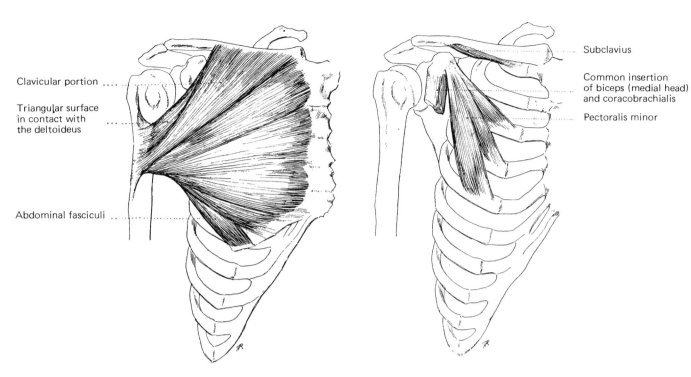

Clavicular portion

Triangular surface
in contact with ...
the deltoideus

Abdominal fasciculi ...

Subclavius

Common insertion
of biceps (medial head)
and coracobrachialis

Pectoralis minor

FIGURE 1: PECTORALIS MAJOR

FIGURE 2: PECTORALIS MINOR

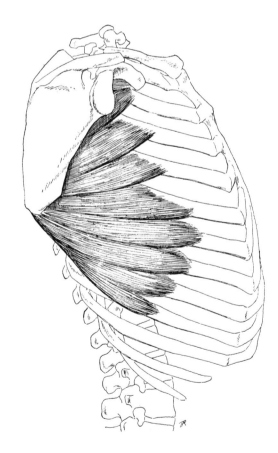

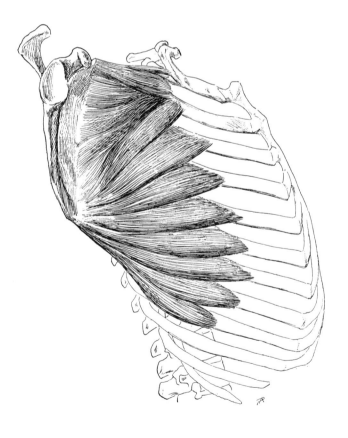

FIGURE 3: SERRATUS ANTERIOR
(scapula in normal position)

FIGURE 4: SERRATUS ANTERIOR
(the scapula separated from the thorax to show
the insertions of the muscle into its spinal border)

Plate 49: MUSCLES OF THE SHOULDER

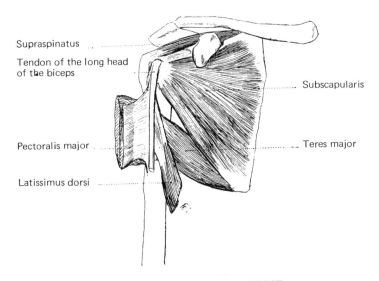

Supraspinatus

Tendon of the long head of the biceps

Subscapularis

Pectoralis major

Teres major

Latissimus dorsi

FIGURE 1: ANTERIOR ASPECT

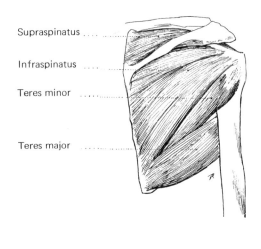

Supraspinatus

Infraspinatus

Teres minor

Teres major

FIGURE 3: POSTERIOR ASPECT

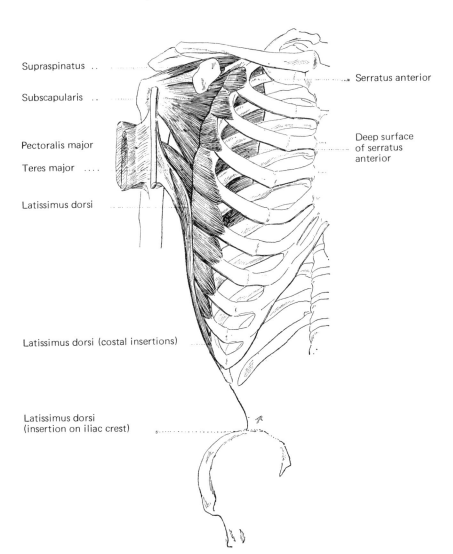

Supraspinatus

Subscapularis

Serratus anterior

Pectoralis major

Teres major

Deep surface of serratus anterior

Latissimus dorsi

Latissimus dorsi (costal insertions)

Latissimus dorsi (insertion on iliac crest)

FIGURE 2: ANTERIOR ASPECT

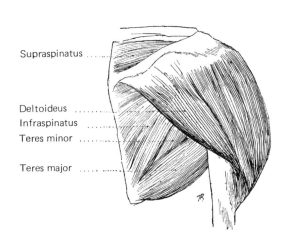

Supraspinatus

Deltoideus
Infraspinatus
Teres minor

Teres major

FIGURE 4: DELTOIDEUS
POSTERIOR ASPECT

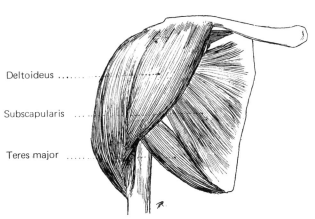

Deltoideus

Subscapularis

Teres major

FIGURE 5: DELTOIDEUS
ANTERIOR ASPECT

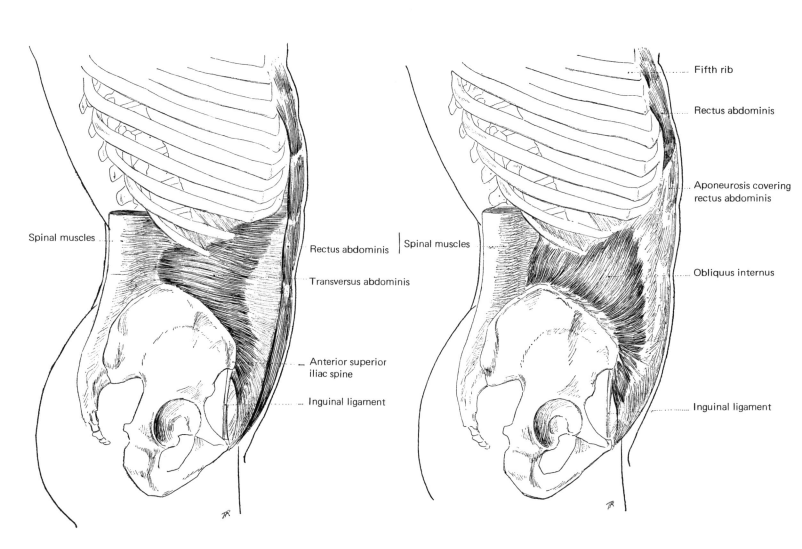

Spinal muscles

Rectus abdominis

Transversus abdominis

Anterior superior iliac spine

Inguinal ligament

Spinal muscles

Fifth rib

Rectus abdominis

Aponeurosis covering rectus abdominis

Obliquus internus

Inguinal ligament

FIGURE 1: TRANSVERSUS ABDOMINIS

FIGURE 2: OBLIQUUS INTERNUS, MIDDLE LAYER

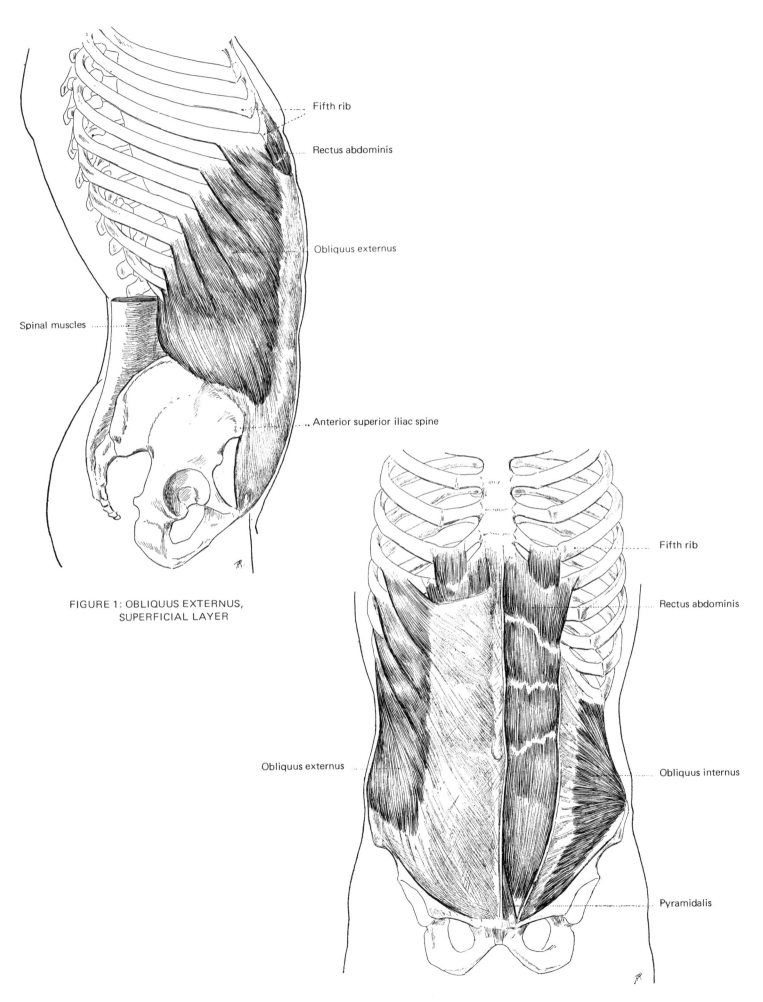

Fifth rib

Rectus abdominis

Obliquus externus

Spinal muscles

Anterior superior iliac spine

FIGURE 1: OBLIQUUS EXTERNUS,
SUPERFICIAL LAYER

Fifth rib

Rectus abdominis

Obliquus externus

Obliquus internus

Pyramidalis

FIGURE 2: RECTUS ABDOMINIS

189

Plate 52: MUSCLES OF THE PELVIS

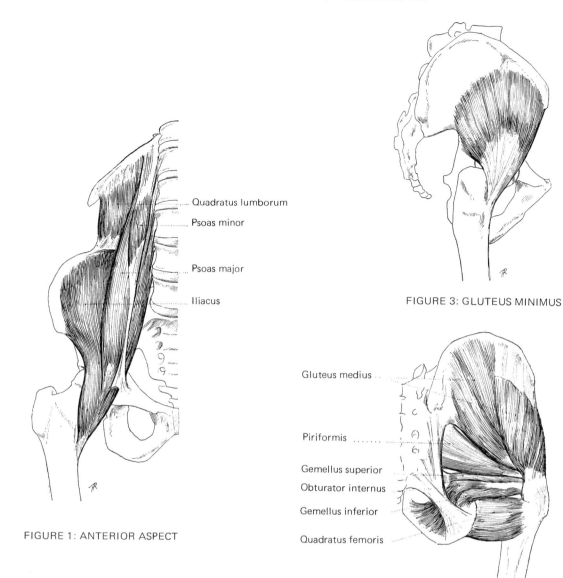

Quadratus lumborum

Psoas minor

Psoas major

Iliacus

FIGURE 1: ANTERIOR ASPECT

FIGURE 3: GLUTEUS MINIMUS

Gluteus medius

Piriformis

Gemellus superior

Obturator internus

Gemellus inferior

Quadratus femoris

FIGURE 4: POSTERIOR ASPECT
DEEP LAYER

Aponeurosis covering
gluteus medius

Gluteus maximus

Union of femoral
aponeurosis with tendon
of gluteus maximus

Tendon of
gluteus maximus

Femoral aponeurosis

FIGURE 2: POSTERIOR ASPECT
SUPERFICIAL LAYER

Aponeurosis covering
gluteus medius

Gluteus minimus

Gluteus maximus

Inferior tendon
of gluteus maximus

Inferior fasciculi
of gluteus maximus

Insertion of gluteus maximus
into femoral aponeurosis

FIGURE 5: LATERAL ASPECT
SUPERFICIAL LAYER

190

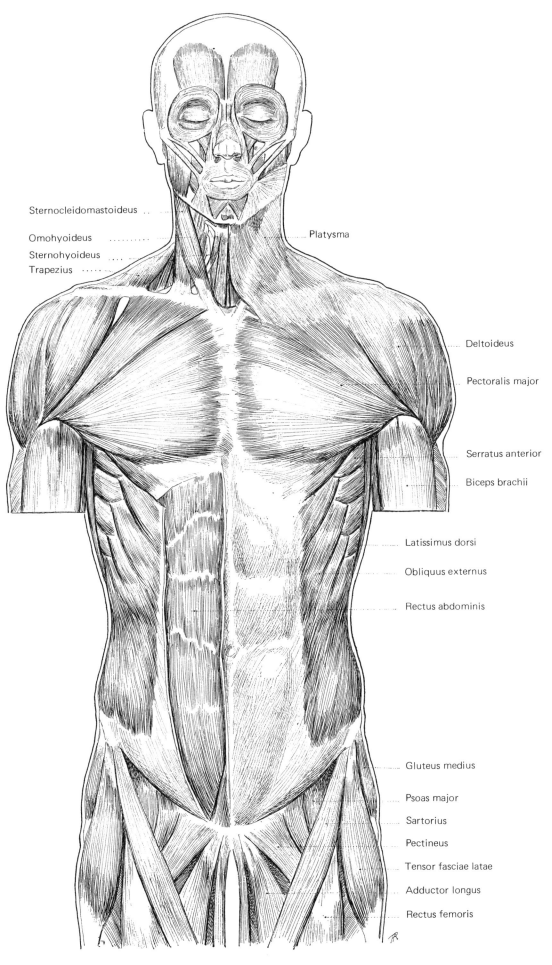

Plate 53: MUSCLES OF THE TRUNK AND OF THE HEAD

Sternocleidomastoideus ..

Omohyoideus

Sternohyoideus

Trapezius

Platysma

Deltoideus

Pectoralis major

Serratus anterior

Biceps brachii

Latissimus dorsi

Obliquus externus

Rectus abdominis

Gluteus medius

Psoas major

Sartorius

Pectineus

Tensor fasciae latae

Adductor longus

Rectus femoris

ANTERIOR ASPECT

Plate 54: MUSCLES OF THE TRUNK AND HEAD

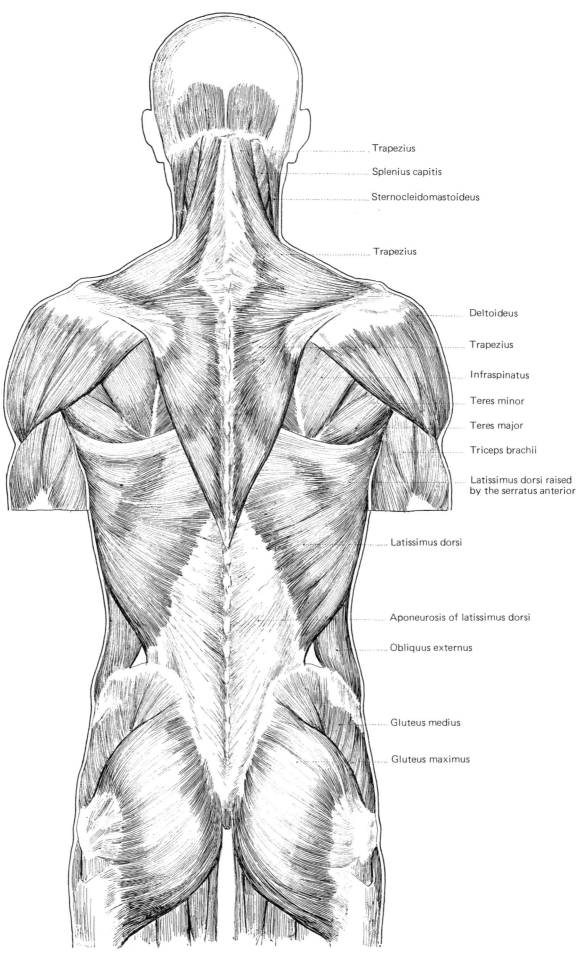

Trapezius

Splenius capitis

Sternocleidomastoideus

Trapezius

Deltoideus

Trapezius

Infraspinatus

Teres minor

Teres major

Triceps brachii

Latissimus dorsi raised
by the serratus anterior

Latissimus dorsi

Aponeurosis of latissimus dorsi

Obliquus externus

Gluteus medius

Gluteus maximus

POSTERIOR ASPECT

Plate 55: MUSCLES OF THE TRUNK AND HEAD

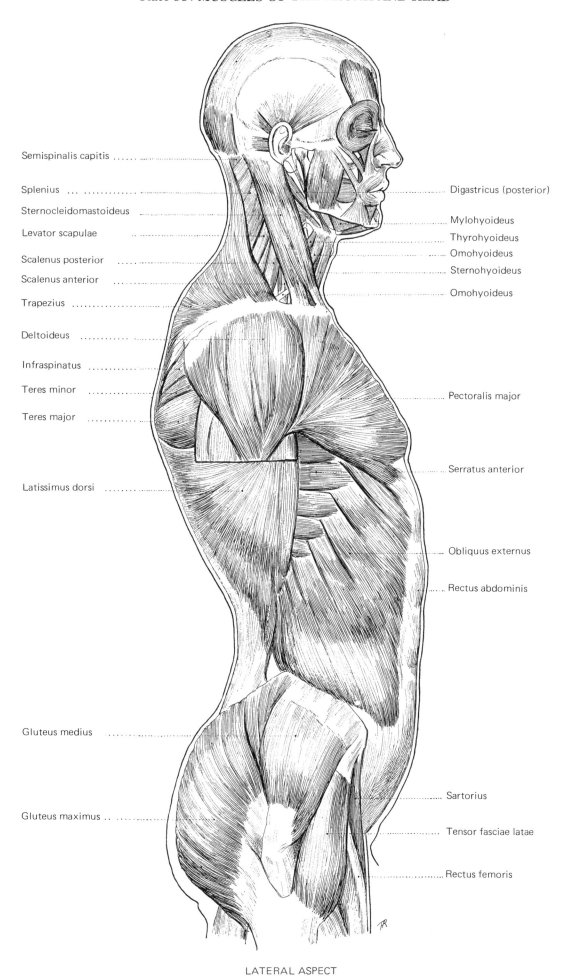

Semispinalis capitis

Splenius

Sternocleidomastoideus

Levator scapulae

Scalenus posterior

Scalenus anterior

Trapezius

Deltoideus

Infraspinatus

Teres minor

Teres major

Latissimus dorsi

Gluteus medius

Gluteus maximus

Digastricus (posterior)

Mylohyoideus

Thyrohyoideus

Omohyoideus

Sternohyoideus

Omohyoideus

Pectoralis major

Serratus anterior

Obliquus externus

Rectus abdominis

Sartorius

Tensor fasciae latae

Rectus femoris

LATERAL ASPECT

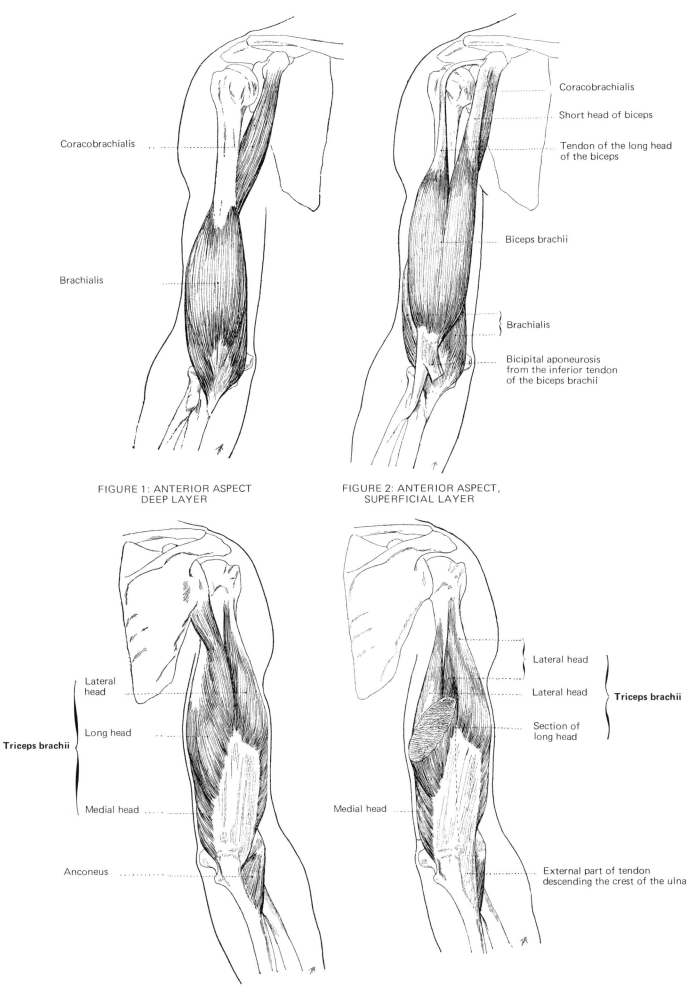

Coracobrachialis

Brachialis

Coracobrachialis

Short head of biceps

Tendon of the long head of the biceps

Biceps brachii

Brachialis

Bicipital aponeurosis from the inferior tendon of the biceps brachii

FIGURE 1: ANTERIOR ASPECT
DEEP LAYER

FIGURE 2: ANTERIOR ASPECT,
SUPERFICIAL LAYER

Lateral head

Long head

Triceps brachii

Medial head

Anconeus

Lateral head

Lateral head

Section of long head

Triceps brachii

Medial head

External part of tendon descending the crest of the ulna

FIGURE 3 AND 4: POSTERIOR ASPECT
TRICEPS BRACHII

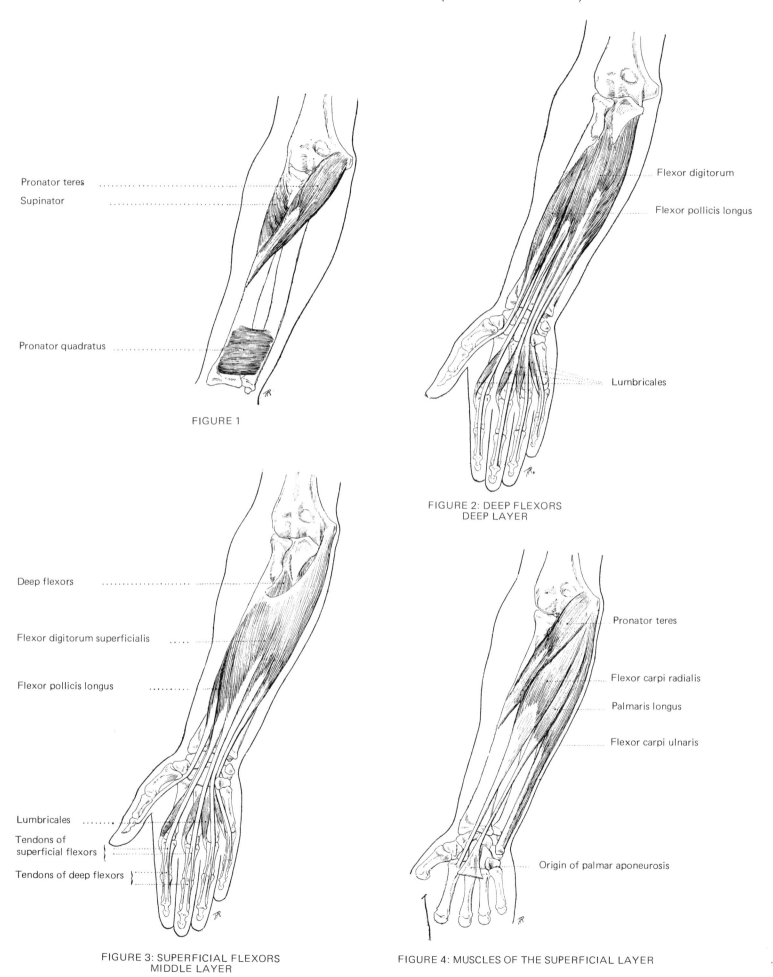

Pronator teres

Supinator

Pronator quadratus

FIGURE 1

Flexor digitorum

Flexor pollicis longus

Lumbricales

FIGURE 2: DEEP FLEXORS
DEEP LAYER

Deep flexors

Flexor digitorum superficialis

Flexor pollicis longus

Lumbricales

Tendons of
superficial flexors

Tendons of deep flexors

FIGURE 3: SUPERFICIAL FLEXORS
MIDDLE LAYER

Pronator teres

Flexor carpi radialis

Palmaris longus

Flexor carpi ulnaris

Origin of palmar aponeurosis

FIGURE 4: MUSCLES OF THE SUPERFICIAL LAYER

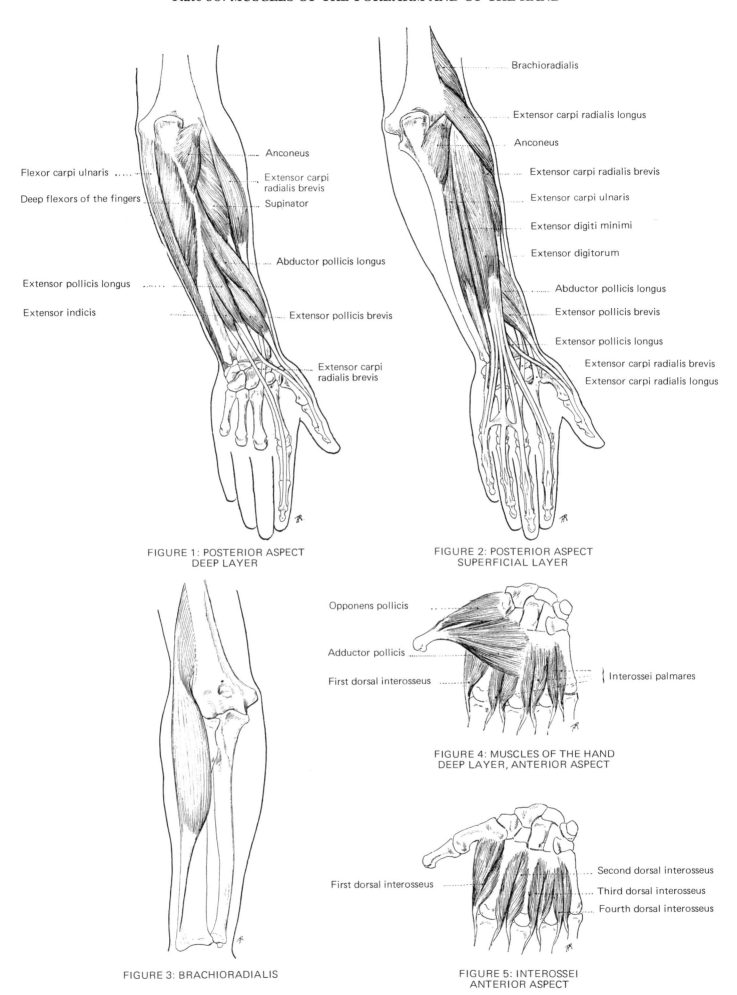

Anconeus

Flexor carpi ulnaris

Extensor carpi
radialis brevis

Deep flexors of the fingers

Supinator

Abductor pollicis longus

Extensor pollicis longus

Extensor indicis

Extensor pollicis brevis

Extensor carpi
radialis brevis

FIGURE 1: POSTERIOR ASPECT
DEEP LAYER

Brachioradialis

Extensor carpi radialis longus

Anconeus

Extensor carpi radialis brevis

Extensor carpi ulnaris

Extensor digiti minimi

Extensor digitorum

Abductor pollicis longus

Extensor pollicis brevis

Extensor pollicis longus

Extensor carpi radialis brevis

Extensor carpi radialis longus

FIGURE 2: POSTERIOR ASPECT
SUPERFICIAL LAYER

Opponens pollicis

Adductor pollicis

First dorsal interosseus

Interossei palmares

FIGURE 4: MUSCLES OF THE HAND
DEEP LAYER, ANTERIOR ASPECT

FIGURE 3: BRACHIORADIALIS

Second dorsal interosseus

First dorsal interosseus

Third dorsal interosseus

Fourth dorsal interosseus

FIGURE 5: INTEROSSEI
ANTERIOR ASPECT

196

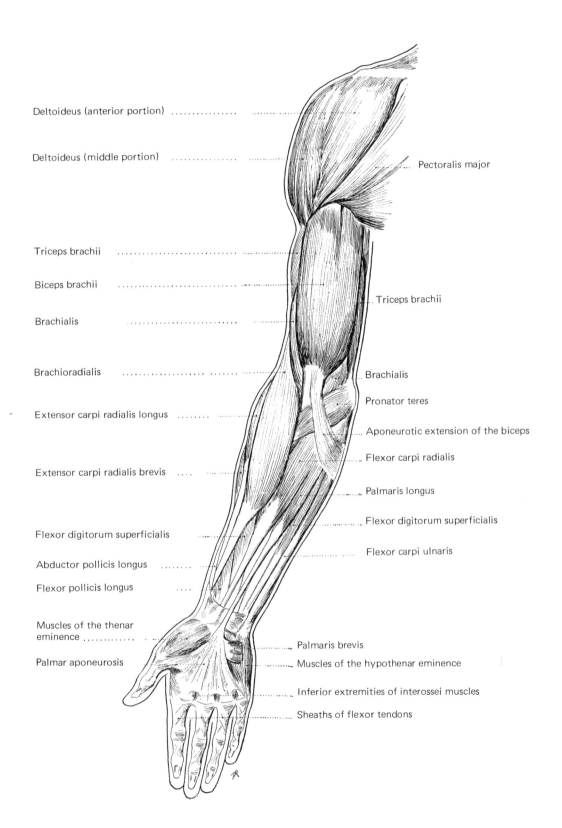

Deltoideus (anterior portion)

Deltoideus (middle portion)

Triceps brachii

Biceps brachii

Brachialis

Brachioradialis

Extensor carpi radialis longus

Extensor carpi radialis brevis

Flexor digitorum superficialis

Abductor pollicis longus

Flexor pollicis longus

Muscles of the thenar eminence

Palmar aponeurosis

Pectoralis major

Triceps brachii

Brachialis

Pronator teres

Aponeurotic extension of the biceps

Flexor carpi radialis

Palmaris longus

Flexor digitorum superficialis

Flexor carpi ulnaris

Palmaris brevis

Muscles of the hypothenar eminence

Inferior extremities of interossei muscles

Sheaths of flexor tendons

ANTERIOR ASPECT

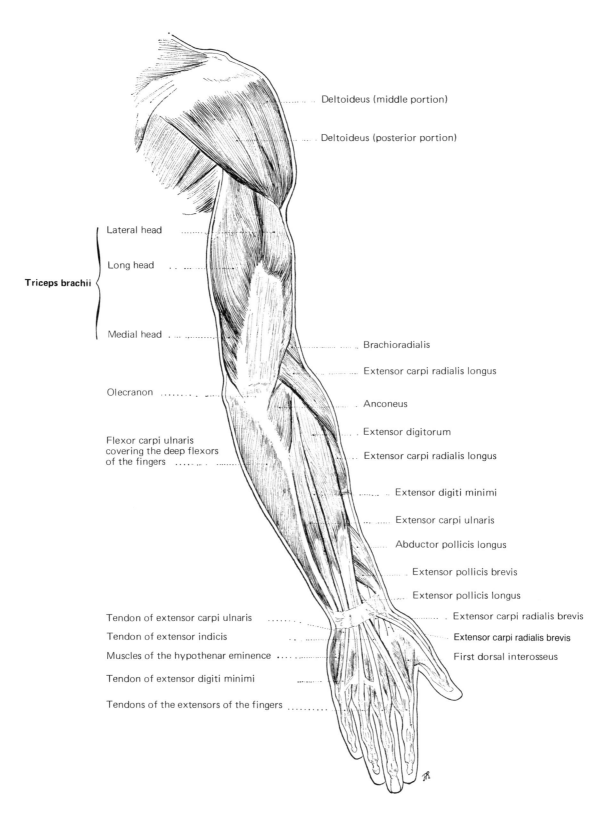

Deltoideus (middle portion)

Deltoideus (posterior portion)

Triceps brachii

Lateral head

Long head

Medial head

Olecranon

Flexor carpi ulnaris
covering the deep flexors
of the fingers

Brachioradialis

Extensor carpi radialis longus

Anconeus

Extensor digitorum

Extensor carpi radialis longus

Extensor digiti minimi

Extensor carpi ulnaris

Abductor pollicis longus

Extensor pollicis brevis

Extensor pollicis longus

Extensor carpi radialis brevis

Tendon of extensor carpi ulnaris

Tendon of extensor indicis

Muscles of the hypothenar eminence

Tendon of extensor digiti minimi

Tendons of the extensors of the fingers

Extensor carpi radialis brevis

First dorsal interosseus

POSTERIOR ASPECT

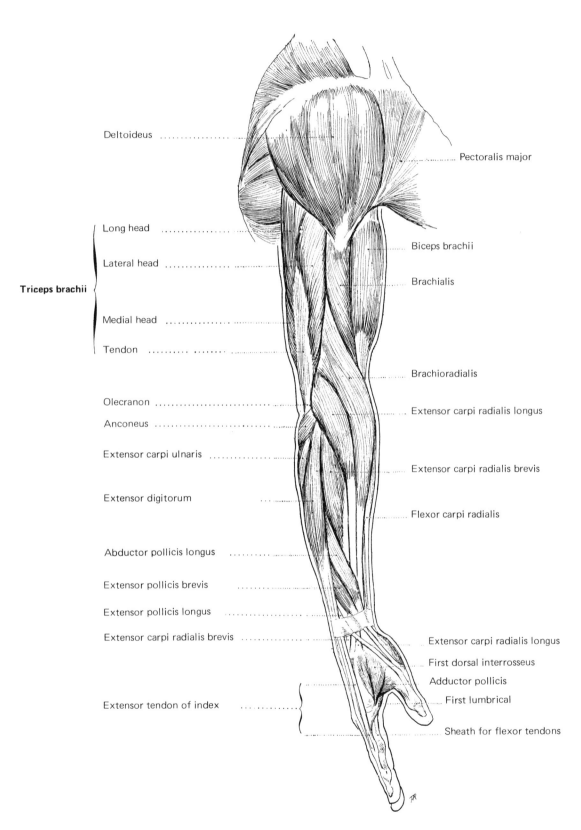

Deltoideus

Pectoralis major

Triceps brachii
 Long head
 Lateral head
 Medial head
 Tendon

Biceps brachii

Brachialis

Brachioradialis

Olecranon

Anconeus

Extensor carpi radialis longus

Extensor carpi ulnaris

Extensor carpi radialis brevis

Extensor digitorum

Flexor carpi radialis

Abductor pollicis longus

Extensor pollicis brevis

Extensor pollicis longus

Extensor carpi radialis brevis

Extensor carpi radialis longus

First dorsal interrosseus

Adductor pollicis

First lumbrical

Extensor tendon of index

Sheath for flexor tendons

LATERAL ASPECT

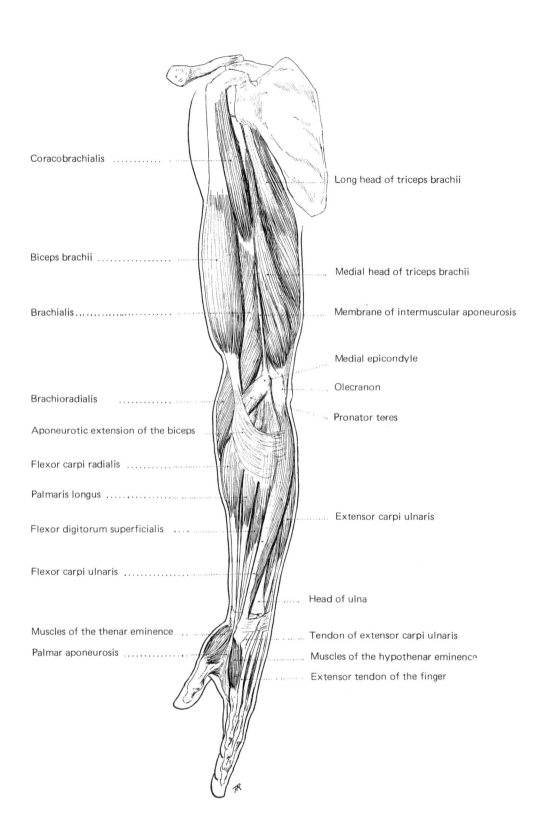

Coracobrachialis

Biceps brachii

Brachialis.............................

Brachioradialis

Aponeurotic extension of the biceps

Flexor carpi radialis

Palmaris longus

Flexor digitorum superficialis

Flexor carpi ulnaris

Muscles of the thenar eminence ..

Palmar aponeurosis

Long head of triceps brachii

Medial head of triceps brachii

Membrane of intermuscular aponeurosis

Medial epicondyle

Olecranon

Pronator teres

Extensor carpi ulnaris

Head of ulna

Tendon of extensor carpi ulnaris

Muscles of the hypothenar eminence

Extensor tendon of the finger

MEDIAL ASPECT

Plate 63: MUSCLES OF THE THIGH

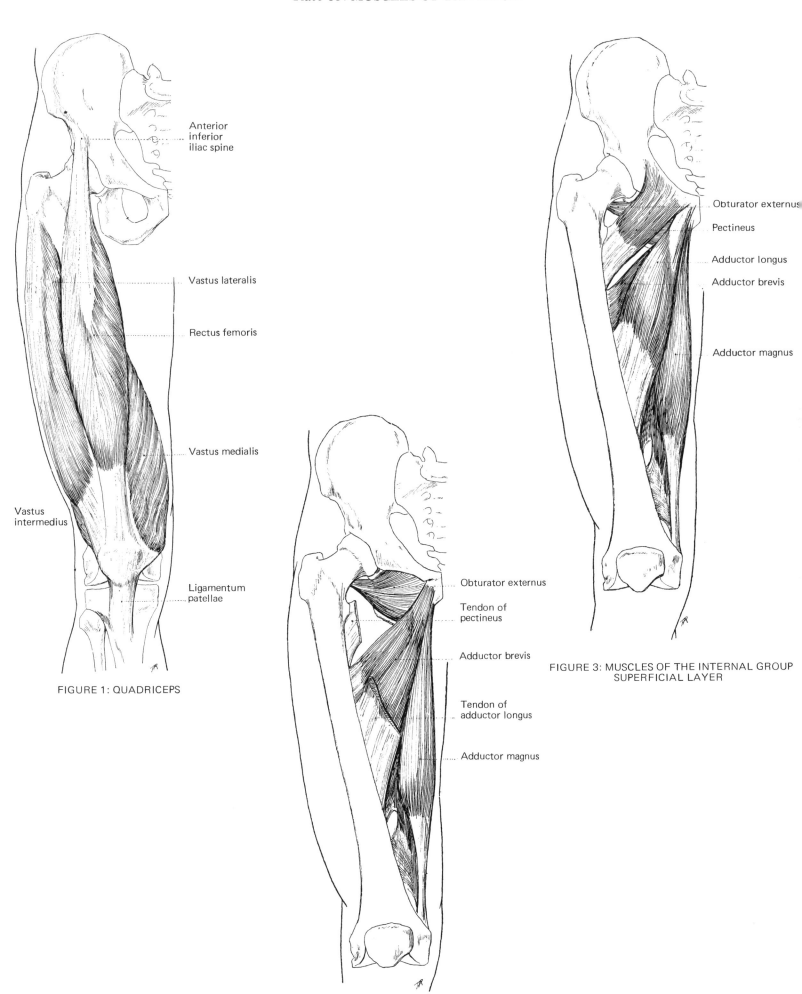

Anterior
inferior
iliac spine

Vastus lateralis

Rectus femoris

Vastus medialis

Vastus
intermedius

Ligamentum
patellae

FIGURE 1: QUADRICEPS

Obturator externus

Tendon of
pectineus

Adductor brevis

Tendon of
adductor longus

Adductor magnus

FIGURE 2: MUSCLES OF THE INTERNAL GROUP
DEEP LAYER

Obturator externus

Pectineus

Adductor longus

Adductor brevis

Adductor magnus

FIGURE 3: MUSCLES OF THE INTERNAL GROUP
SUPERFICIAL LAYER

Plate 64: MUSCLES OF THE THIGH

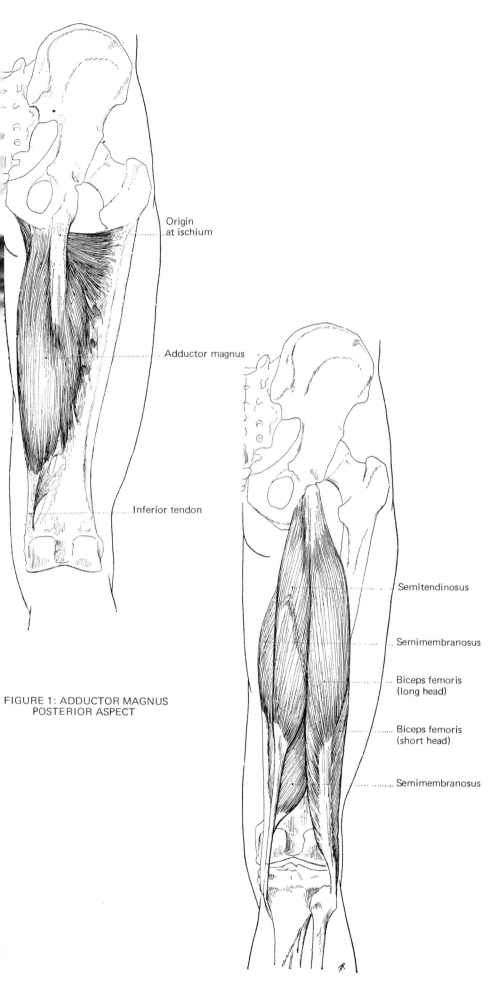

Origin
at ischium

Adductor magnus

Inferior tendon

FIGURE 1: ADDUCTOR MAGNUS
POSTERIOR ASPECT

Semitendinosus

Semimembranosus

Biceps femoris
(long head)

Biceps femoris
(short head)

Semimembranosus

FIGURE 2: MUSCLES OF THE POSTERIOR GROUP
SUPERFICIAL LAYER

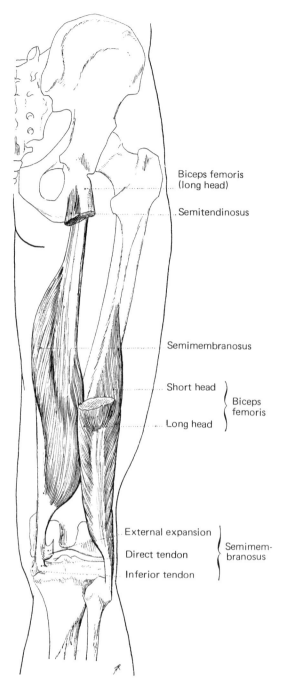

Biceps femoris
(long head)

Semitendinosus

Semimembranosus

Short head }
 Biceps
 femoris
Long head }

External expansion
 } Semimem-
Direct tendon branosus
Inferior tendon

FIGURE 3: MUSCLES OF THE POSTERIOR GROUP
DEEP LAYER

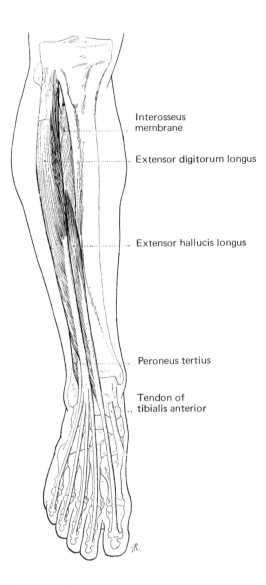

Interosseus
membrane

Extensor digitorum longus

Extensor hallucis longus

Peroneus tertius

Tendon of
tibialis anterior

FIGURE 1: MUSCLES OF THE INTERIOR REGION
Tibialis Anterior (cut)

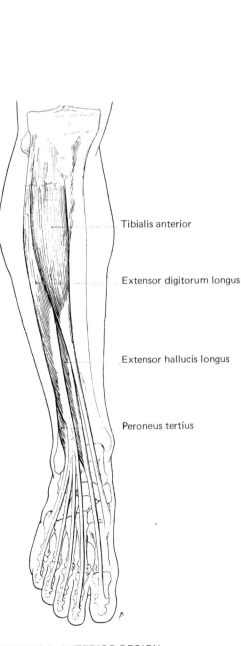

Tibialis anterior

Extensor digitorum longus

Extensor hallucis longus

Peroneus tertius

FIGURE 2: ANTERIOR REGION

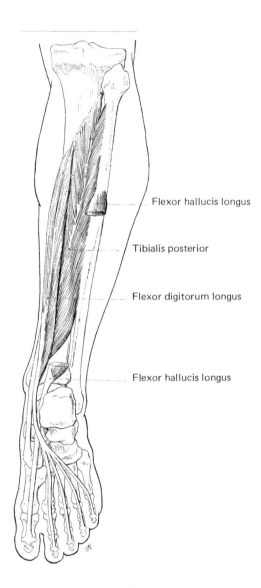

Flexor hallucis longus

Tibialis posterior

Flexor digitorum longus

Flexor hallucis longus

FIGURE 3: POSTERIOR REGION
DEEP LAYER

Plate 66: MUSCLES OF THE LEG

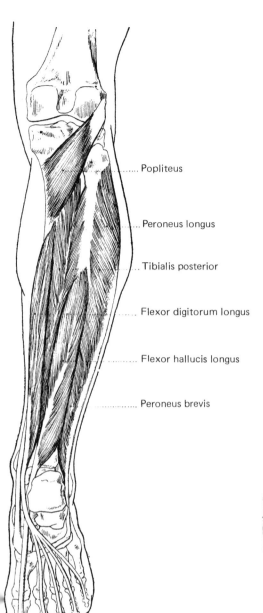

...... Popliteus

... Peroneus longus

... Tibialis posterior

Flexor digitorum longus

Flexor hallucis longus

Peroneus brevis

FIGURE 1: POSTERIOR REGION
DEEP LAYER

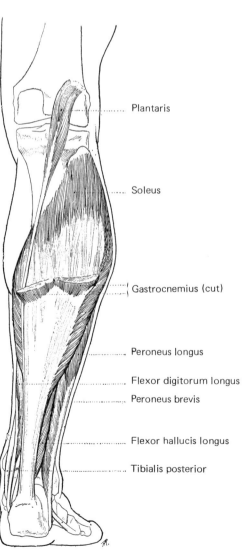

Plantaris

.... Soleus

Gastrocnemius (cut)

Peroneus longus

Flexor digitorum longus

Peroneus brevis

Flexor hallucis longus

Tibialis posterior

FIGURE 2: SOLEUS

Plantaris

Gastrocnemius
(lateral head)

Gastrocnemius
(medial head)

Soleus

Achilles tendon
or tendo calcaneus

FIGURE 3: TRICEPS SURAL

Plate 67: MUSCLES OF THE FOOT

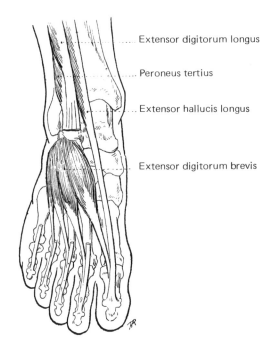

Extensor digitorum longus

Peroneus tertius

Extensor hallucis longus

Extensor digitorum brevis

FIGURE 1: DORSAL REGION

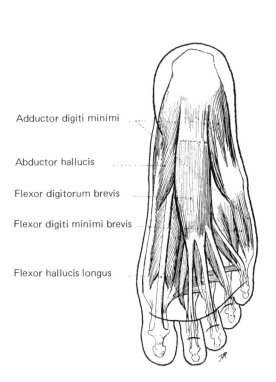

Tendon of peroneus longus

Interossei muscles

Flexor hallucis brevis

Adductor hallucis (oblique head)

Adductor hallucis (transverse head)

FIGURE 2: PLANTAR REGION, DEEP LAYER

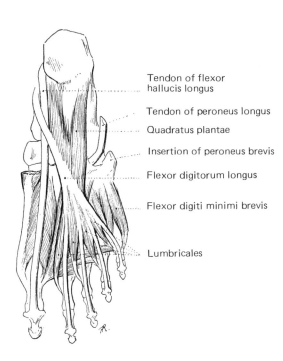

Tendon of flexor hallucis longus

Tendon of peroneus longus

Quadratus plantae

Insertion of peroneus brevis

Flexor digitorum longus

Flexor digiti minimi brevis

Lumbricales

FIGURE 3: PLANTAR REGION MIDDLE LAYER

Adductor digiti minimi

Abductor hallucis

Flexor digitorum brevis

Flexor digiti minimi brevis

Flexor hallucis longus

FIGURE 4: PLANTAR REGION, SUPERFICIAL LAYER

205

Plate 68: MUSCLES OF THE LOWER LIMB

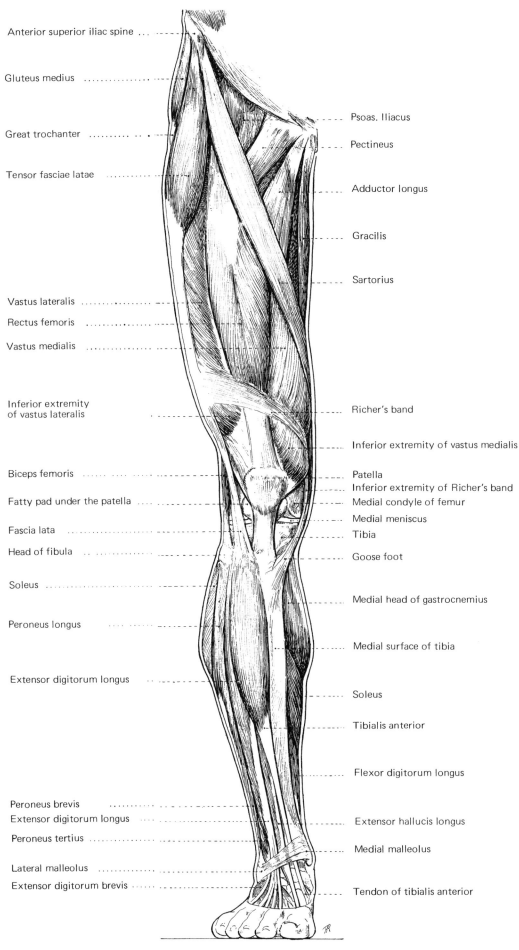

Anterior superior iliac spine ...

Gluteus medius

Great trochanter ·

Tensor fasciae latae

Vastus lateralis · ----

Rectus femoris · ----

Vastus medialis ----

Inferior extremity
of vastus lateralis

Biceps femoris

Fatty pad under the patella

Fascia lata

Head of fibula

Soleus ------

Peroneus longus ----

Extensor digitorum longus · ------

Peroneus brevis

Extensor digitorum longus ------

Peroneus tertius

Lateral malleolus

Extensor digitorum brevis ------

Psoas. Iliacus

Pectineus

Adductor longus

Gracilis

Sartorius

Richer's band

Inferior extremity of vastus medialis

Patella

Inferior extremity of Richer's band

Medial condyle of femur

Medial meniscus

Tibia

Goose foot

Medial head of gastrocnemius

Medial surface of tibia

Soleus

Tibialis anterior

Flexor digitorum longus

Extensor hallucis longus

Medial malleolus

Tendon of tibialis anterior

ANTERIOR ASPECT

Plate 69: MUSCLES OF THE LOWER LIMB

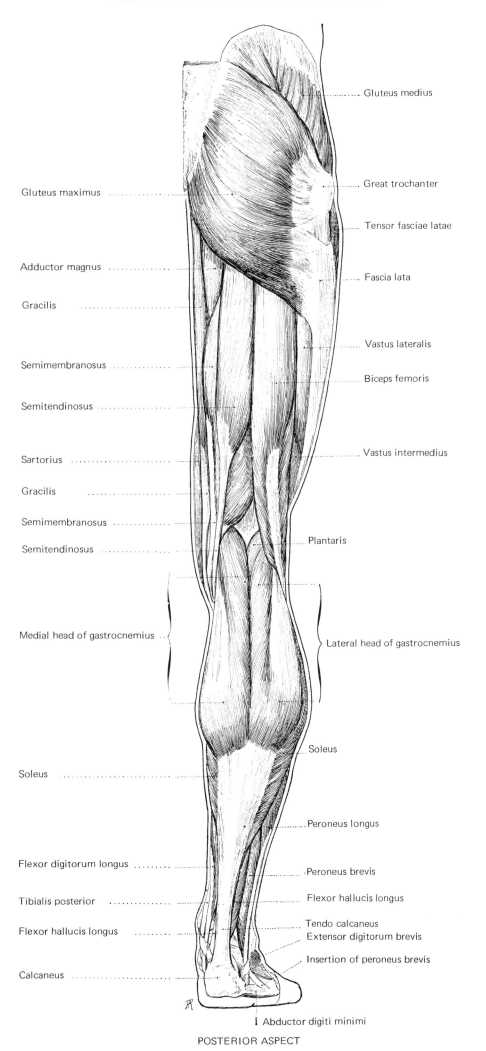

Gluteus medius

Great trochanter

Gluteus maximus

Tensor fasciae latae

Adductor magnus

Fascia lata

Gracilis

Vastus lateralis

Semimembranosus

Biceps femoris

Semitendinosus

Sartorius

Vastus intermedius

Gracilis

Semimembranosus

Semitendinosus

Plantaris

Medial head of gastrocnemius

Lateral head of gastrocnemius

Soleus

Soleus

Peroneus longus

Flexor digitorum longus

Peroneus brevis

Tibialis posterior

Flexor hallucis longus

Flexor hallucis longus

Tendo calcaneus

Extensor digitorum brevis

Insertion of peroneus brevis

Calcaneus

Abductor digiti minimi

POSTERIOR ASPECT

207

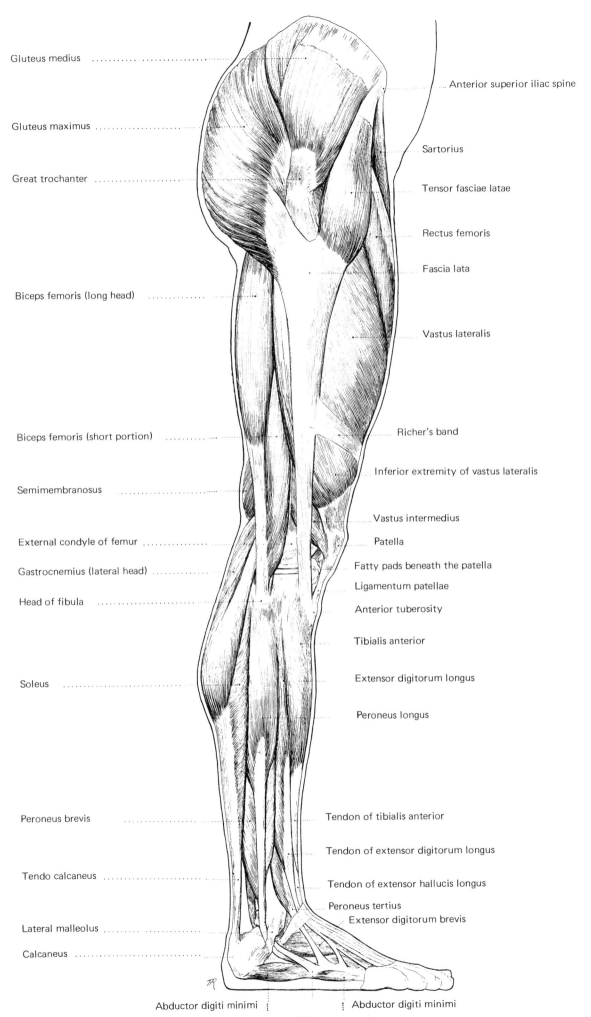

Gluteus medius

Gluteus maximus

Great trochanter

Biceps femoris (long head)

Biceps femoris (short portion)

Semimembranosus

External condyle of femur

Gastrocnemius (lateral head)

Head of fibula

Soleus

Peroneus brevis

Tendo calcaneus

Lateral malleolus

Calcaneus

Anterior superior iliac spine

Sartorius

Tensor fasciae latae

Rectus femoris

Fascia lata

Vastus lateralis

Richer's band

Inferior extremity of vastus lateralis

Vastus intermedius

Patella

Fatty pads beneath the patella

Ligamentum patellae

Anterior tuberosity

Tibialis anterior

Extensor digitorum longus

Peroneus longus

Tendon of tibialis anterior

Tendon of extensor digitorum longus

Tendon of extensor hallucis longus

Peroneus tertius

Extensor digitorum brevis

Abductor digiti minimi

Abductor digiti minimi

Tuberosity of fifth metatarsal

EXTERNAL ASPECT

Plate 71: MUSCLES OF THE LOWER LIMB

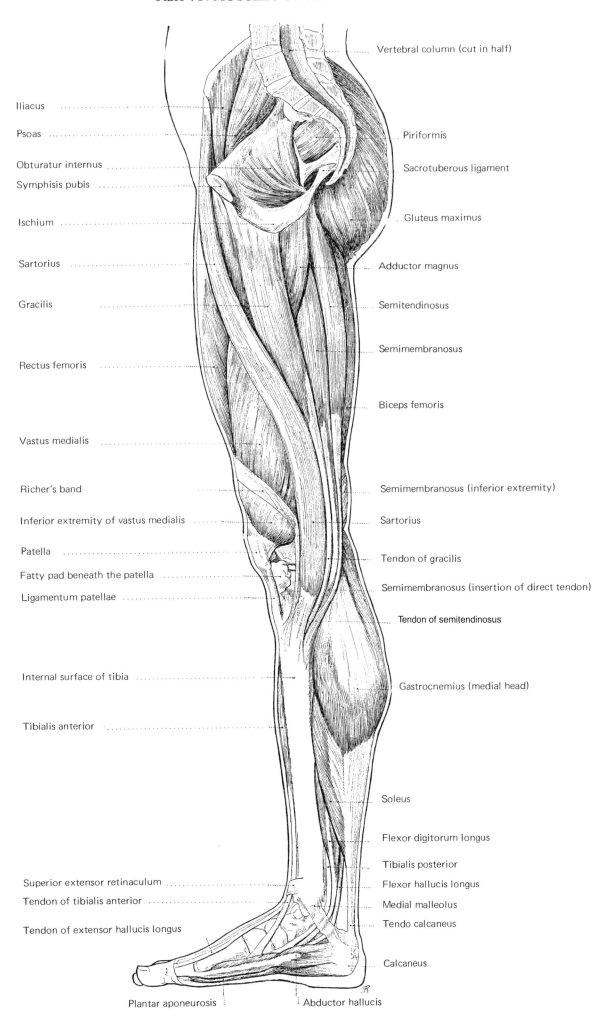

Iliacus

Psoas

Obturatur internus

Symphisis pubis

Ischium

Sartorius

Gracilis

Rectus femoris

Vastus medialis

Richer's band

Inferior extremity of vastus medialis

Patella

Fatty pad beneath the patella

Ligamentum patellae

Internal surface of tibia

Tibialis anterior

Superior extensor retinaculum

Tendon of tibialis anterior

Tendon of extensor hallucis longus

Vertebral column (cut in half)

Piriformis

Sacrotuberous ligament

Gluteus maximus

Adductor magnus

Semitendinosus

Semimembranosus

Biceps femoris

Semimembranosus (inferior extremity)

Sartorius

Tendon of gracilis

Semimembranosus (insertion of direct tendon)

Tendon of semitendinosus

Gastrocnemius (medial head)

Soleus

Flexor digitorum longus

Tibialis posterior

Flexor hallucis longus

Medial malleolus

Tendo calcaneus

Calcaneus

Plantar aponeurosis

Abductor hallucis

INTERNAL ASPECT

Plate 72: SUPERFICIAL VEINS

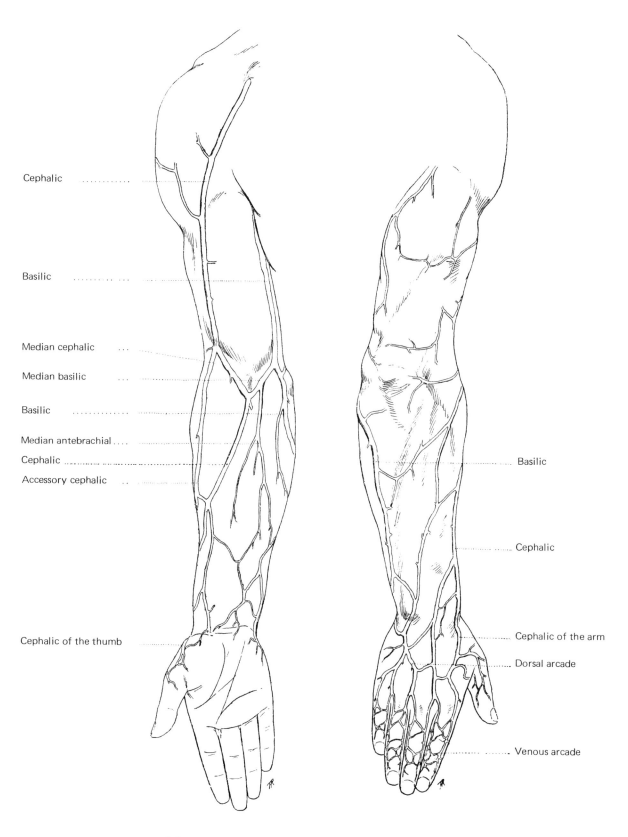

Cephalic

Basilic

Median cephalic

Median basilic

Basilic

Median antebrachial

Cephalic

Accessory cephalic

Cephalic of the thumb

Basilic

Cephalic

Cephalic of the arm

Dorsal arcade

Venous arcade

FIGURE 1: UPPER LIMB
ANTERIOR ASPECT

FIGURE 2: UPPER LIMB,
POSTERIOR ASPECT

Plate 73: SUPERFICIAL VEINS

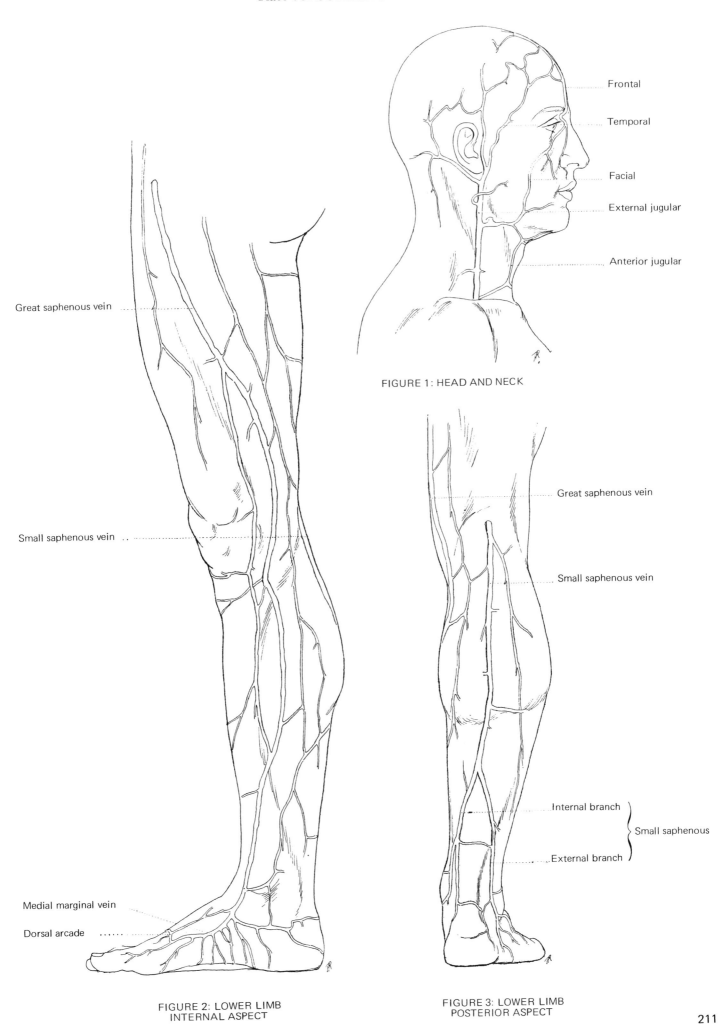

Frontal

Temporal

Facial

External jugular

Anterior jugular

FIGURE 1: HEAD AND NECK

Great saphenous vein

Small saphenous vein

Medial marginal vein

Dorsal arcade

FIGURE 2: LOWER LIMB
INTERNAL ASPECT

Great saphenous vein

Small saphenous vein

Internal branch ⎫
⎬ Small saphenous
External branch ⎭

FIGURE 3: LOWER LIMB
POSTERIOR ASPECT

Plate 74: MORPHOLOGICAL TOPOGRAPHY

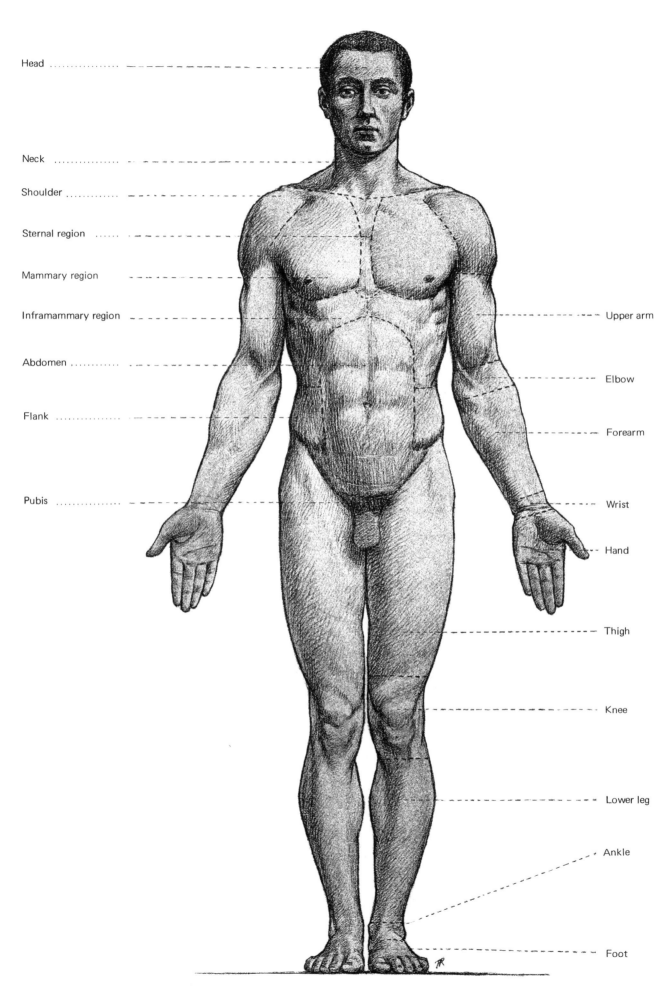

Head

Neck

Shoulder

Sternal region

Mammary region

Inframammary region

Abdomen

Flank

Pubis

Upper arm

Elbow

Forearm

Wrist

Hand

Thigh

Knee

Lower leg

Ankle

Foot

ANTERIOR ASPECT

Plate 75: MORPHOLOGICAL TOPOGRAPHY

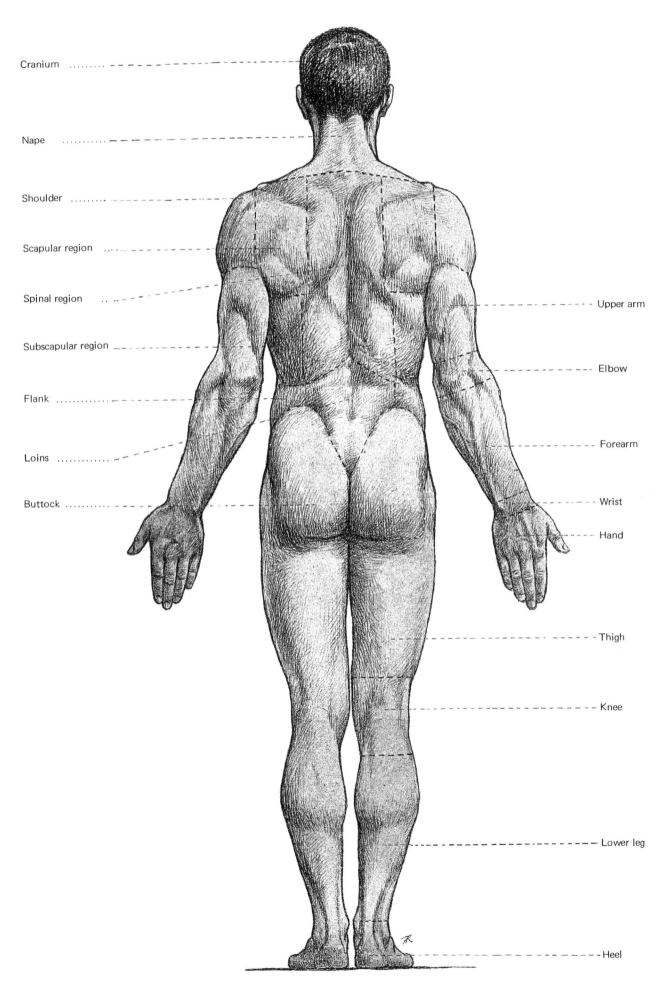

Cranium

Nape

Shoulder

Scapular region

Spinal region

Subscapular region

Flank

Loins

Buttock

Upper arm

Elbow

Forearm

Wrist

Hand

Thigh

Knee

Lower leg

Heel

POSTERIOR ASPECT

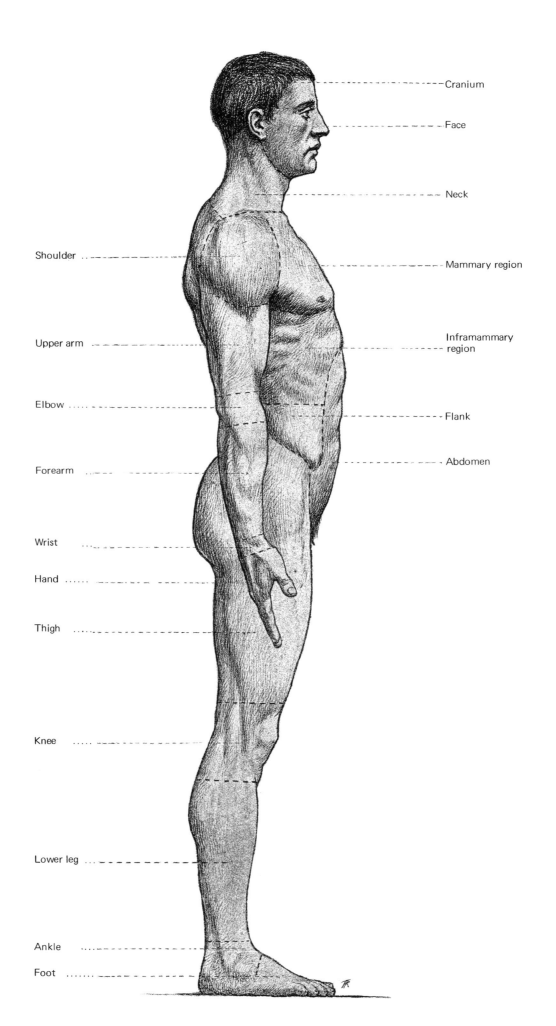

Cranium

Face

Neck

Shoulder

Mammary region

Upper arm

Inframammary region

Elbow

Flank

Forearm

Abdomen

Wrist

Hand

Thigh

Knee

Lower leg

Ankle

Foot

LATERAL ASPECT

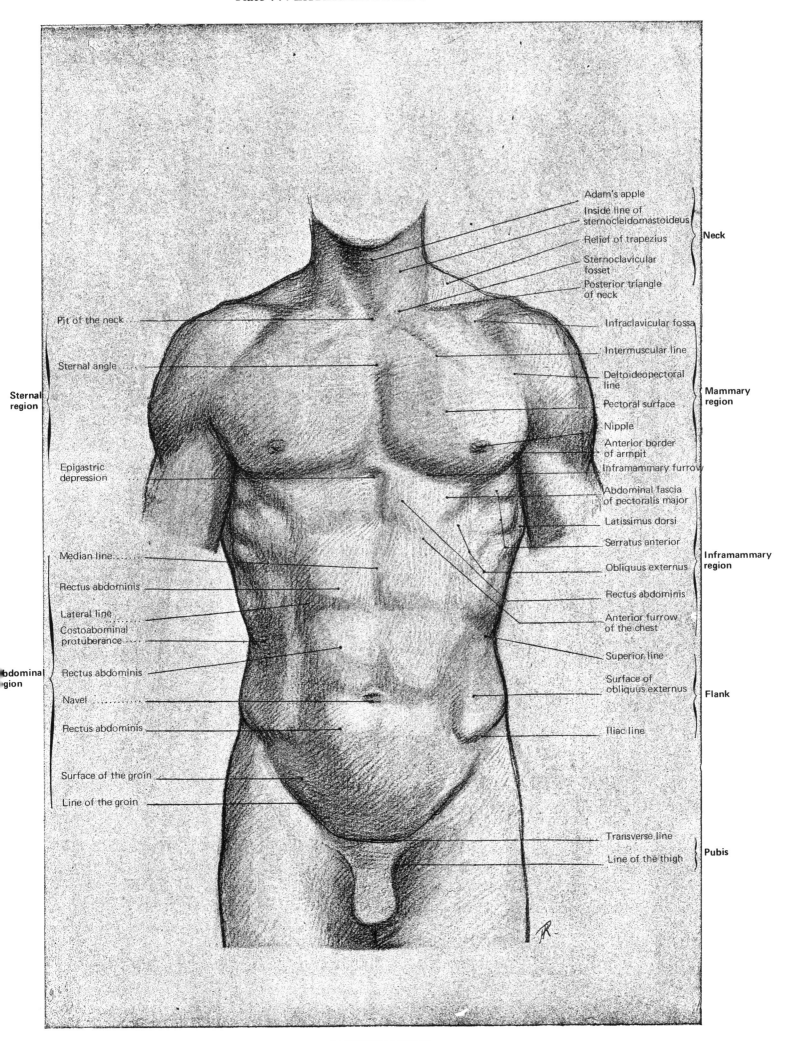

Adam's apple

Inside line of
sternocleidomastoideus

Relief of trapezius

Sternoclavicular
fosset

Posterior triangle
of neck

Neck

Pit of the neck

Sternal angle

Sternal
region

Epigastric
depression

Infraclavicular fossa

Intermuscular line

Deltoideopectoral
line

Pectoral surface

Nipple

Anterior border
of armpit

Inframammary furrow

Abdominal fascia
of pectoralis major

Latissimus dorsi

Serratus anterior

Obliquus externus

Rectus abdominis

Anterior furrow
of the chest

Superior line

Surface of
obliquus externus

Iliac line

Mammary
region

Inframammary
region

Median line

Rectus abdominis

Lateral line

Costoabdominal
protuberance

Rectus abdominis

Abdominal
region

Navel

Rectus abdominis

Surface of the groin

Line of the groin

Flank

Transverse line

Line of the thigh

Pubis

ANTERIOR ASPECT

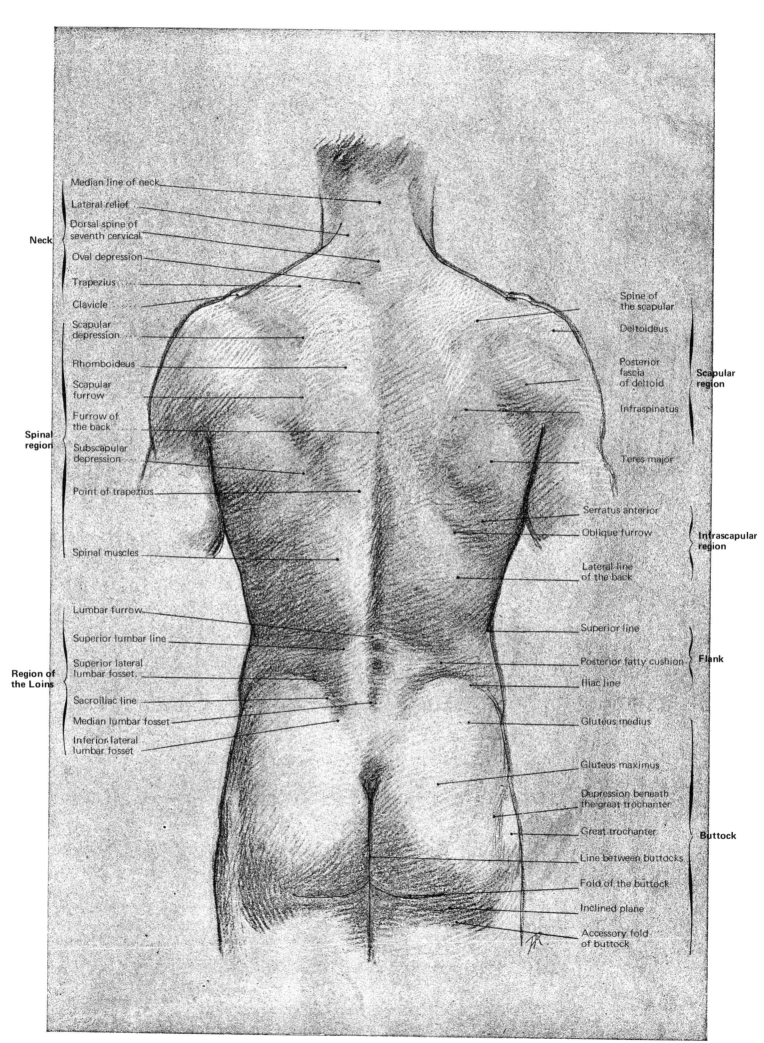

Median line of neck

Lateral relief

Dorsal spine of seventh cervical

Oval depression

Trapezius

Clavicle

Scapular depression

Rhomboideus

Scapular furrow

Furrow of the back

Subscapular depression

Point of trapezius

Spinal muscles

Lumbar furrow

Superior lumbar line

Superior lateral lumbar fosset

Sacroiliac line

Median lumbar fosset

Inferior lateral lumbar fosset

Neck

Spinal region

Region of the Loins

Spine of the scapular

Deltoideus

Posterior fascia of deltoid

Infraspinatus

Teres major

Serratus anterior

Oblique furrow

Lateral line of the back

Superior line

Posterior fatty cushion

Iliac line

Gluteus medius

Gluteus maximus

Depression beneath the great trochanter

Great trochanter

Line between buttocks

Fold of the buttock

Inclined plane

Accessory fold of buttock

Scapular region

Intrascapular region

Flank

Buttock

POSTERIOR ASPECT

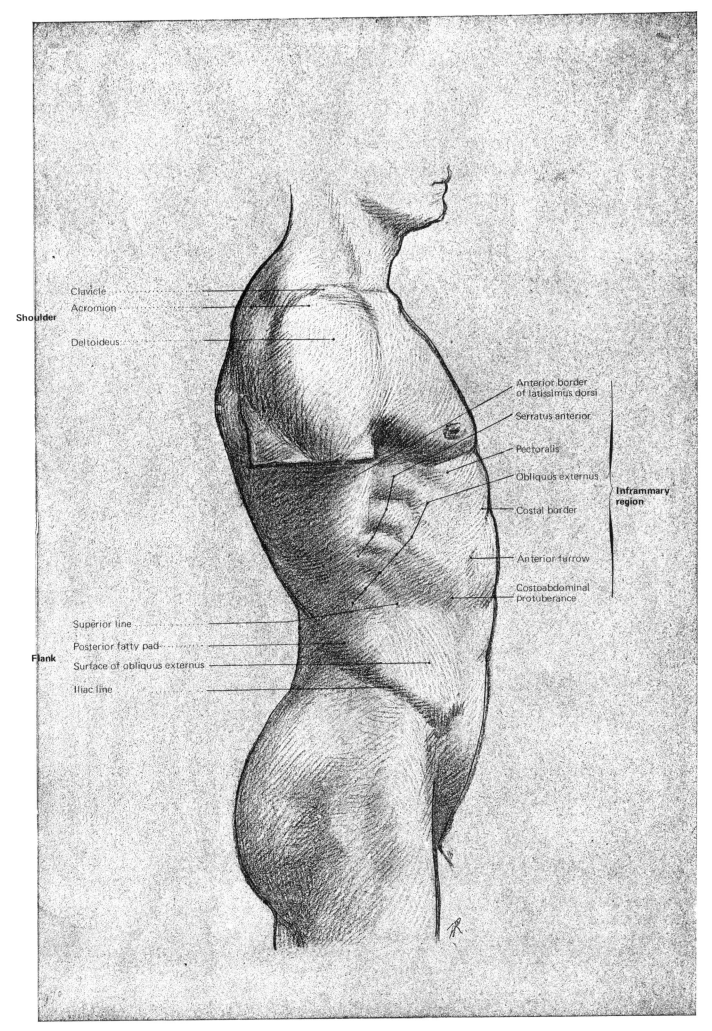

Clavicle

Acromion

Shoulder

Deltoideus

Anterior border
of latissimus dorsi

Serratus anterior

Pectoralis

Obliquus externus

Inframmary
region

Costal border

Anterior furrow

Costoabdominal
protuberance

Superior line

Posterior fatty pad

Flank

Surface of obliquus externus

Iliac line

LATERAL ASPECT

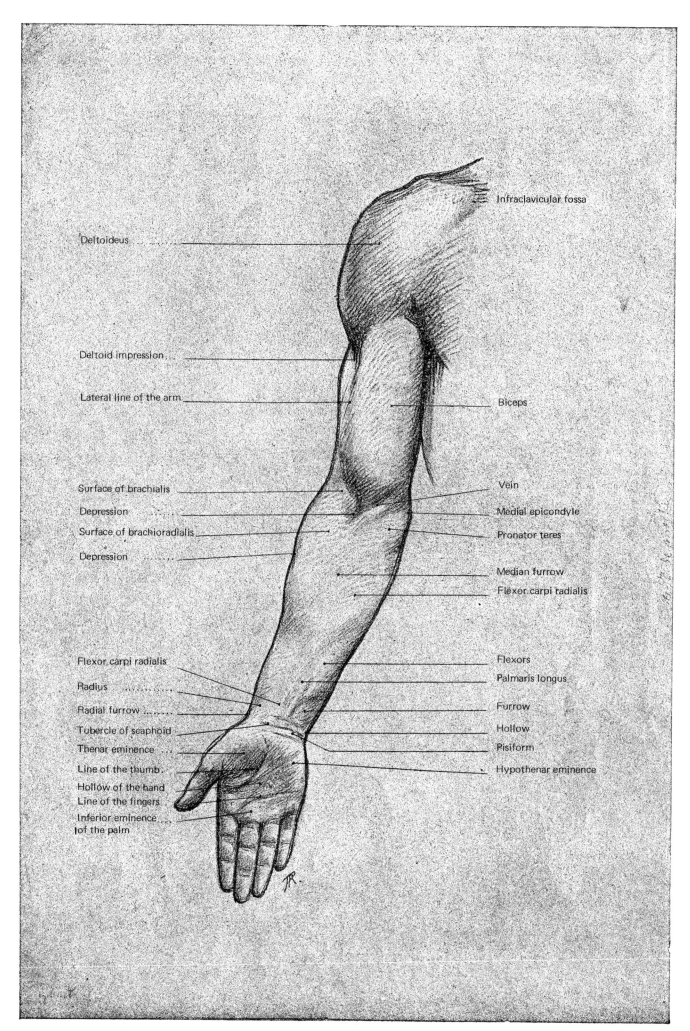

Infraclavicular fossa

Deltoideus

Deltoid impression

Lateral line of the arm

Biceps

Surface of brachialis

Vein

Depression

Medial epicondyle

Surface of brachioradialis

Pronator teres

Depression

Median furrow

Flexor carpi radialis

Flexor carpi radialis

Flexors

Radius

Palmaris longus

Radial furrow

Furrow

Tubercle of scaphoid

Hollow

Thenar eminence

Pisiform

Line of the thumb

Hypothenar eminence

Hollow of the hand

Line of the fingers

Inferior eminence
of the palm

ANTERIOR ASPECT

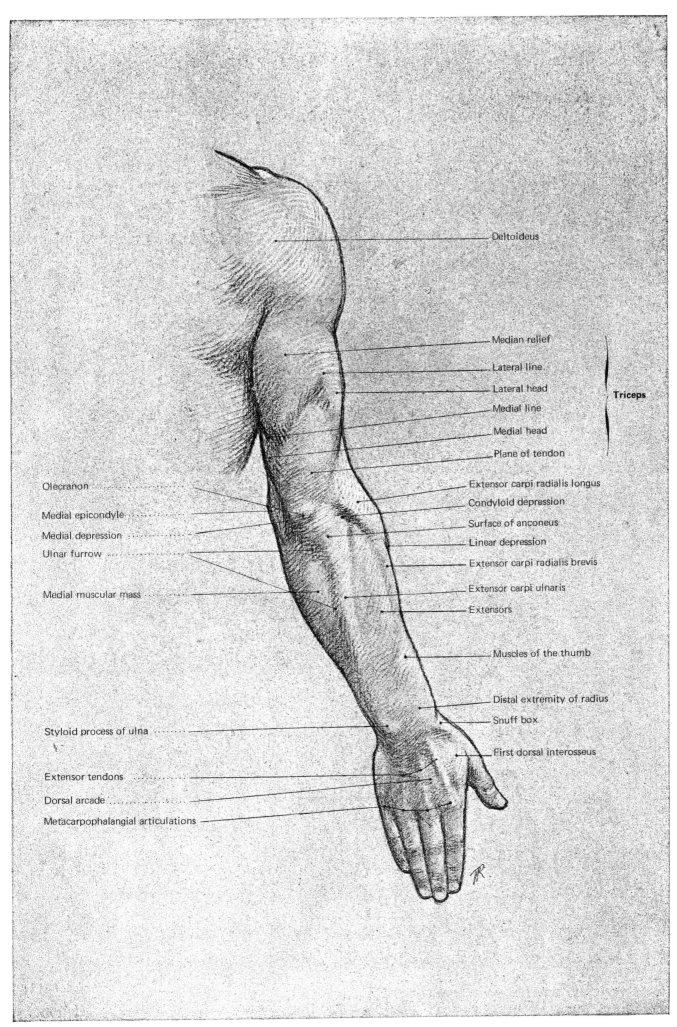

Deltoideus

Median relief

Lateral line

Lateral head

Medial line

Medial head

Plane of tendon

Triceps

Olecranon

Extensor carpi radialis longus

Condyloid depression

Medial epicondyle

Surface of anconeus

Medial depression

Linear depression

Ulnar furrow

Extensor carpi radialis brevis

Extensor carpi ulnaris

Medial muscular mass

Extensors

Muscles of the thumb

Distal extremity of radius

Snuff box

Styloid process of ulna

First dorsal interosseus

Extensor tendons

Dorsal arcade

Metacarpophalangial articulations

POSTERIOR ASPECT

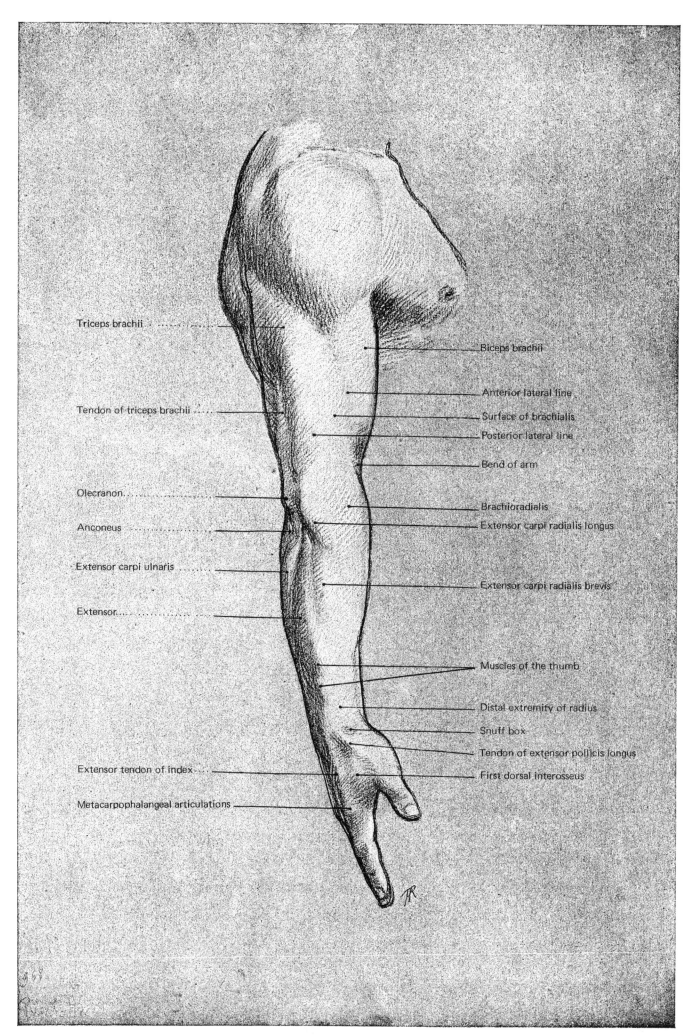

Triceps brachii

Tendon of triceps brachii

Olecranon

Anconeus

Extensor carpi ulnaris

Extensor

Extensor tendon of index

Metacarpophalangeal articulations

Biceps brachii

Anterior lateral line

Surface of brachialis

Posterior lateral line

Bend of arm

Brachioradialis

Extensor carpi radialis longus

Extensor carpi radialis brevis

Muscles of the thumb

Distal extremity of radius

Snuff box

Tendon of extensor pollicis longus

First dorsal interosseus

LATERAL ASPECT

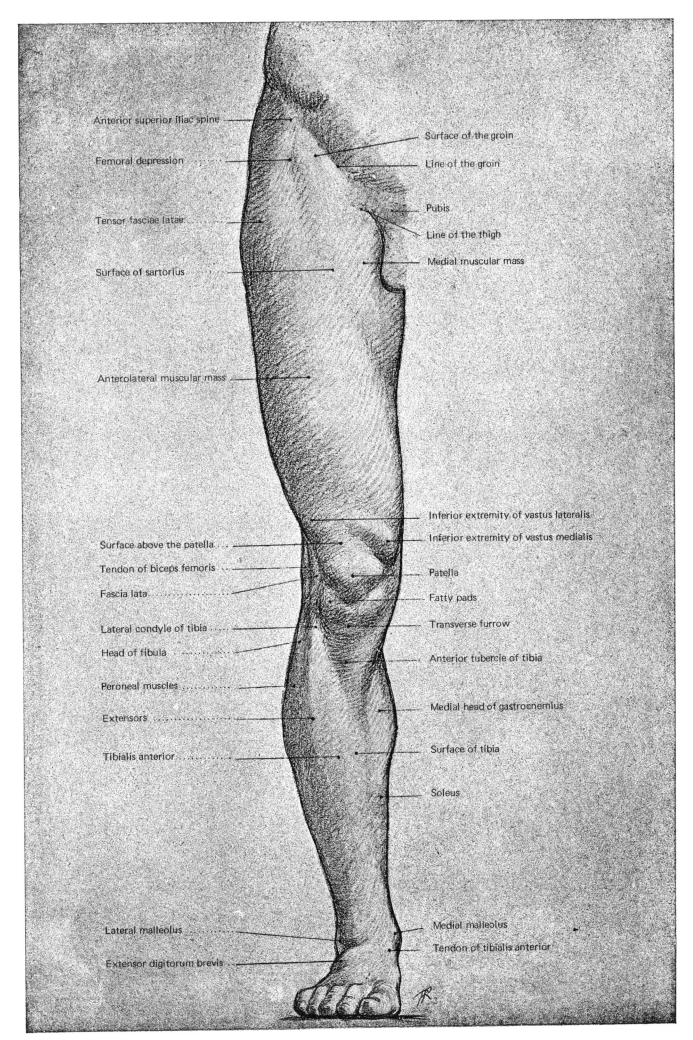

Anterior superior iliac spine

Surface of the groin

Femoral depression

Line of the groin

Pubis

Tensor fasciae latae

Line of the thigh

Medial muscular mass

Surface of sartorius

Anterolateral muscular mass

Inferior extremity of vastus lateralis

Inferior extremity of vastus medialis

Surface above the patella

Tendon of biceps femoris

Patella

Fascia lata

Fatty pads

Lateral condyle of tibia

Transverse furrow

Head of fibula

Anterior tubercle of tibia

Peroneal muscles

Medial head of gastrocnemius

Extensors

Surface of tibia

Tibialis anterior

Soleus

Lateral malleolus

Medial malleolus

Tendon of tibialis anterior

Extensor digitorum brevis

ANTERIOR ASPECT

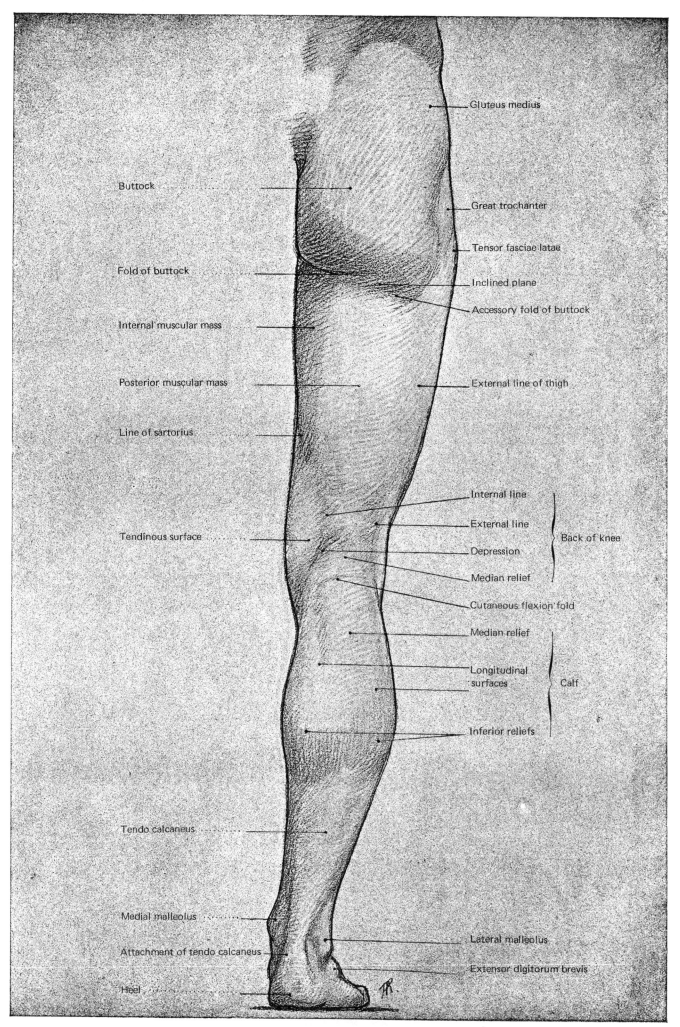

Gluteus medius

Buttock

Great trochanter

Tensor fasciae latae

Fold of buttock

Inclined plane

Accessory fold of buttock

Internal muscular mass

Posterior muscular mass

External line of thigh

Line of sartorius

Internal line

External line

Back of knee

Tendinous surface

Depression

Median relief

Cutaneous flexion fold

Median relief

Longitudinal surfaces

Calf

Inferior reliefs

Tendo calcaneus

Medial malleolus

Lateral malleolus

Attachment of tendo calcaneus

Extensor digitorum brevis

Heel

POSTERIOR ASPECT

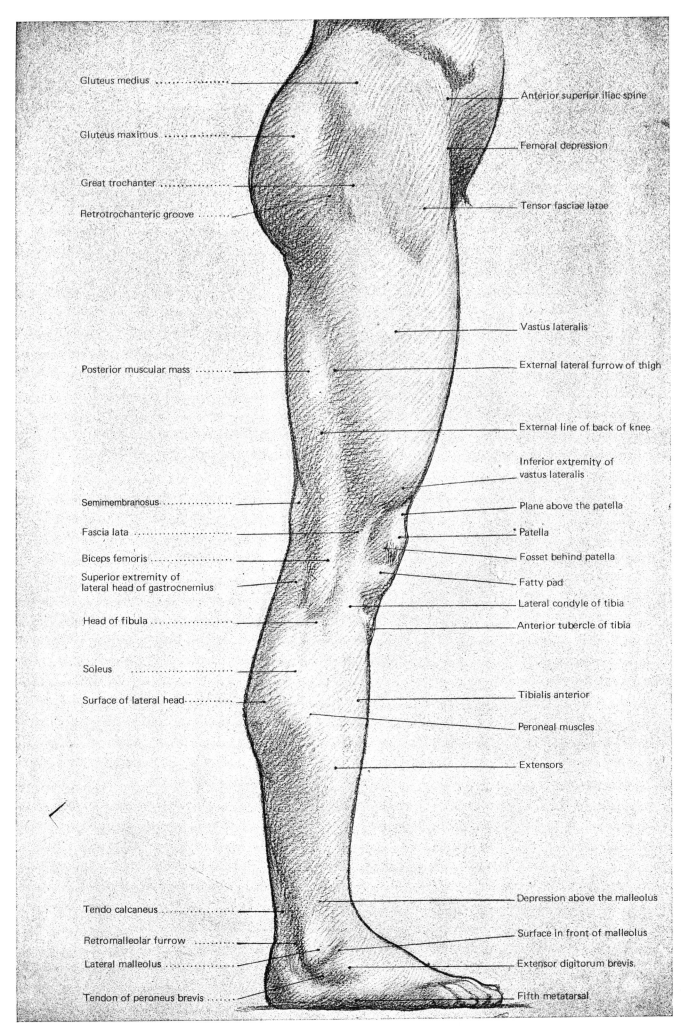

Gluteus medius

Gluteus maximus

Great trochanter

Retrotrochanteric groove

Posterior muscular mass

Semimembranosus

Fascia lata

Biceps femoris

Superior extremity of
lateral head of gastrocnemius

Head of fibula

Soleus

Surface of lateral head

Tendo calcaneus

Retromalleolar furrow

Lateral malleolus

Tendon of peroneus brevis

Anterior superior iliac spine

Femoral depression

Tensor fasciae latae

Vastus lateralis

External lateral furrow of thigh

External line of back of knee

Inferior extremity of
vastus lateralis

Plane above the patella

Patella

Fosset behind patella

Fatty pad

Lateral condyle of tibia

Anterior tubercle of tibia

Tibialis anterior

Peroneal muscles

Extensors

Depression above the malleolus

Surface in front of malleolus

Extensor digitorum brevis

Fifth metatarsal

LATERAL ASPECT

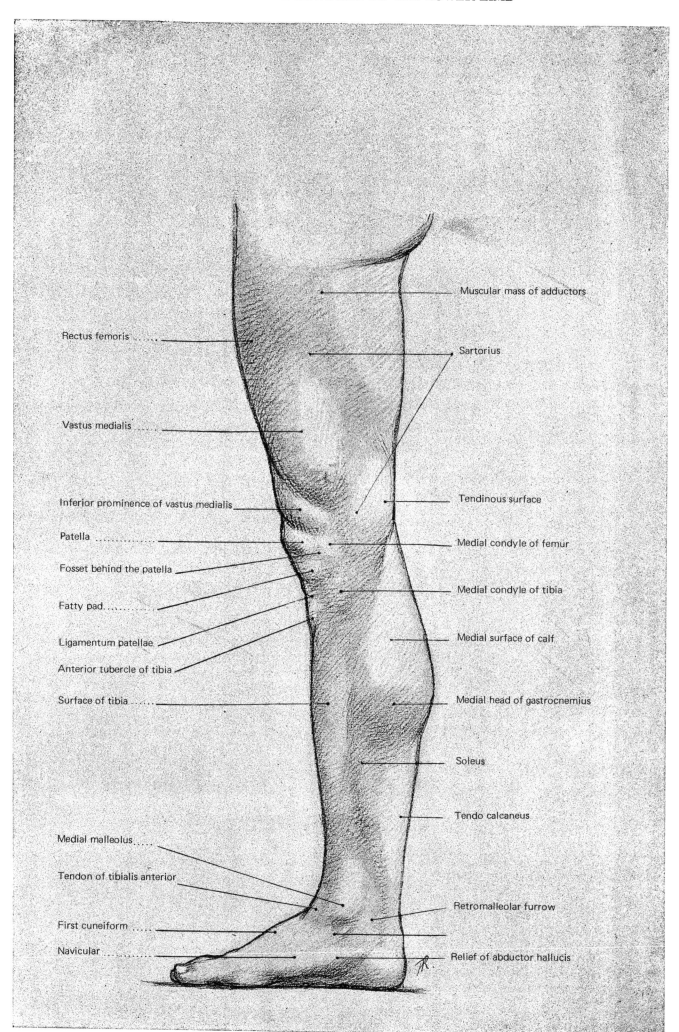

Muscular mass of adductors

Rectus femoris

Sartorius

Vastus medialis

Tendinous surface

Inferior prominence of vastus medialis

Medial condyle of femur

Patella

Fosset behind the patella

Medial condyle of tibia

Fatty pad

Medial surface of calf

Ligamentum patellae

Anterior tubercle of tibia

Surface of tibia

Medial head of gastrocnemius

Soleus

Tendo calcaneus

Medial malleolus

Tendon of tibialis anterior

First cuneiform

Retromalleolar furrow

Navicular

Relief of abductor hallucis

MEDIAL ASPECT

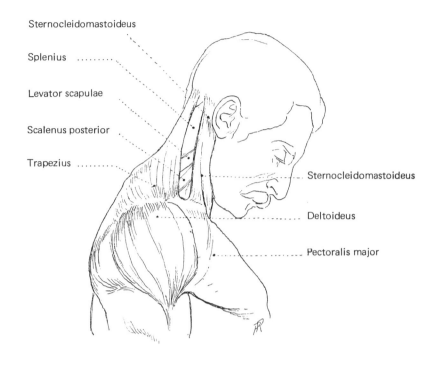

Sternocleidomastoideus

Splenius

Levator scapulae

Scalenus posterior

Trapezius

Sternocleidomastoideus

Deltoideus

Pectoralis major

FIGURE 1: FLEXION

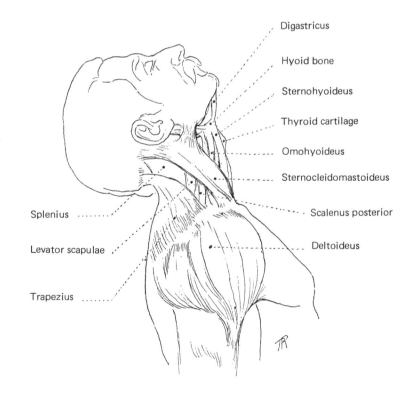

Digastricus

Hyoid bone

Sternohyoideus

Thyroid cartilage

Omohyoideus

Sternocleidomastoideus

Scalenus posterior

Deltoideus

Splenius

Levator scapulae

Trapezius

FIGURE 2: EXTENSION

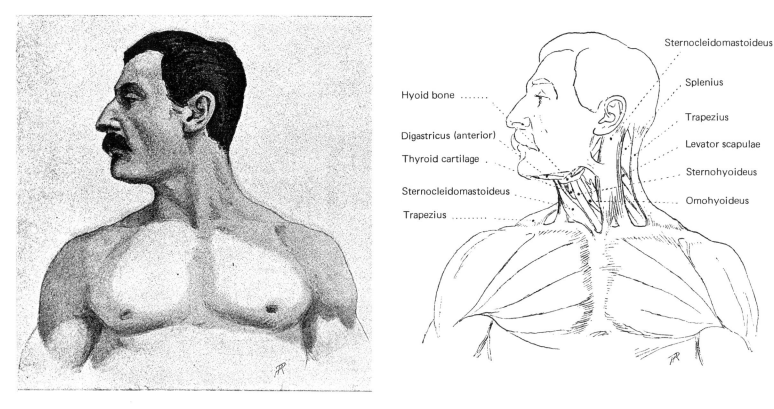

FIGURE 1: ROTATION

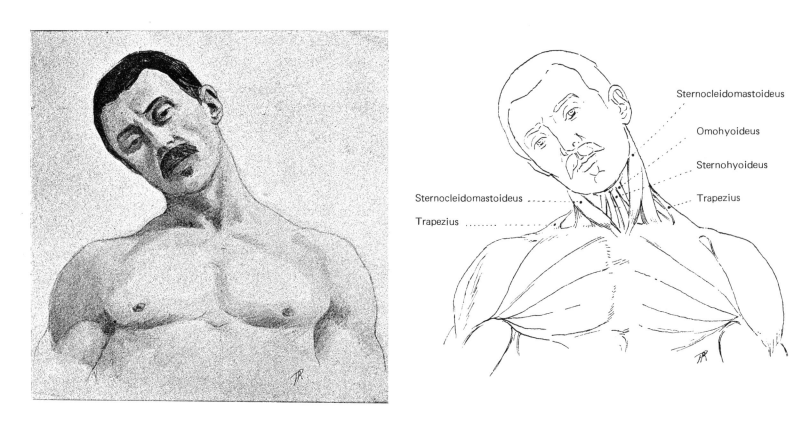

FIGURE 2: LATERAL INCLINATION

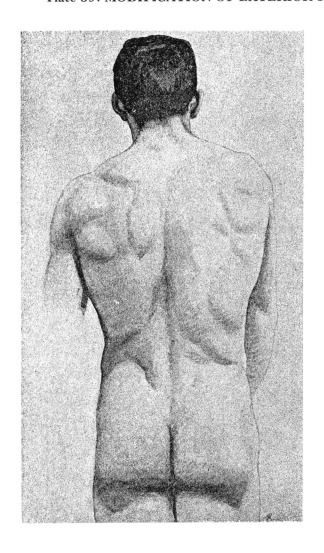

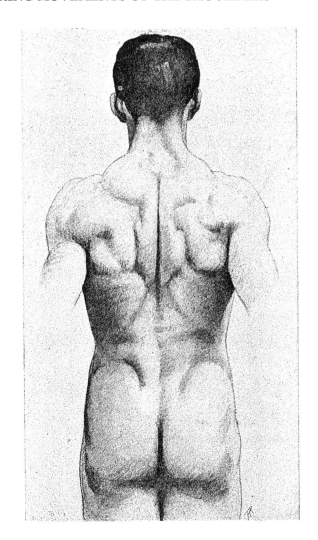

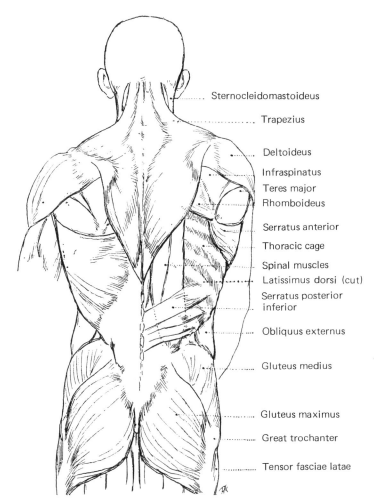

Sternocleidomastoideus

Trapezius

Deltoideus

Infraspinatus

Teres major

Rhomboideus

Serratus anterior

Thoracic cage

Spinal muscles

Latissimus dorsi (cut)

Serratus posterior inferior

Obliquus externus

Gluteus medius

Gluteus maximus

Great trochanter

Tensor fasciae latae

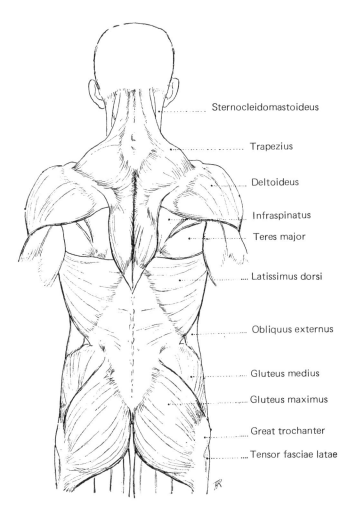

Sternocleidomastoideus

Trapezius

Deltoideus

Infraspinatus

Teres major

Latissimus dorsi

Obliquus externus

Gluteus medius

Gluteus maximus

Great trochanter

Tensor fasciae latae

FIGURE 1: RIGHT SHOULDER CARRIED TO THE FRONT

FIGURE 2: BOTH SHOULDERS DRAWN BACK

Plate 90: MODIFICATION OF EXTERIOR FORM
DURING MOVEMENTS OF THE SHOULDERS

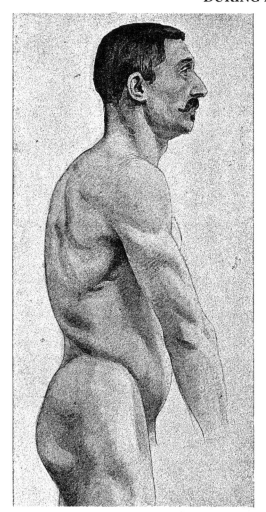

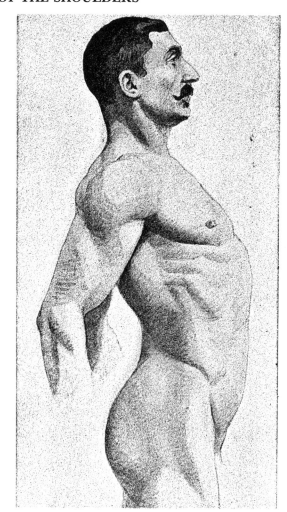

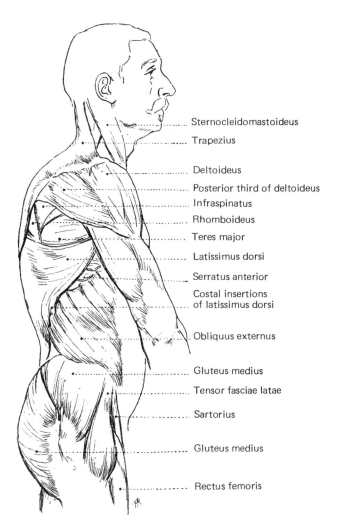

Sternocleidomastoideus

Trapezius

Deltoideus

Posterior third of deltoideus

Infraspinatus

Rhomboideus

Teres major

Latissimus dorsi

Serratus anterior

Costal insertions
of latissimus dorsi

Obliquus externus

Gluteus medius

Tensor fasciae latae

Sartorius

Gluteus medius

Rectus femoris

FIGURE 1: SHOULDERS DRAWN FORWARD

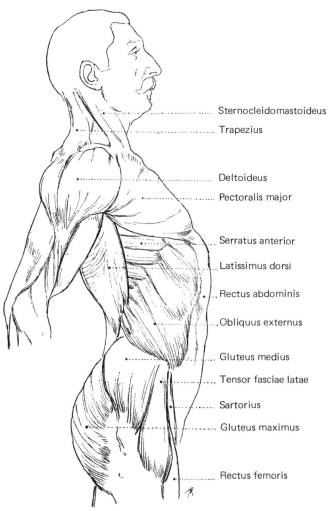

Sternocleidomastoideus

Trapezius

Deltoideus

Pectoralis major

Serratus anterior

Latissimus dorsi

Rectus abdominis

Obliquus externus

Gluteus medius

Tensor fasciae latae

Sartorius

Gluteus maximus

Rectus femoris

FIGURE 2: SHOULDERS DRAWN BACK

Plate 91: MODIFICATIONS OF EXTERIOR FORM
DURING MOVEMENTS OF THE ARM

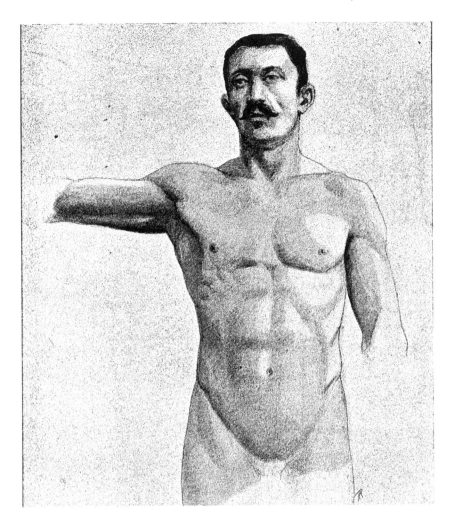

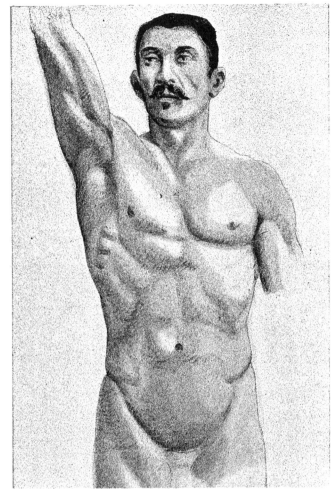

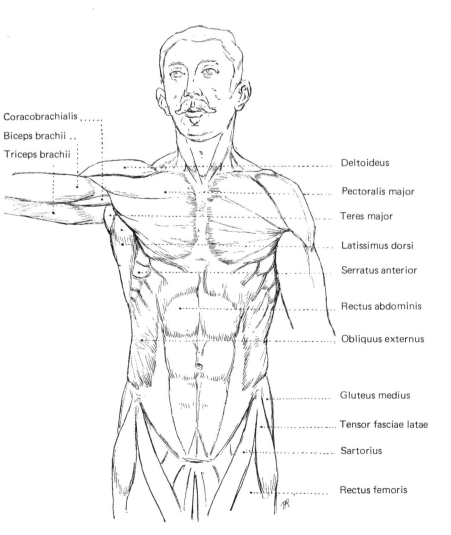

Coracobrachialis
Biceps brachii
Triceps brachii

Deltoideus

Pectoralis major

Teres major

Latissimus dorsi

Serratus anterior

Rectus abdominis

Obliquus externus

Gluteus medius

Tensor fasciae latae

Sartorius

Rectus femoris

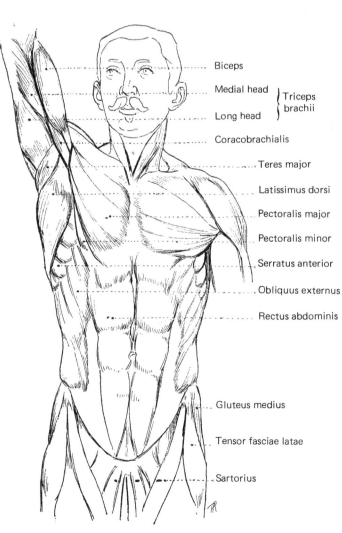

Biceps

Medial head ⎫ Triceps
Long head ⎭ brachii

Coracobrachialis

Teres major

Latissimus dorsi

Pectoralis major

Pectoralis minor

Serratus anterior

Obliquus externus

Rectus abdominis

Gluteus medius

Tensor fasciae latae

Sartorius

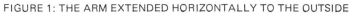

FIGURE 1: THE ARM EXTENDED HORIZONTALLY TO THE OUTSIDE

FIGURE 2: THE ARM LIFTED VERTICALLY

Plate 92: MODIFICATIONS OF EXTERIOR FORM
DURING MOVEMENTS OF THE ARM

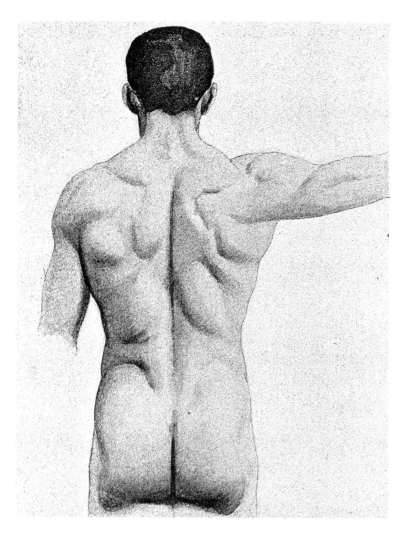

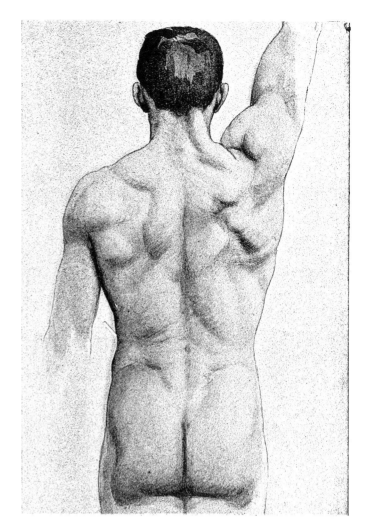

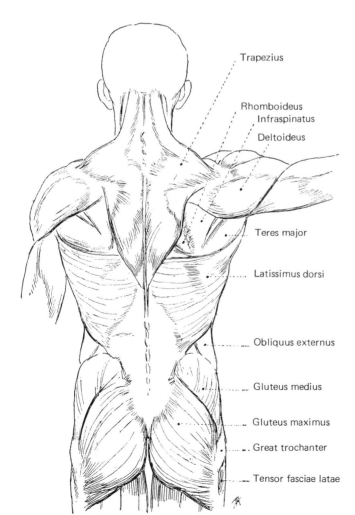

Trapezius

Rhomboideus
Infraspinatus

Deltoideus

Teres major

Latissimus dorsi

Obliquus externus

Gluteus medius

Gluteus maximus

Great trochanter

Tensor fasciae latae

FIGURE 1: THE ARM EXTENDED HORIZONTALLY TO THE OUTSIDE

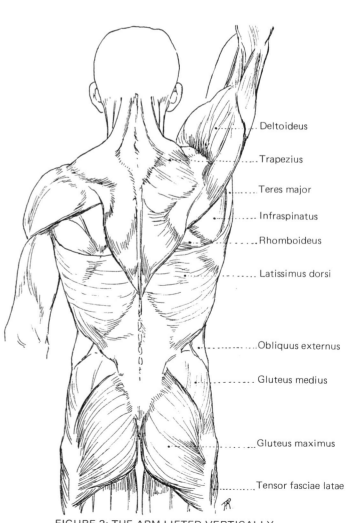

Deltoideus

Trapezius

Teres major

Infraspinatus

Rhomboideus

Latissimus dorsi

Obliquus externus

Gluteus medius

Gluteus maximus

Tensor fasciae latae

FIGURE 2: THE ARM LIFTED VERTICALLY

Plate 93: MODIFICATIONS OF EXTERIOR FORM DURING MOVEMENTS OF THE ARM

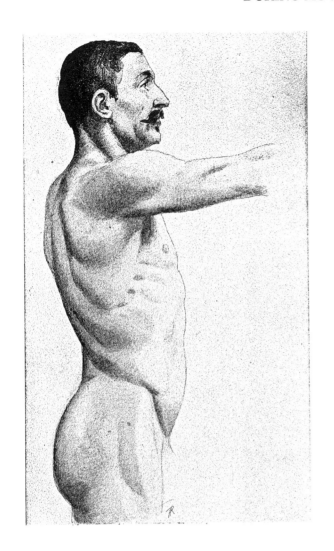

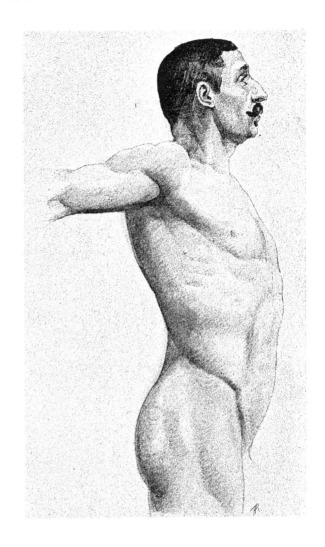

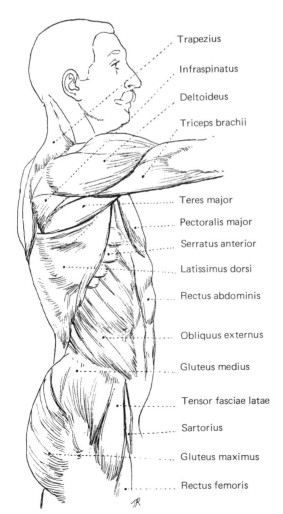

Trapezius

Infraspinatus

Deltoideus

Triceps brachii

Teres major

Pectoralis major

Serratus anterior

Latissimus dorsi

Rectus abdominis

Obliquus externus

Gluteus medius

Tensor fasciae latae

Sartorius

Gluteus maximus

Rectus femoris

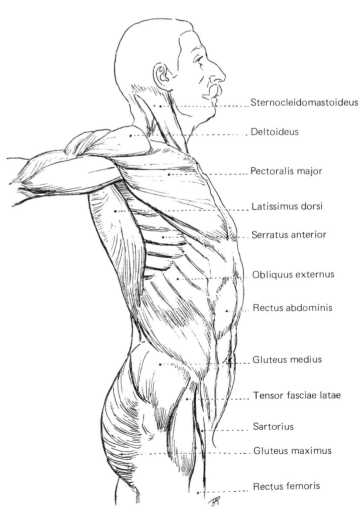

Sternocleidomastoideus

Deltoideus

Pectoralis major

Latissimus dorsi

Serratus anterior

Obliquus externus

Rectus abdominis

Gluteus medius

Tensor fasciae latae

Sartorius

Gluteus maximus

Rectus femoris

FIGURE 1: THE ARM EXTENDED HORIZONTALLY TO THE FRONT

FIGURE 2: THE ARM EXTENDED HORIZONTALLY TO THE BACK

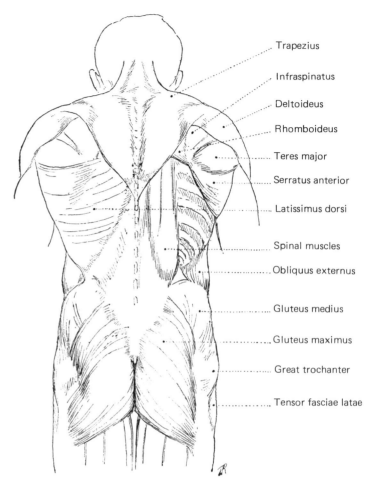

Trapezius

Infraspinatus

Deltoideus

Rhomboideus

Teres major

Serratus anterior

Latissimus dorsi

Spinal muscles

Obliquus externus

Gluteus medius

Gluteus maximus

Great trochanter

Tensor fasciae latae

Note: The latissimus dorsi muscle on the right side has been completely left out to allow the deep muscles to show.

LIGHT FLEXION

Plate 95: MOVEMENTS OF THE TRUNK

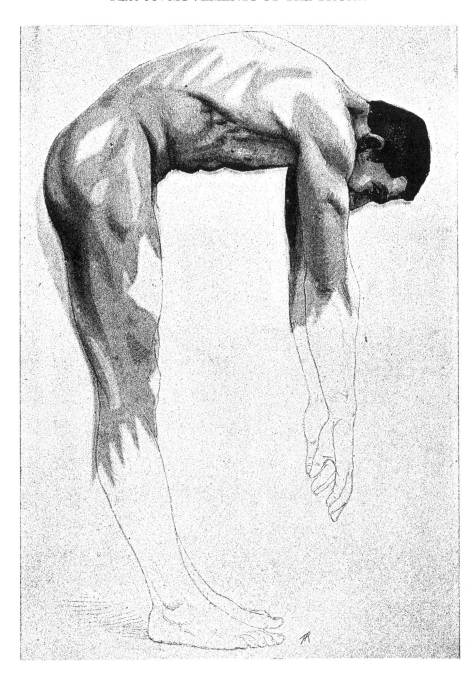

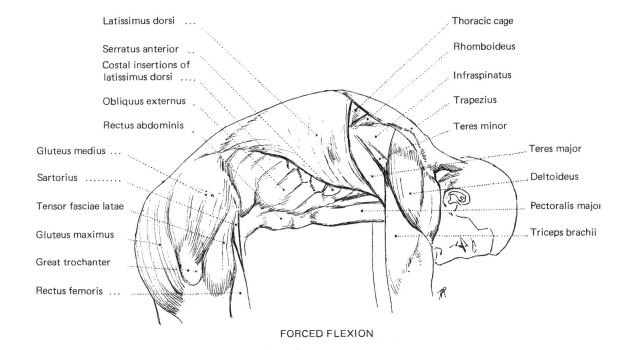

Latissimus dorsi ...
Serratus anterior ..
Costal insertions of
latissimus dorsi
Obliquus externus
Rectus abdominis
Gluteus medius ...
Sartorius
Tensor fasciae latae
Gluteus maximus
Great trochanter
Rectus femoris ...

Thoracic cage
Rhomboideus
Infraspinatus
Trapezius
Teres minor
Teres major
Deltoideus
Pectoralis major
Triceps brachii

FORCED FLEXION

Plate 96: MOVEMENTS OF THE TRUNK

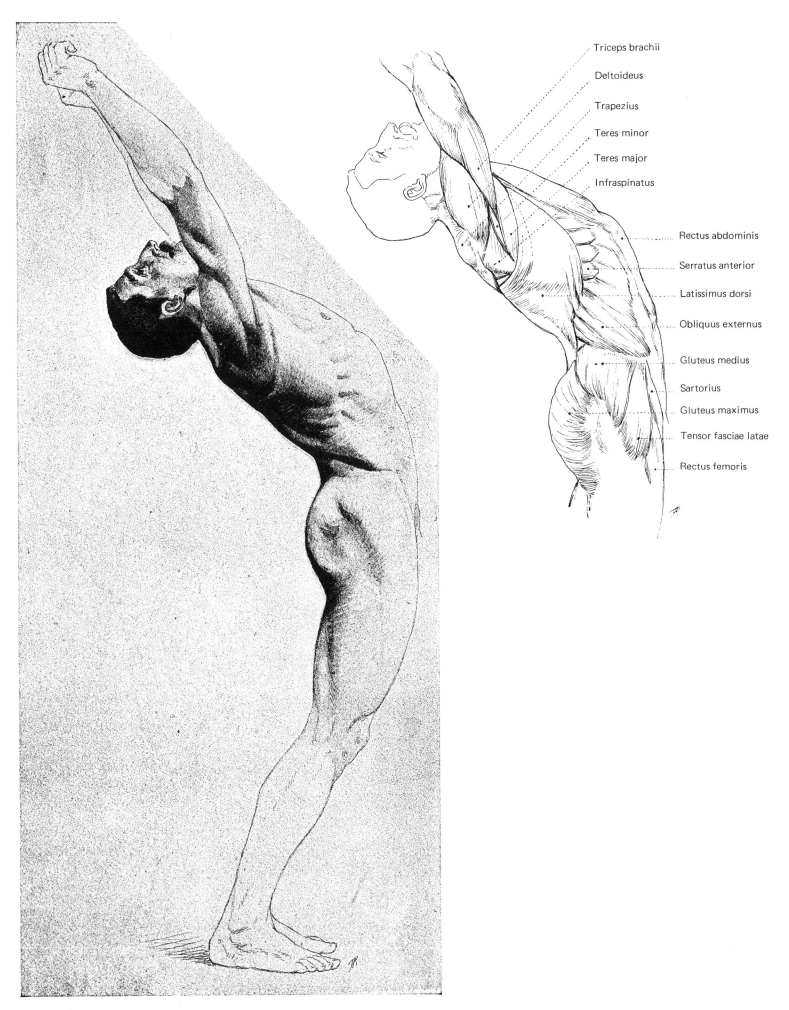

Triceps brachii

Deltoideus

Trapezius

Teres minor

Teres major

Infraspinatus

Rectus abdominis

Serratus anterior

Latissimus dorsi

Obliquus externus

Gluteus medius

Sartorius

Gluteus maximus

Tensor fasciae latae

Rectus femoris

EXTENSION

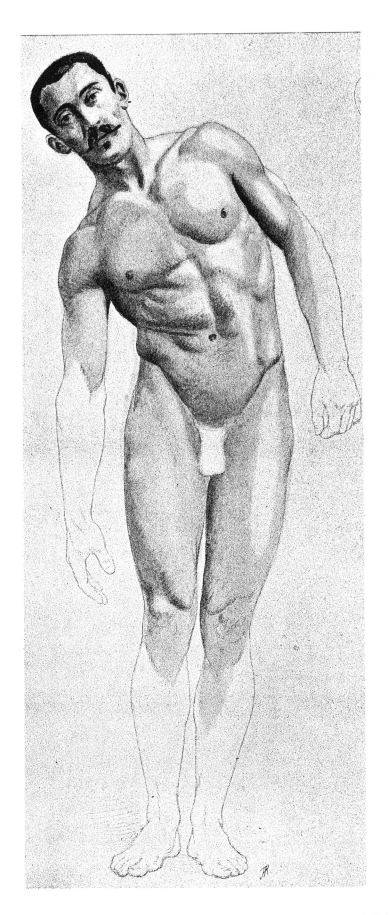

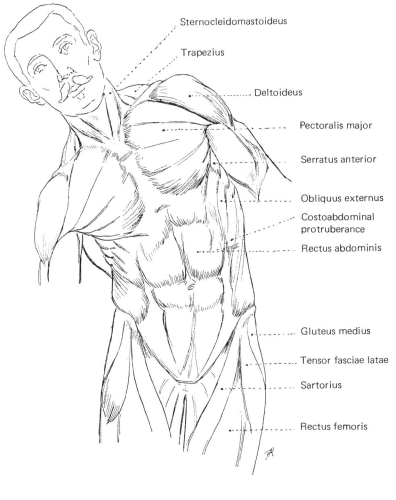

Sternocleidomastoideus

Trapezius

Deltoideus

Pectoralis major

Serratus anterior

Obliquus externus

Costoabdominal
protruberance

Rectus abdominis

Gluteus medius

Tensor fasciae latae

Sartorius

Rectus femoris

LATERAL INCLINATION
ANTERIOR ASPECT

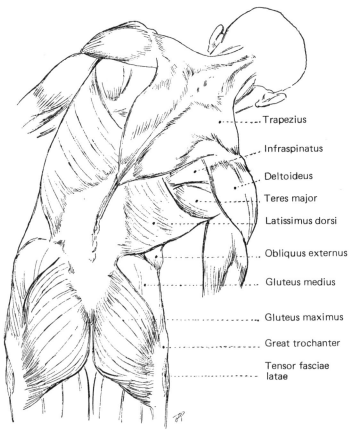

Trapezius

Infraspinatus

Deltoideus

Teres major

Latissimus dorsi

Obliquus externus

Gluteus medius

Gluteus maximus

Great trochanter

Tensor fasciae latae

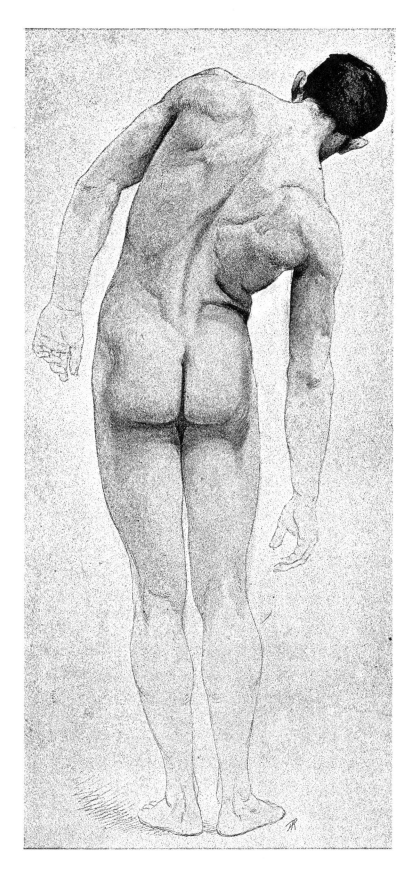

LATERAL INCLINATION
POSTERIOR ASPECT

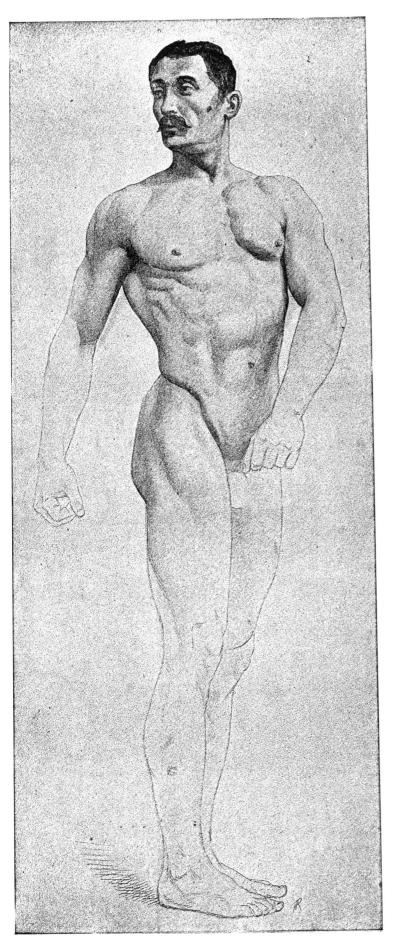

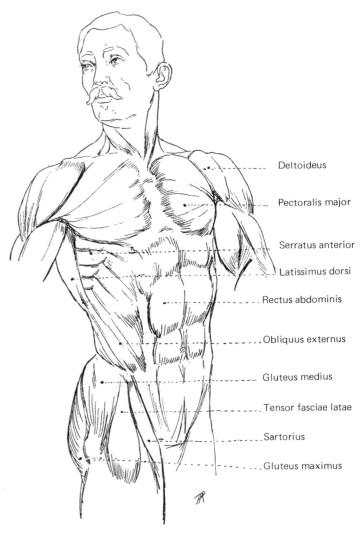

Deltoideus

Pectoralis major

Serratus anterior

Latissimus dorsi

Rectus abdominis

Obliquus externus

Gluteus medius

Tensor fasciae latae

Sartorius

Gluteus maximus

ROTATION
(towards the right)

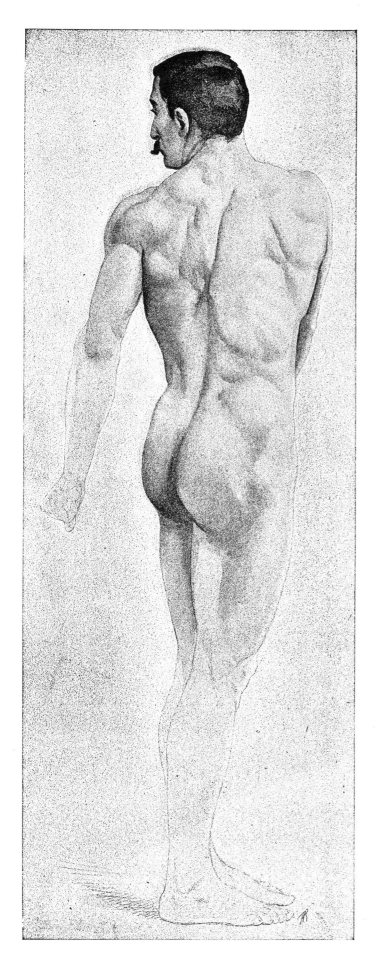

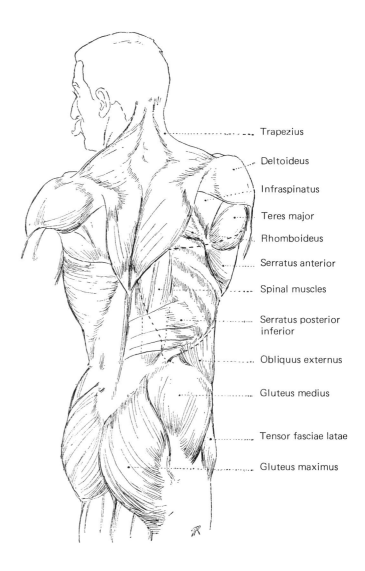

Trapezius

Deltoideus

Infraspinatus

Teres major

Rhomboideus

Serratus anterior

Spinal muscles

Serratus posterior
inferior

Obliquus externus

Gluteus medius

Tensor fasciae latae

Gluteus maximus

Note: In this sketch, the latissimus dorsi on the right side has been
left out. The dotted lines indicate the area occupied by its
fleshy body.

ROTATION
(towards the left)

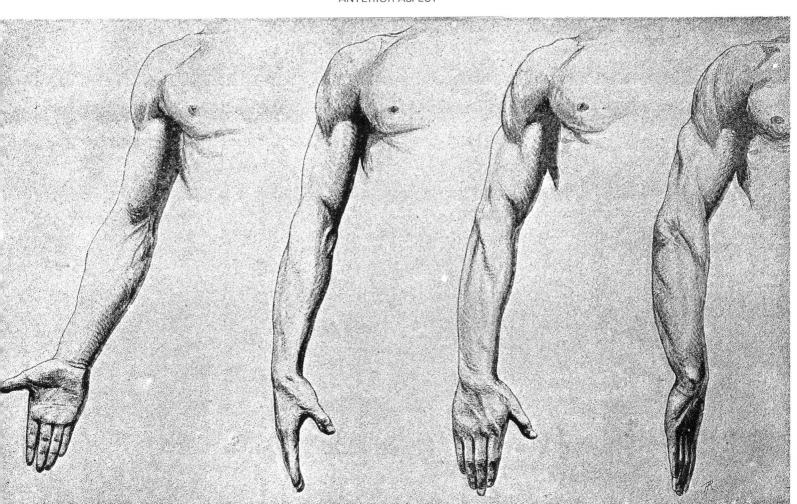

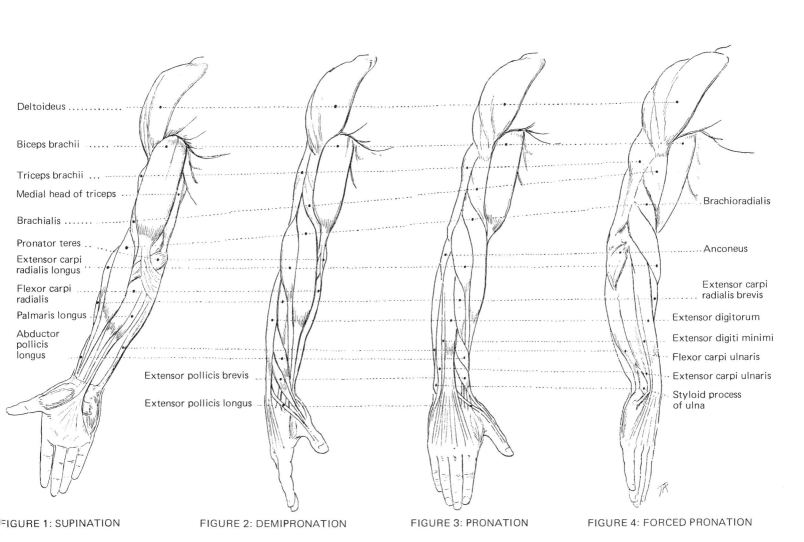

Deltoideus

Biceps brachii

Triceps brachii

Medial head of triceps

Brachialis

Pronator teres

Extensor carpi radialis longus

Flexor carpi radialis

Palmaris longus

Abductor pollicis longus

Extensor pollicis brevis

Extensor pollicis longus

Brachioradialis

Anconeus

Extensor carpi radialis brevis

Extensor digitorum

Extensor digiti minimi

Flexor carpi ulnaris

Extensor carpi ulnaris

Styloid process of ulna

FIGURE 1: SUPINATION FIGURE 2: DEMIPRONATION FIGURE 3: PRONATION FIGURE 4: FORCED PRONATION

Plate 102: MOVEMENTS OF THE UPPER LIMB

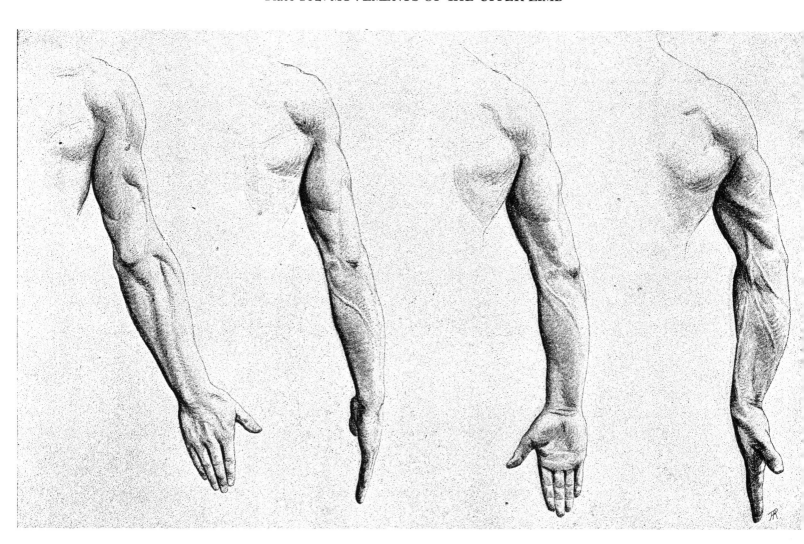

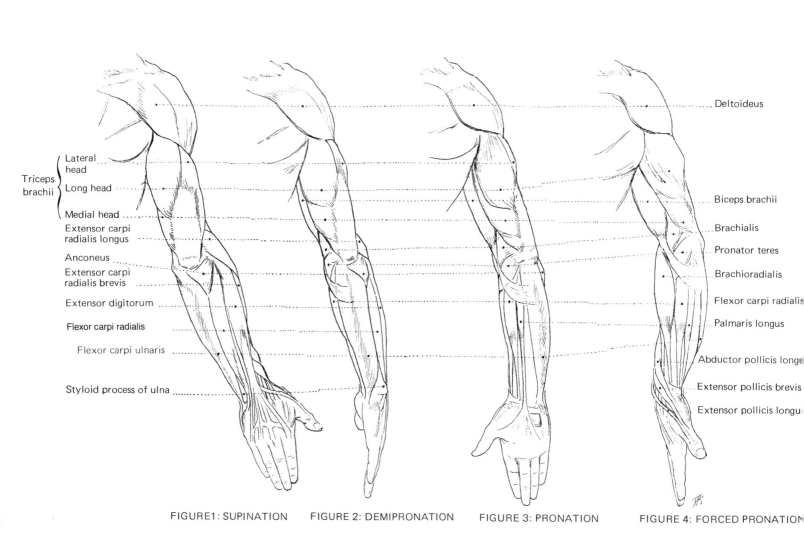

Triceps brachii
- Lateral head
- Long head
- Medial head

Extensor carpi radialis longus

Anconeus

Extensor carpi radialis brevis

Extensor digitorum

Flexor carpi radialis

Flexor carpi ulnaris

Styloid process of ulna

Deltoideus

Biceps brachii

Brachialis

Pronator teres

Brachioradialis

Flexor carpi radialis

Palmaris longus

Abductor pollicis longus

Extensor pollicis brevis

Extensor pollicis longus

FIGURE1: SUPINATION FIGURE 2: DEMIPRONATION FIGURE 3: PRONATION FIGURE 4: FORCED PRONATION

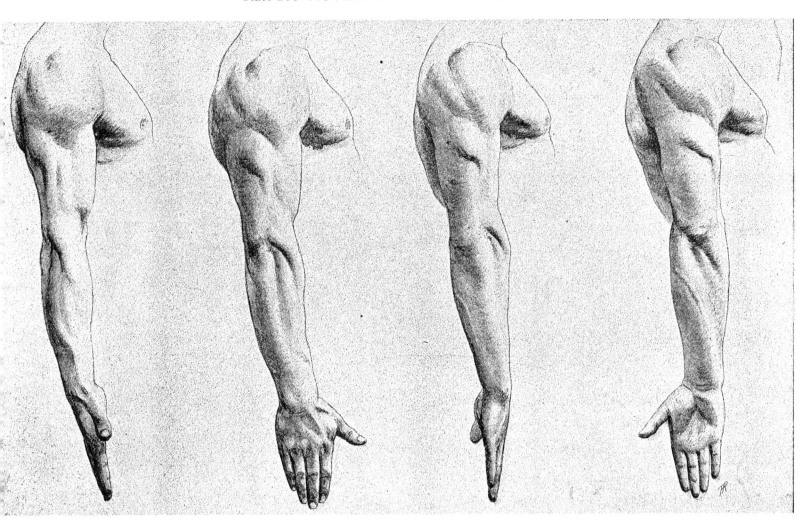

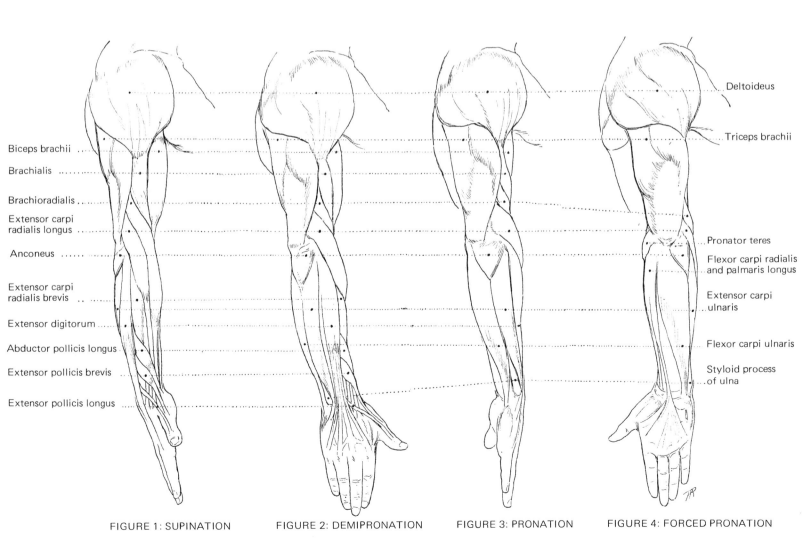

Deltoideus

Triceps brachii

Biceps brachii

Brachialis

Brachioradialis

Extensor carpi
radialis longus

Pronator teres

Anconeus

Flexor carpi radialis
and palmaris longus

Extensor carpi
radialis brevis

Extensor carpi
ulnaris

Extensor digitorum

Abductor pollicis longus

Flexor carpi ulnaris

Extensor pollicis brevis

Styloid process
of ulna

Extensor pollicis longus

FIGURE 1: SUPINATION FIGURE 2: DEMIPRONATION FIGURE 3: PRONATION FIGURE 4: FORCED PRONATION

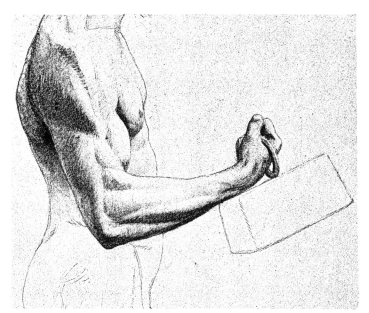

FIGURE 1: FLEXION AT RIGHT ANGLE

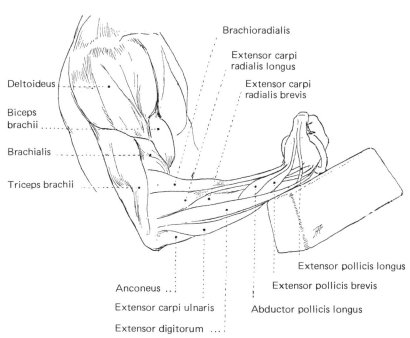

Deltoideus

Biceps
brachii

Brachialis

Triceps brachii

Brachioradialis

Extensor carpi
radialis longus

Extensor carpi
radialis brevis

Extensor pollicis longus

Extensor pollicis brevis

Abductor pollicis longus

Anconeus

Extensor carpi ulnaris

Extensor digitorum

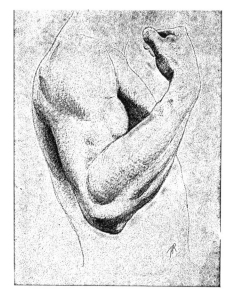

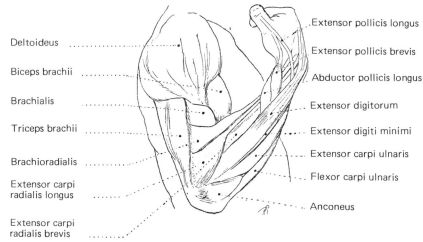

Deltoideus

Biceps brachii

Brachialis

Triceps brachii

Brachioradialis

Extensor carpi
radialis longus

Extensor carpi
radialis brevis

Extensor pollicis longus

Extensor pollicis brevis

Abductor pollicis longus

Extensor digitorum

Extensor digiti minimi

Extensor carpi ulnaris

Flexor carpi ulnaris

Anconeus

FIGURE 2: FLEXION AT ACUTE ANGLE

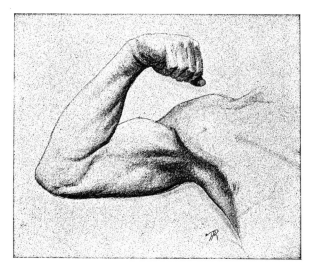

FIGURE 3: FLEXION AT ACUTE ANGLE

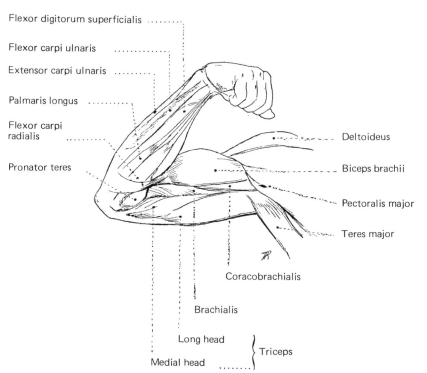

Flexor digitorum superficialis

Flexor carpi ulnaris

Extensor carpi ulnaris

Palmaris longus

Flexor carpi
radialis

Pronator teres

Deltoideus

Biceps brachii

Pectoralis major

Teres major

Coracobrachialis

Brachialis

Long head

Medial head

} Triceps

242

Plate 105: MOVEMENTS OF THE LOWER LIMB

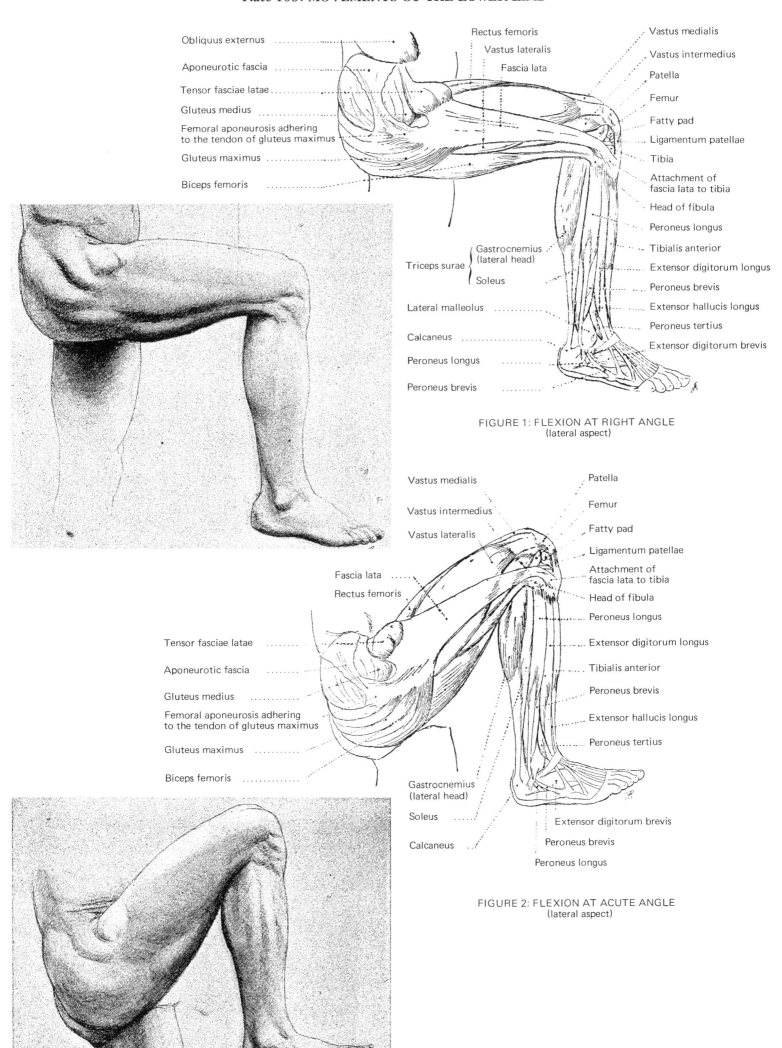

Obliquus externus

Aponeurotic fascia

Tensor fasciae latae

Gluteus medius

Femoral aponeurosis adhering
to the tendon of gluteus maximus

Gluteus maximus

Biceps femoris

Rectus femoris

Vastus lateralis

Fascia lata

Vastus medialis

Vastus intermedius

Patella

Femur

Fatty pad

Ligamentum patellae

Tibia

Attachment of
fascia lata to tibia

Head of fibula

Peroneus longus

Tibialis anterior

Extensor digitorum longus

Peroneus brevis

Extensor hallucis longus

Peroneus tertius

Extensor digitorum brevis

Triceps surae { Gastrocnemius (lateral head) / Soleus }

Lateral malleolus

Calcaneus

Peroneus longus

Peroneus brevis

FIGURE 1: FLEXION AT RIGHT ANGLE
(lateral aspect)

Vastus medialis

Vastus intermedius

Vastus lateralis

Fascia lata

Rectus femoris

Tensor fasciae latae

Aponeurotic fascia

Gluteus medius

Femoral aponeurosis adhering
to the tendon of gluteus maximus

Gluteus maximus

Biceps femoris

Patella

Femur

Fatty pad

Ligamentum patellae

Attachment of
fascia lata to tibia

Head of fibula

Peroneus longus

Extensor digitorum longus

Tibialis anterior

Peroneus brevis

Extensor hallucis longus

Peroneus tertius

Gastrocnemius
(lateral head)

Soleus

Calcaneus

Extensor digitorum brevis

Peroneus brevis

Peroneus longus

FIGURE 2: FLEXION AT ACUTE ANGLE
(lateral aspect)

Plate 106: MOVEMENTS OF THE LOWER LIMB

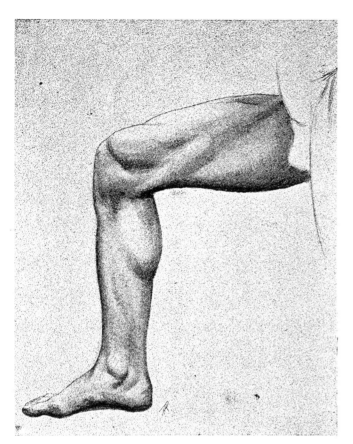

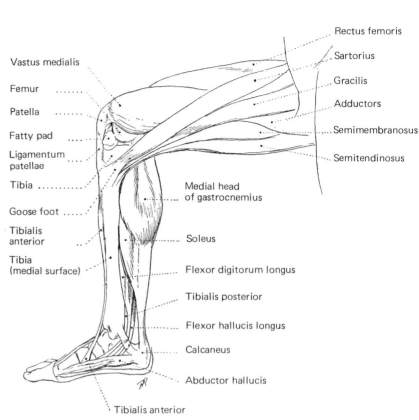

Vastus medialis

Femur

Patella

Fatty pad

Ligamentum patellae

Tibia

Goose foot

Tibialis anterior

Tibia (medial surface)

Rectus femoris

Sartorius

Gracilis

Adductors

Semimembranosus

Semitendinosus

Medial head of gastrocnemius

Soleus

Flexor digitorum longus

Tibialis posterior

Flexor hallucis longus

Calcaneus

Abductor hallucis

Tibialis anterior

FIGURE 1. FLEXION AT RIGHT ANGLE
MEDIAL ASPECT

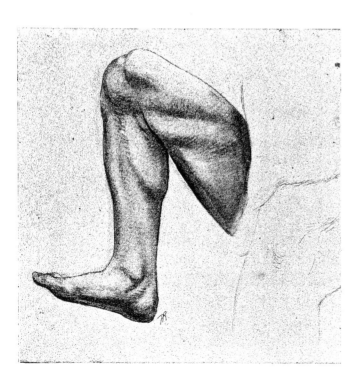

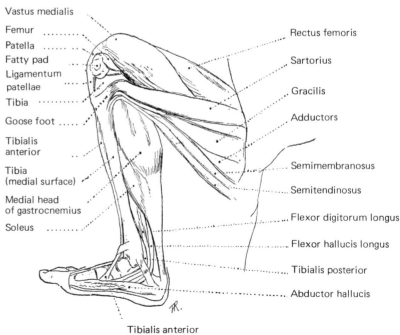

Vastus medialis

Femur

Patella

Fatty pad

Ligamentum patellae

Tibia

Goose foot

Tibialis anterior

Tibia (medial surface)

Medial head of gastrocnemius

Soleus

Rectus femoris

Sartorius

Gracilis

Adductors

Semimembranosus

Semitendinosus

Flexor digitorum longus

Flexor hallucis longus

Tibialis posterior

Abductor hallucis

Tibialis anterior

FIGURE 2. FLEXION AT ACUTE ANGLE
MEDIAL ASPECT

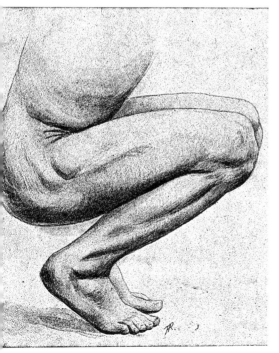
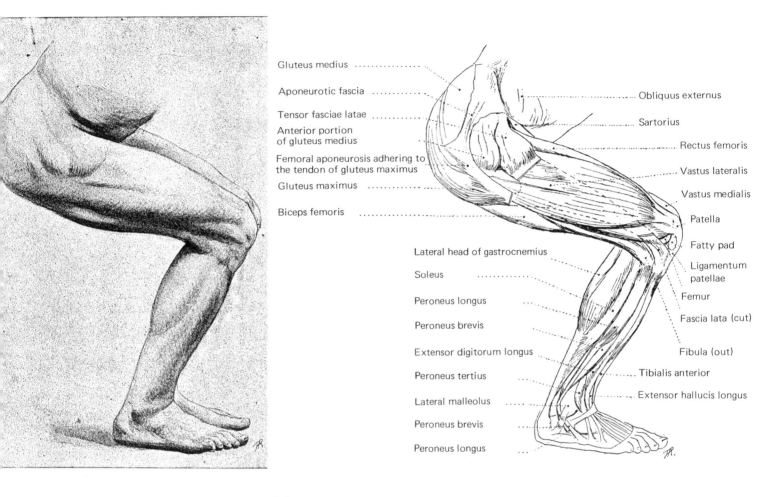

Gluteus medius ·············

Aponeurotic fascia ··········

Tensor fasciae latae ·········

Anterior portion
of gluteus medius

Femoral aponeurosis adhering to
the tendon of gluteus maximus

Gluteus maximus ············

Biceps femoris ···············

Obliquus externus

Sartorius

Rectus femoris

Vastus lateralis

Vastus medialis

Patella

Fatty pad

Ligamentum
patellae

Femur

Fascia lata (cut)

Fibula (out)

Tibialis anterior

Extensor hallucis longus

Lateral head of gastrocnemius

Soleus ··············

Peroneus longus

Peroneus brevis

Extensor digitorum longus

Peroneus tertius

Lateral malleolus ·········

Peroneus brevis

Peroneus longus

FIGURE 1. FLEXION TO RIGHT ANGLE,
FEET ON THE GROUND

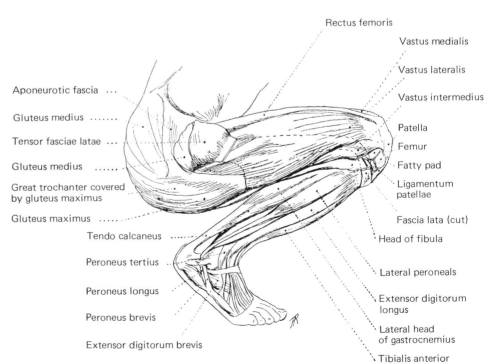

Rectus femoris

Vastus medialis

Vastus lateralis

Vastus intermedius

Patella

Femur

Fatty pad

Ligamentum
patellae

Fascia lata (cut)

Head of fibula

Lateral peroneals

Extensor digitorum
longus

Lateral head
of gastrocnemius

Tibialis anterior

Aponeurotic fascia ···

Gluteus medius ·······

Tensor fasciae latae ···

Gluteus medius ······

Great trochanter covered
by gluteus maximus

Gluteus maximus ·····

Tendo calcaneus

Peroneus tertius

Peroneus longus

Peroneus brevis

Extensor digitorum brevis

FIGURE 2. FLEXION TO ACUTE ANGLE,
FEET ON THE GROUND

245

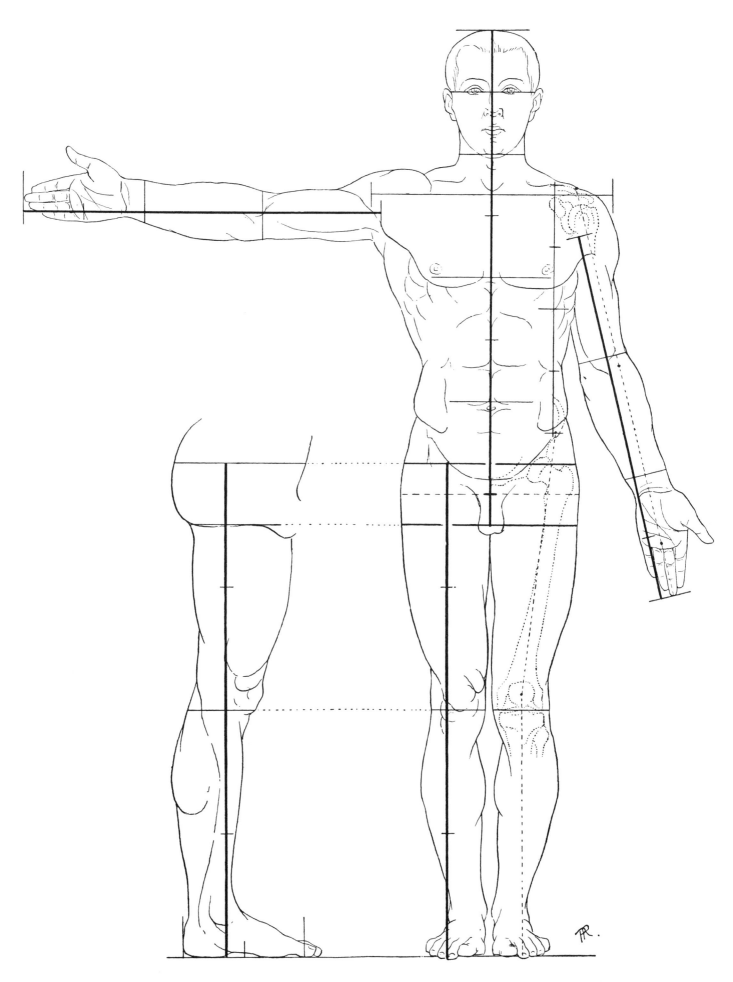

ANTERIOR ASPECT

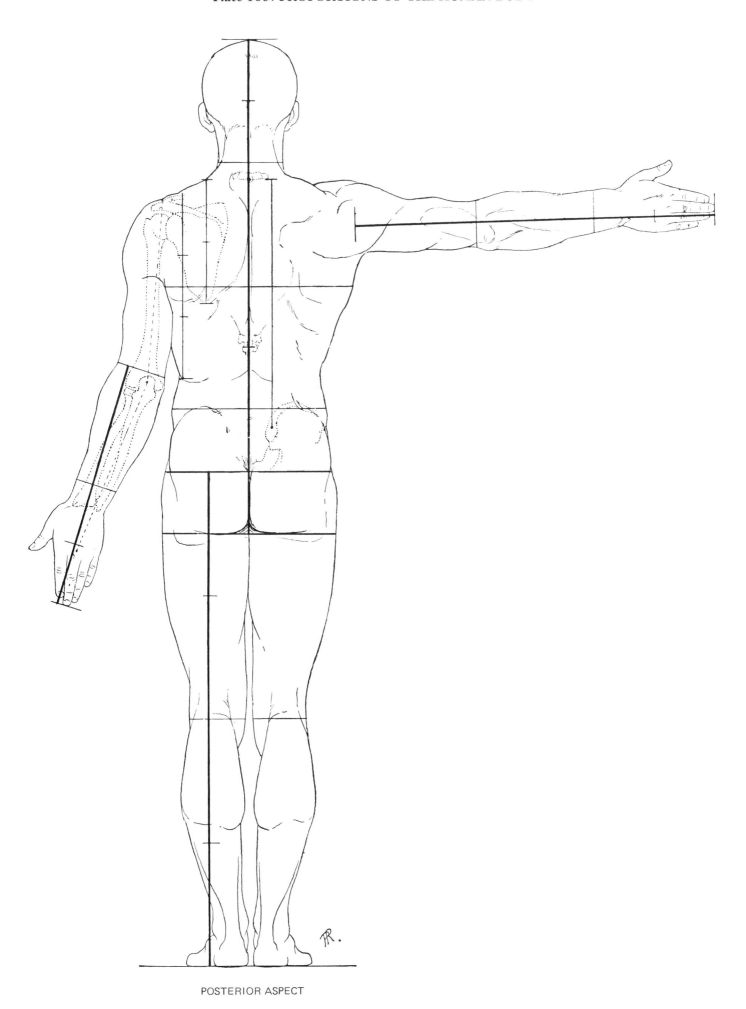

POSTERIOR ASPECT

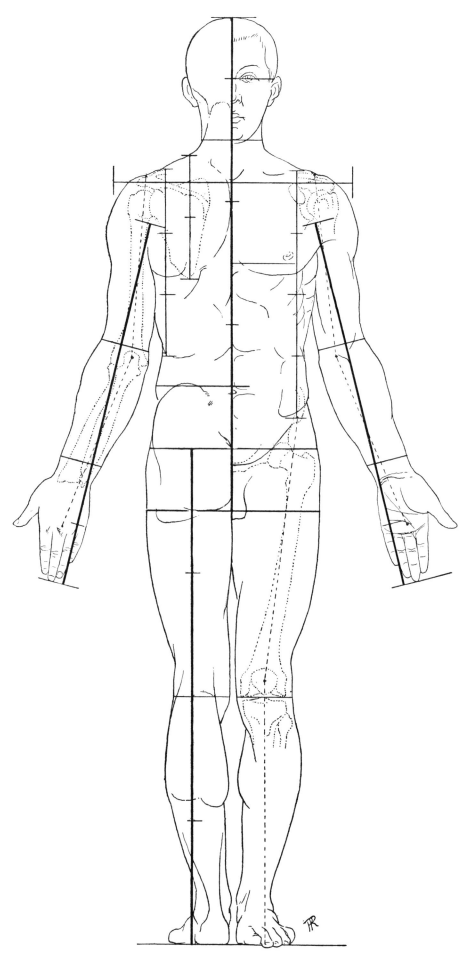

ANTERIOR AND POSTERIOR ASPECTS UNITED

Index

casians, Europeans, Negroes, Yellow races), 27; influence on form of, 34; lateral aspect of, 27; movements of, 28; posterior aspect of, 27

Vertebral arch, 24-25

Vertebral foramen, 24-25

Vertebral column, in general, 26-27; mechanism of, 27

Vomer, 22

Wrinkles, 80-81; of age, 81; of bend of arm, 80; of extensors of fingers, 80; of bend of knee, 80; of flexion of neck, 80; of flexion of trunk, 80; of locomotion, 80; of skin, 80-81; papilliary, of hand, 81; papilliary, of foot, 81; semicircular, of abdomen, 80

Wrist, articulation with hand 38-39; exterior form of, 112-113; mechanism with hand, 39

Xiphoid process, 29, 31

Yellow ligaments, 25-26

Zygomatic arch, 22

Zygomatic bones, 21, 22

Zygomatic processes, 21, 23

Zygomaticus major, 51

Zygomaticus minor, 51

Edited by Heather Meredith-Owens
Designed by James Craig and Robert Fillie.
Set in eleven point Baskerville
Graphic Production by Frank De Luca